# 中国出土壁画全集

徐光冀／主编

科学出版社

北京

# 版 权 声 明

本书所有内容，包括文字内容（中英文）、图片内容、版面设计、内容分类以及其他任何本书信息，均受《中华人民共和国著作权法》保护，为相关权利人专属所有。未经本书相关权利人特别授权，任何人不得转载、复制、重制、改动或利用本书内容，否则我们将依法追究法律责任。特此声明！

图书在版编目（CIP）数据

中国出土壁画全集／徐光冀主编.—北京：科学出版社，2011
ISBN 978-7-03-030720-0

Ⅰ．①中... Ⅱ．①徐... Ⅲ．①墓室壁画-美术考古-中国-图集
Ⅳ．①K879.412

中国版本图书馆CIP数据核字（2011）第058079号

审图号：GS（2011）76号

责任编辑：闫向东／封面设计：黄华斌 陈 敬
责任印制：赵德静

科学出版社出版
北京东黄城根北街16号
邮政编码：100717
http://www.sciencep.com

北京天时彩色印刷有限公司印刷
科学出版社发行 各地新华书店经销

\*

2012年1月第 一 版　开本：889×1194　1/16
2012年1月第一次印刷　印张：160
印数：1-2 000　字数：1280 000

定价：3980.00元
（如有印装质量问题，我社负责调换）

# THE COMPLETE COLLECTION OF MURALS UNEARTHED IN CHINA

Xu Guangji

Science Press

Beijing

**Science Press**

**16 Donghuangchenggen North Street, Beijing,**

**P.R.China, 100717**

*Copyright 2011, Science Press and Beijing Institute of Jade Culture*

**ISBN 978–7–03–030720–0**

# 《中国出土壁画全集》编委会

# 凡　例

1. 《中国出土壁画全集》为"中国出土文物大系"之组成部分。

2. 全书共10册。出土壁画资料丰富的省区单独成册，或为上、下册；其余省、自治区、直辖市根据地域相近或所收数量多寡，编为3册。

3. 本书所选资料，均由各省、自治区、直辖市的文博、考古机构提供。选入的资料兼顾了壁画所属时代、壁画内容及分布区域。所收资料截至2009年。

4. 全书设前言、中国出土壁画分布示意图、中国出土壁画分布地点及时代一览表。每册有概述。

5. 关于图像的编辑排序、定名、时代、尺寸、图像说明：

**编辑排序**：图像排序时，以朝代先后为序；同一朝代中纪年明确的资料置于前面，无纪年的资料置于后面。

**定　名**：每幅图像除有明确榜题外，均根据内容定名。如是局部图像，则在原图名后加"（局部）"；如是同一图像的不同部分，则在图名后加"（一）（二）（三）……"；临摹图像均注明"摹本"。

**时　代**：先写朝代名称，再写公元纪年。

**尺　寸**：单位为厘米。大部分表述壁画尺寸，少数表述具体物像尺寸，个别资料缺失的标明"尺寸不详"。

**图像说明**：包括墓向、位置、内容描述。个别未介绍墓向、位置者，因原始资料缺乏。

6. 本全集按照《中华人民共和国行政区划简册·2008》的排序编排卷册。卷册顺序优先排列单独成册的，多省市区合卷的图像资料亦按照地图排序编排。编委会的排序也按照图像排序编定。

《中国出土壁画全集》编委会

# 中国出土壁画全集

— **10** —

北京　江苏　浙江　福建　江西　湖北　广东
BEIJING JIANGSU ZHEJIANG FUJIAN JIANGXI HUBEI GUANGDONG
重庆　四川　云南　西藏
CHONGQING SICHUAN YUNNAN XIZANG

主　编：宋大川　王奇志　刘　斌　杨　琮　樊昌生　孟华平　黄道钦
　　　　邹后曦　高大伦　杨德聪　俞达瓦

Edited by Song Dachuan, Wang Qizhi, Liu Bin, Yang Cong, Fan Changsheng, Meng Huaping, Huang Daoqin,

Zou Houxi, Gao Dalun, Yang Decong, Yu Dawa

科学出版社
Science Press

## 北京 江苏 浙江 福建 江西 湖北 广东 重庆 四川 云南 西藏卷
## 编委会名单

**编　委**

宋大川　丁丽娜　董坤玉　张立芳　王奇志　邹厚本　刘　斌　张玉兰　杨　琮
吕锦燕　樊昌生　杨　军　胡　胜　杨　一　孟华平　田桂萍　陈千万　黄道钦
邹后曦　林必忠　刘春鸿　高大伦　于　春　杨德聪　俞达瓦　哈比布　张建林

## 北京 江苏 浙江 福建 江西 湖北 广东 重庆 四川 云南 西藏卷
## 参编单位

北京市文物研究所　　　　　　　　湖北省文物考古研究所
南京博物院　　　　　　　　　　　广东省文物考古研究所
浙江省文物考古研究所　　　　　　重庆市考古研究所
浙江省杭州市博物馆　　　　　　　四川省考古研究院
福建省博物院　　　　　　　　　　云南省文物考古研究所
江西省文物考古研究所　　　　　　西藏自治区文物局

# 北京、江苏、浙江、福建、江西、湖北、广东、重庆、四川、云南、西藏地区出土壁画概述

宋大川　董坤玉　王奇志　文人言　杨琮　杨军　胡胜　田桂萍　林必忠

刘春鸿　于春　杨德聪　张建林　哈比布

## 一、北京地区

迄今为止，北京市共发现魏晋至明清时期的壁画墓40余座，但多数墓的壁画已漫漶不清，保存较好的10余座均为唐、辽、金时期的壁画墓。现择其中重要的加以介绍。

### 1.唐代壁画墓

北京地区共发现唐壁画墓8座，其中保存较完整、最有代表性的是何府君墓与王公淑墓。

1988年清理的何府君墓位于宣武区陶然亭公园东侧的燕京汽车修理厂内，据出土墓志该墓的时代为史思明天顺元年（759年）[1]。墓为单室砖墓，由墓门、甬道、墓室三部分组成。壁画两幅，绘于墓室西壁北侧和北壁西侧。西壁绘墓主像，北壁绘马厩图[2]。

1991年清理的王公淑墓位于海淀区八里庄，为弧方形单室砖墓，由墓道、甬道、墓室三部分组成。墓门外西侧、甬道两侧和墓室东、西、北三壁均绘有壁画。其中墓室北壁的大型屏风画式花鸟图保存最好，在一株花枝繁茂的牡丹花旁，两只嬉戏的芦雁和对舞的蝴蝶栩栩如生[3]。

### 2.辽代壁画墓

北京地区共发现辽代壁画墓16座，这些壁画墓以辽兴宗时期为界，可分为前、后两期。

前期为辽穆宗至辽兴宗时期。这一时期契丹族正由奴隶社会向封建社会过度，北京地区发现的契丹贵族壁画墓极少，而汉族显贵沿袭唐代丧葬习俗，壁画墓较多。典型墓葬以赵德钧与种氏合葬墓、韩佚墓和大兴区青云店墓为代表。

1960年清理的赵德钧与种氏合葬墓位于永定门外马家堡。该墓有前、中、后三进主室，每进主室两侧各有一侧室，每室均绘有壁画。发现时壁画大多已残毁，仅左中室东壁的赏画图、右前室东壁的庖厨图和西壁的侍女图保存较好。根据墓志，该墓埋葬于穆宗应历八年（958年）[4]。墓主赵德钧曾任后唐节度使，封北平王，后归辽，其子赵延寿任辽南京留守，其家族在辽早期显赫一时。这是迄今北京市发现的年代最早、规模最大的辽代壁画墓。

1981年发现的韩佚墓位于石景山区八宝山革命公墓院内。该墓为单室穹隆顶砖墓，甬道和室内满绘壁画。甬道壁绘门吏图。墓室北壁绘两扇花鸟围屏，围屏两侧各绘二侍女；墓室东、西两壁各绘一幅侍女图；墓顶正中绘莲花，四周绘有十二生肖人物。根据墓志，该墓葬于圣宗统和十三年（995年）[5]。墓主韩佚，燕人，其祖韩延徽深得辽太祖耶律阿保机器重，曾任宰相，其家族在辽朝世代显贵。

青云店一、二号辽墓，位于大兴区青云店镇西杭子村王致和腐乳厂西墙外，2002年清理。两墓形制相同，均为圆形单室穹隆顶砖墓，壁画绘于墓室内，其中一号墓壁画保存较好。一号墓室壁四角绘有立柱和斗拱，将壁面分为四个画栏。南壁的墓门两侧各绘一侍女，墓门上方绘花草图案。西壁中央砌棂窗，窗南绘两侍女，窗北绘一簪花侍女，其北绘晾布场面。东壁中央亦砌一棂窗，窗下砖砌桌椅，椅后绘一侍女，窗北绘有妇人手牵童子的戏婴图。北壁中央绘两扇红门，一托盘侍女启门欲入[6]。

后期为辽道宗至辽天祚帝时期。这一时期，契丹贵族已经深受汉族葬俗影响，壁画墓数量大量增加。墓室壁画题材也与中原壁画墓趋同，多家居饮宴和散乐歌舞等内容。刘六符家族墓和斋堂镇辽墓为这一时期辽壁画墓的代表。

刘六符家族墓位于丰台区云岗镇的中国航天科工集团第三研究院院内，共发现两座壁画墓，一号墓为

辽燕国公刘六符及其四位夫人的合葬墓，二号墓为刘六符之子刘雨墓，两墓于2007年发现并清理。刘六符墓为多室砖墓，由墓道、天井、墓门、前室及东西侧室、后室组成，壁画主要绘于墓门、甬道、前室和侧室。墓门两侧和甬道两侧壁各绘一门吏，前室东、西两壁绘出行图。刘雨墓为双室砖墓，由墓道、天井、墓门、前室和后室组成。壁画主要分布在前、后室内，内容有设宴图、托盘侍女图和备宴图等[7]。刘六符，祖籍河间。祖刘景，景宗朝任宰相。其家族在辽累世高官，地位显赫。刘六符卒于辽道宗清宁三年（1057年），刘雨卒于辽天祚帝乾统元年（1101年）。

1979年清理的斋堂镇辽墓位于门头沟区西斋堂村东。该墓为单室穹窿顶砖墓，由墓道、墓门、墓室及东、西侧室组成。壁画分布于甬道两侧、墓室四壁和顶部。甬道东、西两侧壁各绘有二侍女。墓室内的壁画只有西壁、南壁和顶部的保存较好，西壁绘有祭祀、刑讯场面的图像，南壁和墓室西部棺床床档上绘有山水画四幅，墓室顶部绘有莲花图案。在甬道的东、西两壁有"乐堂"和"安堂斋"两条墨书楷体题记。在该墓墓顶附近的地堰上，发现了一件辽天祚帝天庆元年（1111年）的石刻墓幢，因此推测该墓时代为辽代晚期[8]。

### 3. 金代壁画墓

北京地区共清理了金代壁画墓4座，其中有代表性的是晏家堡村金墓和赵励墓。

晏家堡村金墓，2002年发现于延庆县张山营镇晏家堡村北，是一座金初的砖室壁画墓。该墓圆形单室，坐北朝南，由墓道、墓门、甬道、墓室四部分组成。墓室内壁由砖砌倚柱分为八等分，倚柱上饰砖砌斗拱，壁画绘于甬道和墓室内壁。壁画大多残毁，只有四幅保存较好，分别为出行仪仗、侍女、伎乐等内容。壁画线条流畅，色彩艳丽，人物生动，眉目传神[9]。

2002年发现的赵励墓，位于石景山区八角村，墓主赵励为汉族士人，葬于金皇统三年（1143年）。该墓为穹窿顶圆形单室砖墓，南向，由墓道、照壁、墓门、甬道、墓室五部分组成，壁画绘于照壁和墓室内。照壁上的三幅壁画分别绘于墓门的东、西侧和上方，其中墓门东、西侧的壁画已剥落残毁，仅墓门上方的花卉图保存较好。墓室内满绘壁画。墓壁共绘壁画五幅，北壁正中为床榻图，东北壁为备茶图，东南壁为备宴图，西南壁为散乐图，西北壁为奉酒图。墓室顶部绘天象图，天象图下方绘缠枝花图案和十二生肖[10]。

### 4. 小结

北京地区保存较好的唐、辽、金壁画墓，墓主多为贵族，庶民墓较少，贵族墓壁画繁复华美，庶民墓壁画简约朴素。壁画客观反映了当时的社会生活和审美情趣。壁画内容以人物画最多，再现了墓主的日常生活场景；宗教内容壁画占有相当比例，展现了当时社会的思想和信仰；山水画数量较少，直到辽代晚期才出现。辽、金时期的壁画墓，一方面继承了唐壁画墓的传统，又吸收了五代以来盛行的砖雕影作工艺，形成了鲜明的时代特点。这些墓葬壁画，为研究、了解北京地区的古代社会提供了一批全新的形象资料。

## 二、江苏地区

江苏境内发现的古代壁画墓数量屈指可数。最早当推徐州市黄山陇东汉晚期壁画墓[11]，此墓为石结构多室墓，仅在前室发现壁画，画面大多已经剥落。其题材内容，墓门两旁为门吏，门楣上为车马出行；室内壁画为车马出行行列和宴饮场景。同样的题材东汉时期十分盛行。

南朝墓葬有彩绘壁画肯定无疑，南京西善桥陈义阳郡公黄法氍墓是较明显的一座[12]。此墓墓室内壁先涂一层约5毫米的石灰层，其上有断断续续隐约可见的以黄、红、绿等色彩绘的壁画线条，惜其内容因墓室潮湿已漫漶不清，无法辨认。相似的现象还见于南朝帝王陵墓，丹阳胡桥吴家村、建山金家村南朝大墓，原报告推定为齐的帝王陵墓，两墓的甬道口均发现有彩绘壁画，以青绿色为底，用红、白、蓝三色绘龙凤图像[13]。

位于南京市南郊的南唐二陵均为壁画墓[14]。烈主

李昇(937～943年)钦陵墓室内砖砌的阑额、柱头枋、立枋、倚柱、斗拱、转角铺作和补间铺作上均施彩画，主题内容都属花卉图案，色彩浓重艳丽。在后室顶部绘有大幅的天象图，日在东，月在西，其间配置星宿等图像。

1959年，在淮安市楚州区（原淮安县）杨庙镇清理发掘了宋代杨氏家族的五座墓葬[15]，其中一号、二号墓为壁画墓。壁画直接绘在石灰涂白的砖墙上，两墓都有确切的纪年。一号墓为长方形砖券墓，拱门涂朱色，上有"嘉祐五年(1060年)十月初□□"题记，顶部用朱、黑两色彩绘卷草、云纹装饰图案。东、西两壁和后壁绘有壁画，东、西壁中心位置均绘桌椅，桌上置果品和杯、盘、壶、盒之类器皿，旁为众侍仆忙碌的场景；后壁绘床帷。二号墓为长方形平顶砖墓，壁画仅绘在东、西壁和后壁，东、西壁为女伎散乐，后壁绘供案。从二号墓出土的墓志可知，墓主为死于北宋绍圣元年(1094年)的左班殿直杨公佐。

杨氏家族是宋代楚州望族，从两墓的壁画内容可以看到宋代官绅阶层的丧葬观念。两墓壁画内容都以祭奠为主题，一号墓图像线条流畅，人物清晰，二号墓图像人物丰润，线条刚劲，表现出高超的绘画水平，是宋墓壁画中的精品之作。

## 三、浙江地区

浙江省出土壁画全部出自墓葬。早在抗日战争期间，上虞县东关就曾发现东晋太宁年间的一座壁画墓，墓室内残存有人物、凤鸟等图像[16]。20世纪50年代以来，先后在杭州、临安等地，发现了四座墓室顶部绘有天象图的晚唐、吴越时期钱氏家族墓[17]，在嘉善县陶家祠发现了一座墓室内绘有山水、天象、仙人、佛像等图像的明墓[18]。1997年发掘的五代时期第二代吴越王钱元瓘元妃马氏的康陵[19]，是迄今浙江省发现的壁画面积最大、保存最好的壁画墓。

康陵位于临安市玲珑镇祥里村，是一座规模庞大的砖石结构墓，由斜坡墓道、前室及东、西耳室、中室、后室组成，前室及东、西耳室为砖结构，中、后两室为石壁砖券结构，墓向45°。墓虽早年被盗，仍

出土了瓷器、玉器、银器、铜器、铁器、石雕、墓志等珍贵文物312件。根据墓志，墓主马氏葬于后晋天福四年（939年）。

康陵的墓门和前室及东、西耳室、中室均绘有壁画。在红色砂岩墓门门扉和墓门外的拱券砖面上，抹有石灰面地仗层，上绘缠枝牡丹图案。前室壁画因石灰地仗层剥落严重，内容大多已经无法辨识，但墓室转角处彩绘的三组斗拱和后壁门券上的朱红色缠枝牡丹花仍历历可见。东、西两耳室的三壁各绘一株高大的朱红色牡丹。中室壁画配置在东、西两壁，每壁的两上角各绘一朵红绿色云气纹，两下角绘红色火焰状纹饰，壁面中部绘一株盛开的高大牡丹，红花绿叶，花蕊用菱形金箔点缀，色泽鲜艳夺目。

康陵后室的装饰极富特色。其东、西壁和后壁的上缘雕刻出高约50厘米的上下两层牡丹图案花纹带，上层为缠枝牡丹，下层为莲瓣团花牡丹，底色均为红色，用金箔装饰莲瓣边线，白色勾勒花蕊、花叶及花瓣轮廓，花蕊及花叶绘成绿色，花瓣为红色，色彩极为艳丽。在东、西壁的上部浅浮雕的白虎和青龙图像，与墓室石门背面上部和后壁上部小龛中浅浮雕的朱雀、玄武图像构成一组完整的四神图像。四神图像均以彩绘贴金，强烈的色彩反差，使图像充满神秘和动感。在三壁下部和墓室石门背面下部的十二个小龛内，各刻有一尊彩绘贴金的浅浮雕生肖神像。室顶的石板正中刻天象图，用阴线刻出紫微垣和二十八宿的218颗星和一条银河，银河绘成白色，星体和星际间的连线用金箔贴饰。在后室石棺床的四根石枋柱和前后石枋额上，也绘有精美的金凤流云图像。后室的壁面图像虽属于雕刻，但因其色彩艳丽如新，视觉效果与壁画有异曲同工之妙。

综观康陵的壁画题材，大体有两类。一类是牡丹和金凤流云图像，暗喻墓主君王元妃的宫廷贵妇身份。另一类是具有信仰色彩的四神和十二生肖图像，起着护佑墓主、辟除不祥的作用。由于该墓装饰巧妙使用了彩画、浮雕与彩绘贴金相结合的手法，使整个墓室显得富丽堂皇，雍荣华贵，在我国古代壁画墓中别具一格。可以说，康陵的墓室壁画，是我国古代绘

画史上的一枝奇葩。

# 四、福建地区

福建省出土的古代壁画全部为墓葬壁画。迄今为止，福建省共发现壁画墓30余座，均属宋元时期。其中，进行科学清理的13座壁画墓分别是：尤溪县的潘山宋墓[20]、公山宋墓[21]、麻阳宋墓[22]、梅仙坪寨一号和二号宋墓[23]、第一中学宋墓[24]、埔头村宋墓[25]、拥口村宋墓[26]，南平市的来舟宋墓[27]和三官堂元墓[28]，三明市岩前宋墓[29]，将乐县光明元墓[30]，松溪县祖墩元墓。发现时已遭破坏的壁画墓也有多座，其中南平市西芹宋墓[31]、尤溪县水库淹没区宋墓群[32]、将乐县城郊宋墓[33]等经过专业考古人员做过勘查。在建瓯、邵武也发现过宋代壁画墓[34]。从发现地点可以看出，福建宋元时期的壁画墓主要分布在闽中、闽西北地区。

## 1. 墓葬特点与分期

福建的宋元时期壁画墓均为砖室墓，与普通庶民的土坑墓相比，其墓主无疑是地方豪富或达官贵人。其墓葬形制可大致分为五型。第一型为前后室券顶墓，前室较小，平面近方形，后室为长方形。尤溪麻阳宋墓和南平来舟宋墓均属此型。两墓前、后室均绘有壁画，前室绘亭台人物，后室绘十二辰图像。第二型为并列双室券顶墓，其典型代表有尤溪公山宋墓、梅仙坪寨一号宋墓、埔头村宋墓等。壁画一般绘在墓室内壁，内容以表现墓主生活的人物画为主。第三型为单室券顶墓，为宋元时期最流行的墓型，尤溪潘山宋墓、梅仙坪寨二号宋墓为此型墓的代表。第四型为平顶或非完全意义的券顶墓，没有墓门，下葬后封闭墓顶。此型墓发现较少，仅见尤溪一中宋墓和三明岩前宋墓。尤溪一中墓单室，平面长方形。三明岩前墓左右双室，两室均长方形。两墓墓室四壁均绘有壁画。第五型为仿木构殿堂建筑砖室墓，仅见南平三官堂元墓一例。

在福建发现的宋元壁画墓中，只有两座纪年墓，尤溪城关埔头村宋墓为北宋靖康元年（1126年），南平三官堂元墓为大德二年（1298年）。其余壁画墓，可依据墓型、出土遗物和壁画内容，大体推定其年代。福建的宋元壁画墓，可分为四期。第一期为北宋中期至后期前段，属于该期的壁画墓有尤溪麻阳宋墓、梅仙坪寨一号墓和南平来舟宋墓。第二期为北宋晚期，壁画墓大量出现，尤溪潘山墓、公山墓、梅仙坪寨二号墓、第一中学墓和埔头村墓均属该期。第三期为南宋时期，属于本期的壁画墓有尤溪拥口村墓和三明岩前村墓。第四期为元代前期，共有三座壁画墓，即将乐光明墓、南平三官堂墓和松溪祖墩墓。福建元代壁画墓与两宋壁画墓的分布区基本重合，可以说元代壁画墓是宋代壁画墓的延续和发展。

## 2. 壁画的题材内容和艺术特点

福建宋元壁画墓的题材广泛，内容丰富。真实而形象地反映了当时的社会观念、社会生活和当地的民风民俗。概括归纳，可将其题材内容分为以下几类。

### （1）人物画

在这批宋元墓壁画中，人物画占有相当大比例。所绘人物，以墓主形象、文武侍吏、佣婢侍役、仪卫随从等为主。这类人物图像，一般都绘在墓室两侧壁。后壁多绘侍寝图，如梅仙坪寨二号宋墓的两室后壁均绘有侍女捧物侍立床侧的图像。麻阳宋墓、公山宋墓、来舟宋墓的后壁，也可见类似的图像。

这些人物画，在艺术表现上各具特色，以坪寨一号宋墓最为出色，比例准确，用笔酣畅，赋色淡雅，别有韵致。麻阳宋墓和岩前宋墓、将乐元墓的人物图像也是上品之作，轮廓铁线如行云流水，显示出画匠高超的艺术造诣。

### （2）四灵及十二辰图像

四灵及十二辰图像的流行，是福建宋元墓室壁画的一大特色。在三明岩前宋墓中，四灵和十二辰图像按方位准确配置在墓室壁面上。在其他墓中，多配置青龙、白虎图像，或青龙、白虎配以十二辰图像，或只有四灵，或只有十二辰。所有十二辰图像均绘成头戴动物冠的人物形象。在第一期和第二期的宋墓中，青龙、白虎的形象比较写实，健硕而威猛，但到了第三、第四期，白虎的形象已经高度抽象，变成长颈神兽造型了。

**（3）建筑画**

在福建宋元壁画墓中，建筑图像也是最常见的题材，目前只有龙溪潘山宋墓没见建筑图像。在尤溪一中宋墓中，绘有府第、廊院、门庭等整体相连的建筑图像。很多墓的两侧壁绘有府第、仓廪等建筑图像。麻阳、来舟墓中，还见风格不同的亭台图像。公山宋墓中的木楼建筑极具地方特色。壁画中风格迥异的各类建筑，无疑是当地现实生活中各种建筑的真实写照。

**（4）山水画**

在梅仙一号宋墓两侧壁表现墓主家居生活的壁画中，在四扇床屏上各绘了一幅水墨山水，树石小景，使整幅壁画更加情趣盎然。

**（5）其他内容**

在福建宋元壁画墓中，除了上述题材，庭院中的鸡、犬图像也相当常见。此外，鞍马、轿舆、庖厨、天象等图像也时有所见。

福建宋元壁画墓在艺术上具有鲜明的特色。其绘画手法多见墨色铁线绘轮廓然后涂施单彩，一般以施红彩者居多，施黄彩者次之，个别的用墨线白描，色彩丰富的壁画极少见。与中原同时期的壁画墓相比，福建壁画墓以线条见长，而非靠色彩取胜。

# 五、江西地区

2006年5月，江西省文物考古研究所在江西省德安县聂桥镇芦溪村清理了一座宋代壁画墓。这是江西省迄今发现的唯一一座壁画墓。

该墓背靠大山，面向水库，地势高敞开阔。墓凿山为圹，圹坑长方形，长5.3、宽4米，南侧有斜坡墓道。石圹内砖砌东西并列的两个券顶墓室，两室之间有砖砌过洞相通。两室结构相同，均长3.06、宽1.2、深1.6米，其中西室绘有壁画。

壁画绘在厚1厘米的石灰地仗层上，分布在东、西、北三壁和墓室顶部，面积约13平方米。其中东、西壁的壁画保存较好，顶部壁画保存较差，北壁壁画已遭破坏。

壁画均以铁线勾勒物象轮廓，再赋彩，主要有

红、黑、蓝、赭、黄等色彩。推测其工艺为：先在壁面上涂施石灰砂浆作为地仗层，然后用石灰水抹面作为底色层，再在底色层上用"干画法"即用调和好的颜料作画。图像内容分为导卫、武吏、文侍、侍女和星象图五类。东、西壁由南而北各绘分立的人物九人，东壁题材主要为仪卫、侍女，西壁题材主要为武吏、文侍，人物像高度1.1～1.15米。仪卫、武吏均头戴幞帽，身着圆领窄袖袍，仪卫双手持骨朵，武吏手执宝剑；文侍头戴交脚幞头，身着圆领广袖袍，双手捧笏；侍女均梳高髻，上身外罩褙子，下着漫足罗裙，体态丰腴。各类人物职司明确，恭候伫立，共同组成一个仪卫和奉侍场面，虽然没有绘出墓主人像，其威仪已充溢整个墓室。墓室顶部的星象图，由金乌（日）、玉蟾（月）、星辰、云气组成。壁画布局疏朗，手法洗练，特别是东、西两壁的人物像，设色淡雅，形神兼备，是不可多得的宋人手笔。

根据墓葬结构、壁画内容和墓内出土的钱币、瓷器残片推断，该墓年代为北宋时期。据地方志记载，望夫山一带为北宋神宗年间著名将领王韶的墓地，墓主可能为北宋的高级官吏。该墓的发现，为江南地区古代壁画墓的研究提供了宝贵的资料。

# 六、湖北地区

湖北省出土的古代壁画，全部出自墓葬。迄今为止，共发现壁画墓16座，时代集中在唐和两宋时期。而壁画保存较好的只有4座唐墓和2座宋墓。

## 1.唐墓壁画

湖北发现的五座唐代壁画墓，均为唐代宗室的高等级贵族墓，墓室壁画无疑也代表了当时绘画的最高水平。

1980年在安陆县王子山清理的吴王母杨氏墓，是一座唐代早期壁画墓。墓主杨氏为唐太宗之妃、吴王李恪的生母。该墓多次被盗，壁画已经全部剥落，仅在甬道两壁和主室内残留少量彩绘痕迹[35]。

20世纪七八十年代，在郧县马檀山的唐濮王李泰家族墓地，先后发掘了濮王李泰墓、李泰妃阎婉墓、

李泰长子嗣濮王李欣墓、李泰次子李徽墓共四座壁画墓。四座墓均出土了墓志，墓主身份明确，埋葬时间清楚，是研究唐代早、中期墓室壁画的珍贵资料。

濮王李泰墓，由墓道、甬道、四个耳室和一个弧方形墓室组成，全长36.6米。墓门外上方绘楼阁图，甬道、墓室四壁绘人物像，顶部绘星象图。墓葬虽然被盗，仍出土了金、银、玉、瓷器和陶俑等珍贵文物442件[36]。墓主李泰，为唐太宗李世民嫡次子，因争夺皇位失败而徙住均州郧乡县，高宗永徽三年（652年）"薨于郧乡第"，次年二月葬于均州郧乡县之马檀山[37]。

李泰次子新安郡王李徽墓，由斜坡墓道、甬道、两个小龛和方形墓室组成。该墓墓道、墓门、甬道和墓室均绘有壁画。墓道壁画已全部剥落。小龛门以红彩勾勒边线，券门上部残存缠枝卷草纹图案。墓室四壁绘男女侍从、鞍马及花卉图像，顶部绘天象图。据墓志，李徽死于永淳二年（683年），于次年即嗣圣元年（684年）葬于马檀山[38]。

李泰妃阎婉墓，由斜坡墓道、一个天井、一个过洞、甬道和方形墓室构成。甬道和墓室内满绘壁画。甬道的东、西两壁各残存二男侍吏像。墓室内四壁壁画剥蚀殆尽，仅东壁下部隐约可见两个侍女的下半身像，室顶绘天象图。由于墓内过于潮湿，壁画色泽黯淡。据墓志，阎婉于天授元年（690年）客死邵州，权葬洛阳，开元十二年（724年）迁葬于马檀山[39]。

李泰长子嗣濮王李欣墓，由斜坡墓道、一个天井、两个过洞、甬道、七个小龛和方形墓室构成。墓内壁画绝大部分经水浸泡已经破碎脱落，仅在甬道西壁残存一个男侍吏头像。据墓志，李欣死于武则天垂拱年间（685～689年），开元十二年（724年）迁葬于马檀山先茔[40]。

这五座唐代壁画墓，其地仗层做法不同，壁画的保存效果也不同。李徽墓是直接在砖壁上涂抹一层白灰面作为地仗层，因而壁画保存较好。而其他墓是先在砖壁上抹一层细黄泥，黄泥层外涂抹一层白灰面作为地仗层，由于黄泥层易脱落，壁画保存相对较差。其绘制方法，一般是人物像先以墨线勾勒轮廓，

内填红、绿、黄、白、黑等色彩，花卉则以没骨法直接用不同色彩绘出。其题材内容，从保存较好的李徽墓的残存壁画看，大体可分为仪仗、建筑、生活场景和星象四大类。其配置规律是，甬道绘侍卫仪仗，墓门前绘楼阁建筑，墓室四壁绘生活场景，墓室顶部绘星象。

从墓葬形制、壁画的题材内容及其配置可以看出，湖北五座唐壁画墓与陕西同时期的宗室贵族壁画墓基本相同，证明当时对宗室贵族的丧葬有着严格的制度规定。但李徽墓墓室西壁和北壁的六扇花卉屏风画，比西安地区唐墓同类图像早了约半个世纪。

## 2. 宋墓壁画

湖北迄今共发现宋代壁画墓11座，其中北宋墓9座，南宋墓2座。与唐壁画墓分布地点集中不同，宋代壁画墓分布较广，除鄂东外，均有发现。

北宋壁画墓虽然发现较多，但壁画大多损毁严重，比较重要的荆门县车桥乡的赵王墓[41]、随县唐镇北宋壁画墓[42]、秭归县杨家沱北宋中晚期壁画墓[43]，也仅存部分图像，难以窥其全貌。

2007年在襄樊市襄城区檀溪路清理的两座南宋壁画墓，是湖北发现的保存最好的宋代壁画墓。两墓东西并列，均为长方形券顶砖墓。位于西侧的196号墓，墓室内四角影作抹角倚柱和转角铺作，东西两壁各影作一斗三升式补间铺作一朵。四壁壁画均以白灰面作地仗层，以普柏枋为界分为上下两层。四壁上层在拱眼壁内绘对称的青龙、白虎、朱雀、玄武四神图像和牡丹图案。主要图像绘于四壁下层，南、北壁绘双扇闭合的板门和侍女图，东壁绘有10位男女仆侍的庖厨图和进奉图，西壁绘有10位仆侍的备奉图和仓储图。位于东侧的197号墓稍小，四壁共绘有六幅互相对称的"海棠开光"图像，南、北壁各绘一幅，东、西壁各绘两幅[44]。

湖北的宋代壁画墓一般规模较小，多仿木结构，墓主身份多为当地富豪或中下级官员。从相对年代明确、题材和布局比较清楚的襄樊市两座南宋壁画墓看，题材内容大体有三类，第一类为反映向墓主奉茶进酒的进奉图、庖厨图和备奉图，第二类为辟除不

祥、标示方位的四神图，第三类为模仿人间居室装饰的花卉图案和几何纹图案，如"海棠开光"图和云纹图案等。两墓壁画继承和沿袭了中原地区北宋壁画墓的传统，壁画绘制多采用勾线平涂和白描的手法，人物和花卉多以轮廓线加以表现而少填色，线条流畅简洁，具有浓厚的生活气息。

## 七、广东地区

广东省有两座墓葬中出土过彩绘壁画。一座为西汉中期的南越王墓[45]，一座为盛唐时期的张九龄墓[46]。

南越王墓位于广州市区北面的象岗山上，为凿山为圹的大型石结构王陵。墓坐北朝南，全长21.31米，由墓道、前室及东、西耳室、主室及东、西侧室、后藏室八部分组成，在墓道北端和墓门之间设置外藏椁。在前室的周壁、室顶及南北两道石门上满绘云纹图案。图案直接绘在石面上，以朱彩为地，以墨彩绘云纹。云纹流畅飘逸，使墓室充溢着一种神秘而肃穆的气氛。根据墓中出土的"文帝行玺"的龙钮金印和"眜"字玉印，该墓为死于公元前122年前后的西汉第二代南越王赵眜（胡）的陵墓。该墓壁画虽然只有简单的云纹图案，却是迄今我国发现的时代最早的墓室壁画，在绘画史上有着特殊意义。结合河南永城芒砀山西汉中期梁王墓出土的大幅飞龙壁画，可以推断壁画墓起源于西汉早期的帝王陵墓。

张九龄墓位于韶关市西北郊的罗源洞山麓，是一座由甬道、南、北耳室、主室组成的砖室墓，墓向125°，全长8米。壁画分布在主室及甬道。由于该墓经多次盗扰破坏，壁画大部已经剥落，可辨识的只有甬道北壁的侍女蟠桃图、主室东壁的侍女残画和北壁的青龙图。其做法是先在砖壁上施1厘米厚的泥灰地仗层，然后用墨线勾勒轮廓，再施以朱、绿彩。壁画线条沉稳流畅，人物形象具有典型的盛唐风格。根据墓中出土墓志，该墓是死于唐开元二十八年（740年），开元二十九年（741年）由中原迁葬于此的张九龄墓。张九龄，韶州人，为开元名相，他的墓室壁画，应该是当时高级官吏墓葬壁画的典型代表。

## 八、重庆地区

重庆市的出土壁画全部出自墓葬。重庆市共发现了3座古代壁画墓。其中巫山县土城坡宋墓的壁画已经剥蚀殆尽，只有巫山县大庙元墓和重庆市永川区凌阁堂明墓的壁画保存较好。

2005年发掘清理的大庙元墓，位于巫山县庙宇镇大庙，为竖穴土洞墓，墓向南，有东、西两个墓室，系同穴异室夫妻合葬墓。两室墓壁满绘壁画，壁画以白灰墙皮作地仗层，采用墨线淡彩，色彩以黑、红为主色。两个墓室的壁画题材有着明显差异，东室即女墓主人的墓室壁画，除了男女侍从人物外，主要以花鸟为主题；西室即男墓主人的墓室壁画，则主要以文人雅士活动为主题，其中东壁绘有鉴赏图、教授图和居室图，西壁绘有听琴图、对弈图和画案图，北壁绘祠堂牌位图。两室顶部均绘祥云纹。东西两室绘画题材上的差异，表现了男女墓主人不同的文化情趣。壁画布局有序，主次分明；画面构图严谨，线条流畅，具有很高的艺术水平。由于洞室潮湿，发现时壁画下部已经漫漶不清。

2008年清理的凌阁堂明墓，位于永川区青峰镇凌阁堂村二社，为平面长方形的岩坑竖穴单室双券顶砖墓，由墓门、墓室、壁龛组成，方向175°。壁画以白灰墙皮为地仗层，先用墨线勾勒轮廓，然后敷彩施色。色彩以墨黑、赭红、石黄为主。其中东壁自南而北分别绘有效盏侍女图、瑞鹿图和东苍（仓）图，西壁自南而北分别绘有持注壶侍女图、鞍马图、西库图和人面三足乌，北壁绘插花图。室顶壁画以墨书的巨大粗体"福"字为中心，外环两周墨绘圆环，圆环外绘八瓣莲花图案。这些壁画，清晰地反映了祈求墓主升仙的愿望。壁画布局疏朗，人物形神兼备，是明代墓室壁画的精品之作。

## 九、四川地区

四川省出土的古代壁画全部出自墓葬。已发现东汉至明代的壁画墓近10座。可惜多数墓葬中的壁画漫漶剥落严重，已经无法辨识。壁画保存较好的只有三

台县柏林坡一号墓和中江县塔梁子三号墓，两墓均为东汉崖墓。古代壁画崖墓目前仅见于四川，其分布也仅限于郪江流域。

柏林坡一号墓位于绵阳市三台县郪江镇柏林坡山东南端，墓向108°，为隧洞式多室墓，由墓道、墓门、甬道、前室、中室、后室和侧室、耳室构成，全长20米[47]。墓内有"元初四年"（117年）朱书纪年题记。墓内共发现彩绘壁画和彩绘画像石46幅，彩绘壁画主要分布在中室北侧室的西壁和北壁，内容为人物像、宴饮图、升仙图等[48]。

塔梁子三号墓位于德阳市中江县民主乡桂花村塔梁子中段的西南侧，墓向225°。该墓规模宏大，结构复杂，有前后五重主室，前室两侧各设一侧室，二室西北设一侧室，三室两侧各设一侧室，四室无侧室，后室东南设一侧室，全长33.25米。壁画主要分布在三室东南侧室内，后室甬道壁上也有少量壁画。壁画内容主要有宴饮图、门吏图和四神图像等[49]。

四川的墓室壁画，有的直接在墓壁上施地作画，如柏林坡一号墓；有的在细泥灰地仗层上绘制壁画，如塔梁子三号墓。壁画的绘制方法有两种，一种是先用墨线勾画轮廓，再填彩；另一种是直接用颜料涂绘的没骨画法。壁画色彩以红、黄、绿、黑、白为主。

两墓的壁画内容与四川的汉代画像石墓、画像砖墓的图像内容相近，主要有车马出行、宴饮、升仙等。以塔梁子三号墓为例，其主要图像虽为家居饮宴，但结合榜题看，用图像形式炫耀其家世的内容占有重要位置，与内蒙古和林格尔壁画墓用一系列车马出行图来表现墓主生前官宦经历的手法相似[50]。该墓"鸿芦拥十万众平羌"的题记，为研究当时政治、军事与民族关系提供了重要信息，可补史书记载之阙。

# 十、云南地区

云南出土壁画，全部出自墓葬。已发现曲靖梁堆壁画墓、昆明西山昭宗村壁画墓、昆明官渡云山村壁画墓和昭通霍承嗣墓[51]四座壁画墓。前三座墓属东汉时期，霍承嗣墓为东晋时期。三座汉墓壁画剥落严重，梁堆墓和昭宗村墓仅见零碎的三色彩绘莲花图像，云山村墓只残留用朱墨两色绘制的两个人物残像。壁画保存完好的只有霍承嗣墓。

霍承嗣墓位于昭通市昭阳区西北20公里处的后海子中寨，1963年清理。该墓坐北朝南，为石结构单室穹窿顶墓，墓室平面正方形，边长3米。根据北壁的墨书题记，该墓是东晋太元十一年至十九年间（386～394年）从蜀郡迁葬于此的霍承嗣墓。

壁画绘于墓室四壁石灰地仗层上，绘画主要方法是先用竹木片在地仗层上刻划出物像轮廓，然后用墨线勾勒，最后加彩着色，而二方连续图案花纹带则是模压出图案后直接着色，壁画色彩为黑、黄、赭、红四色。

墓室四壁的壁画均分为上下两层，中间用二方连续图案花纹带区隔。上层为四神图，上部均绘流云纹，下部按西、东、南、北方向分别绘青龙、白虎、朱雀、玄武四神，四周配以鸟、兽、莲蕊、楼阁、人物等，四神图像旁有神名的墨书题记。下层壁画描绘的是与现实生活相关的场景，是该墓壁画最具独特价值的地方。

北壁下层正中绘墓主正襟危坐于榻上，比例明显大于周边的人物，突出地表明其主人地位。墓主像东侧依次绘旄节一个、侍者一人、兵器架一个，兵器架上插放华盖、旗幡、矛、戟等，兵器架下部绘七个比例很小的属役。墓主像西侧绘两排共11个人物，其上部有八行墨书题记。

东壁下层绘上下两列人物。上部绘一列持幡人物共13人，均头戴元宝式黑帽，双手持幡。下部甲马持矛骑吏一列，可辨识出五骑，马呈缓行或站立状。

西壁下层绘人物三列共40人，其下绘四名骑吏。

南壁壁画位于墓门上方，下层正中绘一瓦顶屋宇，屋宇西侧绘一披甲持刀武士，其旁有"中门侯"墨书题记。武士西侧有"天米"二字的花体变形文字墨书题记。

壁画虽然分绘于墓室四壁，却是一个互相关联的整体。四壁上层所绘的四神图像，无疑是起着护佑墓主在冥界安宁的作用。东西壁下层的图像，表现的应是祭祀超度北壁所画墓主的场面。史载南部参军

霍戈（霍承嗣的先祖）"甚善参毗之礼"。所谓"参毗"，即佛教密宗的一种仪式，多用来超度亡魂。北、东、西三壁下层图像所表现的，应就是用"参毗之礼"超度墓主霍承嗣的场面[52]。

从霍承嗣墓的图像内容和配置特点看，该墓壁画无疑继承了东汉壁画墓的传统。尽管该墓壁画稚嫩朴拙，却有重要历史价值。作为当时南中首届一指的豪族代表，霍承嗣身任"晋使持节都督交、宁二州诸军事，建宁、越巂、兴古三郡太守，南夷校尉，交、宁二州刺史，成都县侯"等显要官爵，声势显赫。墓室西壁下层所绘的三列人物，其穿着与近代四川凉山地区彝族的服饰相同，说明霍氏家族在当地拥有大量的"夷汉部曲"。这组壁画，为研究三国两晋时期的云南历史提供了珍贵的形象资料。

# 十一、西藏地区

从全国范围来看，考古发掘出土的壁画大多出自墓葬，只有少数出寺观建筑遗址、石窟遗址、宫殿建筑遗址。而在西藏自治区境内，虽然发掘过的墓葬不下百座，但至今未发现墓葬壁画。迄今发现的出土壁画几乎都出自藏传佛教寺院遗址。西藏自治区的考古工作开展较晚，正式的考古发掘工作20世纪70年代末才开始（西藏昌都地区的卡若遗址发掘）。20世纪80年代，随着全自治区文物普查工作的开展，一大批古代遗址、墓葬被发现，其中一些进行了发掘。90年代以来配合文物保护工程的考古调查与发掘陆续开展，其中出土壁画的遗址主要有阿里地区札达县的古格故城遗址、托林寺遗址、东嘎·皮央遗址、达巴城堡遗址以及日喀则地区萨迦县的萨迦北寺遗址等，以托林寺遗址出土最多。

托林寺创建于十世纪末十一世纪初，由古格王室主持修建。主要建筑迦萨大殿仿自吐蕃大寺——桑耶寺，整体设计成结构严密的立体曼荼罗形式，由中心五殿、外围十九殿和四座高耸的小塔组成，用以象征须弥山、四大部洲、八小洲的佛教世界模式，布局紧凑，气势恢弘，建筑面积达1200余平方米，是藏传佛教寺院建筑的经典之作。由于受人为破坏，原

有各殿顶均遭拆毁，塑像、壁画所剩无几，且埋于土中。经发掘清理，出土大量塑像残块、壁画残迹、经书残页和其他文物，其中不少是托林寺初创时期的遗迹、遗物。出土壁画约40平方米，大多还保存在原壁面上，少数残块出自废墟堆积中。其中出土壁画最为集中，保存最好的是迦萨大殿的F11礼拜道回廊，壁面上分幅排列着用连环画形式表现的佛传故事画，有白象入胎、树下诞生、阿斯陀占相、学书习定、婚配赛艺、降魔、荼毗、涅槃、建八塔等情节。在西藏佛教后弘期较早的佛传故事画中，托林寺迦萨大殿的壁画自有其特点：画面中只绘出与核心人物（释迦牟尼）直接关联的人物；构图较为松散，留有较多空白；用色不多，线条简洁。与古格故城遗址红殿、白殿、托林寺红殿佛传故事画的风格有较大差别。

此外在玛尼拉康、乃举拉康、阿扎惹拉康、50号塔、55号塔也都出土有较多壁画。玛尼拉康（经轮殿）是位于迦萨殿东南方的小型佛堂，面积仅27平方米，殿内原安装有高达3米的圆桶形可旋转经轮，故称经轮殿。殿堂破坏严重，已成废墟，发掘出土有铜塔、镏金铜雕迦楼罗鸟、经书残页等遗物，残垣断壁上隐约可见部分佛传壁画和千佛壁画。乃举拉康（十六罗汉殿）由连为一体的罗汉殿和小佛堂组成，面积75平方米。小佛堂原供有释迦牟尼塑像，罗汉殿两侧对称排列十六罗汉和菩萨泥塑坐像，从发掘清理出的罗汉塑像残躯、残头可以看到汉族地区寺院雕塑风格的影响。殿内壁面残留少量佛传、千佛、高僧壁画。

50号塔是托林寺内四塔之一，建造年代应与迦萨殿同时，位于迦萨殿的东北。塔的上半部被破坏，暴露出面积7平方米的塔中殿堂，朝东的殿门在建塔时即被封闭，殿内残留的壁画有六臂观音、八臂观音、十一面观音、观音救八难等内容，出土有塑像残块和大量擦擦（模制小泥塔、泥造像）、藏文佛经写本残页。壁画有明显的印度、克什米尔风格，很可能就是克什米尔画匠的作品。南壁的观音救八难图像是西藏保存最早的同类题材图像，画面完整阐述了佛教经典中观音救度众生的内容。

55号塔位于迦萨殿西北。塔的北部被破坏，塔中殿堂建筑及塑像、壁画也毁损过半。殿门向西，东、北、南三面各有一龛，东龛为泥塑立佛，南北龛为站立的泥塑菩萨，残存的壁画色彩至今仍浓艳如初，壁画内容有度母、金刚、护法神、僧人礼佛、供养人等，其中排列整齐的供养人上多有藏文题记，其中一些供养人的名字表明他（她）们是古格王室的成员。壁画的风格与东北塔迥然不同，显系来自不同地区的画匠所绘。

扎达县东嘎·皮央遗址是古格王国时期极为重要的遗存，保留有大量古格王国时期的佛教壁画。上世纪90年代，考古工作者调查遗址期间发现洞口坍塌封堵的洞窟，出土有壁画，其中不乏古格王国早期（11~12世纪）的作品。

达巴城堡遗址位于阿里地区扎达县达巴乡政府所在地南面的土山上，遗址分为A、B两区。1998年当地文物部门在遗址的A区清理佛殿遗址一处，发现有残存的佛传故事壁画局部，时代约为14世纪。

古格故城遗址经过发掘的佛殿遗址仅有两座，其中在毗沙门天殿出土有壁画，残存壁画年代晚至清代中期，是噶厦政府统治阿里时期的作品。

位于日喀则地区萨迦县的萨迦北寺遗址出土有少量壁画遗迹，均为下部的装饰纹样，可辨有金刚杵纹、卷草纹等，从纹饰的风格和绘画技法分析，应为清代初期所绘。

## 注　释

[1]《大燕柳城何府君墓志铭并序》，现存放于北京市文物研究所。

[2]王策：《燕京汽车厂出土的唐代墓葬》，《北京文博》1999年第1期。

[3]北京市海淀区文物管理所：《北京市海淀区八里庄唐墓》，《文物》1995年第11期。

[4]北京市文物工作队：《北京南郊辽赵德钧墓》，《考古》1962年第5期。

[5]北京市文物工作队：《辽韩佚墓发掘报告》，《考古学报》1984年第3期。

[6]北京市文物研究所：《北京大兴区青云店辽墓》，《考古》2004年第2期。

[7]周宇：《丰台区航天三院厂际中心工程墓葬》，待刊。

[8]北京市文物事业管理局、门头沟区文化办公室：《北京市斋堂辽壁画墓发掘简报》，《文物》1980年第7期。

[9]北京市文物研究所、延庆县文物管理所：《延庆县时尚纺织品有限公司壁画墓发掘简报》，《北京文博》2005年第第3期。

[10]王清林、周宇：《石景山八角村金赵励墓墓志与壁画》，《北京文物与考古》（第五辑），北京燕山出版社，2002年。

[11]《徐州黄山陇发现汉代壁画墓》，《文物》1961年第1期。

[12]南京市博物馆：《南京西善桥南朝墓》，《文物》1993年第11期。

[13]南京博物院：《江苏丹阳县胡桥、建山两座南朝墓葬》，《文物》1980年第2期。

[14]南京博物院：《南唐二陵发掘报告》，文物出版社，1957年。

[15]江苏省文物管理委员会、南京博物院：《江苏淮安宋代壁画墓》，《文物》1960年第8、9期。

[16]王伯敏：《中国绘画史》107~108页，上海人民美术出版社，1982年。

[17]浙江省文物管理委员会、杭州师范学院历史系：《杭州郊区施家山古墓发掘报告》，《杭州师范学院学报》（社会科学版）1960年第7期；浙江省文物管理委员会：《杭州、临安五代墓中的天文图和秘色瓷》，《考古》1975年第3期；浙江省博物馆、杭州市文管会：《浙江临安晚唐钱宽墓出土天文图及"官"字款白瓷》，《文物》1979年第12期；明堂山考古队：《临安县唐水邱氏墓发掘报告》，《浙江省文物考古所学刊》1981年。

[18]朱伯谦：《浙江嘉善县发现宋墓及带壁画的明墓》，《文物参考资料》1954年第10期。

[19]杭州市文物考古研究所、临安市文物馆：《浙江临安五代吴越国康陵发掘简报》，《文物》2000年第2期。

[20]福建省博物馆、尤溪县文管会：《福建尤溪宋代壁画墓》，《文物》1985年第6期。

[21]福建省博物馆、尤溪县文管会、尤溪县博物馆：《福建尤溪城关宋代壁画墓》，《文物》1988年第4期。

[22]福建省博物馆、三明市博物馆、尤溪县博物馆：《福建尤溪麻阳宋壁画墓清理简报》，《考古》1989年第7期。

[23]福建省博物馆、尤溪县博物馆：《福建尤溪梅仙宋代壁画墓》，《福建文博》2008年第1期。

[24]福建省博物馆、尤溪县博物馆：《福建尤溪发现宋代壁画墓》，《考古》1991年第4期。

[25]陈长根：《福建尤溪县城关镇埔头村宋代纪年壁画墓》，《考古》1995年第7期。

[26]尤溪县博物馆：《福建尤溪拥口村宋代壁画墓》，待刊。

[27]张文崟：《福建南平宋代壁画墓》，待刊。

[28]张文崟、林蔚起：《福建南平市三官堂元代纪年墓的清理》，《考古》1996年第6期。

[29]福建省博物馆、三明市文管会：《福建三明市岩前村宋代壁画墓》，《考古》1995年第10期。

[30]福建省博物馆、将乐县文化局、将乐县博物馆：《福建将乐元代壁画墓》，《考古》1995年第1期。

[31]张文崟：《南平市发现大型宋代铜镜》，《福建文博》1988年第1期。文中说铜镜出土于绘壁画的宋墓中。

[32]王祥堆：《尤溪发现宋代墓群》，《中国文物报》1990年12月27日。

[33]笔者在将乐县调查发现。

[34]林忠干：《福建宋墓分期研究》，《考古》1992年第5期。文中记述建瓯曾发现北宋咸平六年壁画墓。另据林钊先生说，邵武曾发现宋代壁画墓。

[35]孝感地区博物馆、安陆县博物馆：《安陆王子山唐吴王妃杨氏墓》，《文物》1985年第2期。宋焕文：《安陆县发现初唐王妃墓》，《江汉考古》1980年第1期。

[36]湖北省文物考古研究所李泰墓发掘资料。

[37]湖北省文物考古研究所藏李泰墓志。

[38]湖北省博物馆、郧县博物馆：《湖北郧县唐李徽、阎婉墓发掘简报》，《文物》1987年第8期。

[39]同[38]。

[40]高仲达：《唐嗣濮王李欣墓发掘简报》，《江汉考古》1980年第2期。

[41]湖北省文管会：《湖北省文管会调查荆门县赵王墓》，《文物参考资料》1954年第9期。

[42]李元魁、毛在善：《随县唐镇发现带壁画宋墓及东汉石室墓》，《文物》1960年第1期。

[43]湖北省文物考古研究所：《秭归杨家沱遗址发掘简报》，《湖北库区考古报告集·第二卷》，科学出版社。湖北省三峡考古工作队杨家沱工作组：《秭归杨家沱遗址发现壁画砖室墓》，《江汉考古》1997年第3期。

[44]依据襄樊市文物考古研究所发掘资料。

[45]广州市文物管理委员会、中国社会科学院考古研究所、广东省博物馆：《西汉南越王墓》，文物出版社，1991年。

[46]广东省文物管理委员会、华南师范学院历史系：《唐代张九龄墓发掘简报》，《文物》1961年第6期。

[47]四川省文物考古研究院、绵阳市博物馆、三台县文物管理所：《三台郪江崖墓》，文物出版社，2007年。

[48]报告中称壁画分布在"中室左侧室右壁、后壁"，现根据墓葬平面图改按东、西、南、北方向。

[49]四川省文物考古研究院、德阳市文物考古研究所、中江县文物保护管理所：《中江塔梁子崖墓》，文物出版社，2008年。

[50]宋治民：《四川中塔梁子M3部分壁画考释》，《考古与文物》2005年第5期。

[51]云南省文物工作队：《云南昭通后海子东晋壁画墓清理简报》，《文物》1963年第12期。

[52]方国瑜：《晋霍承嗣墓壁画概说》，《云南史料丛刊》第一卷。

# Murals Unearthed from Beijing, Jiangsu, Zhejiang, Fujian, Hubei, Guangdong, Chongqing, Sichuan, Yunnan and Xizang

Song Dachuan, Dong Kunyu, Wang Qizhi, Wen Renyan, Yang Cong, Yang Jun, Hu Sheng, Tian Guiping, Lin Bizhogn, Liu Chunhong, Yu Chun, Yang Decong, Zhang Jianlin

## 1. The Murals Unearthed in Beijing

So far, more than 40 mural tombs, dating upon Wei-Jin to Ming-Qing dynasties, have been found in Beijing area, but most of them were too dampened to be illegible, only about 10 tombs dating upon Tang, Liao, and Jin dynasties have survived in a better condition, some of which will be presented in the following.

### (1) Mural Tombs of Tang Dynasty

In Beijing area, eight mural tombs of Tang dynasty have been found, the most representative and well-preserved tombs are owned by He Fujun and Wang Gongshu respectively.

He Fujun's tomb was excavated at Yanjing Auto Maintenance Workshop, east of the Taoranting Park, Xuanwu District in 1988. According to the recovered epitaph, the tomb was built in 759 CE, the First Year of Tian Shun Era in Shi Siming's Reign[1]. The tomb was a single-chambered brick tomb, consisting of an entryway, a corridor and a chamber; two murals were painted on the north side of west wall and west side of north wall, respectively depicting the portrait of the tomb occupant and the scene of a stable[2].

Wang Gongshu's tomb, a wall-curved rectangular brick single-chambered tomb, was excavated at Balizhuang, Haidian, in 1991, consisting of an entryway, a corridor and a chamber. It was painted at the west side, outside of the entryway, both sides of the corridor, and the east, west and north walls of the chamber. A large-sized screen-styled depiction of flower and birds on the north wall has been survived in best condition, two frolicking wild geese and dancing butterflies were depicted vividly against a blooming peony[3].

### (2) Mural Tombs of the Liao Dynasty

16 mural tombs of Liao dynasty have been found in Beijing area, which could be dated upon two successive periods, just divided by the reign of Emperor Xingzong. In the former period, from Emperor Muzong's reign to Xiongzong's reign while the Khitan was in a transition status from the slavery society to the feudal society, few mural tombs of Khitan nobles has been found in Beijing; on the contrary, more of the Han elite's mural tombs have been found, as an inherited Tang dynasty's custom, which could be represented by the joint tomb of Zhao Dejun and his wife, the tomb of Han Yi, and the tomb at Qingyundian, Daxing District.

The joint tomb of Zhao Dejun and his wife was excavated at Majiabu, outside the Yongding Gate, in 1960. The tomb consisted of three main chambers: front, central and rear; two side chambers were linked with each main chamber; it was depicted on walls of each chamber, but mostly were ruined when found, only the depiction of painting-watching on east wall of the left central chamber, the depiction of kitchen on east wall and maid on west wall of the right front chamber have survived in a better condition. According to the epitaph, the tomb was buried in 958 CE, the 8th year of Yingli Era in Muzong's reign[4]; the owner, Zhao Dejun, was once a local governor in Later Tang dynasty, and enfeoffed with the title of Beiping Prince; later he paid allegiance to Liao court, meanwhile his son, Zhao Yanshou, stayed for duty at the Southern Capital of Liao; apparently Zhao family was an illustrious one during the earlier years of Liao dynasty. This tomb was the earliest and largest mural tombs of the Liao dynasty ever found in Beijing.

The tomb of Han Yi was found inside the Babaoshan Revolution ary Cemetery in 1981, which is a single-chambered brick tomb with a vaulted ceiling and was depicted all over the walls of corridor and chamber: door guards in corridor's wall, screen with flower and birds and two maids on north wall, maids respectively on east and west walls of chamber, and a lotus at center of the ceiling surrounded by the Twelve Zodiac Animal-shaped Figures. According to the epitaph, the tomb was buried in 995 CE, 13th year of Tonghe Era in Emperor Shengzong's reign[5], and occupied by Han Yi, who had a local Yan origin and an illustrious clan background: his grandfather was once highly esteemed by Emperor Yelü Abaoji as a prime minister.

The Liao Tomb No.1 and 2 at Qingyundian was excavated in 2002, just outside of the west wall of the Wang Zhihe Fermented Bean Curd Factory. Both tombs are identical in shape: a single-chambered round brick tomb with a vault ceiling. The tombs were depicted in the inner walls of the chamber, those in No.1 have survived in a better condition: columns and corbel-bracket sets at the corners dividing the walls into four parts; two maids on the door sides at the south wall; some flowers and plants above the door; a lattice window was built at the center of the west wall, two maids were depicted at its south, another maid with hair flowers and a cloth-airing scene were depicted at its north; another lattice window and some tables and chairs were built at the center of the east wall, a maid was depicted behind the chair, and a having-fun scene of woman and child was depicted at the north; a red-painted door was depicted at the center of the north wall, a maid with a plate in hand was walking through the door[6].

The following period is from the reign of Emperor Daozong to the reign of Emperor Tianzuo, while the funeral customs of Khitan nobles were influenced by the Han's practices, consequently the mural tombs had increased greatly. The motifs tended to resemble with those in the Central Plain, more scenes of domestic feasting and music band appeared. The tombs of Liu Liufu's family members' and the one at Zhaitang Town were representative of this period.

The Liu Liufu's family cemetery was located inside the courtyard of the 3rd Institute, China Aerospace Science and Industry Corporation (CASIC) at Yungang Town, Fengtai District. Two tombs were found and excavated in 2007, the No.1 was occupied by Liu Liufu, Duke Yanguo, and his four spouses, while the No.2 was occupied by Liu Yu, the Duke's son. The former was a multi-chambered brick tomb, consisting of a passageway, air shafts, an entryway, a front chamber and two side chambers, and rear chamber. It was depicted at the entryway, the inner corridor, the front chamber and its side chambers, e.g. door guardians at both side of the entryway and the inner corridor, a procession scene on the west and east sides of the front chamber. The latter one was a double-chambered brick tomb, consisting of a passageway, air shafts, entryway, the front and the rear chambers; it was depicted at both chambers, including scenes of feasting, maids with plates in hands, and preparing for feasting[7]. Liu Liufu's clan, with an origin of Hejian, was an illustrious one in the Liao dynasty, many of the clan members occupied high positions, especially Liu Jing, his grandfather, was once a prime minister during the reign of Emperor Jingzong. Liu Liufu died in 1057, the 3rd year of Qingning Era, Daozong's Reign, and Liu Yu died in 1101, the first year of Qiantong Era, Tianzuo's Reign.

The Liao tomb of Zhaitang Town, which was excavated at east of Zhaitang Village, Mentougou District in 1979, is a single-chambered brick tomb with a vault ceiling, consisting of a passageway, an entryway, and two side chambers. It was depicted on both side of the inner corridor, the chamber walls and west side chamber: two maids on the corridor's walls; scenes of offering sacrifice and torturing on west wall of the chamber, four landscape paintings on the south wall and the side board of a coffin platform placed near the west wall; a lotus pattern on the ceiling; besides, two inked scripts in regular handwriting styles, Le Tang乐堂  and An Tang Zhai安堂斋 were found on both side of the corridor. According to the inscriptions of the stone tomb tablet found near the mound, which demonstrated its date in 1111, the 1st year of Tian Qing Era, Emperor Tianzuo, this tomb could be dated upon the late Liao dynasty[8].

### (3) Mural Tombs of the Jin Dynasty

Totally four mural tombs of the Jin Dynasty have been excavated in Beijing area, which could be represented by two tombs: the Tomb of Yanjianbu Village and Zhao Li's Tomb.

The Tomb of Yanjianbu Village, which was found at north of the Yanjiabu Village, Zhangshanying Town, Yanqing County in 2002, was a brick mural tomb of early Jin dynasty. The tomb was built into a round shape with a single chamber, facing south and consisting of a passageway, an entryway, a inner corridor and a round chamber; the inner side of the chamber was divided into eight parts by brick columns topped with corbel bracket sets. It was depicted at the corridor and inner sides of the chamber, but mostly ruined except the four scenes: procession with guards of honor, maids, music band, etc; the scenes were depicted in a smooth drawing style and colored brightly, the figures were portrayed vividly[9].

The tomb of Zhao Li was found at Bajiao Village of Shijingshan District in 2002, which was buried in 1143, the 3rd year of Huangtong Era, and occupied by Zhao Li, a Han official. It was a round single-chambered tomb built of bricks, facing south and consisting of a passageway, a screen wall, an entryway, an inner corridor and a chamber. It was depicted on the screen wall and the chamber's walls: the depictions on both sides of the entryway were ruined and flaked off, only the flower designs above the entryway survived well; on the chamber's walls, five scenes have survived: a set of bed centered at the north wall, tea preparation and feast preparation on the east wall, from north to south respectively; music band and wine serving on the west wall, from north to south respectively; the constellation on the ceiling which was surrounded by flowers and Zodiac animals[10].

### (4) Conclusion

The mural tombs in good condition, which were dated upon the Tang, Liao and Jin dynasties in Beijing area, were mostly occupied by the nobles, few was occupied by the common people; in the former cases, the murals were elaborate and gorgeous, but in the latter cases, the murals were simple and plain, therefore the murals could be a real reflection of the society and aesthetic appreciation of that time. As for the mural motifs, the figure depiction was the primary one, describing the scenes of daily life; the religious themes also occupied a large proportion, demonstrating the social thoughts and reliefs of that time; the landscape was relatively few, and didn't appear until the late Liao dynasty. The murals of Liao and Jin dynasties inherited some traditions of Tang tombs, at the same time they absorbed some techniques of brickworks which had been popular since Five Dynasties, as a result, a new distinct mural style appeared. These murals provided some new vivid information for the studies of ancient Beijing societies.

## 2. The Murals Unearthed in Jiangsu Province

Only a few ancient mural tombs have been found in Jiangsu province, the earliest one should be the mural tomb of late Eastern Han dynasty found at Huangshanlong, Xuzhou City[11]. It's a multi-chambered tomb built of stone; the murals were found in the front chamber, but mostly flaked off; the motifs were popular in Eastern Han dynasty: door guards at the door's sides, procession scene above the door, procession and feasting scenes on the chamber walls.

The tombs of Southern Dynasties were undoubtedly painted, one typical example was the tomb of Huang Fashi, a duke of Yiyang Prefecture of the Chen dynasty, which was found at Xishanqiao of Nanjing[12]. It was plastered (up to 5mm thick) on the wall before being painted, some yellow, red or green lines were still visible, but unfortunately the themes were illegible because of the dampened circumstances. Similarity occurred in some imperial mausoleums, such as the large tombs found at Wujiacun of Huqiao and Jinjiacun of Jianshan in Danyang, both were inferred to be imperial mausoleums of the Qi Dynasty, in which some depictions of dragons and phoenixes were found at the end of the inner corridors, all grounded in bluish green color and painted in red, white and blue[13].

Both Mausoleums of the Southern Tang in the suburb of Nanjing City were mural tombs[14], in the Qin Mausoleum of

Emperor Li Bian (937-943 CE) , the brick-built architraves, beams, columns, struts, bracket sets, column bracing types and corner bracing types were all color-painted brightly with themes of flowers and plants; besides, the ceiling of the rear chamber was depicted with constellation in large size, the Sun at east and Moon at west.

In 1959, five tombs, which belonged to Yang Family of the Song Dynasty, were excavated at Yangmiao Town of Chuzhou District (former Huai'an County), Huai'an City[15]. Among them, the No.1 and No.2 were mural tombs, the murals of which were painted directly on the plastered brick walls; both tombs were explicitly dated. The No.1 tomb was a rectangular brick tomb with a barrel-vault ceiling, the arched door was painted in red and labeled with the date "Earlier tenth month, 5th Year of Jiayou Era (1060)"; the ceiling was depicted with tendrils and clouds in red and black; other walls were also painted: the side walls were centered with tables and chairs, on which some fruits and cups, dishes, plates, kettles and boxes were placed, some attendants bustling about; the back wall was depicted with a bed and a canopy. The No.2 tomb was a rectangular brick tomb with a flat ceiling, the murals were painted on the inner walls: the side walls were depicted with female musicians; the back wall was depicted with a sacrificial table. According to the epitaph, the occupant was Yang Gongzuo, a court official, who died in 1094, the 1st year of Shaosheng Era, Northern Song.

Yang was once a prominent family of Chuzhou in the Song dynasty, their tomb murals might demonstrate a typical mortuary practice which was popular among the elites; the motif was a ceremony of offering a sacrifice, demonstrating a high painting skill by the smooth lines (as in the No.1) and fleshy figural representations (as in the No.2); these depictions could be considered as exquisite examples of the Song dynasty's murals.

## 3. The Mural Unearthed in Zhejiang Province

All of the murals unearthed in Zhejiang were from the tombs. As early as in the Anti-Japan War, a mural tomb dated upon Taining Era of the Eastern Jin dynasty was found at Dongguan, Shangyu County, in which some depictions of figures, phoenixes had survived[16]. Since 1950s, four tombs with depictions of constellations on the ceiling, which belonged to Qian Family of late Tang and Wuyue Kingdom, had been found in Hangzhou and Lin'an respectively[17]; a tomb of the Ming dynasty, which was depicted with landscapes, constellations, immortals and Buddhist images in the chamber, was found at Taojiaci of Jiashan County[18]. Anyway, the Kang Mausoleum excavated in 1997, which belonged to Ma, a consort of Qian Yuanguan who was the second emperor of Wuyue Kingdom during the Five Dynasties, was known so far to be the best survived and largest in mural coverage[19].

The Kang Mausoleum, which was located at Xiangli Village, Linglong Town, Lin'an City, was a large brick-stone tomb, consisting of a ramp passageway, a front chamber and its side chambers, a central chamber and a rear chamber; the front parts were made of bricks, but the central and rear chambers were made of stones; the tombs faces southeast at 45°. The tomb was robbed in the past times, but lots of valuable antiquities, 312 in all, had survived, including ceramics, jades, silvers, bronzes, irons, stone sculptures, and an epitaph, which demonstrated that the tomb was built in 939 CE, the 4th year of Tianfu Era, the Later Jin Dynasty.

The murals of Kang Mausoleum were found at the door, front chamber and its side chambers, and the central chamber. At the sandstone door leaves and brick barrel vault, it was plastered, and then painted, depicting some peony flowers; but the depictions in the front chamber were mostly illegible because of the flaked-off plaster, only the color-painted bracket sets at the corner and the red peony flowers at the arched door were visible; a tall red peony flower was depicted respectively on each wall of the side chambers; the central chamber was depicted on its east and west walls: a tall blooming peony red flower and green leaves centered the wall, the peony was brightly colored, its pistil was adorned with rhombus gold foils; around the peony, there were two red-green cloud designs at its upper corner, and red flame designs at its lower corner.

The rear chamber's mural were featured by the carving bands of peony at top of the walls, which was around 50 cm high and divided into two registers: the upper register depicting the intertwined peonies, the lower register depicting peonies and

lotuses, all had a red ground color and adorned with gold foils; the pistils, profiles, and petals were painted either in white, green or red. The White Tiger and Green Dragon in bas-relief at the upper parts of the side walls, together with the Scarlet Bird at back of the door and the Sombre Warrior in the niche, formed an integrated set of Four-Supernastard Beings; all depictions of the animals were adorned with gold foils, displaying a dynamic and mystical taste by the strong contrast in color. At the lower parts of the three walls, as well as in the twelve niches at the back of the stone door, the Zodiac Animals were carved in bas relief, each being color-painted and adorned with gold foils. On the slab of the ceiling, the representation of constellations was carved, including 218 stars and the Milky Way. In the rear chamber, the columns and beams of the stone coffin platform were painted exquisitely, depicting phoenixes and running clouds; however, the walls of the rear chamber were carved, but demonstrating a similar visual effect to murals by its bright colors.

In a conclusion, the mural motifs of the Kang Mausoleum could be divided into two types: (1) peony and phoenix, clouds, inferring to the noble status of the occupant as an honorable consort; (2) the Four Supernaturd Beings and Twelve Zodiac Animals as apotropaic objects, inferring to the beliefs of that time. In this tomb, the distinct decorating skills, like color-painting, bas relief, carvings and gold-leaf coverings, were combined and applied perfectly, displaying a splendid and graceful circumstance. Therefore, the Kang Mausoleum's murals could be regarded as a wonderful representation of ancient Chinese paintings.

# 4. The Murals Unearthed in Fujian Province

All of the unearthed murals in Fujian province were from the tombs, so far, over 30 mural tombs have been found, all dating upon Song and Yuan dynasties; among those tombs, 13 have been excavated archaeologically, i.e. Song Tomb of Panshan[20], Song Tomb of Gongshan[21], Song Tomb of Mayang[22], No.1 and No.2 Song Tomb at Meixian Pingzhai[23], Song Tomb of First Middle School[24], Song Tomb at Putou Village[25] and Yongkou Village[26], in Youxi county, Song Tomb of Laizhou[27], Yuan Tomb of Sanguantang[28] in Nanping City, Song Tomb of Yanqian[29] in Sanming City, Yuan Tomb of Guangming[30] in Jiangle County, and Yuan Tomb of Zudun in Songxi County. Besides, some other mural tombs have been found in ruined conditions, such as the Song Tomb of Xiqin in Nanping City[31], the Song Tomb Cluster at the flooding area of Youxi Reservoir[32], the Song Tomb at the suburb of Jiangle County town[33]. Meanwhile, some mural tombs of Song dynasty have been also found in Jian'ou and Shaowu areas[34]. From the locations mentioned above, the Fujian mural tombs of Song and Yuan dynasties were mostly found at the central area and northwestern area of this province.

## (1) Features and Periodization

All of the mural tombs of Song and Yuan dynasties were made of bricks, which were apparently owned by the local rich or officials, contrasting to the pit-type tomb which were owned by common people. The tomb structures could be divided into five types: (1) length-way double chambers (front and rear) with a barrel-vaulted ceiling; the front chamber is nearly a square in plan, but smaller in size; the rear chamber is rectangular in plan, e.g. the Song Tomb of Mayang in Youxi and of Laizhou in Nanping; both tombs were painted in the chambers, depicting figures in pavilion in the front chamber, and Twelve Zodiac Animals in the rear chamber. (2) juxtaposed double chambers with a barrel-vaulted ceiling, e.g. Song Tomb of Gongshan, No.1 Song Tomb at Meixian and Song Tomb at Putou Village; the murals were painted on the inner walls, mostly depicting portrait, representing the daily life of the occupants. (3) single chamber with a barrel-vaulted ceiling, which was popular during the Song and Yuan dynasties, e.g. Song Tomb of Panshan and No.2 Song Tomb of Meixian. (4) with a flat ceiling or untypical barrel-vaulted ceiling, no doors, usually sealed from the ceiling when buried. Few of this type of tomb have been found, e.g. Song Tomb of Youxi First Middle School and Song Tomb of Yanqian in Sanming City; the former has a single rectangular chamber, the latter has juxtaposed double chambers, both were painted on walls. (5) the brick tomb simulating the wooden constructions, the Yuan Tomb of Sanguantang in Nanping City was the only example.

Among those mural tombs, only two were definitely dated: the Song Tomb of Putou Village in Youxi County seat,

which was dated upon 1126, the 1st year of Jingkang Era of the Northern Song dynasty; the Yuan Tomb of Sanguantang in Nanping, which was dated upon 1298, the 2nd year of Dade Era of the Yuan dynasty. However, other mural tombs could be dated according to the structures, funerary objects and mural motifs. The mural tombs could be divided into four periods: (1) From the middle Northern Song dynasty to the earlier stage of the late Northern Song dynasty, including the Song Tomb of Mayang, No.1 Song Tomb of Meixian Pingzhai in Youxi County, and Song Tomb of Laizhou in Nanping City. (2) the Late Northern Song dynasty, while the mural tombs occurred rapidly, including the Song Tomb of Panshan, Song Tomb of Gongshan, No.2 Song Tomb of Meixian Pingzhai, the tombs at the First Middle School and Putou Village. (3) the Southern Song dynasty, including the tomb at Yongkou Village of Youxi County and the tomb at Yanqian Village of Sanming City. (4) Yuan dynasty, including three mural tombs, i.e. Guangming Tomb in Jiangle, Sanguantang Tomb in Nanping, and Zudun Tomb in Songxi; the distribution zone of Yuan dynasty's mural tombs coincided with those of Song dynasty, therefore the Yuan's mural tombs inherited and developed from the Song's ones.

## (2) Mural motifs and artistic features

The mural motifs of the Song and Yuan dynasties were extensive, which were a real reflection of the social ideas, daily life and customs of that time. In summary, the motifs could be divided into the following categories:

### 1) Figure paintings

The figure paintings occupy a large proportion among the murals of the Song and Yuan dynasties. The figural representations, which were mostly depictions of the tomb occupant, attendants, warriors, servants and maids, or kinds of ceremonial guards, were usually painted on both side walls of chamber; however, the depictions of Attending in Bedroom were mostly found on the back wall, for example, on the double-chamber's back walls of the No.2 Song Tomb of Meixian Pingzhai, the scenes of a maid attending in bedroom with some objects in hands have been found; some similar depictions occurred in the back walls of the Song Tombs at Mayang, Gongshan and Laizhou. All of these figure paintings demonstrated various artistic features, however, those found in the No.1 Song Tomb at Pingzhai might be the most remarkable example by its appropriate profiling, smooth drawing, and quietly elegant coloring. Besides, those figural representations found in the Song tombs of Mayang, Yanqian, and Yuan Tomb of Jiangle also demonstrated a high painting skill, especially the natural and smooth outlines.

### 2) Four Supernaturd Beings and Twelve Zodiac Animals

The Four Mythical Animals and Twelve Zodiac Animals was a characteristic motif which was popular in the Song and Yuan murals of Fujian area. In the Song Tomb of Yanqian, Sanming City, the Four Mythical Animals and Twelve Zodiac Animals were arranged along the walls according to the directions that they might stand for. However, in other tombs, only incomplete combinations have been found, such as the combinations of Green Dragon and White Tiger, or Green Dragon, White Tiger, together with Twelve Zodiac Animals, or only Four Mythical Animals, or only Twelve Zodiac Animals; each animal was depicted as a human figure with an animal-typed crown. In the first and second periods, the Green Dragon and White Tiger were depicted realistically and looked strong and brave; however, in the third and fourth periods, the White Tiger was represented symbolically, looking like a mythical animal with a long neck.

### 3) Architectures

The depiction of architectures was also a very popular motif in the Song and Yuan murals, except for the tomb of Panshan in Youxi. For example, in the Song Tomb of Youxi No.1 Middle School, an architectural complex was depicted, including halls, porches, and courtyards. In many tombs, some halls and storage houses were depicted; some depictions of pavilion or tower in various styles could be also found in other tombs. The wooden buildings found in the Song Tomb of Gongshan were apparently a local type. The depiction of various architectures was undoubtedly a reflection of the real local buildings.

### 4) Landscape

In the scene of Domestic Life which was depicted on both side walls of Meixian No.1 Song Tomb, a brush-painted landscape was depicted on each screen.

**5) Other motifs**

Except for those mentioned above, the chickens and dogs were also popular depictions in the murals of Song and Yuan tombs in Fujian. In addition, the depictions of saddled horses, sedans, kitchen activities, and constellations were usually found.

The tomb murals of the Song and Yuan dynasties in Fujian area displayed a distinct artistic style. The painting skills were unique: most of the depictions were outlined with ink lines firstly, then colored in red or yellow, while very few were only drawn with ink and brush, no coloring; therefore, these murals were skilled in lines, not in colors as those seen in the Central Plain.

## 5. The Murals Unearthed in Jiangxi Province

In May, 2006, a mural tomb of the Song dynasty, which has been the only mural tomb found so far in Jiangxi, was excavated by Jiangxi Provincial Institute of Archaeology at Luxi Village, Nieqiao Town, De'an County. The tomb was located at a spacious terrain, facing a reservoir and leaning against a mountain. The tomb was built in the mountain, consisting of a rectangular stone pit at $5.3m^{by}4m$, and a ramp passageway at its southern side; in the stone pit, a pair of juxtaposed chambers with a barrel vaulted ceiling was built of bricks. The chambers were identical in structure, both were 3.06m in length, 1.2m in width, 1.6m in depth, but only the west chamber was depicted. The mural was depicted on the plastered layer (1cm thick), covering the east, west, north walls and the ceiling, up to an area of $13m^2$ . The depictions on the east and west walls have survived well, but those on the ceiling remained in a bad condition, those on the north wall was ruined. The depictions were outlined in black lines, and then colored in red, black, blue, brown, or yellow; the procedure should be as the following: firstly, plastering the wall with combinations of limes and sands so as to form a ground layer; secondly, brushing the layer with liquid lime so as to form a background color; then, painting with mixed pigments on the background color. The themes could be divided into five types: vanguards, warriors, attendants, maids, and constellations. On the east and west walls, nine standing figures were depicted from south to north: guards of honor and maids on the east wall, warriors and attendants on the west wall, the figures' height ranging from 1.1 to 1.15m. All figures had different attires according to their role: the guards of honor and warriors wearing the same scarf hat and tight-sleeve robe, but holding a mace and sword in hands respectively; the attendants wearing Futou hat and wide-sleeve robe, holding a tablet in hands; the waitress wearing a high hair chignon, a short robe and a long skirt, displaying a fleshy representation. Although the portrait of the tomb occupant was excluded in this mural, a grand scene of guarding and attending was presented. The constellations on the ceiling consisted of the Sun, the Moon, the stars and clouds.

From the composition, as well as the painting skills and coloring, this mural, especially the figural representation on the east and west walls, demonstrated an outstanding painting achievements of the Song dynasty.

According to the structure, mural themes, unearthed coins and ceramics, this tomb could be dated upon the Northern Song dynasty. It's believed by the local chronicles that this area was once the cemetery of Wang Shao, the famous general in Shenzong's reign of the Northern Song dynasty, therefore, this tomb was possibly occupied by an official in higher rank. The discovery of this tomb will provide some valuable information for the studies of ancient mural tombs in southern China.

## 6. The Murals Unearthed in Hubei Province

All of the ancient murals in Hubei province were from tombs, so far 16 in all mural tombs have been found, dating upon the Tang and Song dynasties; unfortunately only the murals in 4 Tang tombs and 2 Song tombs have survived well.

## (1) Murals in Tang Tombs

All of the five mural tombs of the Tang dynasty in Hubei were occupied by Tang's imperial clam members, undoubtedly the murals should reflect the best achievements of paintings in the Tang dynasty. The tomb of Yang, mother of Prince Wu, was excavated at Wangzishan of Anlu County in 1980, which was a mural tomb dating upon the early Tang dynasty. The occupant Yang was a concubine of Emperor Taizong, biological mother of Li Ke, Prince Wu. The tomb had been robbed for many times, all of the murals had flaked off, except some colorful traces remained on the walls of entryway and main chamber[35].

In 1980s, in the family cemetery of Li Tai (Prince Pu) in Matanshan of Yunxian County, four tombs had been excavated, being occupied respectively by Li Tai (Prince Pu), Yan Wan (Li Tai's concubine), Li Xin(Li Tai's eldest son), Li Hui(Li Tai's second son). Due to the discovery of epitaphs from every tomb, the occupants' identities and their burial dates could be clearly recognized, therefore, this group of tombs will provide some important information for the studies of tomb murals of the early and middle Tang dynasty.

The tomb of Li Tai is 36.6m long, consisting of a passageway, an entryway, four side chambers and a curved-square main chamber. It depicted buildings over the door, figures on chamber walls, constellations on the ceiling. This tomb was robbed, but some valuable artifacts were unearthed, including gold, silver, jade, ceramics and pottery figurines[36]. Li Tai was the second trueborn son of Li Shimin, Emperor Taizong, exiled to Yunxiang County after his loss in the struggling for the throne; died in 652, the 3rd year of Yonghui Era, and buried at Matanshan of Yunxiang County on the second month of the following year[37].

The tomb of Li Hui, the second son of Li Tai, consisted of a ramp passageway, an entryway, two niches and a square chamber. It was depicted on the passageway, door, entryway and chamber, unfortunately the depictions of the passageway flaked off; the niches' doors were outlined in red, some intertwined grasses being depicted above the door; on the chamber's walls, the attendants, the saddled horses and flowers were depicted; the constellations were depicted on the ceiling. According to the epitaph, Li Hui died in 683 CE, the 2nd year of Yongchun Era, and buried at Matanshan in 684, the first year of Sisheng Era[38].

The tomb of Yan Wan, Li Tai's concubine, consisted of a ramp passageway, a shaft, a corridor, an entryway and a square chamber. The entryway and the chamber were covered by murals: two male attendants survived on both walls of the entryway; the lower parts of two maids were still visible at the east wall, although most of the depictions on the chamber walls flaked off; the constellation was depicted on the ceiling. Due to the moist circumstances in the tomb, the mural looks a little dim. According to the epitaph, Yan Wan died at Shaozhou in 690 CE, the first year of Tianshou Era, buried temporarily at Luoyang, and then moved to Matanshan in 724 CE, the 12th year of Kaiyuan Era[39].

The tomb of Li Xin, the eldest son of Li Tai, consisted of a ramp passageway, a shaft, two corridors, an entryway, seven niches and a square chamber. Most of the murals in the tomb flaked off after being soaked in the water for a long time, only a male attendant's head was visible on the west wall of the entryway. According to the epitaph, Li Xin died between 685-689 CE, Chuigong Era of Wu Zentian's reign, and moved to be buried at Matanshan, the family cemetery[40].

The five mural tombs mentioned above displayed some differences in the skills of ground layer, as well as in the surviving statuses. In Li Hui's tomb, a layer of lime was plastered directly on the brick walls, which might help the murals to survive well; however, in other tombs, a layer of fine yellow mud was applied on the walls before the layer of lime was plastered, the layer of mud was easy to flake off, therefore the murals were difficult to survive. As for the painting procedure, the figures were usually outlined in ink, and then filled with red, green, yellow, white, and black; the flowers and plants were usually painted directly with pigments.

The motifs, for the example of Li Hui's tomb, could be divided into four types: guard of honor; buildings; scenes of daily life; constellations. The principle of arrangement was usually as following: guards of honor at the entryway, buildings in

front of the door, scenes of daily life on chamber's walls, constellation on the ceiling.

According to the structures, mural motifs and arrangements, the five Tang mural tombs were believed to be similar with those contemporary imperial tombs found in Shaanxi, which demonstrated that some funerary rules must be strictly observed by the imperial members. However, in Li Hui's tomb, the painting of flowers on the six-panel-screen was believed to be half century earlier than those found in Xi'an.

## (2) Murals in Song Tombs

So far, 11 mural tombs of the Song dynasty have been found in Hubei Province, including nine of the Northern song dynasty and two of the Southern song dynasty. Contrary to the relatively intensive distribution of Tang Tombs, the mural tombs of Song dynasty were found in a more widespread area, almost all over the province except its eastern areas. Although so many mural tombs have been found, most of the murals were ruined seriously. For example, in the Zhaowang Tomb at Cheqiao of Jingmen[41], the Mural Tomb of the Northern Song Dynasty at Tangzhen of Suixian County[42], the Mural Tomb of the Later Northern Song Dynasty at Yangjiatuo of Zigui County[43], only parts of the murals have survived.

Two mural tombs of Southern Song dynasty, which were excavated at Tanxi Rd. Xiangcheng District, Xiangfan City in 2007, should be the best survived mural tombs in Hubei. The two juxtaposed tombs were rectangular brick tombs with barrel vaulted ceilings. The tomb No.196, lying at the west, was built of bricks imitating the wooden structures, its walls were plastered before being painted; the paintings were divided into two registers by the imitated beam: the Four Mythical Animals and Peony at the upper, the attendants, maids, and scenes of wine-serving, cooking, storage houses at the lower, 10 attendants on both side wall being depicted. The tomb No.197, lying at the east, was smaller, in which 6 paintings of Chinese crabapple flowers were depicted symmetrically on the four walls: one on the north wall and south wall respectively; two on the east wall and west wall respectively[44]. The Song tombs of Hubei province, which are smaller in size and mostly built of bricks imitating the wooden structures, usually belonged to the local rich people or officials.

Based on the two Southern Song mural tombs in Xiangfan, which were definitely dated and explicitly recognized, the murals of the Southern Song dynasty could be divided into three types: first, scenes of cooking, wine-serving, tea-serving, inferring to serving for the tomb occupant; second, the Four Mythical Animals, meaning exorcising or indicating the directions; third, the geometric designs and flowers, meaning to imitate the designs of domestic rooms, e.g. the Chinese crabapple flowers and clouds. The murals inherited some traditions from those in the Central Plain, for example, the drawing skills of outlining with ink were frequently adopted, but coloring was seldom applied, especially in representations of figures or flowers; the lines were simple and smooth, displaying a vivid daily life taste.

## 7. The Mural Unearthed in Guangdong Province

In Guangdong Province, there are two tombs in which the painted murals have been found: the tomb of King Nanyue, dating upon the middle Western Han dynasty[45]; the tomb of Zhang Jiuling, dating upon the High Tang dynasty[46].

The tomb of King Nanyue, which was located at the Mountain Xianggang, north of Guangzhou City, was a large mausoleum built in rocks, facing south, 21.31m in length, consisting of a passageway, front chamber and its side chambers, main chamber and its side chambers, rear chamber, and an additional chamber between the door and the north end of the passageway. Some cloud designs were depicted on the front chamber's walls, the ceiling, and the stone doors; the designs being painted directly on the stone surfaces. According to the unearthed gold seal with a dragon-shaped knob and a jade seal, this tomb was believed to the mausoleum of Zhao Mo, who was the second King of Nanyue Kingdom in the Western Han dynasty and died around 122 BCE. The murals in this tomb were just some simple cloud designs, however, it was believed to be the earliest tomb murals ever found in China, therefore it's a significant discovery in Chinese art history. Considering the murals of flying dragons in the tomb of King Liang of Western Han in Yongcheng, it could be deduced that the mural tombs might originated from the mausoleums of the early Western Han dynasty.

The tomb of Zhang Jiuling was located at the foothill of Luoyuandong, northwestern suburb of Shaoguan City. It was built of bricks, 8 meters long, facing southeast at 125°, consisting of an entryway, two side chambers and a main chamber. It depicted on the main chamber and the entryway, but most of the murals flaked off due to the repeated robbing and damages, only a few could be recognized: the peaches and maids on the north wall of entryway; the incomplete waitress on the east wall and the Green Dragon on the north wall of the main chamber. The procedure of painting is believed to plaster the brick wall with 1 cm thick layer of mud, and then outline the profiles, finally apply the red and green colors; the lines were smooth and steady, the figural representations demonstrated a typical High Tang style. According to the epitaph, the occupant was Zhang Jiuling, who was a native in Shaozhou, once a famous prime minister in Kaiyuan Era, died in 740, the 28th year of Kaiyuan Era, moved to be buried here from the Central Plain in the following year. The murals in Zhang's tomb could be a typical representative of the tomb murals of officials in higher ranks of that time.

## 8. The Murals Unearthed in Chongqing

All murals unearthed in Chongqing were from three tombs. Among them, the murals in the Song dynasty's tomb at Tuchengpo of Wushan County have flaked off, only the murals in the Yuan dynasty's tomb at Damiao of Wushan County, and the Ming dynasty's tomb at Linggetang of Yongchuan District have survived well.

The Yuan dynasty's tomb at Damiao, which was excavated in 2005, was located at Damiao of Miaoyu Town, Wushan County. It's a shaft pit, facing south, consisting of two juxtaposed chambers which might mean a joint burial of a couple. The walls in both chambers were plastered before being outlined with ink and then colored with black and red; the motifs differed in the two chambers: the east chamber of the female occupant was mainly depicted with flowers and birds with some attendants; the west chamber of the male occupant was depicted largely with themes of the elite's life, including the depictions of enjoying, teaching, and a domestic room on the east wall, and enjoying the music, playing the chess and a painting table on the west wall, clan tablets on the north wall. On the ceilings of both tombs, some cloud designs were depicted. The differences of the motifs demonstrated the occupants' distinct cultural interests.

The Ming dynasty's tomb at Linggetang, which was excavated in 2008, was located at Linggetang Village of Qingfeng Town, Yongchuan District. It's a rectangular single-chambered brick tomb with double barrel-vaulted ceiling, consisting of a door, a chamber and a niche, facing south at 175°. The wall was plastered before being outlined with ink and colored with deep black, brownish red, yellow; on the east wall, the scenes of wine-serving, the lucky deer, and storage house were depicted from south to north respectively; on the west wall, the scenes of waitress holding a pitcher, saddled horse, storage house, and three-footed bird were depicted from south to north respectively; on the north wall, the flower in vase was depicted; on the ceiling, a large character "happiness" was written in ink, around it two concentric circles and lotus petals were depicted. All of these motifs might demonstrate the occupant's wish of transcending.

## 9. The Murals Unearthed in Sichuan Province

All of the unearthed murals were from nearly 10 tombs which were dated from the Eastern Han to Ming Dynasties, unfortunately most of them had flaked off and became unrecognized because of the moist circumstances. The well survived murals were from the Bailinpo No.1 Tomb of Santai County and the Taliangzi No.3 Tomb of Zhongjiang County, both were tombs built in cliffs, dating upon the Eastern Han dynasty. The ancient murals in cliffs tombs have been found only in Sichuan area, especially in the Qi River Valley.

Bailinpo No.1 Tomb, facing to 108°, was located at the southeast end of the Moutain Bailinpo of Qijiang Town, Mianyang City; it was a tunnel-shaped multi-chambered rock tomb, consisting of a passageway, a door, an entryway, a front chamber, a rear chamber and some side chambers, ear chambers, reaching 20 meters long in all[47]. A red label with characters "4th year of Yuanchu Era (117 CE)" was found in this tomb, which revealed the tomb's definite date. In this tomb, totally 46 paintings including the murals and relief stone sculptures were found; the motifs were mostly figures, scenes of banquet or transcending[48].

Taliangzi No.3 Tomb, facing to 225°, was located at Taliangzi of Guihua Village, Minzhu Town, Zhongjiang County, Deyang City. This tomb was large in size and complicated in structures, consisting of five main chambers and several side chambers, reaching a total length of 33.25m; the paintings were mostly found in the side chamber of the third main chamber, as well as on the walls of the entryway, including the depictions of banquet, door guards, the Four Mythical Animals, etc[49].

Some tomb murals in Sichuan were painted directly on the walls, e.g. in the Bailinpo No.1 tomb; others were plastered before being painted, e.g. in the Taliangzi No.3 tomb. There were two kinds of skills of painting: outlining the profile with ink and then filling colors in it; painting directly with pigments; the colors were usually red, yellow, green, black and white.

The mural motifs mentioned above were similar with those found in the tombs with relief stone sculptures or modeled bricks in Sichuan area, usually including the scenes of procession, banquet, transcending, etc. For an example, the motif of murals in the Taliangzi No.3 tomb was depictions of domestic life and banquet, but considering its labels, we can find that the highlighting of family background was similar with that in the murals of Horinger tomb in Inner Mongolia, in the latter example, the scenes of procession with carriages and horses were depicted to display the occupant's official career [50]. The labels in this tomb also provided some important information for the studies of politics, military, and relations of ethnic groups of that time.

## 10. The Mural Unearthed in Yuannan Province

All unearthed murals in Yunnan province were from four mural tombs: Liangdui Mural Tomb at Qujing, Zhaozongcun Mural Tomb at Xishan of Kunming, Yunshancun Mural Tomb at Guandu of Kunming, and Huo Chengsi's Tomb at Zhaotong[51]; the former three tombs were dated upon the Eastern Han dynasty, Huo Chengsi's Tomb was dated on the Eastern Jin dynasty.

In the three Han dynasty's tombs, the murals flaked off severely, only some fragments were visible: triple-colored lotuses in Liangdui Tomb and Zhaozongcun Tomb, two incomplete red-black figures in Yunshancun Tomb. Only the murals in Huo Chengsi's Tomb have survived well.

Huo Chengsi's tomb was located at Zhongzhai, Houhaizi, 20km northwest to Zhaotong City, and excavated in 1963. This tomb, facing south, was a single-chambered stone tomb with a domed ceiling; the chamber was square in plan, 3m long each side. According to the label on the north wall, this tomb was owned by Huo Chengsi, who was moved to be buried here in 386-394 CE, the 11th to 19th year of Taiyuan Era, Eastern Jin dynasty.

The murals were painted on the plastered walls, the ordinary procedure was as following: firstly outlining on the ground layer with wood or bamboo chips, and then drawing with ink lines, and finally coloring it; however, some pattern bands were directly colored after being modeled; all murals were painted in four colors: black, yellow, brown and red.

The mural in the chamber was divided into two registers by a band of successive pattern: at the upper register, it depicted the Four Mythical Animals, and some designs of clouds, birds, lotus, buildings and figures around them, each animal was labeled with names in ink; at the lower register, it depicted some scenes related with the occupant's real life, which was also the most valuable feature in this tomb; the occupant was depicted to be seated at the platform at the center of the lower north wall, the occupant's status being highlighted by a bigger proportion; at east of the occupant, it depicted respectively a flag, an attendant, a weapon's rack with a canopy, a flag, and some weapons on it, and seven attendants short in scale under the rack; at west of the occupant, it depicted 11 figures and an ink label above it. On the east wall, two lines of figures were depicted at the lower part, above it there were 13 additional attendants, each wearing a black ingot-shaped hat and holding a flag in hands; beneath there was a line of mounted warriors, each holding a spear. On the west wall, three lines of figures, totally 40, were depicted at the lower part, and four mounted warriors beneath. On the south wall, the paintings were above the door: a building with tiled ceiling centered at the lower part, an armored warrior standing at its west, holding a knife, and being labeled with "Zhong Men Hou"; another label with transformed characters "Tian Mi" was depicted at west of the warrior.

The mural was depicted on the four walls respectively, however it could be treated as an integrate painting: the Four Mythical Animals at the upper register functioned as guards to protect the tomb occupant; the depictions at the lower register of the east and west walls were believed to be a ceremonial scene of releasing souls from purgatory. It's recorded historically that Huo Ge, an ancestor of Huo Chengsi, was skilled at the ceremony of releasing souls from purgatory which was associated with Tantra Faction of Buddhism, and possibly appeared at the lower register of the north, east and west walls, i.e. the depictions represented the ceremony held for Huo Chengsi, the tomb's occupant[52].

According to the themes and arrangements, the mural of this tomb apparently inherited some traditions from those of Eastern Han dynasty. Although it appeared simple and unadorned in skills, it was a very significant discovery in the historical studies. As one of the top powerful persons in Nanzhong area of that time, Huo Chengsi held a series of important positions in the government, and was undoubtedly a strong local elite. In addition, the costume of figures at the lower register of the west wall seems to be similar with those worn by the modern Yi people in Liangshan prefecture of Sichuan Province; this might demonstrate that Huo Family owned a lot of private soldiers and servants from both Han and Yi ethnic groups. This group of murals provided some valuable visual information for the historical studies of 3rd to 5th centuries in Yunnan province.

## 11. The Murals unearthed in Tibet Autonomous Region

Most of the unearthed murals with archaeological contexts across the country were from the tombs, only a few were from the sites of temples, Buddhist caves, and palaces; however, within the Tibet Autonomous Region, no mural were from the tombs although hundreds of tombs have been excavated, almost all of the unearthed murals were from the sites of Tibetan Buddhist Temples.

The archaeological works haven't begun until 1970s when the Karuo Site at Qamdo Prefecture was excavated, then in 1980s, when the archaeological surveys were carried out in the autonomous region, lots of ancient sites and tombs were found, some of which were excavated. Since 1990s, more archaeological surveys and excavations have been conducted as a part of the preservation programs on the cultural relics; murals were found from some of these sites, including the Guge Ancient City at Zanda County of Ngari Prefecture, the Toding Temple, the site of Dongdkar Piyang, the site of Dabat Castle, and the site of North Sakya Monastery at Sakya, Shigatse; among them, the site of Toding Temple owned the most abundant murals.

The Toding Temple was established by the Guge Royal court at early 11th century. The Gaza Hall, the main body of the temple, was designed to imitate the Sam Ye Monastery of Tubo Kingdom with a perfect structure in the Mandala form, consisting of five central halls, 19 peripheral halls and four small lofty pagodas symbolizing the Buddhist world centered by Mount Sumeru. This magnificent building, totally 1200sqm in area, was exquisitely designed and regarded as a typical Tibetan Buddhist temple.

Unfortunately due to some unnatural reasons, the original ceilings were destroyed and few of the statues and murals have survived. After the excavations, lots of incomplete statues, murals, sutras, and other artifacts was unearthed, some of them could be dated back to the earliest times of the temple; around 40sqm murals were survived at the original walls, other fragments found in the ruins. The murals in the best condition were found mostly at the ambulatory of the F11, the Gaza Hall, depicting the Buddha's life stories in form of the serial pictures, including the story of White Elephant, the Birth under a Tree, Facial Divination, Studying and Meditation, Marriage and Show, Demons Quelling, Nirvana, Cremation, and Eight-Pagoda Building. As an earlier style of the Buddha's life stories during the second diffusion of Tibetan Buddhism, the mural in this hall is distinctive from those in the Red Hall, the White Hall of the Guge Ancient City, and as well as the Red Hall of the Toding Temple, the former only depicting the figures who might need to be related directly to Buddha, demonstrating a concise composition with less color, simple lines and more blanks.

In addition, some murals have been unearthed from the sites at Manilhkang, Naijulhkang, Azharelhkang, Pagoda No.50, Pagoda No.55.

The Manilhkang, also called Hall of Praying Wheel, was a small hall at southeast of the Gaza Hall, only covering 27sqm, in which a rotatable barrel-shaped praying wheel in 3m high was originally installed; it has been destroyed seriously

into ruins, where some relics of bronze pagoda, gilded statue of Garuda Bird, and pages of sutras were unearthed, some depictions of Buddha's Life Stories and Thousand Buddha were still slightly visible.

The Naijulhkang, also called Hall of Sixteen Arhat, consisted of the Arhat halls and a small Buddha Hall, covering 75sqm. In the Buddha Hall, a statue of Shakyamuni was originally installed; in the Arhat halls, 16 statues of Arhats and Bodhisattvas were arranged symmetrically along both sides. In the unearthed bodies and heads of the statues of Arhat, the Han style could be noticed. Besides, few murals depicting the Buddha's life stories, Thousand Buddha and senior monks have survived on the walls.

The Pagoda No. 50 was one of the four pagodas in the Toding Temple, lying at northeast of the Gaza Temple, probably established concurrently with the Temple. Its upper part was destroyed, exposing an inner hall of 7sqm: the door facing east was closed originally, inside some murals were survived, depicting Avalokitesvara Bodhisattva in the shapes of six arms, eight arms, eleven-face, and Rescuing Bodhisattva; in addition, some relics of statues, tiny pagodas, and pages of Tibetan Sutras were unearthed. The mural demonstrated an obvious Indian or Kashmir style, probably works of some Kashmir artist. The depiction of the Rescuing Avalokitesvara Bodhisattva on the south wall was the earliest one among murals with the same themes found in Tibet, fully describing the Avalokitesvara's rescuing stories according to the Buddhist scriptures.

The Pagoda No. 55 lies at the northwest of the Gaza Temple, its northern part was destroyed, and most of its halls, statues and murals were ruined as well. The hall faces west, at each of the other three walls one niche was carved, in which the statues were installed: a standing Buddha in the east niche, a standing Bodhisattva in the south and north niches. Some murals have survived, even the original color existing, depicting the Tara, Vajra, Heavenly Guardians, worshipping monks, and donors; some Tibetan scripts were also found over the depictions of donors, demonstrating their royal identities of Guge Kingdom; the style was distinctive from those in the northeast pagoda, apparently coming from another area.

The Site of Dongdkar Piyang at the Zanda County was a very important site of the Guge Kingdom, where lots of Buddhist mural have survived. In a survey of 1990s, archaeologists found the closed cave, in which some murals were unearthed, some of them could be dated back to 11th-12th centuries, the earlier period of Guge Kingdom.

The site of Dabat Castle was located at a hill, south of the Dabat Town, Zanda County, Ngari Prefecture; it could be divided into two regions: Region A and Region B. In 1998, the local authority excavated a Buddhist hall in the Region A, and found some survived murals which could be dated back to 14th century. Only two Buddhist halls in the Guge Ancient City have been excavated; in the Hall of Vaisravana, some unearthed murals could be dated late to the middle period of the Qing dynasty, which were apparently remains of the Bkav-shag period (the old local government in Tibet).

In the site of North Sakya Monastery at Sakya, Shigatse, a few remains of murals were also unearthed, all of which were decoration designs at lower part of the walls, including the depiction of Vajra Pestle, tendril, etc; according to the styles and techniques, it might be dated back to the early Qing dynasty.

# References

[1] The Epitaph of Mr. He in Liucheng of the Yan Empire, with the Preface. Collected in Beijing Municipal Institute of Cultural Relics.

[2] Wang Ce. 1999. The Tang Tombs Unearthed in Beijing Yanjing Automobile Factory. Beijing Cultural Relics and Museums 1.

[3] CPAM (Committee for Preservation of Ancient Monuments) of the Haidian District, Beijing. 1995. A Tang Tomb Discovered at Balizhuang on the Western Outskirts of Beijing. Wenwu 11.

[4] Archaeological Team of the City of Peking. 1962. The Liao Dynasty Tomb of Chao Tê Chün in the Southern Suburb of Peking. Kaogu, 5.

[5] The Archaeological Team of Beijing. 1984. Excavation of Han Yi's Tomb of the Liao Dynasty. Acta Archaeologica

Sinica, 3.

[6] Beijing Municipal Institute of Cultural Relics. 2004. Liao Period Tombs at Qingyundian in Daxing District, Beijing. Kaogu, 2.

[7] Zhou Yu. Forthcoming. The Tombs on the Site of Inter-factory Center of the the Third Research Institute of CASIC.

[8] The Archaeological Bureau of the City of Beijing et al. 1980. Excavation of the Liao Dynasty Wall Paintings Tomb at Zhaitang. Wenwu, 7.

[9] Beijing Municipal Institute of Cultural Relics et al. 2005. The Mural Tombs in the Site of Yanqing Fashion Textile Company Ltd. Beijing Cultural Relics and Museums, 3.

[10] Wang Qinglin and Zhou Yu. 2002. The Epitaph and Murals of Zhao Li's Tomb in Bajiao Village, Shijingshan District, Beijing. Beijing Cultural Relics and Archaeology vol. 5. Beijing: Yanshan Press.

[11] Ge Zhigong. 1961. A Mural Tomb found at Huangshanlong in Xuzhou. Wenwu, 1.

[12] Nanjing Municipal Museum. 1993. The Southern Dynasties Tomb at Xishanqiao in Nanjing. Wenwu, 11.

[13] The Nanjing Museum. 1980. Two Southern Dynasty Tombs at Huqiao and Jianshan in Danyang County, Jiangsu Province. Wenwu, 2.

[14] The Nanjing Museum. 1957. Report on the Excavation of Two Southern T'ang Mausoleums. Beijing: Cultural Relics Press.

[15] CPAM, Jiangsu Province and Nanjing Museum. 1960. The Mural Tombs of the Song Dynasty in Huai'an, Jiangsu. Wenwu, 8-9.

[16] Wang Bomin. 1982. Zhongguo Huihua Shi (History of Painting in China). Shanghai: Shanghai People's Art Publishing House.

[17] CPAM, Zhejiang Province and History Department, Hangzhou Normal College. 1960. Excavation of the Ancient Tombs at Shijiashan in the Suburb of Hangzhou. Journal of Hangzhou Normal College (Social Science version) 7. CPAM, Chekiang Province. 1975. The Sky Maps and Mi Sê (Secret Glaze-Colour) Porcelains Found in the Five Dynasties Tombs at Lin-an and Hangchow, Chekiang Province. Kaogu 3. Zhejiang Provincial Museum. 1979. The Map and White Porcelains Unearthed from the Late Tang Dynasty Tombs of Qian Kuan at Lin'an County in Zhejiang. Wenwu 12. Mingtangshan Archaeological Team. 1981. The Excavation of nee Shuiqiu's Tomb in Lin'an County. Journal of Zhejiang Provincial Institute of Cultural Relics and Archaeology.

[18] Zhu Boqian. 1954. The Song Tombs and Ming Mural Tombs found in Jiashan County, Zhejiang. Wenwu, 10.

[19] The Institute of Archaeology of Hangzhou, the Institute of Archaeology of Lin'an. 2000. Excavation of the Kang Mausoleum of the Wuyue State during the Five Dynasties at Lin'an, Zhejiang Province. Wenwu, 2.

[20] Fujian Provincial Museum and CPAM, Youxi County. 1985. The Mural Tomb of the Song Dynasty in Youxi County. Wenwu, 6.

[21] Fujian Provincial Museum et al. 1988. The Mural Tomb of the Song Dynasty at Outskirts of Youxi County Seat. Wenwu, 4.

[22] Fujian Provincial Museum et al. 1989. The Mural Tomb of the Song Dynasty at Mayang, Youxi County, Fujian. Kaogu, 7.

[23] Fujian Provincial Museum et al. 2008. The Mural Tomb of the Song Dynasty at Meixian, Youxi County, Fujian. Fujian Wenbo (Fujian Cultural Relics and Museums), 7.

[24] Fujian Provincial Museum et al. 1991. A Song Dynasty Painted Tomb Discovered at Youxi County, Fujian Province. Kaogu, 4.

[25] Chen Changgen 1995. The Dated Mural Tomb of the Song Dynasty Found at Putou Village, Chengguan Township, Youxi County, Fujian. Kaogu, 7.

[26] Youxi County Museum. Forthcoming. The Mural Tomb of the Song Dynasty at Yongkou, Youxi, Fujian.

[27] Zhang Wenyin. Forthcoming. The Mural Tomb of the Song Dynasty at Nanping.

[28] Zhang Wenyin and Lin Wenqi. 1996. The Recovering of the Dated Yuan Tomb at Sanguantang, Nanping City, Fujian. Kaogu, 6.

[29] Fujian Provincial Museum et al. 1995. The Mural Tomb of the Song Dynasty at Yanqian Village, Sanming City, Fujian. Kaogu, 10.

[30] Fujian Provincial Museum et al. 1995. A Painted Tomb of the Yuan Period at Jiangle County, Fujian Province. Kaogu 1.

[31] Zhang Wenyin. 1988. Large-sized Bronze Mirror of the Song Dynasty Found in Nanping City. Fujian Wenbo, 1. This mirror was said to be found in a mural tomb.

[32] Wang Xiangdui. 1990. Tombs of the Song Dynasty Found in Youxi County. China Cultural Relics News Dec. 27.

[33] Found by the authors in Jiangle County during the investigation.

[34] Lin Zhonggan 1992. On the Periodization of the Song Tombs in Fujian. Kaogu, 5.

[35] The Prefectural Museum of Xiaogan and the Museum of Anlu County, Hubei Province. 1985. The Tang Dynasty Tombs of Lady Yang, Prince Wu's Consort. Wenwu 2. Song Huanwen. 1980. The Tomb of a Prince Consort of the Early Tang Dynasty Found in Anlu. Jianghan Kaogu (Jianghan Archaeology), 1.

[36] The Materials of the excavation of Li Tai's tomb collected in Hubei Provincial Institute of Cultural Relics and Archaeology.

[37] Li Tai's epitaph collected in Hubei Provincial Institute of Cultural Relics and Archaeology.

[38] The Provincial Museum of Hubei and the Museum of Yunxian County. 1987. Excavation of the Tang Tomb of Li Hui and Yan Wan at Yunxian, Hubei. Wenwu, 8.

[39] Ibid.

[40] Gao Zhongda. 1980. The Excavation of the Tomb of Li Xin, the Prince Presumptive of Pu of the Tang Dynasty. Jianghan Kaogu, 2.

[41] CPAM, Hubei Province. 1954. The CPAM, Hubei Province Surveys Prince Zhao's Tomb in Jingmen County. Wenwu, 9.

[42] Li Yuankui and Mao Zaishan. 1960. The Mural Tomb of the Song Dynasty and Stone-chamber Tomb of the Eastern Han Dynasty Found in Tang Township, Suixian County. Wenwu, 1.

[43] Hubei Provincial Institute of Cultural Relics and Archaeology. 2005. The Excavation of Yangjiatuo Site in Zigui County. In Collections of the Reports on the Archaeological Excavation in the Three Gorges Dam, Hubei (2). Beijing: Science Press.

[44] Excavation materials collected in Xiangfan Municipal Institute of Cultural Relics and Archaeology. [45] CPAM, Guangdong Province, Institute of Archaeology, Chinese Academy of Social Sciences and Guangdong Provincial Museum. 1991. Nanyue King's Tomb of the Western Han. Beijing: Cultural Relics Press.

[46] CPAM, Guangdong Province et al. 1961. Excavation of Zhang Jiuling's Tomb of the Tang Dynasty. Wenwu, 6.

[47] Sichuan Provincial Institute of Cultural Relics and Archaeology, Mianyang Municipal Museum and CPAM, Santai County. 2007. Santai Qijiang Yamu (Cliff Burials at Qijiang, Santai). Beijing: Cultural Relics Press.

[48] The description of the locations of the murals in the original report was by relative direction (left, right, etc.); we changed into absolute direction (east, north, west and south) as shown by the diagrams.

[49] Sichuan Provincial Institute of Cultural Relics and Archaeology, Deyang Municipal Institute of Cultural Relics and Archaeology and CPAM, Zhongjiang County. 2008. Zhongjiang Taliangzi Yamu (Cliff Burials at Taliangzi, Zhongjiang). Beijing: Cultural Relics Press.

[50] Song Zhimin. 2005. On the Contents of the Murals in M3 at Taliangzi, Zhongjiang. Archaeology and Cultural Relics, 5.

[51] The Archaeological Team of Yunnan Province. 1963. Excavations of an Eastern Tsin Tomb with Wall Paintings at Hou Hai Tzu, Chao T'ung, Yunnan Province. Wenwu, 12.

[52] Fang Guoyu. 1990. An Outlined Introduction of the Murals in Huo Chengsi's Tomb of the Jin Dynasty. in Yunnan Shiliao Congkan (Collection of Historic Materials on Yunnan) vol. 1. Kunming: Yunnan People's Publishing House.

# 目 录 CONTENTS

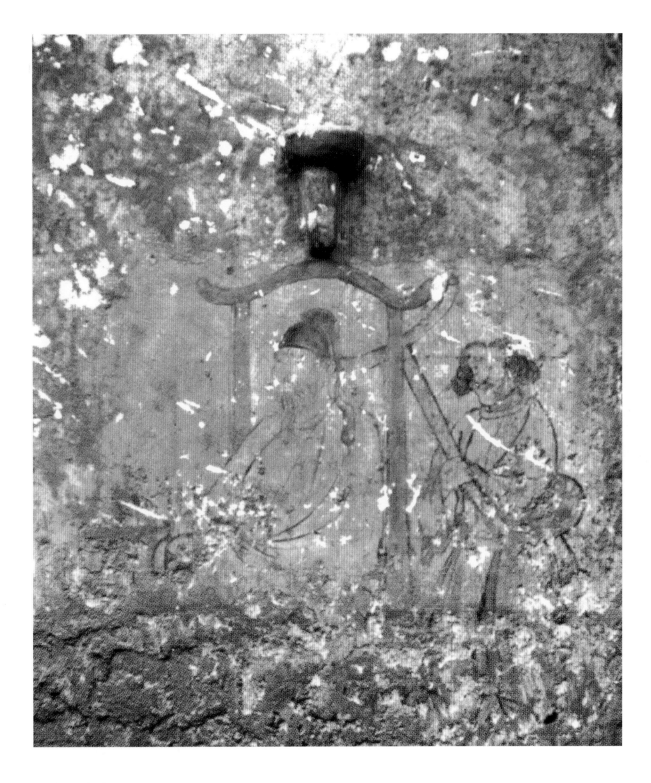

# 1.墓主图

唐史思明天顺元年（759年）

高约140、宽80厘米

1988年北京市宣武区陶然亭唐何府君墓出土。现存于首都博物馆。

墓向南。位于墓室西壁北侧。图为墓主人及侍者形象。墓主人端坐木椅，侍女手持羽扇立侍。

（撰文：丁利娜　摄影：王殿平）

## Portrait of Tomb Occupant

1st Year of Tianshun Era, in Shi Siming's Reign, Tang (759 CE)

Height ca. 140 cm; Width 80 cm

Unearthed from He's Tomb at Taoranting in Xuanwu Distrcit, Beijing, in 1988. Preserved in the Cpital Museum, China.

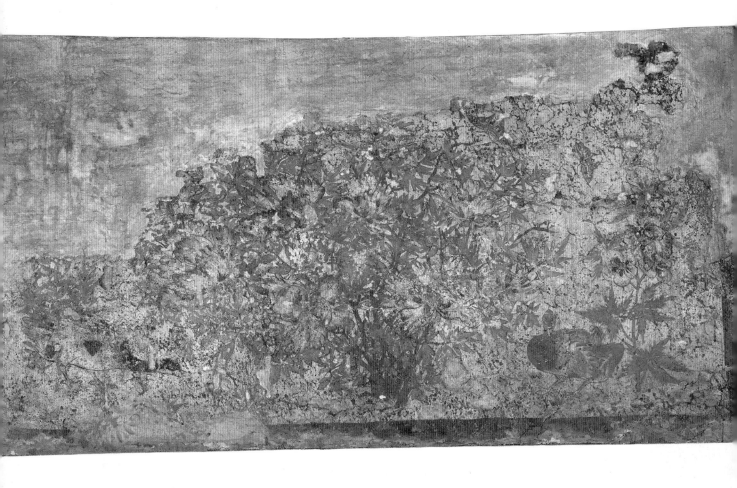

### ▲2.牡丹芦雁图

唐开成三年（838年）

高156、宽290厘米

1991年北京市海淀区八里庄王公淑墓出土。现存于北京市海淀区博物馆。

墓向南。位于墓室北壁，是一幅通景式弧形壁画。画面主体为一株硕大的牡丹和两只芦雁。整株牡丹强壮茂盛，左右两侧花丛下有两只形态各异、相对站立的芦雁。右边的一只侧身正面，眼睛圆睁，平视前方，羽毛微翘。左边的一只侧身探首，长颈直伸，羽毛略张。

（撰文：杨桂梅　摄影：王宁）

### Peony and Wild Geese

3rd Year of Kaicheng Era, Tang (838 CE)

Height 156 cm; Width 290 cm

Unearthed from Wang Gongshu's Tomb at Balizhuang in Haidian District, Beijing, in 1991. Preserved in the Haidian Museum of Beijing.

### 3.牡丹芦雁图（局部）▶

唐开成三年（838年）

1991年北京市海淀区八里庄王公淑墓出土。现存于北京市海淀区博物馆。

墓向南。位于墓室北壁。是牡丹芦雁图局部。为图右下方的芦雁。

（撰文：杨桂梅　摄影：王宁）

### Peony and Wild Geese (Detail)

3rd Year of Kaicheng Era, Tang (838 CE)

Unearthed from Wang Gongshu's Tomb at Balizhuang in Haidian District, Beijing, in 1991. Preserved in the Haidian Museum of Beijing.

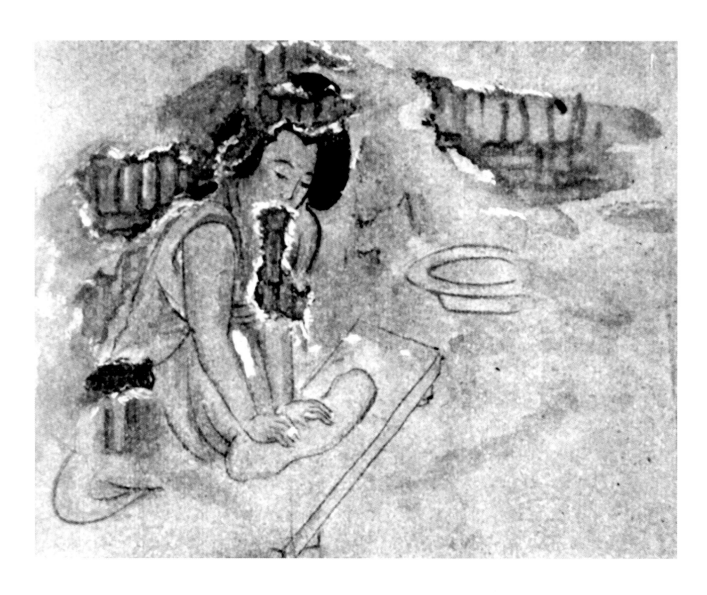

# 4. 厨作图（摹本）

辽应历八年（958年）

1960年北京市丰台区赵德钧墓出土。已残毁。

墓向东。位于墓葬右前室东侧。女仆梳双髻，坐在案前，两袖卷起，正在揉面，旁边放有一水盆。

（临摹：不详　撰文：丁利娜　摄影：王殿平）

## Working In the Kitchen (Replica)

8th Year of Yingli Era, Liao (958 CE)

Unearthed from Zhao Dejun's Tomb at Fengtai District, Beijing, in 1960. Not Preserved.

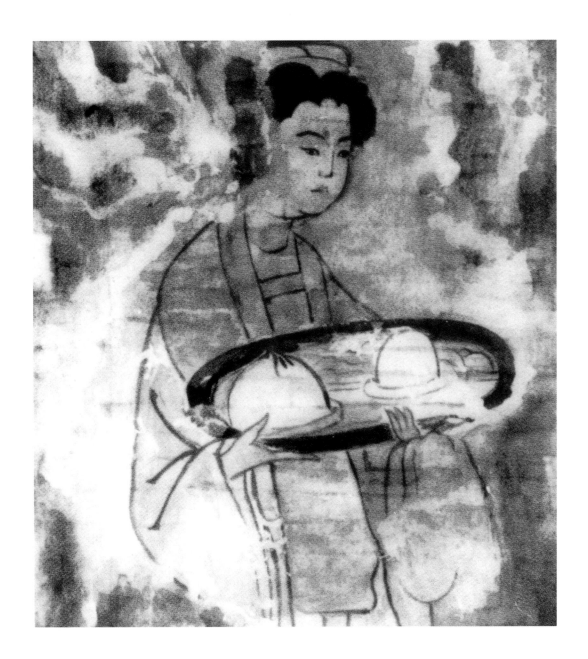

## 5.托盘图（摹本）

辽应历八年（958年）

1960年北京市丰台区赵德钧墓出土。已残毁。

墓向东。位于墓葬右前室西侧。女仆梳高发髻，额饰为三尖巧额着团衫，手托一圆盘，盘底绘有山水画，盘上置面食两枚。

（临摹：不详　撰文：丁利娜　摄影：王殿平）

### Holding a Tray (Replica)

8th Year of Yingli Era, Liao (958 CE)

Unearthed from Zhao Dejun's Tomb at Fengtai District, Beijing, in 1960. Not Preserved.

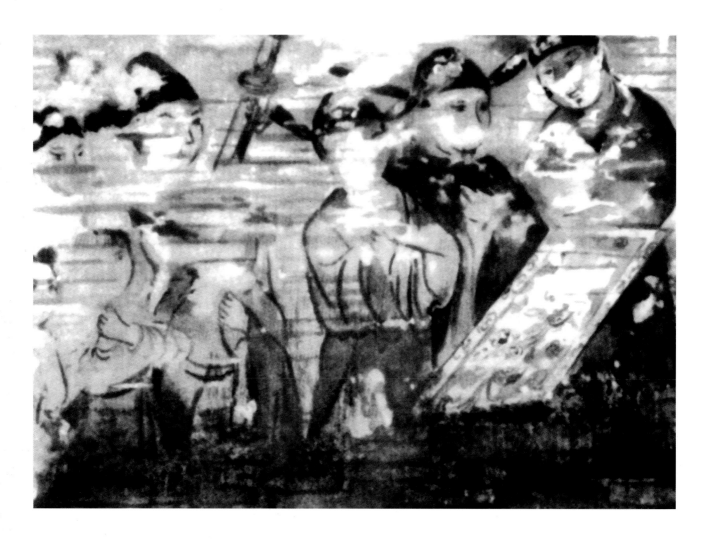

# 6.赏画图（摹本）

辽应历八年（958年）

1960年北京市丰台区赵德钧墓出土。已残毁。

墓向东。位于墓葬中室东侧。共绘九人，右三人着红袍，戴展角幞头，正在欣赏一幅画。左六人为僮仆，有三人戴巾，其中一人手持宝剑；另三人戴软脚幞头，其中一人叉手于胸前。此图为画面的右半部分。

（临摹：不详　撰文：丁利娜　摄影：王殿平）

## Enjoying the Painting (Replica)

8th Year of Yingli Era, Liao (958 CE)

Unearthed from Zhao Dejun's Tomb at Fengtai District, Beijing, in 1960. Not Preserved.

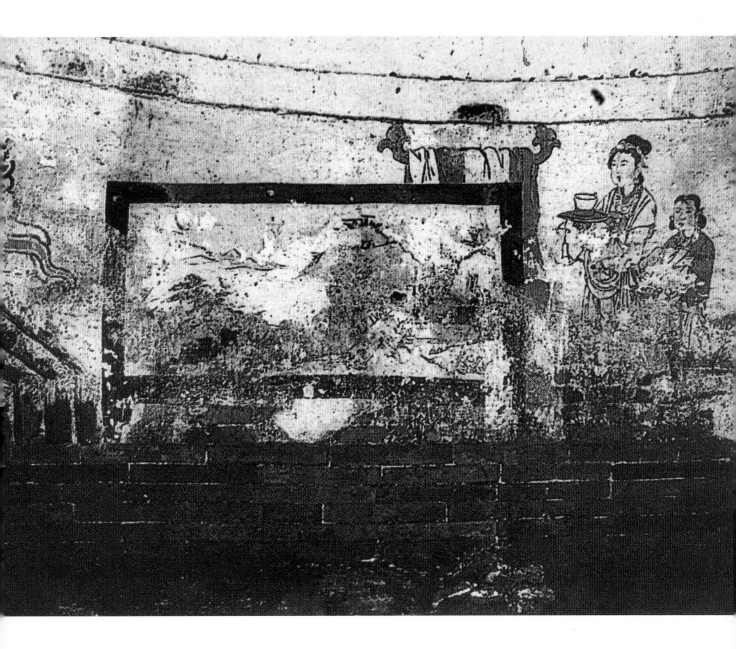

# 7.屏风侍女图（一）

辽统和十三年（995年）

1981年北京市石景山区八宝山韩佚墓出土。已残毁。

墓向187°。位于墓室北壁。围屏正中绘山树风景，围屏后绘半露的衣架，右侧绘有两侍女，一人手捧托盏，为奉茶场景。

<div align="right">（撰文：丁利娜　摄影：王殿平）</div>

## Screen and Maids (1)

13th Year of Tonghe Era, Liao (995 CE)

Unearthed from Han Yi's Tomb at Babaoshan in Shijingshan District, Beijing, in 1981. Not Preserved.

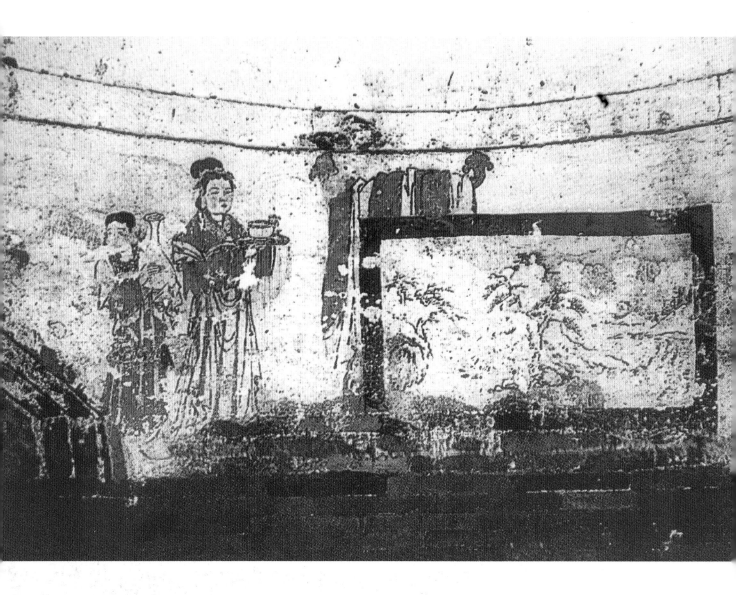

# 8. 屏风侍女图（二）

辽统和十三年（995年）

1981年北京市石景山区八宝山韩佚墓出土。已残毁。

墓向187°。位于墓室北壁。围屏正中绘山树风景，围屏左侧绘有两侍女，东侧者手捧劝盏，西侧者持酒瓶，正翘首眺望，为进酒场景。围屏左侧后部半露衣架。

<div align="right">（撰文：丁利娜　摄影：王殿平）</div>

## Screen and Maids (2)

13th Year of Tonghe Era, Liao (995 CE)

Unearthed from Han Yi's Tomb at Babaoshan in Shijingshan District, Beijing, in 1981. Not Preserved.

# 9.琵琶伎乐图

辽统和十三年（995年）

1981年北京市石景山区八宝山韩佚墓出土。已残毁。

墓向187°。位于墓室东壁。侍女梳双髻，着圆领长袍，头微向南侧，手抱琵琶，伫立桌旁。

（撰文：丁利娜　摄影：王殿平）

## Musician Playing Pipa-4-stringed-Chinese-lute

13th Year of Tonghe Era, Liao (995 CE)

Unearthed from Han Yi's Tomb at Babaoshan, in Shijingshan District, Beijing, in 1981. Not Preserved.

## 10.侍女图（一）

辽统和十三年（995年）

1981年北京市石景山区八宝山韩佚墓出土。已残毁。

墓向187°。位于墓室东壁。侍女梳双髻，着圆领窄袖衫，面北俯身站立，手部漫漶不清。

（撰文：丁利娜　摄影：王殿平）

## Maid (1)

13th Year of Tonghe Era, Liao (995 CE)

Unearthed from Han Yi's Tomb at Babaoshan, in Shijingshan District, Beijing, in 1981. Not Preserved.

# 11.侍女图（二）

辽统和十三年（995年）

1981年北京市石景山区八宝山韩佚墓出土。已残毁。

墓向187°。位于墓室西壁。侍女手部漫漶不清，身右侧置一桌。

<div align="right">（撰文：丁利娜　摄影：王殿平）</div>

## Maid (2)

13th Year of Tonghe Era, Liao (995 CE)

Unearthed from Han Yi's Tomb at Babaoshan, in Shijingshan District, Beijing, in 1981. Not Preserved.

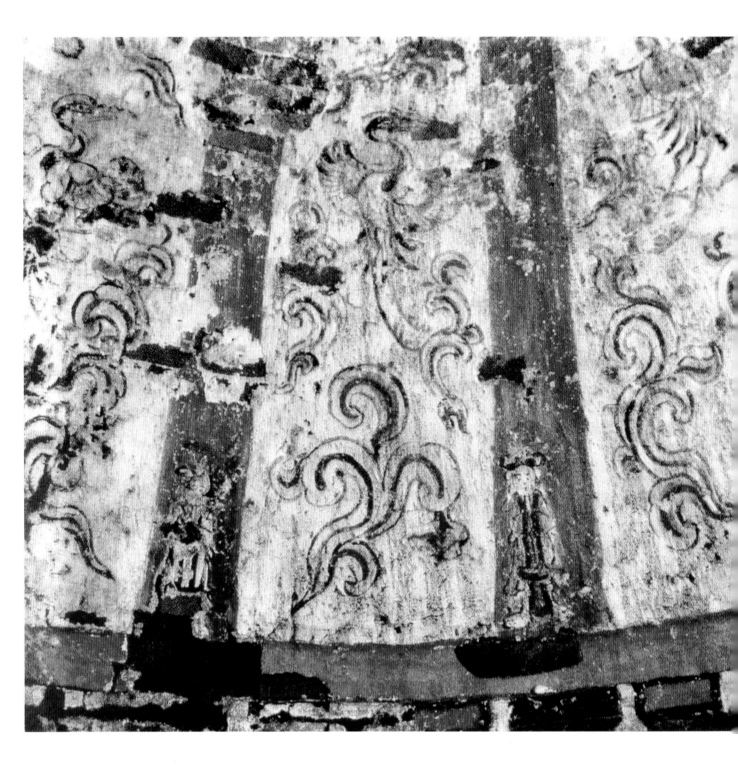

## 12.生肖图（局部）

辽统和十三年（995年）

1981年北京市石景山区八宝山韩佚墓出土。已残毁。

墓向187°。位于墓室内壁穹隆顶下部。生肖位于弧形垂带下部，为人形，头戴生肖冠，面对室内，拱手端立。垂带间绘凤鸟以及卷云纹。

（撰文：丁利娜 摄影：王殿平）

## Zodiac Animals (Detail)

13th Year of Tonghe Era, Liao (995 CE)

Unearthed from Han Yi's Tomb at Babaoshan, in Shijingshan District, Beijing, in 1981. Not Preserved.

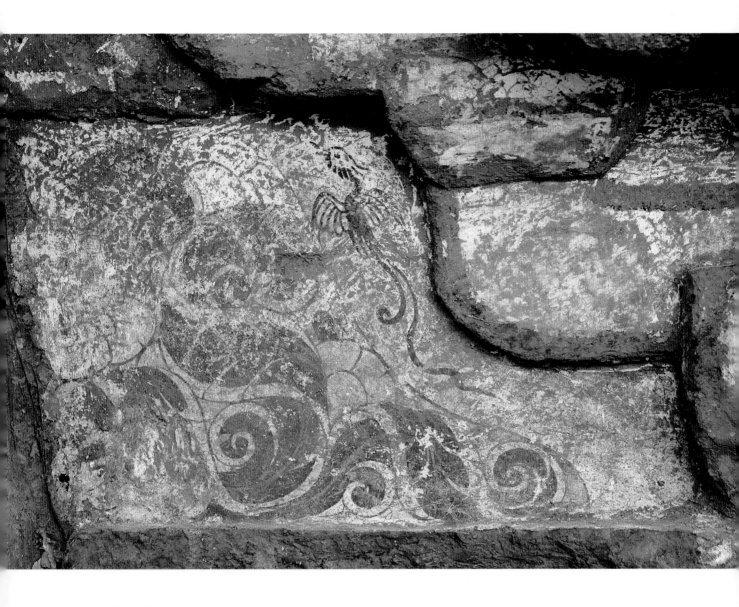

## 13. 凤鸟花卉图

辽清宁三年（1057年）

2007年北京市丰台区云岗刘六符墓出土。现存于北京市大葆台西汉墓博物馆。

墓向205°。位于墓室西壁的拱眼壁。勾勒凤鸟和花卉图案。

（撰文：丁利娜　摄影：周宇）

## Phoenix and Flowers

3rd Year of Qingning Era, Liao (1057 CE)

Unearthed from Liu Liufu's Tomb at Yungang in Fengtai District, Beijing, in 2007. Preserved in Beijing Dabaotai Western Han Tomb Museum.

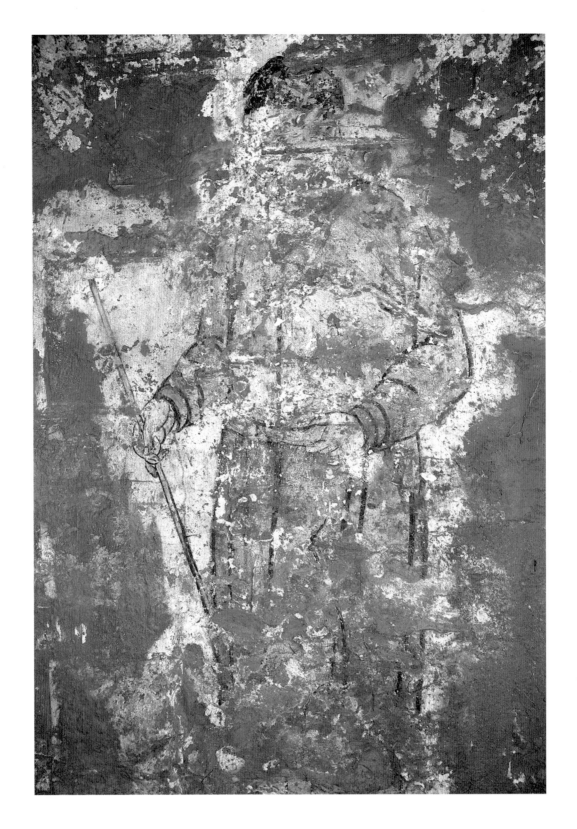

## 14.侍卫图（一）

辽清宁三年（1057年）

人物身高160厘米

2007年北京市丰台区云岗刘六符墓出土。现存于北京市大葆台西汉墓博物馆。

墓向205°。位于甬道东侧。侍卫头戴巾，身穿圆领窄袖蓝袍，右手斜持一棍，左手紧扣腰带侍立，面向室内。

（撰文：丁利娜　摄影：周宇）

## Attendants (1)

3rd Year of Qingning Era, Liao (1057 CE)

Height of Figure 160 cm

Unearthed from Liu Liufu's Tomb at Yungang in Fengtai District, Beijing, in 2007. Preserved in Beijing Dabaotai Western Han Tomb Museum.

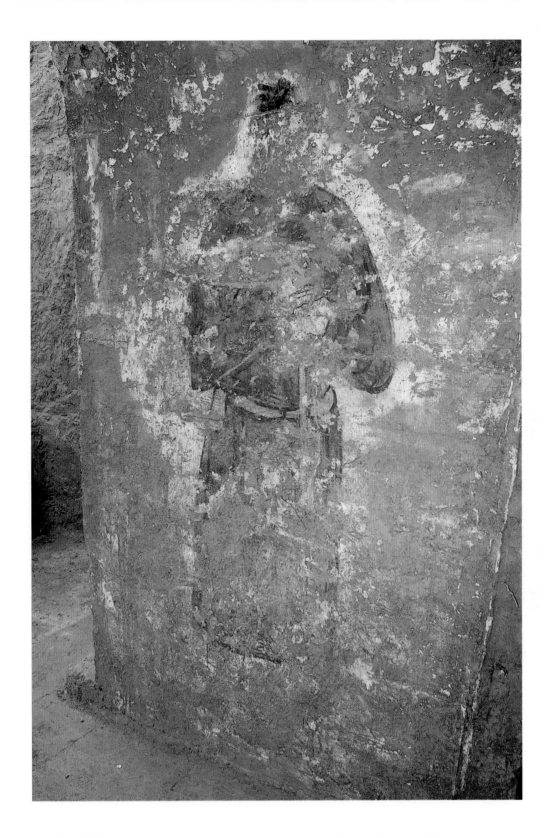

## 15. 侍卫图（二）

辽清宁三年（1057年）

人物身高160厘米

2007年北京市丰台区云岗刘六符墓出土。现存于北京市
大葆台西汉墓博物馆。

墓向205°。位于甬道西侧。侍卫头戴巾，身穿紫色圆领
窄袖袍，双手持棍拥于胸前，面向墓室。

（撰文：丁利娜　摄影：周宇）

## Attendants (2)

3rd Year of Qingning Era, Liao (1057 CE)

Height of Figure 160 cm

Unearthed from Liu Liufu's Tomb at Yun-
gang in Fengtai District, Beijing, in 2007.
Preserved in Beijing Dabaotai Western
Han Tomb Museum.

# 16.侍从图（一）（局部）

辽清宁三年（1057年）

高110、宽约168厘米

2007年北京市丰台区云岗刘六符墓出土。现存于北京市大葆台西汉墓博物馆。

墓向205°。位于墓室东壁耳室的门墙上。为侍从图四人中的两人，因上部墙体被破坏仅见下半身，其中一人手持提梁罐（水路）。

（撰文：丁利娜　摄影：周宇）

## Servants (1) (Datail)

3rd Year of Qingning Era, Liao (1057 CE)

Height 110 cm; Width 168 cm

Unearthed from Liu Liufu's Tomb at Yungang in Fengtai District, Beijing, in 2007. Preserved in Beijing Dabaotai Western Han Tomb Museum.

# 17.侍从图（二）（局部）

辽清宁三年（1057年）

高110、宽约164厘米

2007年北京市丰台区云岗刘六符墓出土。现存于北京市大葆台西汉墓博物馆。

墓向205°。位于墓室西壁耳室的门墙上。为侍从图中的三人，因上部墙体被破坏仅见下半身。均着窄袖长袍。

<div align="right">（撰文：丁利娜　摄影：周宇）</div>

## Servants (2) (Detail)

3rd Year of Qingning Era, Liao (1057 CE)

Height 110 cm; Width ca. 164 cm

Unearthed from Liu Liufu's Tomb at Yungang in Fengtai District, Beijing, in 2007. Preserved in Beijing Dabaotai Western Han Tomb Museum.

# 18.侍从图（三）（局部）

辽清宁三年（1057年）

2007年北京市丰台区云岗刘六符墓出土。现存于北京市大葆台西汉墓博物馆。

墓向205°。位于墓室西壁。为侍从图中的两人，面部涂红，均着长袍，左侧侍者双手合于胸前，右侧侍者手执物，漫漶不清。

（撰文：丁利娜　摄影：周宇）

## Servants (3) (Detail)

3rd Year of Qingning Era, Liao (1057 CE)
Unearthed from Liu Liufu's Tomb at Yungang in Fengtai District, Beijing, in 2007. Preserved in Beijing Dabaotai Western Han Tomb Museum.

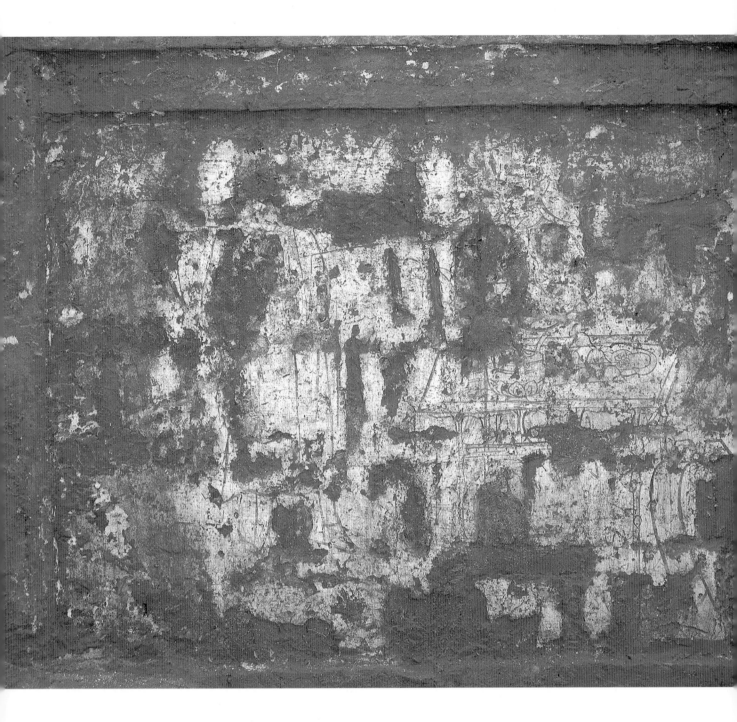

# 19.备宴图

辽乾统元年（1101年）

高116、宽约146厘米

2007年北京市丰台区云岗刘雨墓出土。现存于北京市大葆台西汉墓博物馆。

墓向200°。位于墓室西南壁。画中有高桌一张，桌子上放有海棠形长盘、杯等酒具，桌旁放有经瓶两个。画中人物一侍者立于桌前，另一侍者趋步面桌而来。

（撰文：丁利娜　摄影：周宇）

## Preparing for a Banquet

1st Year of Qiantong Era, Liao (1101 CE)

Height 116 cm; Width ca. 146 cm

Unearthed from Liu Yu's Tomb at Yungang in Fengtai District, Beijing, in 2007. Preserved in the Beijing Dabaotai Western Han Tomb Museum.

## 20.侍女图（一）

辽乾统元年（1101年）

高72～116、宽160厘米

2007年北京市丰台区云岗刘雨墓出土。现存于北京市大葆台西汉墓博物馆。

墓向200°。位于墓室西北壁。画中绘有两人，仅见下半身，两人穿绣花衣裙，抄手而立，应为侍女。

（撰文：丁利娜　摄影：周宇）

## Maids (1)

1st Year of Qiantong Era, Liao (1101 CE)

Height 72-116 cm; Width 160 cm

Unearthed from Liu Yu's Tomb at Yungang in Fengtai District, Beijing, in 2007. Preserved in the Beijing Dabaotai Western Han Tomb Museum.

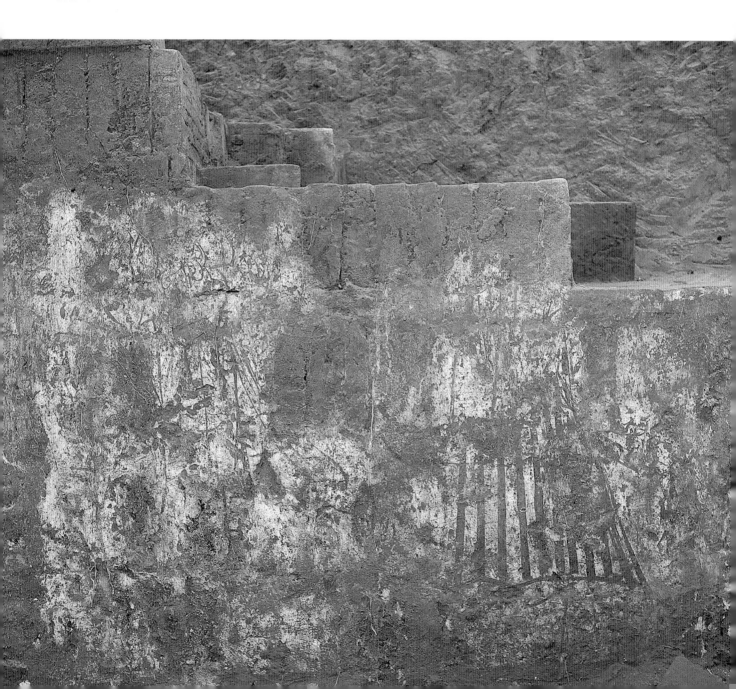

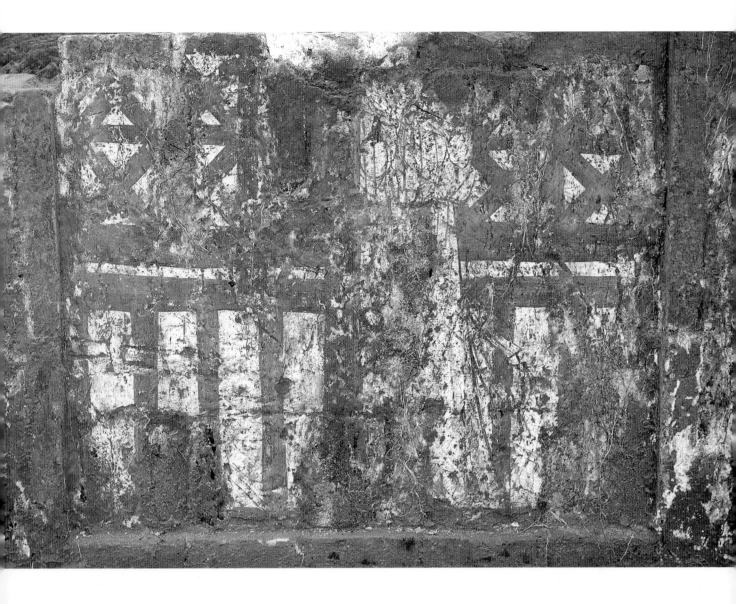

## 21. 妇人启门图

辽乾统元年（1101年）

残高72米、宽168厘米

2007年北京市丰台区云岗刘雨墓出土。现存于北京市大葆台西汉墓博物馆。

墓向200°。位于墓室北壁。画中有朱红大门一合，门有两扇，一妇人半启门，着广袖长袍。

（撰文：丁利娜　摄影：周宇）

## Lady Opening the Door Ajar

1st Year of Qiantong Era, Liao (1101 CE)

Height 72 cm; Width 168 cm

Unearthed from Liu Yu's Tomb at Yungang in Fengtai District, Beijing, in 2007. Preserved in the Beijing Dabaotai Western Han Tomb Museum.

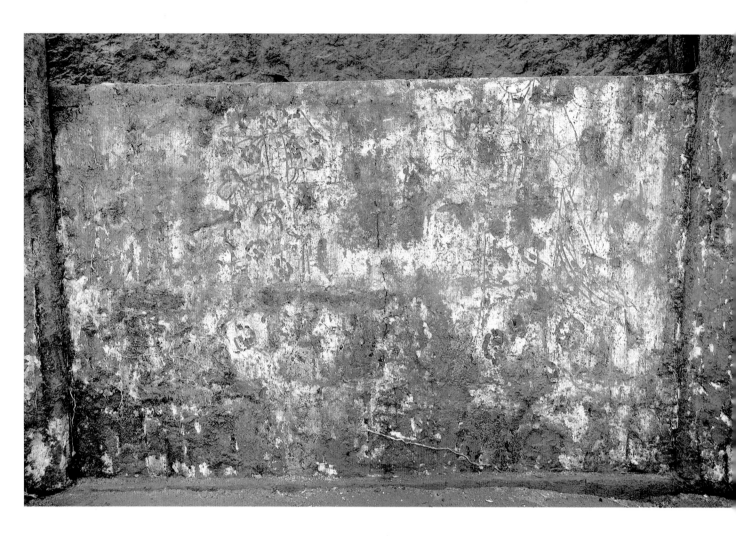

## 22.侍女图（二）

辽乾统元年（1101年）

残高120、宽152厘米

2007年北京市丰台区云岗刘雨墓出土。现存于北京市大葆台西汉墓博物馆。

墓向200°。位于墓室东北壁。画中侍女两人，左侧侍女身穿绣花长袍，抄手而立，右侧侍女双手托盘盏。因上部墙体被破坏，头部不清。

（撰文：丁利娜　摄影：周宇）

## Maids (2)

1st Year of Qiantong Era, Liao (1101 CE)

Height 120 cm; Width 152 cm

Unearthed from Liu Yu's Tomb at Yungang in Fengtai District, Beijing, in 2007. Preserved in the Beijing Dabaotai Western Han Tomb Museum.

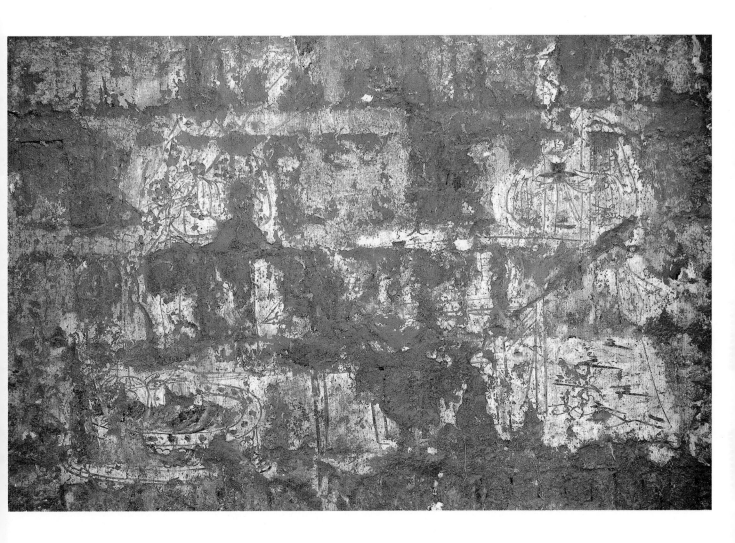

# 23.设宴图

辽乾统元年（1101年）

高116、宽160厘米

2007年北京市丰台区云岗刘雨墓出土。现存于北京市大葆台西汉墓博物馆。

墓向200°。位于墓室东南壁。画中二人，中部置桌子一张，上置盘盏。一侍女双手托茶盏侍立于桌前，另一侍女双手持扇侍立于火盆边，火盆内见汤瓶。

<div align="right">（撰文：丁利娜　摄影：周宇）</div>

## Feasting

1st Year of Qiantong Era, Liao (1101 CE)

Height 116 cm; Width 160 cm

Unearthed from Liu Yu's Tomb at Yungang in Fengtai District, Beijing, in 2007. Preserved in the Beijing Dabaotai Western Han Tomb Museum.

## 24. 墓室南壁壁画

辽（907～1125年）

高约165、宽250厘米

2002年北京市大兴区青云店镇西杭子村一号辽墓出土。现存于北京市文物研究所。

墓向170°。位于墓室南壁。由两组画面组成，一在墓门东侧为持凤首壶侍女图，一在墓门西侧为侍女添灯图。

<div align="right">（撰文：张利芳　摄影：朱志刚）</div>

## Mural on the South Wall of the Tomb Chamber

Liao (907-1125 CE)

Height ca. 165 cm; Width 250 cm

Unearthed from the Tomb No.1 at Xihangzi Village of Qingyundian Town in Daxing District, Beijing, in 2002. Preserved in the Cultural Relics.

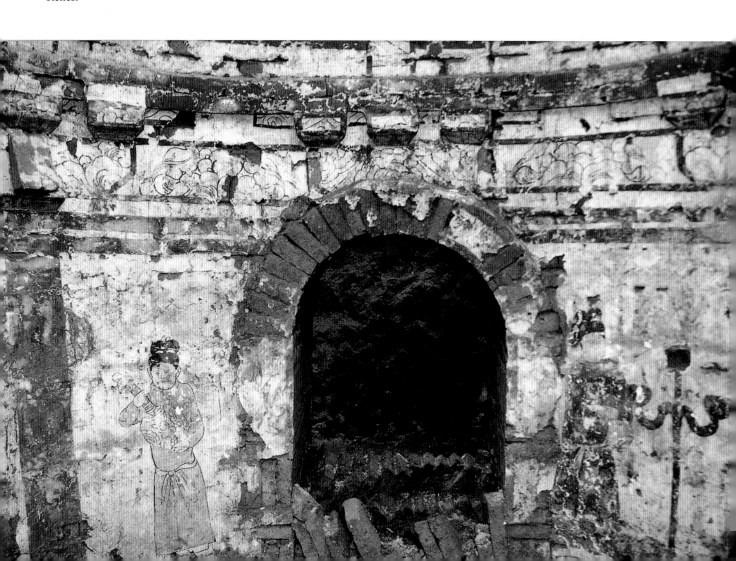

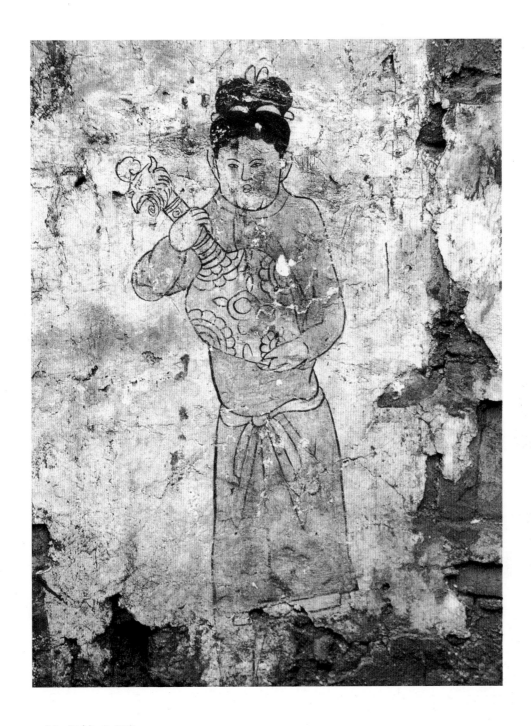

## 25.持壶侍女图

辽（907～1125年）

高约165、宽85厘米

2002年北京市大兴区青云店镇西杭子村一号辽墓出土。现存于北京市文物研究所。

墓向170°。位于墓门东侧。侍女梳高髻，插簪，着青色圆领窄袖长袍，束白丝带，面部丰满，手持一通体饰花纹的圆腹长颈凤首壶。

（撰文：张利芳　摄影：朱志刚）

## Maid Holding a Vase

Liao (907-1125 CE)

Height ca. 165 cm; Width 85 cm

Unearthed from the Tomb No.1 at Xihangzicun of Qingyundian Zhen, in Daxing District, Beijing, in 2002.

Preserved in the Beijing Institute of Cultural Relics.

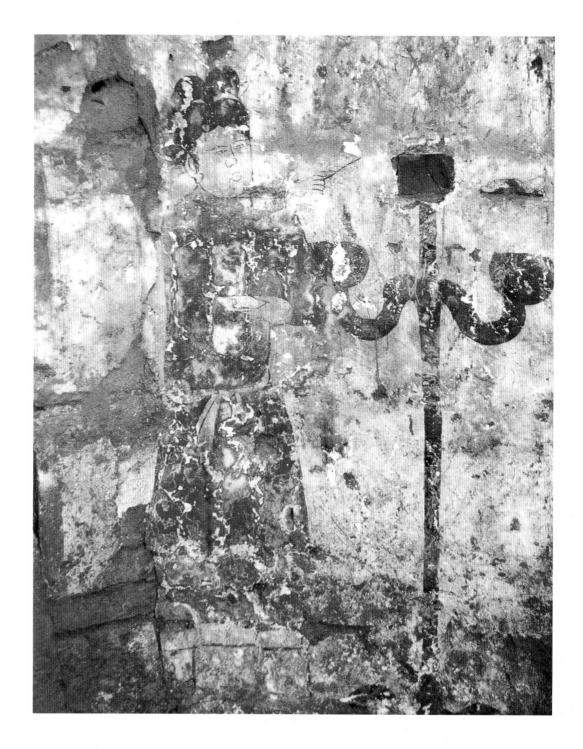

## 26.点灯图

辽（907～1125年）

高约165、宽85厘米

2002年北京市大兴区青云店镇西杭子村一号辽墓出土。现存于北京市文物研究所。

墓向170°。位于墓室南壁的墓门西侧。侍女梳双髻，身着红色圆领窄袖袍，束白丝带，面部丰腴，正为灯檠添油。灯架下面的两个灯碗为绘制，上方中央灯碗为雕砖影作。

（撰文：张利芳　摄影：朱志刚）

### Lighting a Chandelier

Liao (907-1125 CE)

Height ca. 165 cm; Width 85 cm

Unearthed from the Tomb No.1 at Xihangzicun of Qingyundianzhen, in Daxing District, Beijing, in 2002. Preserved in the Beijing Institute of Cultural Relics.

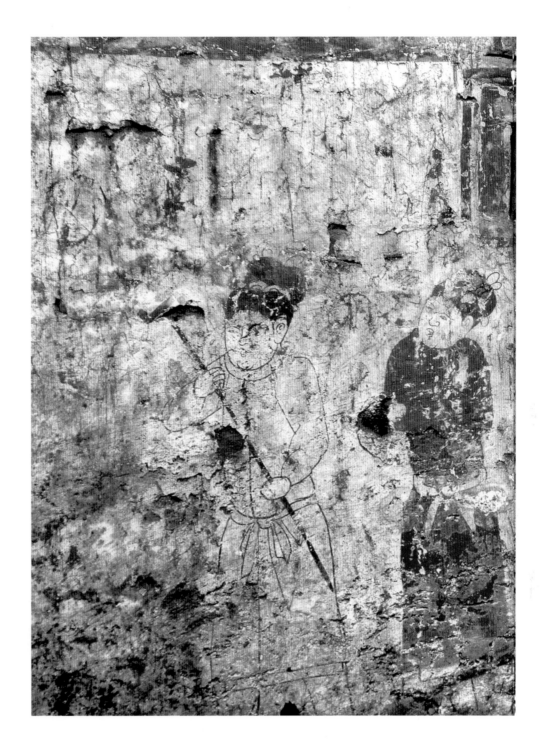

# 27.执杆图

辽（907～1125年）

高约165、宽145厘米

2002年北京市大兴区青云店镇西杭子村一号辽墓出土。现存于北京市文物研究所。

墓向170°。位于墓室西壁中上部棂窗南侧。人物均束白丝带，高髻簪花，面部丰满，着红衣者作抄手状，凝视白衣者，着白衣者双手持一杖。

<div align="right">（撰文：张利芳　摄影：朱志刚）</div>

## Holding a Rod

Liao (907-1125 CE)

Height ca. 165 cm; Width 145 cm

Unearthed from the Tomb No.1 at Xihangzicun of Qingyundian Zhen, in Daxing District, Beijing, in 2002. Preserved in the Beijing Institute of Cultural Relics.

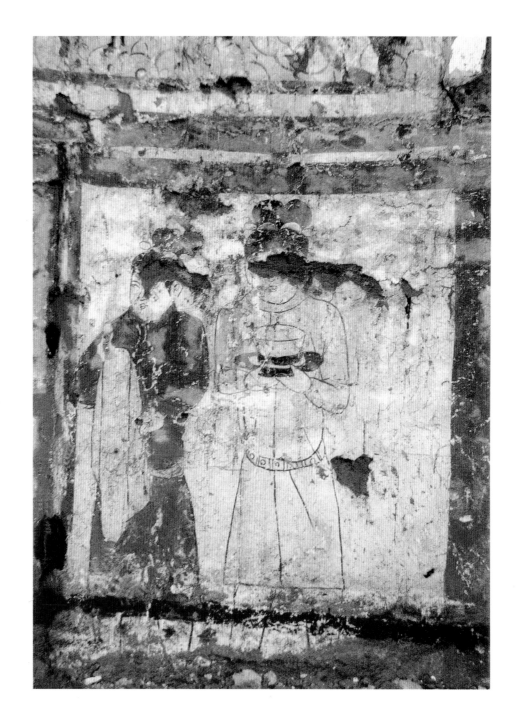

# 28.侍洗图

辽（907～1125年）

高约165、宽70厘米

2002年北京市大兴区青云店镇西杭子村一号辽墓出土。现存于北京市文物研究所。

墓向170°。位于墓室北壁东侧。二侍女均高髻簪花，面部丰腴，红衣者束丝带，手持帨巾；黄衣者束玉带，手托盏。

（撰文：张利芳　摄影：朱志刚）

## Bathroom Maids

Liao (907-1125 CE)

Height ca. 165 cm; Width 70 cm

Unearthed from the Tomb No.1 at Xihangzicun of Qingyundianzhen, in Daxing District, Beijing, in 2002. Preserved in the Beijing Institute of Cultural Relics.

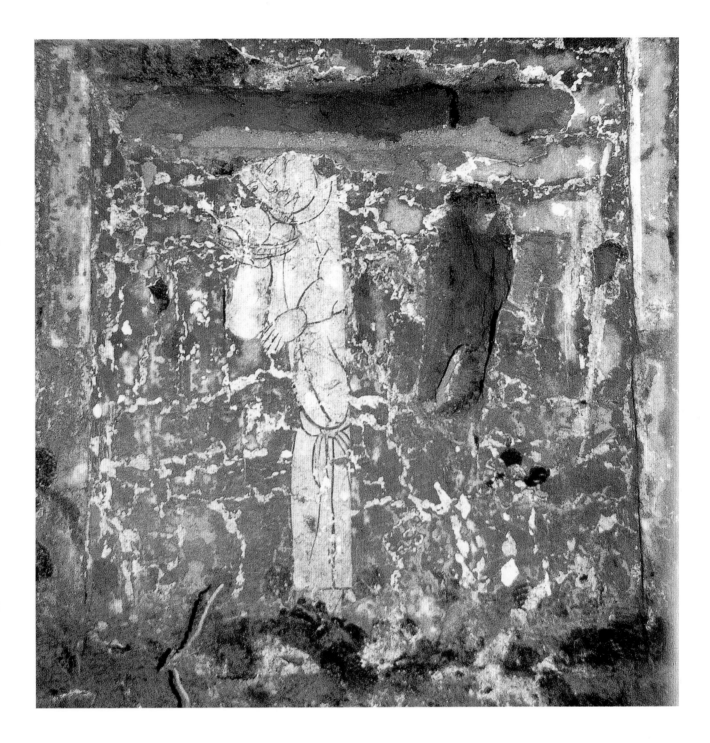

# 29. 启门图

辽（907~1125年）

高约165、宽70厘米

2002年北京市大兴区青云店镇西杭子村一号辽墓出土。现存于北京市文物研究所。

墓向170°。位于墓室北壁。主体为板门，一侍者半启门欲出，右手托举一盘，盘内盛有食物。

<div align="right">（撰文：张利芳　摄影：朱志刚）</div>

## Opening the Door Ajar

Liao (907-1125 CE)

Height ca. 165 cm; Width70 cm

Unearthed from the Tomb No.1 at Xihangzicun of Qingyundianzhen, in Daxing District, Beijing, in 2002. Preserved in the Beijing Institute of Cultural Relics.

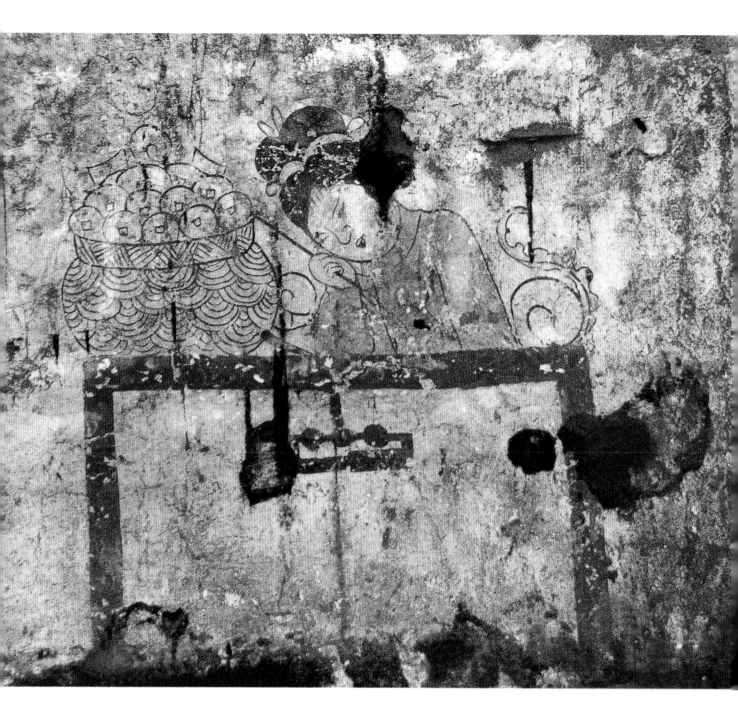

## 30.西库图

辽（907～1125年）

高约165、宽70厘米

2002年北京市大兴区青云店镇西杭子村一号辽墓出土。现存于北京市文物研究所。

墓向170°。位于墓室北壁墓门西侧。红边木箱正面有一黑色锁具，顶部编织篓状的容器内盛满方孔圆形钱币；一侍女坐于椅子上，右手托腮，肘部支撑于箱子顶部。为墓室中常见"东仓西库"之西库图。

<div align="right">（撰文：张利芳　摄影：朱志刚）</div>

## Treasury

Liao (907-1125 CE)

Height ca. 165 cm; Width 70 cm

Unearthed from the Tomb No.1 at Xihangzicun of Qingyundianzhen, in Daxing District, Beijing, in 2002. Preserved in the Beijing Institute of Cultural Relics.

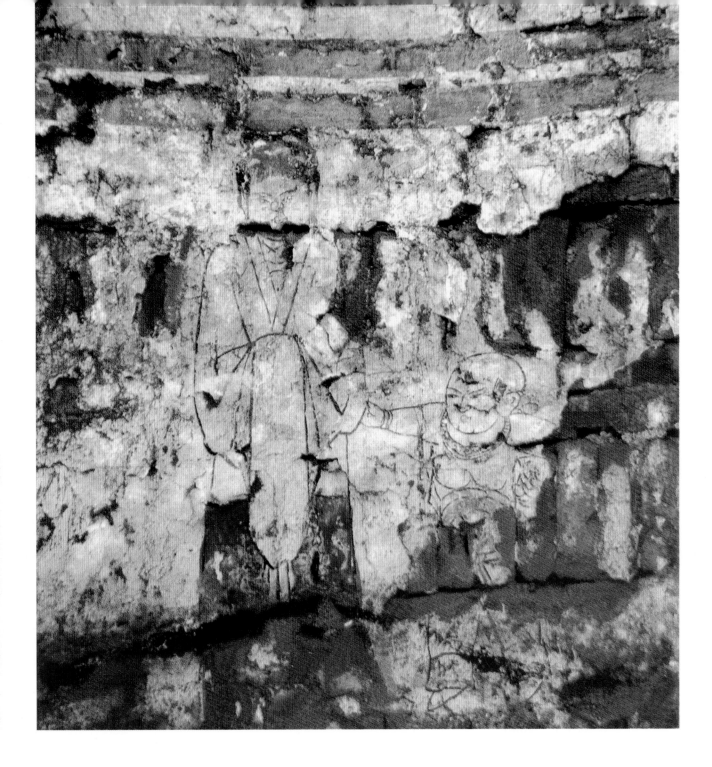

# 31.戏儿图

辽（907～1125年）

高约165、宽80厘米

2002年北京市大兴区青云店镇西杭子村一号辽墓出土。现存于北京市文物研究所。

墓向170°。位于墓室东壁的棂窗北侧。一妇人高髻簪花，面部丰腴，双手持帨巾于胸前，其右有一男童。男童留鹁角，袒上身，戴锁，长裤，右手牵妇人左臂。

<div align="right">（撰文：张利芳　摄影：朱志刚）</div>

## Lady and Child

Liao (907-1125 CE)

Height ca. 165 cm; Width 80 cm

Unearthed from the Tomb No.1 at Xihangzicun of Qingyundianzhen, in Daxing District, Beijing, in 2002. Preserved in the Beijing Institute of Cultural Relics.

## 32.备餐图（局部）

辽（907～1125年）

高约165、宽80厘米

2002年北京市大兴区青云店镇西杭子村一号辽墓出土。现存于北京市文物研究所。

墓向170°。位于墓室东壁的棂窗南侧。主画面为一桌二椅。桌上摆着盛有食物的黑色圈足碗、黑色托盏、带花纹注壶。一红衣侍女站在桌椅后方。

<div align="right">（撰文：张利芳　摄影：朱志刚）</div>

## A Table and Two Unoccupied Chairs (Detail)

Liao (907-1125 CE)

Height ca. 165 cm; Width 80 cm

Unearthed from the Tomb No.1 at Xihangzicun of Qingyundianzhen, in Daxing District, Beijing, in 2002.
Preserved in the Beijing Institute of Cultural Relics.

# 33. 夫妇对坐图

辽（907～1125年）

桌子高58、桌面宽50厘米；椅子高73厘米

2002年北京市大兴区青云店镇西杭子村二号辽墓出土。现存于北京市文物研究所。

墓向170°。位于墓室东壁。中间影作一张桌子，南北各影作一把椅子；右边椅子上可见坐一红衣女子，椅子后边有一侍者。桌上绘托盏、注壶等。

（撰文：张利芳　摄影：朱志刚）

## Tomb Occupant Couple Seated Beside the Table

Liao (907-1125 CE)

Table's height 58 cm; Width 50 cm; Chair's height 73 cm

Unearthed from the Tomb No.1 at Xihangzicun of Qingyundianzhen, in Daxing District, Beijing, in 2002. Preserved in the Beijing Institute of Cultural Relics.

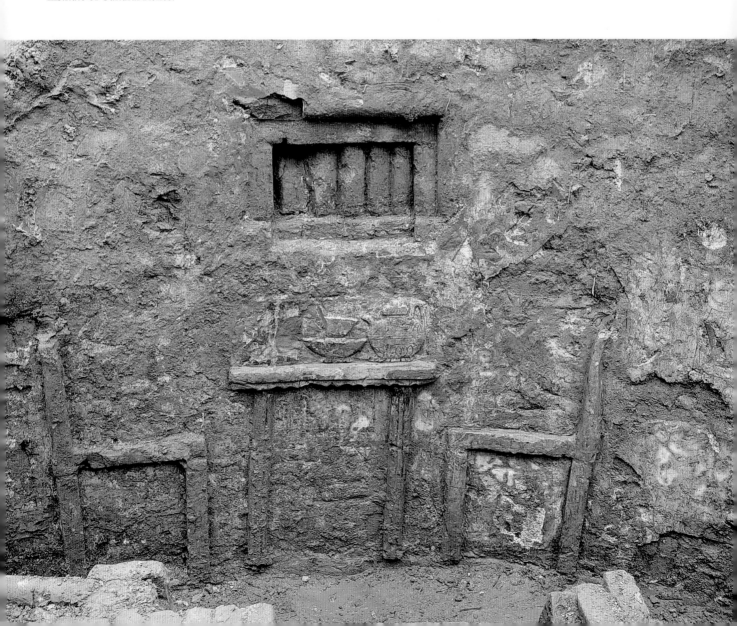

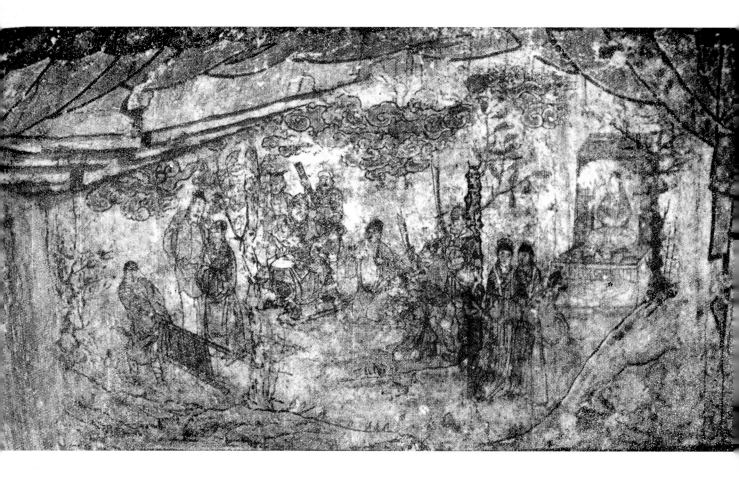

## 34. 人物图

辽（907～1125年）

高约120、宽约260厘米

1979年北京市门头沟区斋堂镇辽墓出土。原址保存。

墓向南。位于墓室西壁。图像分为三组，右边为奉祀先人场面，中间为侍卫环侍的墓主人坐像，左边为三人放置竹担架的场面。

（撰文：丁利娜　摄影：王殿平）

## Figures

Liao (907-1125 CE)

Height ca. 120 cm; Width ca. 260 cm

Unearthed from the tomb of Liao Dynasty at Zhaitang in Mentougou District, Beijing, in 1979. Preserved on the original site.

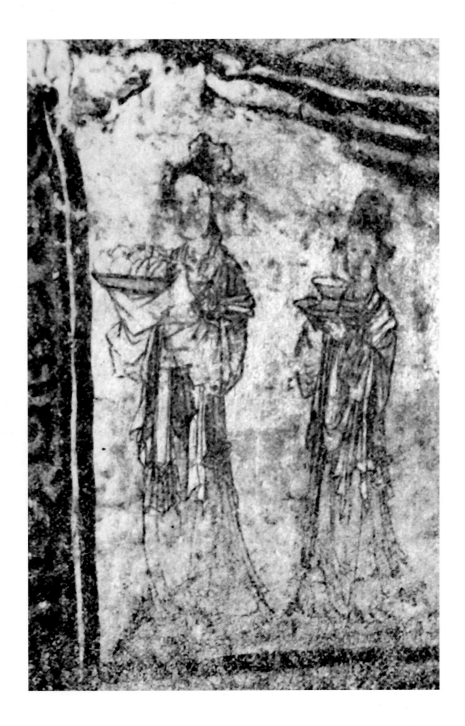

## 35.侍女图

辽（907～1125年）

后者身高56厘米

1979年北京市门头沟区斋堂镇辽墓出土。原址保存。

墓向南。位于甬道西壁。彩绘两侍女，前者着花冠，上着衫，下着裙，双手托盘，盘内盛鲜桃、石榴等；后者双手持托盏。

（撰文：丁利娜　摄影：王殿平）

## Maids

Liao (907-1125 CE)

Height of the right one 56 cm

Unearthed from the tomb of Liao Dynasty at Zhaitang in Mentougou District, Beijing, in 1979. Preserved on the original site.

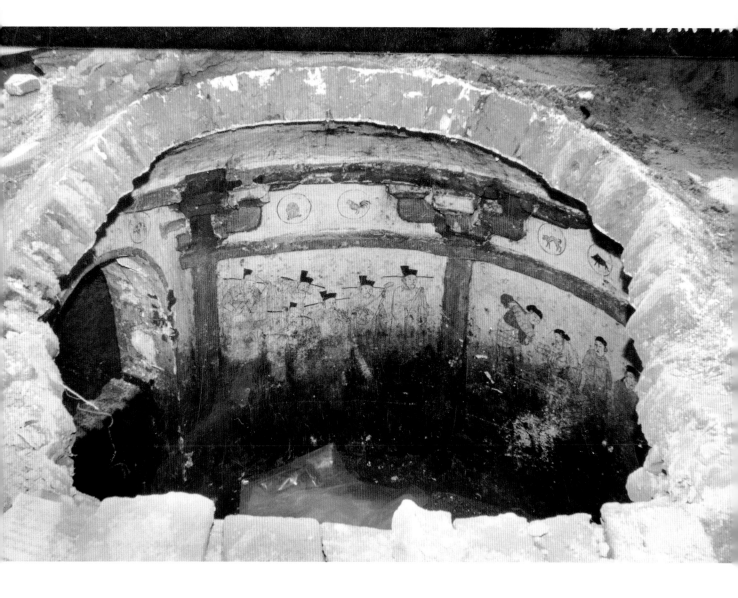

### ▲ 36.墓室西壁壁画

金皇统三年（1143年）

高约84、宽200厘米

2002年北京市石景山区八角村金墓出土。现存于首都博物馆。

墓向南。位于墓室西壁。有两组图画，一组为散乐图，一组为进酒图。

（撰文：张利芳　摄影：朱志刚）

### Mural on the West Wall of the Tomb Chamber

3rd Year of Huangtong Era, Jin (1143 CE)

Height ca. 84 cm; Width 200 cm

Unearthed from the tomb of Jin Dynasty at Bajiaocun in Shijingshan District, Beijing, in 2002. Preserved in the Capital Museum, China.

### 37.散乐图 ▶

金皇统三年（1143年）

高约100、宽81厘米

2002年北京市石景山区八角村金墓出土。现存于首都博物馆。

墓向南。位于墓室西南壁。图中绘有六人，呈前后两排站立，均戴展脚幞头，上有插花，各持乐器在演奏。从左至右依次为大鼓、腰鼓、横笛、觱篥、琵琶、拍板。

（撰文：张利芳　摄影：朱志刚）

### Music Band Playing

3rd Year of Huangtong Era, Jin (1143 CE)

Height ca. 100 cm; Width 81 cm

Unearthed from the tomb of Jin Dynasty at Bajiaocun in Shijingshan District, Beijing, in 2002. Preserved in the Capital Museum, China.

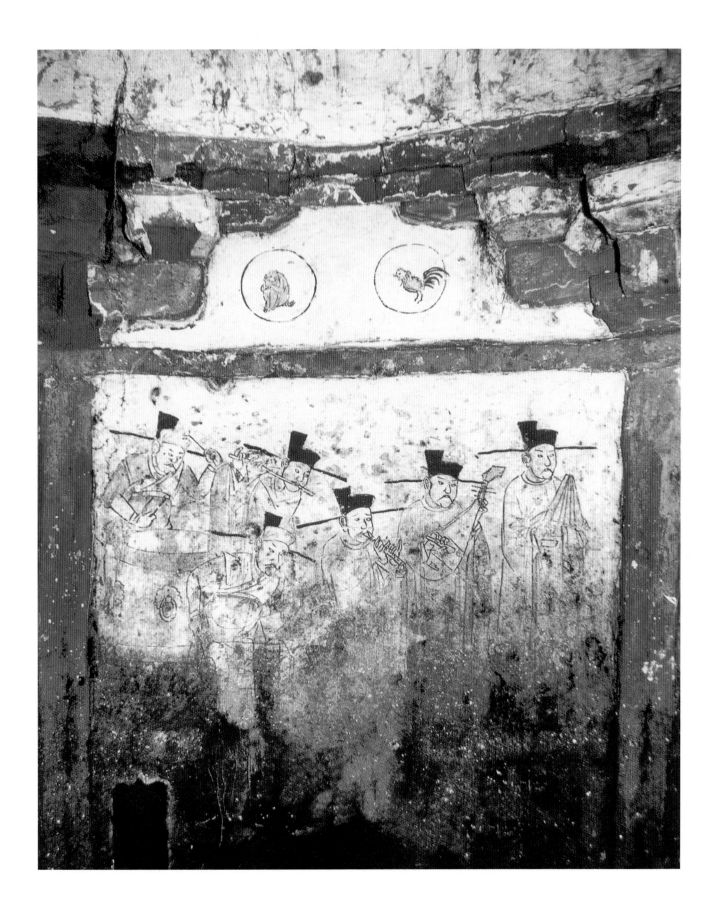

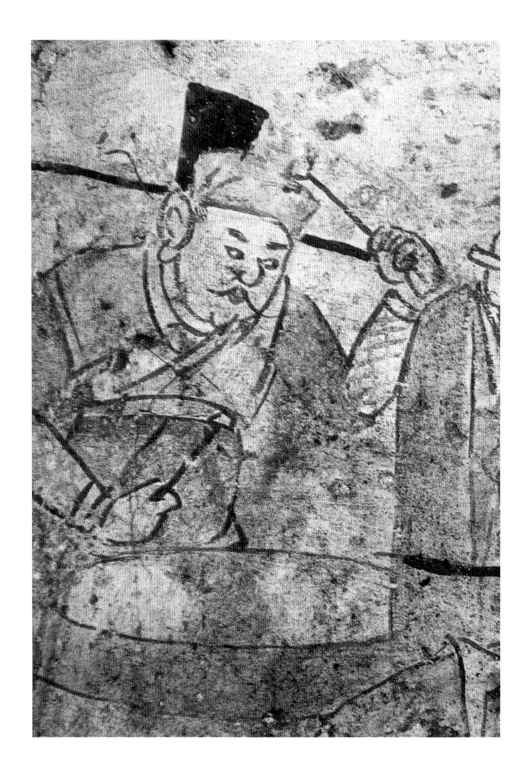

## 38.击鼓者

金皇统三年（1143年）

2002年北京市石景山区八角村金墓出土。现存于首都博物馆。

墓向南。位于墓室西南壁。为散乐图中之左起第一人为击大鼓者，头戴展脚幞头，幞头上插花，且在幞头前部扎有帛巾，手持木槌，双手挥动正在敲鼓。

（撰文：张利芳　摄影：朱志刚）

## Playing Drum

3rd Year of Huangtong Era, Jin (1143 CE)

Unearthed from the tomb of Jin Dynasty at Bajiaocun in Shijingshan District, Beijing, in 2002. Preserved in the Capital Museum, China.

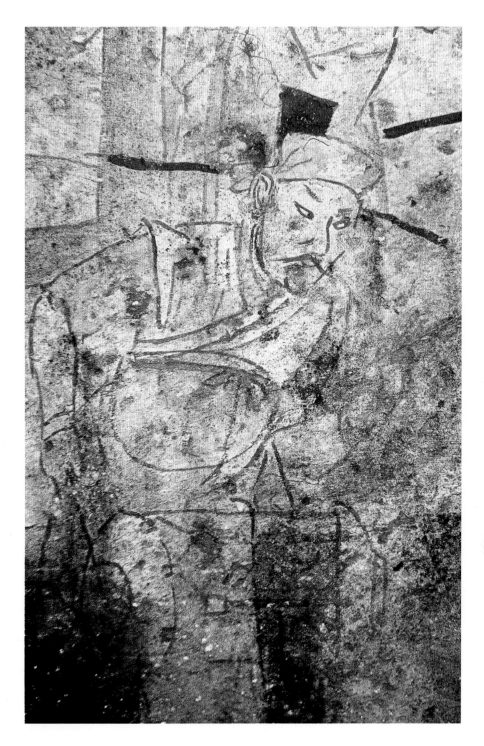

## 39.击腰鼓者

金皇统三年（1143年）

2002年北京市石景山区八角村金墓出土。现存于首都博物馆。

墓向南。位于墓室西南壁。为散乐图中的左起第二人，为击腰鼓者，头戴展脚幞头，幞头上插花，在幞头前部扎有帛巾，着交领窄袖袍，束抱肚，正在击腰鼓。

（撰文：张利芳　摄影：朱志刚）

## Beating Waistdrum

3rd Year of Huangtong Era, Jin (1143 CE)

Unearthed from the tomb of Jin Dynasty at Bajiaocun in Shijingshan District, Beijing, in 2002. Preserved in the Capital Museum, China.

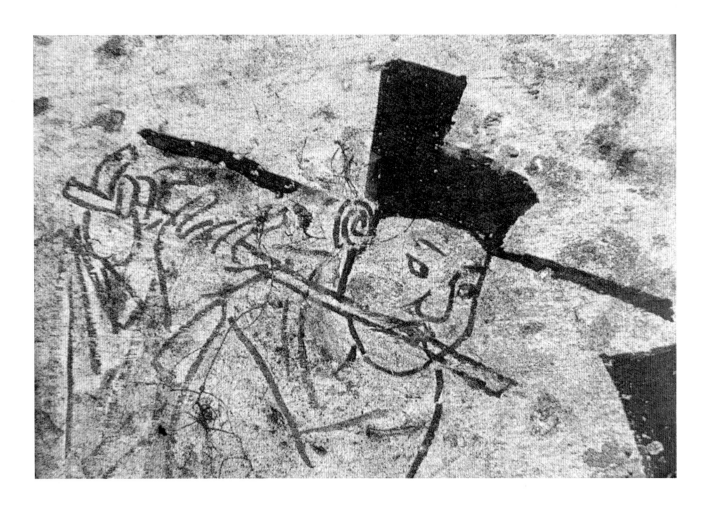

# 40.吹笛者

金皇统三年（1143年）

2002年北京市石景山区八角村金墓出土。现存于首都博物馆。

墓向南。位于墓室西南壁。为散乐图中的左起第三人，身穿圆领广袖长袍，头戴黑色展脚幞头，手持横笛，正在吹奏。

（撰文：张利芳　摄影：朱志刚）

## Playing Flute

3rd Year of Huangtong Era, Jin (1143 CE)

Unearthed from the tomb of Jin Dynasty at Bajiaocun in Shijingshan District, Beijing, in 2002. Preserved in the Capital Museum, China.

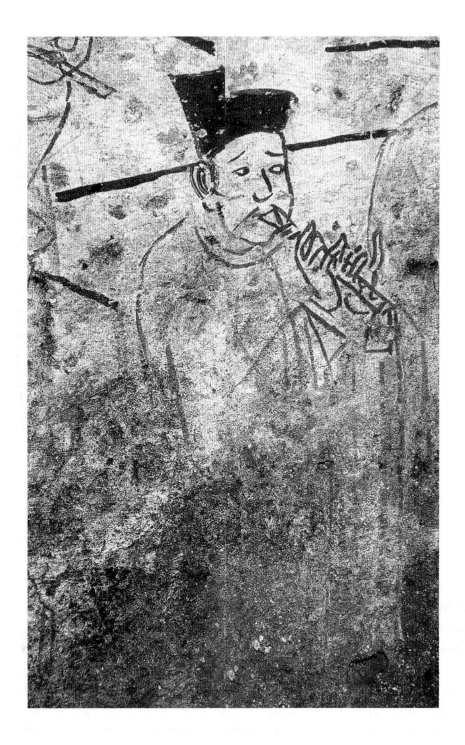

## 41.吹觱篥者

金皇统三年（1143年）

2002年北京市石景山区八角金村墓出土。现存于首都博物馆。

墓向南。位于墓室西南壁。为散乐图中左起第四人。身穿圆领长袍，头戴黑色展脚幞头，不扎巾，手持觱篥，正在吹奏。

<div align="right">（撰文：张利芳　摄影：朱志刚）</div>

## Blowing bili-Whistle

3rd Year of Huangtong Era, Jin (1143 CE)

Unearthed from the tomb of Jin Dynasty at Bajiaocun in Shijingshan District, Beijing, in 2002. Preserved in the Capital Museum, China.

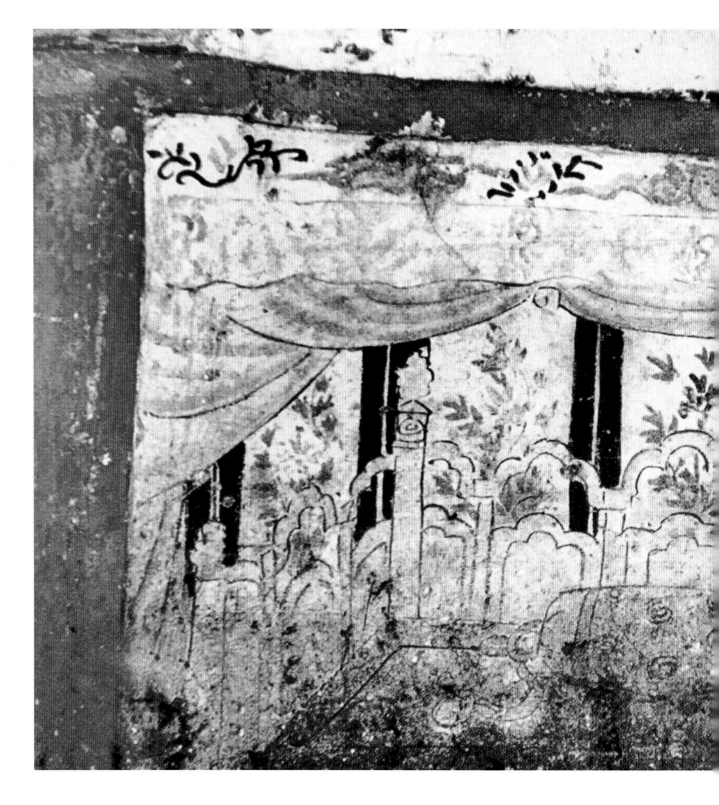

## 42.床榻图

金皇统三年（1143年）

高约110、宽85厘米

2002年北京市石景山区八角村金墓出土。现存于首都博物馆。

墓向南。位于墓壁正北居中，正对墓门的棺床后上方。床上备有被褥，床后为花卉屏风画，一名侍女在卧榻旁奉侍。

<div align="right">（撰文：张利芳　摄影：朱志刚）</div>

# Bed

Height ca. 110cm; Width 85 cm

3rd Year of Huangtong, Jin (1143 CE)

Unearthed from the tomb of Jin Dynasty at Bajiaocun in Shijingshan District, Beijing, in 2002. Preserved in the Capital Museum, China.

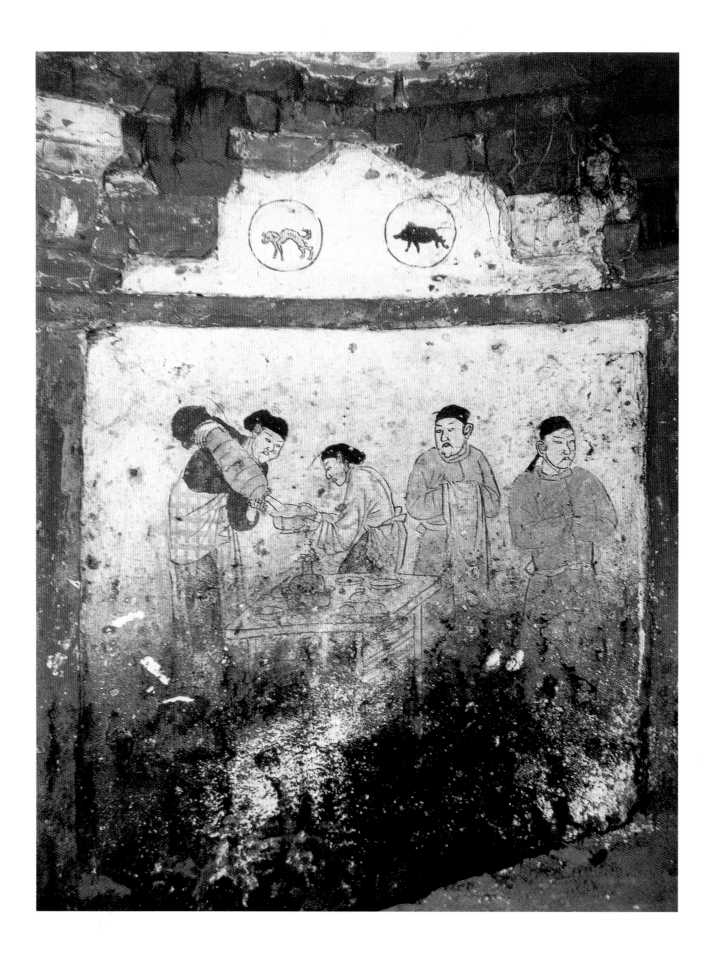

## ◀43.进酒图

金皇统三年（1143年）

高约95、宽75厘米

2002年北京市石景山区八角村金墓出土。现存于首都博物馆。

墓向南。位于墓室西北壁。最左端者，手持鸡腿瓶将酒倒入其旁边侍者所端的大尊中；右边两人，一人持帨巾，一人抄手而立。

（撰文：张利芳　摄影：朱志刚）

## Serving a Drink at Banquet

Height ca. 95 cm; Width 75 cm

3rd Year of Huangtong Era, Jin (1143 CE)

Unearthed from the tomb of Jin Dynasty at Bajiaocun in Shijingshan District, Beijing, in 2002. Preserved in the Capital Museum, China.

## ▼44.备茶图

金皇统三年（1143年）

高约104、宽84厘米

2002年北京市石景山区八角村金墓出土。现存于首都博物馆。

墓向南。位于墓室东北壁。图中最左端者抄手恭立，中间二人正在点茶，后一人手捧食盘，最右端者手握骨朵。

（撰文：张利芳　摄影：朱志刚）

## Preparing for Tea Reception

3rd Year of Huangtong, Jin (1143 CE)

Height ca. 104 cm; Width 84 cm

Unearthed from the tomb of Jin Dynasty at Bajiaocun in Shijingshan District, Beijing, in 2002. Preserved in the Capital Museum, China.

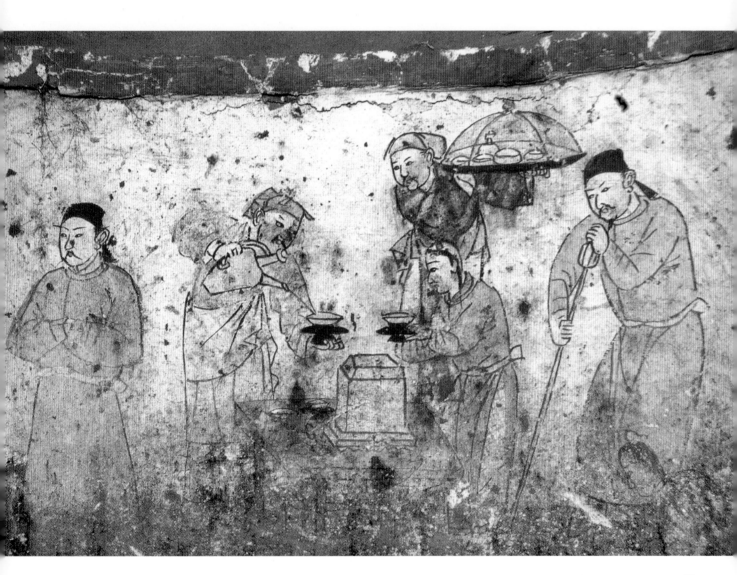

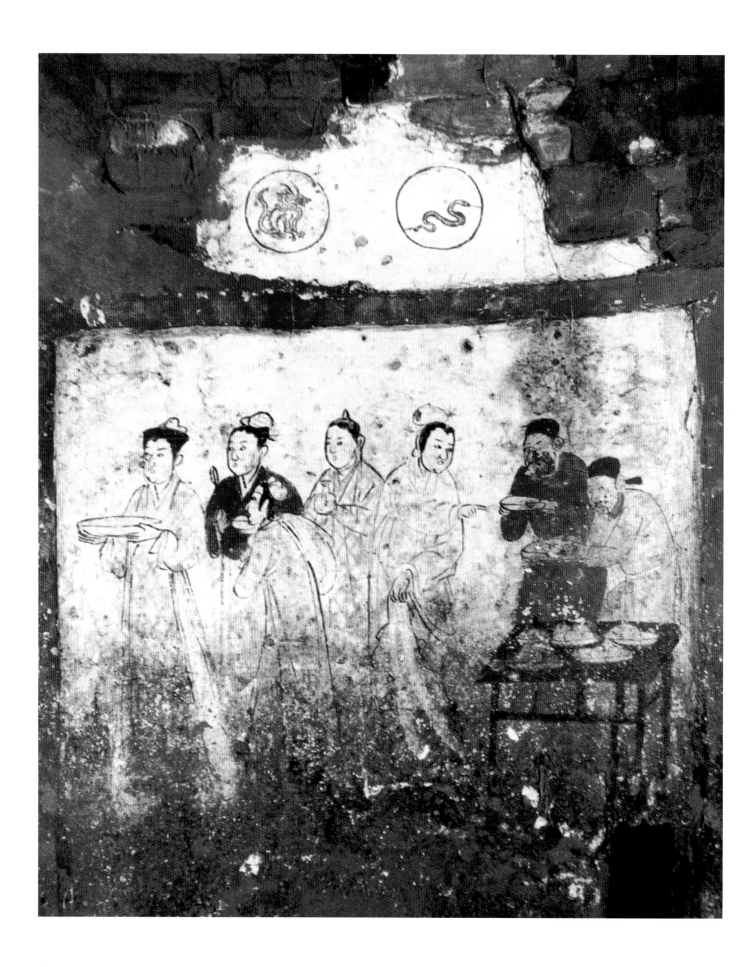

## ◄45.备宴图

金皇统三年（1143年）

高约102、宽82厘米

2002年北京市石景山区八角村金墓出土。现存于首都博物馆。

墓向南。位于墓室东南壁。画面右侧为一案，上置食物，两男侍备奉，桌案左为5位侍女，居中的中年女仆，包髻长袍，身体右侧前行，左手执巾，右手食指指向两男仆，四女仆分执托盘、灯油等左行。

（撰文：张利芳　摄影：朱志刚）

## Preparing for a Banquet

Height ca. 102 cm; Width 82 cm

3rd Year of Huangtong, Jin (1143 CE)

Unearthed from the tomb of Jin Dynasty at Bajiaocun in Shijingshan District, Beijing, in 2002. Preserved in the Capital Museum, China.

## 46.生肖图（鼠）

金皇统三年（1143年）

高约25厘米

2002年北京市石景山区八角村金墓出土。

墓向南。位于墓室北壁床榻图上方的拱眼壁。墨绘圆圈内画鼠。

（撰文：张利芳　摄影：朱志刚）

## Zodiac Animals (Mouse)

3rd Year of Huangtong, Jin (1143 CE)

Height ca. 25 cm

Unearthed from the tomb of Jin Dynasty at Bajiaocun in Shijiangshan District, Beijing, in 2002.

## 47.生肖图（牛）

金皇统三年（1143年）

高约25厘米

2002年北京市石景山区八角村金墓出土。

墓向南。位于墓北壁床榻图上方的拱眼壁。墨绘圆圈内画牛。

（撰文：张利芳　摄影：朱志刚）

## Zodiac Animals (Ox)

3rd Year of Huangtong, Jin (1143 CE)

Height ca. 25 cm

Unearthed from the tomb of Jin Dynasty at Bajiaocun in Shijiangshan District, Beijing, in 2002.

### 48.生肖图（兔）

金皇统三年（1143年）

高约25、宽100厘米

2002年北京市石景山区八角村金墓出土。墓向南。位于墓室东北壁备茶图上方拱眼壁。墨绘圆圈内画兔。

（撰文：张利芳　摄影：朱志刚）

### Zodiac Animals (Rabbit )

3rd Year of Huangtong, Jin (1143 CE)

Height ca. 25 cm; Width 100 cm

Unearthed from the tomb of Jin Dynasty at Bajiaocun in Shijiangshan District, Beijing, in 2002.

### 49.生肖图（龙）

金皇统三年（1143年）

高约25厘米

2002年北京市石景山区八角村金墓出土。墓向南。位于墓室东南壁备宴图上方拱眼壁。墨绘圆圈内画龙。

（撰文：张利芳　摄影：朱志刚）

### Zodiac Animals (Dragon)

3rd Year of Huangtong, Jin (1143 CE)

Height ca. 25 cm

Unearthed from the tomb of Jin Dynasty at Bajiaocun in Shijiangshan District, Beijing, in 2002.

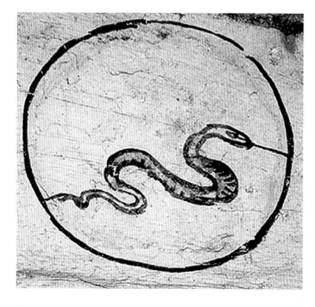

### 50.生肖图（蛇）

金皇统三年（1143年）

高约25厘米

2002年北京市石景山区八角村金墓出土。墓向南。位于墓室东南壁备宴图上方拱眼壁。墨绘圆圈内画蛇。

（撰文：张利芳　摄影：朱志刚）

### Zodiac Animals (Snake )

3rd Year of Huangtong, Jin (1143 CE)

Height ca. 25 cm

Unearthed from the tomb of Jin Dynasty at Bajiaocun in Shijiangshan District, Beijing, in 2002.

## 51. 生肖图（马）

金皇统三年（1143年）

高约25厘米

2002年北京市石景山区八角村金墓出土。

墓向南。位于墓室南壁墓门上方两侧。墨绘圆圈内画马。

（撰文：张利芳　摄影：朱志刚）

### Zodiac Animals (Horse)

3rd Year of Huangtong, Jin (1143 CE)

Height ca. 25 cm

Unearthed from the tomb of Jin Dynasty at Bajiaocun in Shijiangshan District, Beijing, in 2002.

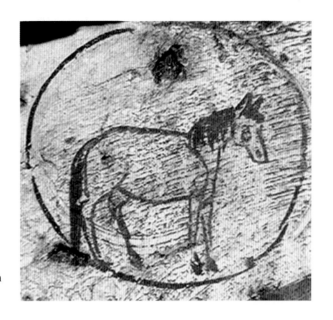

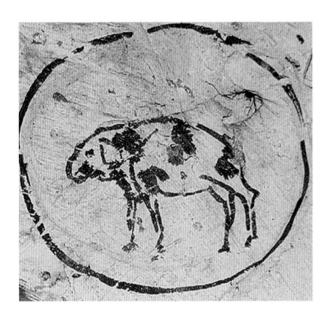

## 52. 生肖图（羊）

金皇统三年（1143年）

高约25厘米

2002年北京市石景山区八角村金墓出土。

墓向南。位于墓室南壁墓门上方两侧。墨绘圆圈内画羊。

（撰文：张利芳　摄影：朱志刚）

### Zodiac Animals (Sheep)

3rd Year of Huangtong, Jin (1143 CE)

Height ca. 25 cm

Unearthed from the tomb of Jin Dynasty at Bajiaocun in Shijiangshan District, Beijing, in 2002.

## 53. 生肖图（猴）

金皇统三年（1143年）

高约25厘米

2002年北京市石景山区八角村金墓出土。

墓向南。位于墓室西南壁散乐图上方拱眼壁。墨绘圆圈内画猴。

（撰文：张利芳　摄影：朱志刚）

### Zodiac Animals (Monkey)

3rd Year of Huangtong, Jin (1143 CE)

Height ca. 25 cm

Unearthed from the tomb of Jin Dynasty at Bajiaocun in Shijiangshan District, Beijing, in 2002.

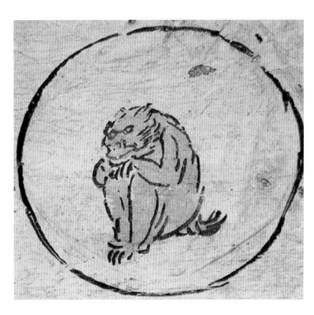

## 54.生肖图（鸡）

金皇统三年（1143年）

高约25厘米

2002年北京市石景山区八角村金墓出土。

墓向南。位于墓室西南壁散乐图上方拱眼壁。墨绘圆圈内画鸡。

（撰文：张利芳　摄影：朱志刚）

### Zodiac Animals (Rooster)

3rd Year of Huangtong, Jin (1143 CE)

Height ca. 25 cm

Unearthed from the tomb of Jin Dynasty at Bajiaocun in Shijiangshan District, Beijing, in 2002.

## 55.生肖图（狗）

金皇统三年（1143年）

高约25厘米

2002年北京市石景山区八角村金墓出土。

墓向南。位于墓室西北壁进酒图上方拱眼壁。墨绘圆圈内画狗。

（撰文：张利芳　摄影：朱志刚）

### Zodiac Animals (Dog)

3rd Year of Huangtong, Jin (1143 CE)

Height ca. 25 cm

Unearthed from the tomb of Jin Dynasty at Bajiaocun in Shijiangshan District, Beijing, in 2002.

## 56.生肖图（猪）

金皇统三年（1143年）

高约25厘米

2002年北京市石景山区八角村金墓出土。

墓向南。位于墓室西北壁进酒图上方拱眼壁。墨绘圆圈内画猪。

（撰文：张利芳　摄影：朱志刚）

### Zodiac Animals (Boar)

3rd Year of Huangtong, Jin (1143 CE)

Height ca. 25 cm

Unearthed from the tomb of Jin Dynasty at Bajiaocun in Shijiangshan District, Beijing, in 2002.

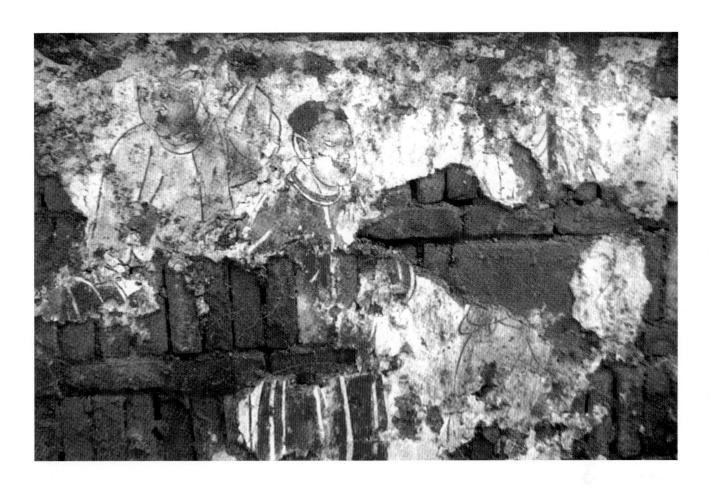

## 57. 出行仪仗图（一）

金（1115～1234年）

高约80、宽110厘米

2005年北京市延庆县晏家堡金墓出土。现存于北京市文物研究所。

墓向170°。位于甬道东壁。绘有四个男性侍者，均圆领窄袖长袍，其中右起第一人手持仗，第二人手作拈花状，第三人左手托一物，第四人不详。

（撰文：丁利娜　摄影：朱志刚）

## Guards of Honor in Procession (1)

Jin (1115-1234 CE)

Height ca. 80 cm; Width 110 cm

Unearthed from the tomb of Jin Dynasty at Yanjiabu in Yanqing County, Beijing, in 2005. Preserved in the Beijing Institute of Cultural Relics.

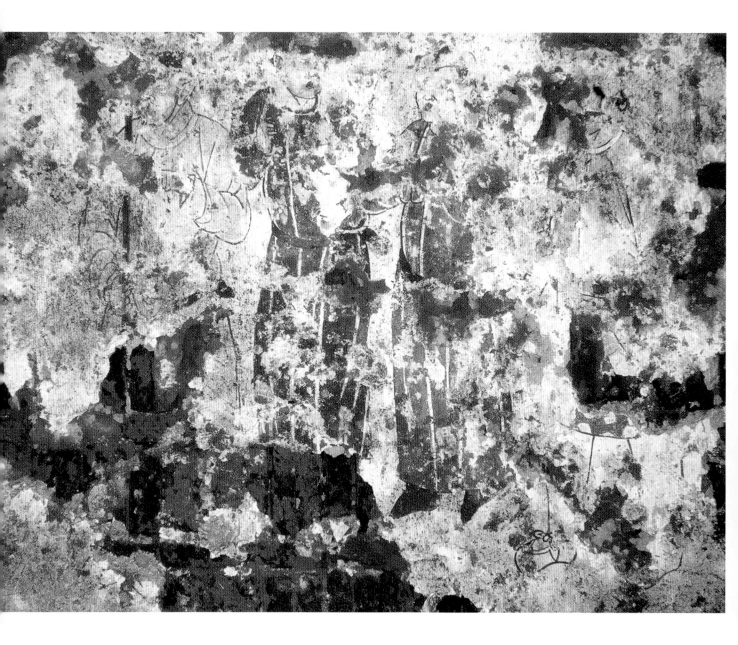

# 58. 出行仪仗图（二）

金（1115~1234年）

高约130、宽150厘米

2005年北京市延庆县晏家堡金墓出土。现存于北京市文物研究所。

墓向170°。位于甬道西壁，绘有四名男性侍者，均着圆领窄袖袍，裹巾。左起第一人左手持仗，第二人左手拈花状，第三人执插手礼，第四人手势不详。

（撰文：丁利娜　摄影：朱志刚）

## Guards of Honor in Procession (2)

Jin (1115-1234 CE)

Height ca. 130 cm; Width 150 cm

Unearthed from the tomb of Jin Dynasty at Yanjiabu in Yanqing County, Beijing, in 2005. Preserved in the Beijing Institute of Cultural Relics.

## 59.出行仪仗图（二）（局部）

金（1115～1234年）

2005年北京市延庆县晏家堡金墓出土。现存于北京市文物研究所。

墓向170°。位于甬道西壁。为出行仪仗队伍四人中的南侧三人上半身细部。

<div align="right">（撰文：丁利娜　摄影：朱志刚）</div>

## Guards of Honor in Procession (2) (Detail)

Jin (1115-1234 CE)

Unearthed from the tomb of Jin Dynasty at Yanjiabu in Yanqing County, Beijing, in 2005. Preserved in the Beijing Institute of Cultural Relics.

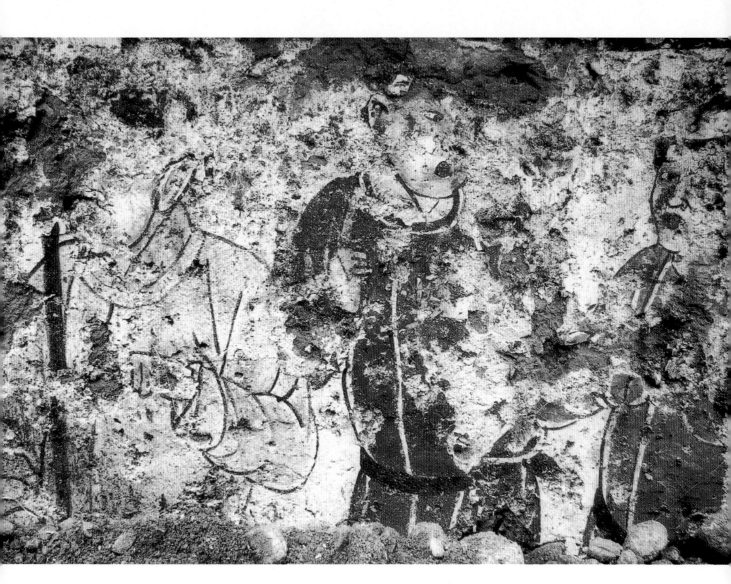

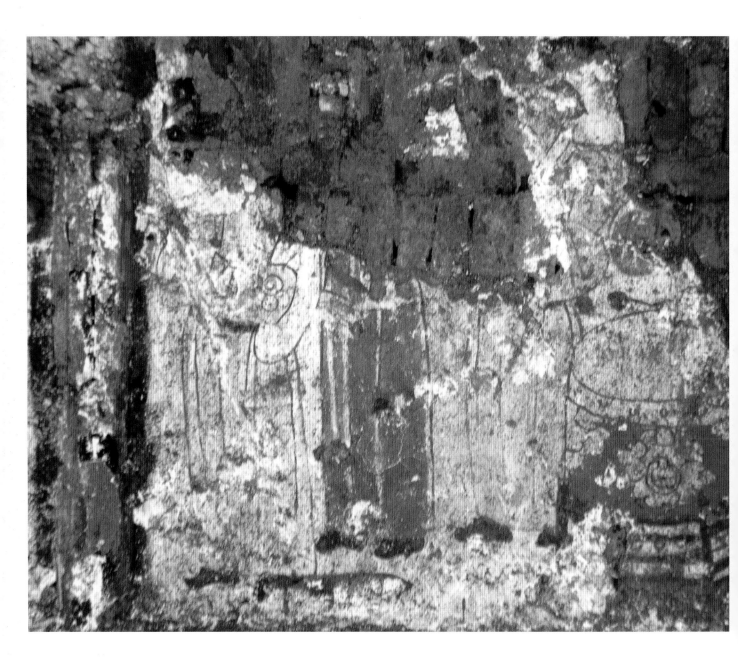

## 60.伎乐图

金（1115~1234年）

高约150、宽150厘米

2005年北京市延庆县晏家堡金墓出土。现存于北京市文物研究所。

墓向170°。位于墓室东南壁。绘有四人，为乐队成员。右起第一人为鼓手，仅存握鼓槌的一只手，身前立一红色大鼓，第二人着青衣黑靴，第三人足蹬黑靴，手持之乐器已漫漶，第四人似在吹觱篥。

<div align="right">（撰文：丁利娜　摄影：朱志刚）</div>

## Music Band Playing

Jin (1115-1234 CE)

Height ca. 150 cm; Width 150 cm

Unearthed from the tomb of Jin Dynasty at Yanjiabu in Yanqing County, Beijing, in 2005. Preserved in the Beijing Institute of Cultural Relics.

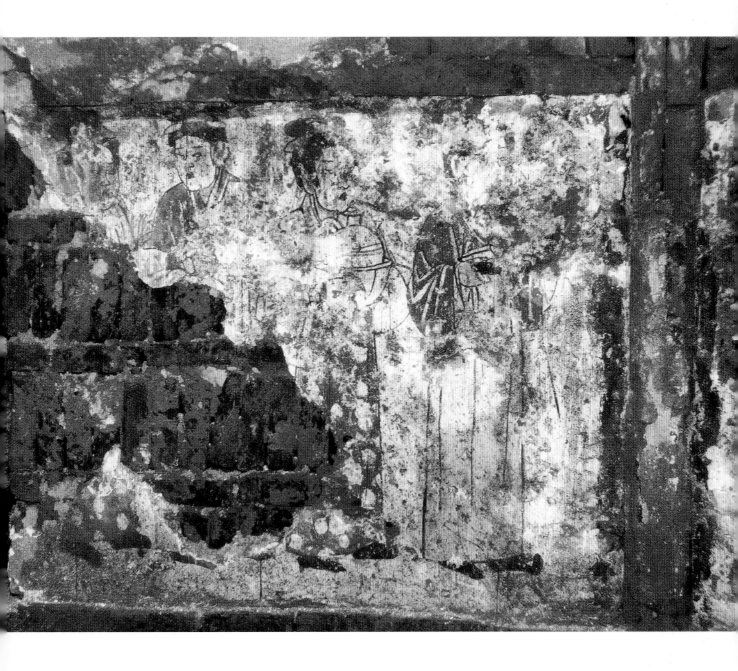

# 61.侍女图

金（1115～1234年）

高约110、宽120厘米

2005年北京市延庆县晏家堡金墓出土。现存于北京市文物研究所。

墓向170°。位于墓室西南壁。绘有四位侍女，均上袄下裙。左起第一人侧身向北，第二人双手托盘，第三人双手托一带温碗的注壶，第四人双手托劝盏。主体表现进酒场景。

（撰文：丁利娜　摄影：朱志刚）

## Maids

Jin (1115-1234 CE)

Height ca. 110 cm; Width 120 cm

Unearthed from the tomb of Jin Dynasty at Yanjiabu in Yanqing County, Beijing, in 2005. Preserved in the Beijing Institute of Cultural Relics.

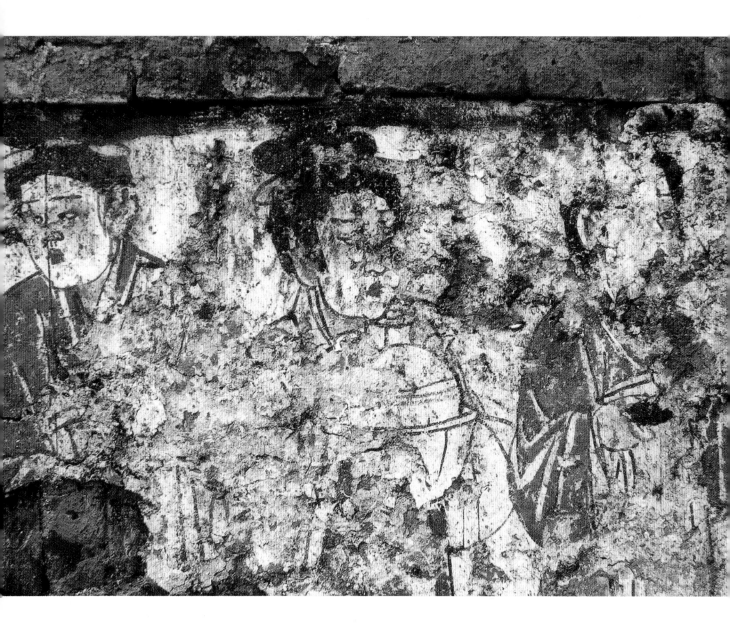

# 62.侍女图（局部）

金（1115～1234年）

2005年北京市延庆县晏家堡金墓出土。现存于北京市文物研究所。

墓向170°。位于墓室西南壁。为四位侍女中的右侧三位的上半身。

（撰文：丁利娜　摄影：朱志刚）

## Maids (Detail)

Jin (1115-1234 CE)

Unearthed from the tomb of Jin Dynasty at Yanjiabu in Yanqing County, Beijing, in 2005. Preserved in the Beijing Institute of Cultural Relics.

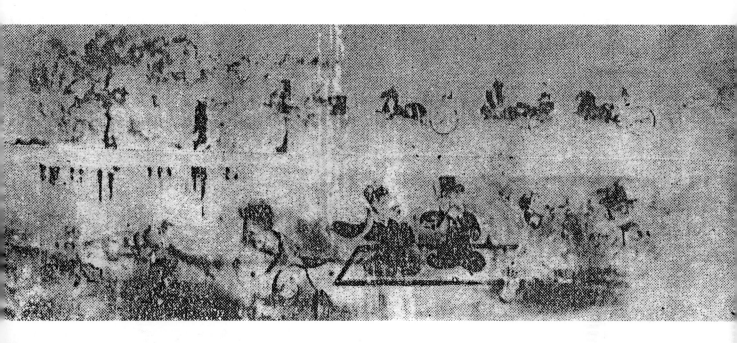

## 63.车马出行、宴饮乐舞图

东汉（25～220年）

高75、宽160厘米

1960年江苏省徐州市黄山陇汉墓出土。已残毁。

墓向南。位于前室西壁。画面分上、下排列，上远下近，上为车马出行队列，下绘乐舞场景，右为伎乐，左为舞者。

（撰文：邹厚本　摄影：不详）

## Procession Scene, Feasting, Music and Dancing Performance

Eastern Han (25-220 CE)

Height 75 cm; Width 160 cm

Unearthed from the tomb of Han Dynasty at Huangshanlong in Xuzhou, Jiangsu, in 1960. Not Preserved.

## 64. 天象图（摹本）

南唐升元七年（943年）

长约708、宽约406厘米

江苏省南京市东善桥南唐李昪钦陵出土。原址保存。

墓向南。位于后室顶部。星辰用红色线勾出轮廓，中填石青，有的用红线联接，东侧有朱红色太阳，其西相对位置有淡蓝色明月。

（临摹：不详　撰文：邹厚本　摄影：不详）

## Constellations (Replica)

7th Year of Shengyuan Era, Southern Tang (943 CE)

Length ca. 708 cm; Width ca. 406 cm

Unearthed from Li Bian's Qin Mausoleum at Dongshanqiao in Nanjing, Jiangsu. Preserved on the original site.

## 65.雕花床图

北宋嘉祐五年（1060年）

高150、宽250厘米

江苏省淮安市楚州区（原淮安县）杨庙镇杨氏墓地一号墓出土。已残毁。

墓向南。位于墓室后壁。床沿雕连续卷草纹，后围镂空栏板，挂有帐幔，卧床一侧放置座枕。

（撰文：邹厚本　摄影：不详）

## Bed with Carved Designs

5th Year of Jiayou Era, Northern Song (1060 CE)

Height 150 cm; Width 250 cm

Unearthed from Tomb No.1 of Yang's Family Cemetery at Yangmiao of Chuzhou District (former Huai'an County) in Huai'an, Jiangsu, in 1959. Not Preserved.

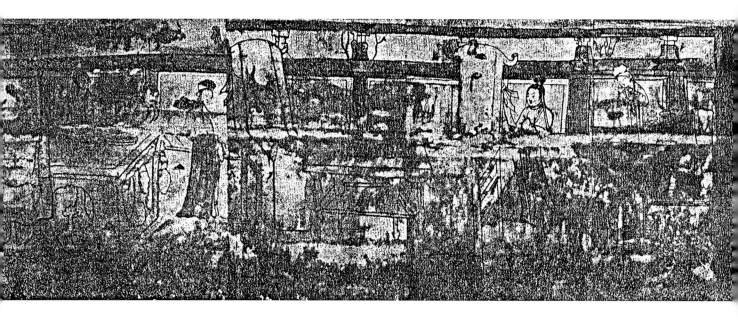

## 66.祭奠图（摹本）

北宋嘉祐五年（1060年）

高140、宽400厘米

1959年江苏省淮安市楚州区（原淮安县）杨庙镇杨氏墓地一号墓出土。已残毁。

墓向南。位于墓室东壁。正中绘桌子，上放果品（盛漆盒内）、杯、盘、壶、盒等，其左右各置高椅，两旁各立一男侍、女侍。右侧另有一桌，桌上置托子等器皿，桌下有一披发小童，弯腰蹲立炉旁煎汤，桌后立一女，双手捧物，应为奉茶场景。左侧亦有一桌，桌后立二侍，桌子置有壶、盒、盆、果品，桌下有四个酒瓶，应为进酒场景。桌左后另有一人，面向一排蒸屉。

（临摹：不详　撰文：邹厚本　摄影：不详）

## A Scene of Memorial Ceremony (Replica)

5th Year of Jiayou Era, Northern Song (1060 CE)

Height 140 cm; Width 400 cm

Unearthed from Tomb No.1 of Yang's Family Cemetery at Yangmiao of Chuzhou District (former Huai'an County) in Huai'an, Jiangsu, in 1959. Not Preserved.

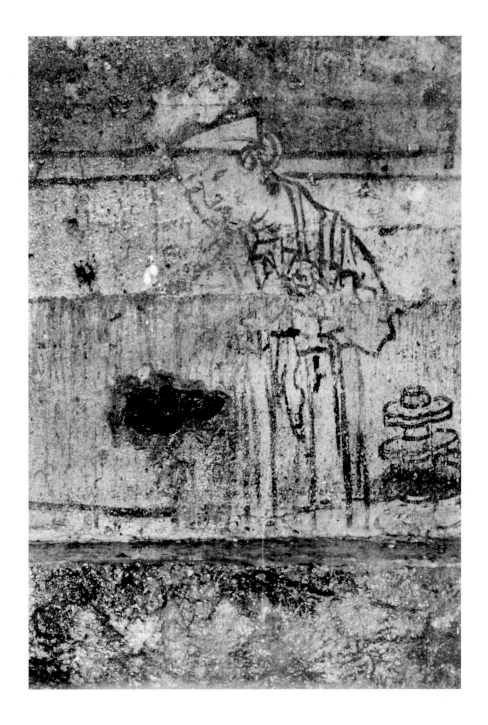

## 67.侍女图（一）

北宋嘉祐五年（1060年）

高40、宽20厘米

1959年江苏省淮安市楚州区（原淮安县）杨庙镇杨氏墓地一号墓出土。已残毁。

墓向南。位于墓室东壁。为祭奠图右数第一人。侍女梳包髻，后插火梳截白花，着褙子，手捧物，右下方一叠托盏。

<div align="right">（撰文：邹厚本　摄影：不详）</div>

## Maid (1)

5th Year of Jiayou Era, Northern Song (1060 CE)

Height 40 cm; Width 20 cm

Unearthed from Tomb No.1 of Yang's Family Cemetery at Yangmiao of Chuzhou District (former Huai'an County) in Huai'an, Jiangsu, in 1959. Not Preserved.

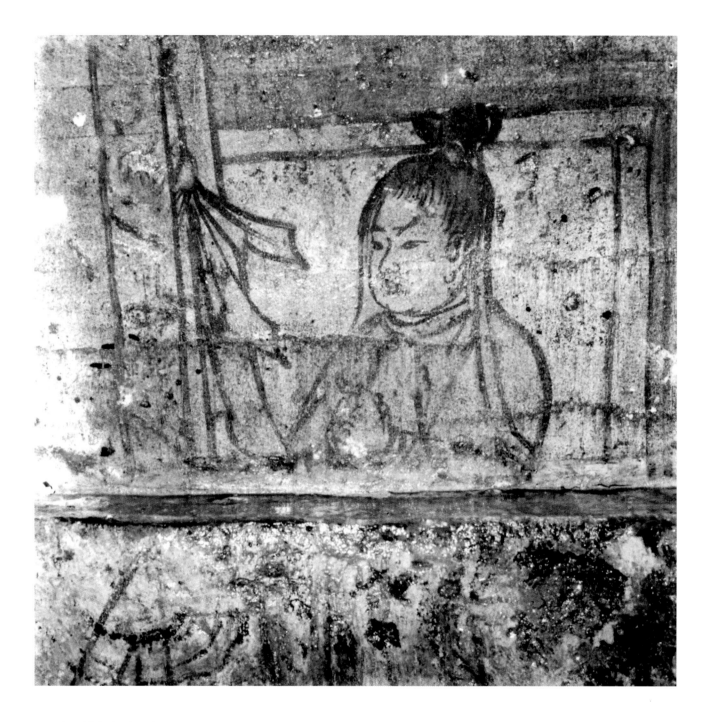

# 68.男侍图（一）

北宋嘉祐五年（1060年）

高44、宽44厘米

1959年江苏省淮安市楚州区（原淮安县）杨庙镇杨氏墓地一号墓出土。已残毁。

墓向南。位于墓室东壁。为祭奠图右数第二人。梳髻，髻中系带飘于耳侧，着窄袖圆领衫，叉手敬立于桌前。

（撰文：邹厚本　摄影：不详）

## Maid (1)

5th Year of Jiayou Era, Northern Song (1060 CE)

Height 44 cm; Width 44 cm

Unearthed from Tomb No.1 of Yang's Family Cemetery at Yangmiao of Chuzhou District (former Huai'an County) in Huai'an, Jiangsu, in 1959. Not Preserved.

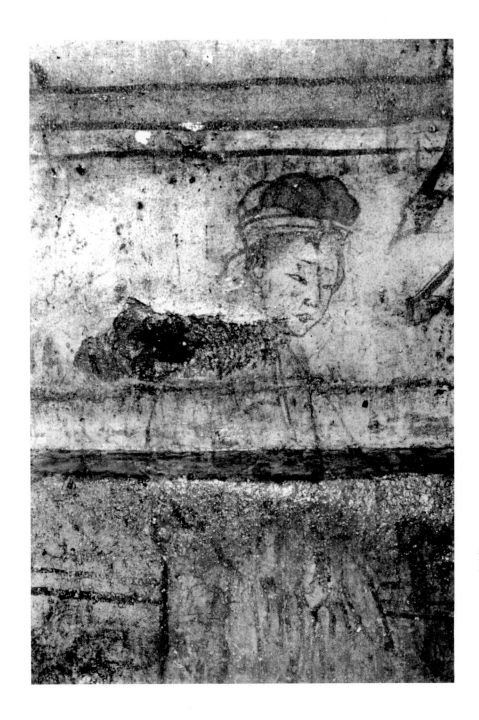

## 69.捧物侍女图（一）

北宋嘉祐五年（1060年）

高40、宽20厘米

1959年江苏省淮安市楚州区（原淮安县）杨庙镇杨氏墓地一号墓出土。已残毁。

墓向南。位于墓室东壁。为祭奠图右数第三人。为一少妇，高髻，额发下梳出尖额，髻下系白带，着褙子，束长裙，面呈哀泣状，双手捧物。

（撰文：邹厚本 摄影：不详）

## Maid in Service (1)

5th Year of Jiayou Era, Northern Song (1060 CE)

Height 40 cm; Width 20 cm

Unearthed from Tomb No.1 of Yang's Family Cemetery at Yangmiao of Chuzhou District (former Huai'an County) in Huai'an, Jiangsu, in 1959. Not Preserved.

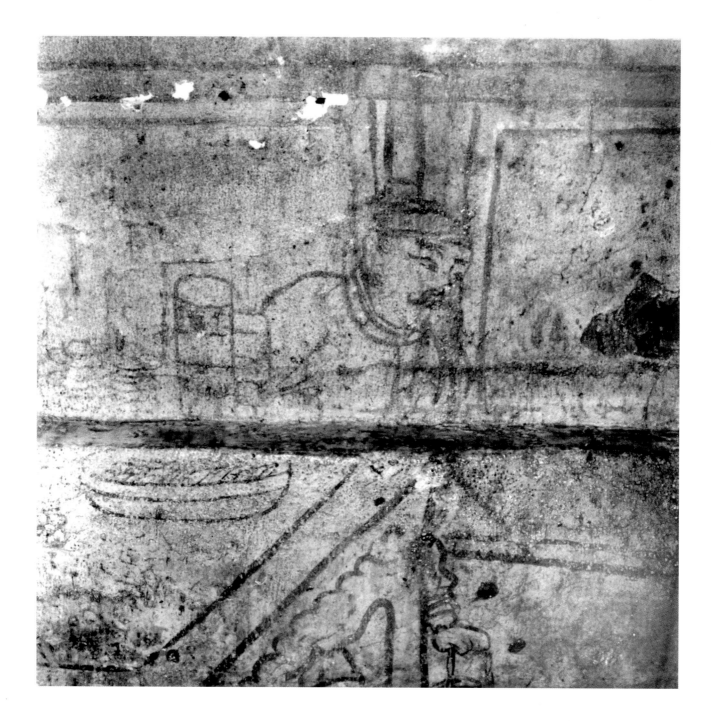

# 70. 男侍图（二）

北宋嘉祐五年（1060年）

高44、宽44厘米

1959年江苏省淮安市楚州区（原淮安县）杨庙镇杨氏墓地一号墓出土。已残毁。

墓向南。位于墓室东壁，为祭奠图右起第四人。男侍身旁置一高桌，桌上放置一盆，内盛摆放齐整的食品，男侍戴头巾，着圆领衫，手提注壶，弯腰前行。

（撰文：邹厚本　摄影：不详）

## Servant (2)

5th Year of Jiayou Era, Northern Song (1060 CE)

Height 44 cm; Width 44 cm

Unearthed from Tomb No.1 of Yang's Family Cemetery at Yangmiao of Chuzhou District (former Huai'an County) in Huai'an, Jiangsu, in 1959. Not Preserved.

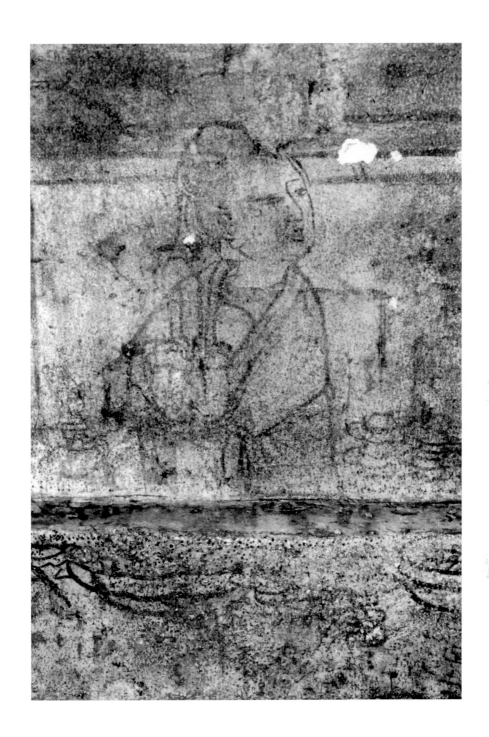

## 71.捧物侍女图（二）

北宋嘉祐五年（1060年）

高70、宽40厘米

1959年江苏省淮安市楚州区（原淮安县）杨庙镇杨氏墓地一号墓出土。已残毁。

墓向南。位于墓室东壁，为祭奠图左端的人物。侍女身旁桌上置放众多菜肴，并有一叠托盏，女侍梳包髻，插簪，手捧葵瓣盖食盒。

<div align="right">（撰文：邹厚本　摄影：不详）</div>

## Maid in Service (2)

5th Year of Jiayou Era, Northern Song (1060 CE)

Height 70 cm; Width 40 cm

Unearthed from Tomb No.1 of Yang's Family Cemetery at Yangmiao of Chuzhou District (former Huai'an County) in Huai'an, Jiangsu, in 1959. Not Preserved.

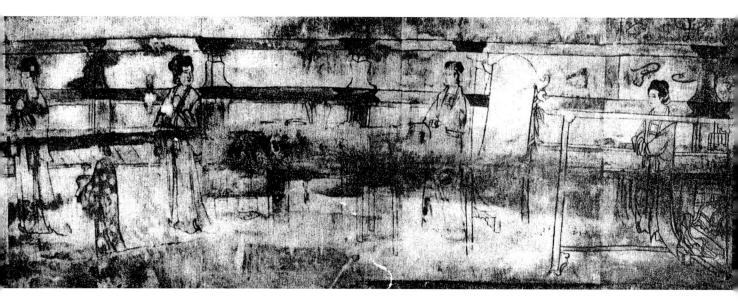

## 72. 奉侍图（摹本）

北宋嘉祐五年（1060年）

高140、宽400厘米

1959年江苏省淮安市楚州区（原淮安县）杨庙镇杨氏墓地一号墓出土。已残毁。

墓向南。位于墓室西壁。正中置方桌一张，上置物品，桌下左侧放两个三足器，桌后高椅一张，椅前立一抄手女童。右侧为衣架，搭衣衫，其后亦立一抄手女子，桌左侧分立三个女子，一作抄手后顾状，其前二个女子，一人着簇团花袍手捧钵状物，另一人手捧圆镜，裙下露尖鞋。

（临摹：不详　撰文：邹厚本　摄影：不详）

## Attending(Replica)

5th Year of Jiayou Era, Northern Song (1060 CE)

Height 140 cm; Width 400 cm

Unearthed from Tomb No.1 ovf Yang's Family Cemetery at Yangmiao of Chuzhou District (former Huai'an County) in Huai'an, Jiangsu, in 1959. Not Preserved.

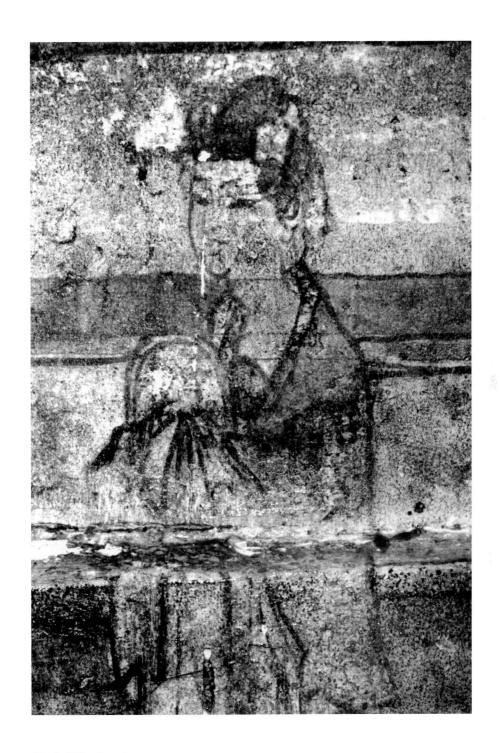

# 73.侍女图（二）

北宋嘉祐五年（1060年）

高42、宽25厘米

1959年江苏省淮安市楚州区（原淮安县）杨庙镇杨氏墓地一号墓出土。已残毁。

墓向南。位于墓室西壁。为奉侍图左侧第一人，侍女梳髻簪白花，着大袖对襟襦，手捧铜镜。

<div align="right">（撰文：邹厚本　摄影：不详）</div>

## Maid (2)

5th Year of Jiayou Era, Northern Song (1060 CE)

Height 42 cm; Width 25 cm

Unearthed from Tomb No.1 of Yang's Family Cemetery at Yangmiao of Chuzhou District (former Huai'an County) in Huai'an, Jiangsu, in 1959. Not Preserved.

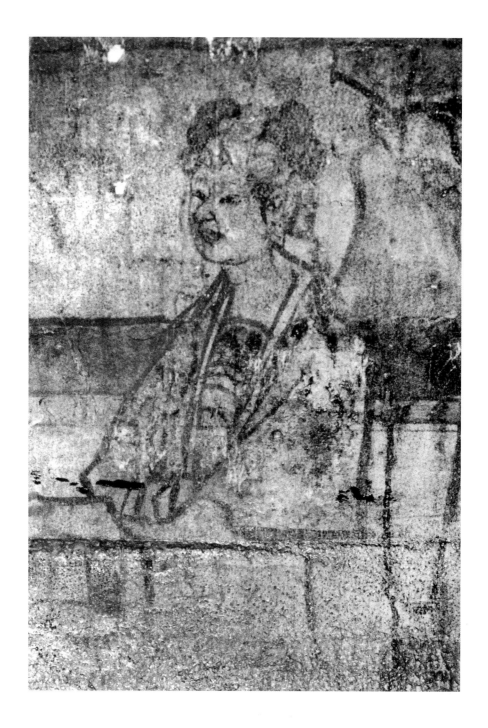

# 74.侍女图（三）

北宋嘉祐五年（1060年）

高50、宽30厘米

1959年江苏省淮安市楚州区（原淮安县）杨庙镇杨氏墓地一号墓出土。已残毁。

墓向南。位于墓室西壁，为奉侍图高椅前侍女。侍女梳双髻，簪花，系带，着花内襦子，外罩褙子，抄手而立。

（撰文：邹厚本　摄影：不详）

## Maid (3)

5th Year of Jiayou Era, Northern Song (1060 CE)

Height 50 cm; Width 30 cm

Unearthed from Tomb No.1 of Yang's Family Cemetery at Yangmiao of Chuzhou District (former Huai'an County) in Huai'an, Jiangsu, in 1959. Not Preserved.

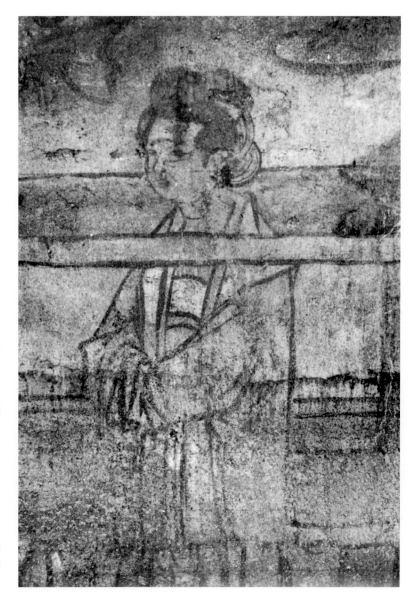

## 75.侍女图（四）▶

北宋嘉祐五年（1060年）

高44、宽44厘米

1959年江苏省淮安市楚州区（原淮安县）杨庙镇杨氏墓地一号墓出土。已残毁。

墓向南。位于墓室西壁，为奉侍图右侧侍女。侍女梳高髻，后插象牙梳，内着宽袖对襟旋袄，外罩褙子，抄手面左而立。

（撰文：邹厚本　摄影：不详）

## Maid (4)

5th Year of Jiayou Era, Northern Song (1060 CE)

Height 44 cm; Width 44 cm

Unearthed from Tomb No.1 of Yang's Family Cemetery at Yangmiao of Chuzhou District (former Huai'an County) in Huai'an, Jiangsu, in 1959. Not Preserved.

## 76.牡丹树图▼

后晋天福四年（939年）

树高约173、宽110厘米

1997年浙江省临安市玲珑镇祥里村吴越国康陵出土。原址保存。

墓向45°。位于中室西壁。牡丹树冠呈圆形，红花绿叶，花蕊贴饰菱形金箔，树干贴饰数枚圆形金箔。画面两上角绘红绿色流云纹，两下角绘红色火焰状纹饰。

（撰文、摄影：张玉兰）

## Peony Tree

4th Year of Tianfu Era, Later Jin (939 CE)

Height of tree 173 cm; Width110 cm

Unearthed from the Kang Mausoleum of Wuyue Kingdom at Xianglicun of Linglong in Lin'an, Zhejiang, in 1997. Preserved on the original site.

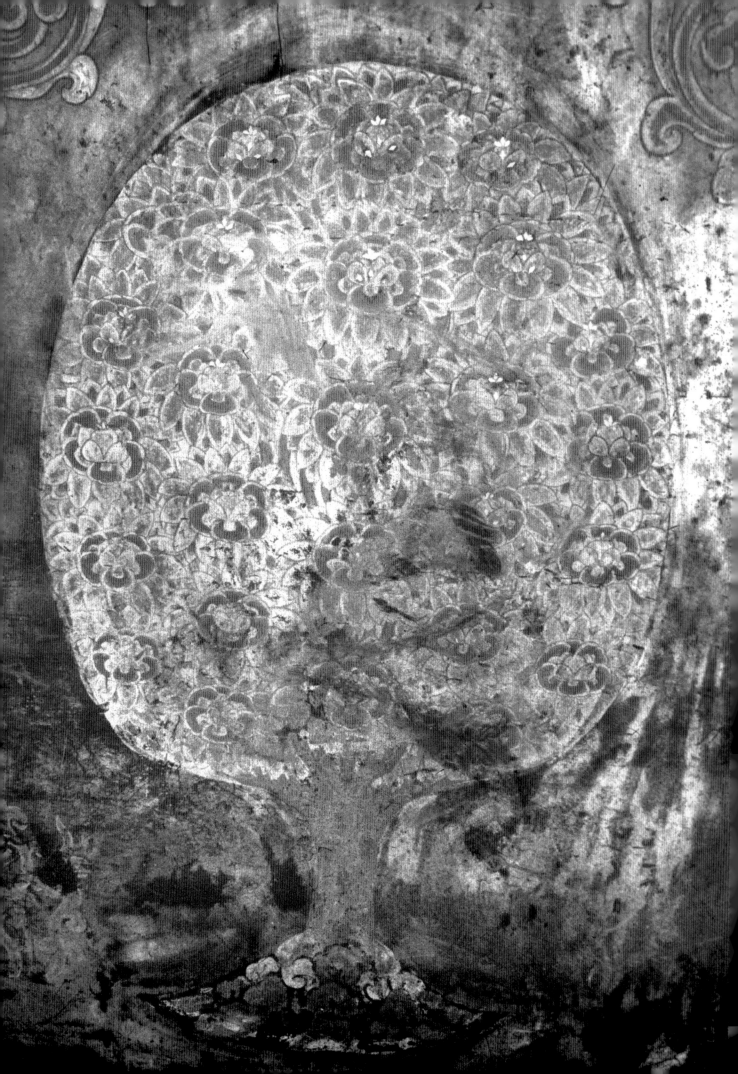

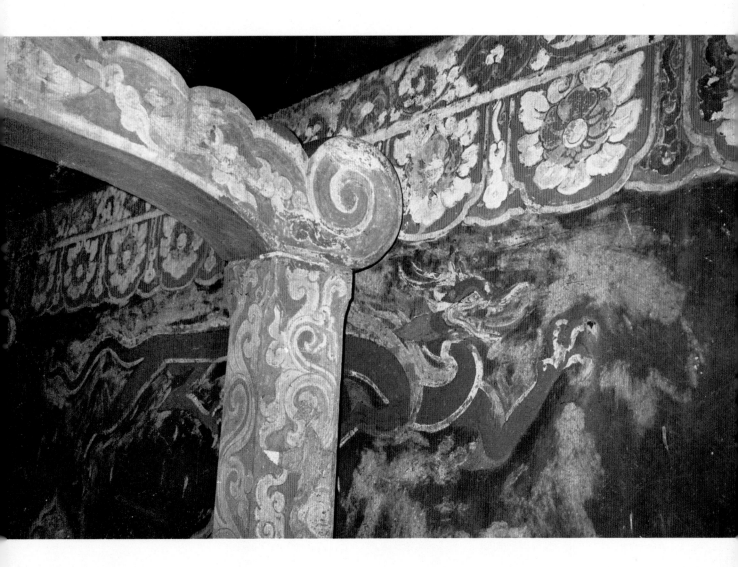

## 77. 青龙图

后晋天福四年（939年）

龙身长约294厘米

1997年浙江省临安市玲珑镇祥里村吴越国康陵出土。原址保存。

墓向45°。位于后室西壁上部。龙体用浅浮雕刻出，用红、白线条勾勒轮廓，龙身绘成青蓝色，上下唇及眼睛用金箔装饰。龙身修长，朝墓门作昂首腾跃状。图中龙身中部被彩绘的石枋柱和石枋额遮蔽。

（撰文、摄影：张玉兰）

### Green Dragon

4th Year of Tianfu Era, Later Jin (939 CE)

Length of dragon ca. 294 cm

Unearthed from the Kang Mausoleum of Wuyue Kingdom at Xianglicun of Linglong in Lin'an, Zhejiang, in 1997. Preserved on the original site.

# 78. 白虎图

后晋天福四年（939年）

白虎全长281厘米

1997年浙江省临安市玲珑镇祥里村吴越国康陵出土。原址保存。

墓向45°。位于后室东壁上部。白虎用浅浮雕技法刻成，用红线勾勒轮廓，以白色绘虎身，黑色绘斑纹，虎的唇、眼、耳和颈部贴饰金箔。白虎神态威猛，朝墓门作张牙舞爪奔腾状。

（撰文、摄影：张玉兰）

## White Tiger

4th Year of Tianfu Era, Later Jin (939 CE)

Whole length of tiger 281 cm

Unearthed from the Kang Mausoleum of Wuyue Kingdom at Xianglicun of Linglong in Lin'an, Zhejiang, in 1997. Preserved on the original site.

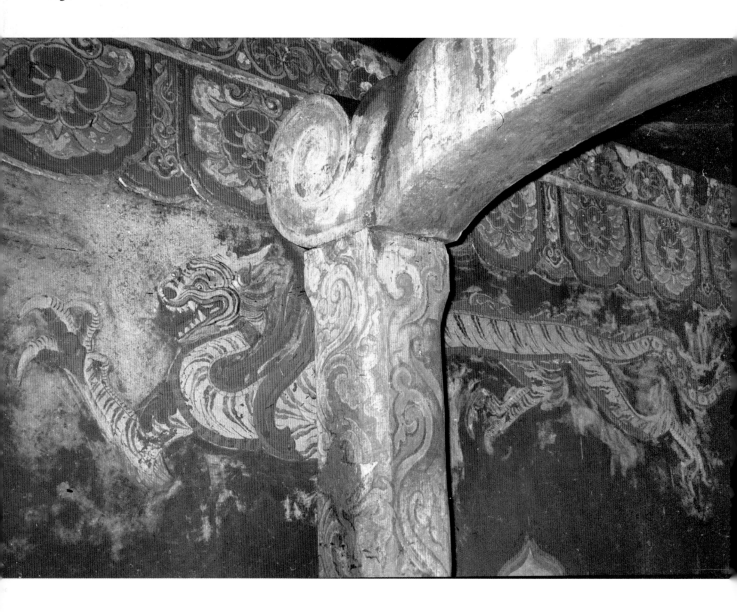

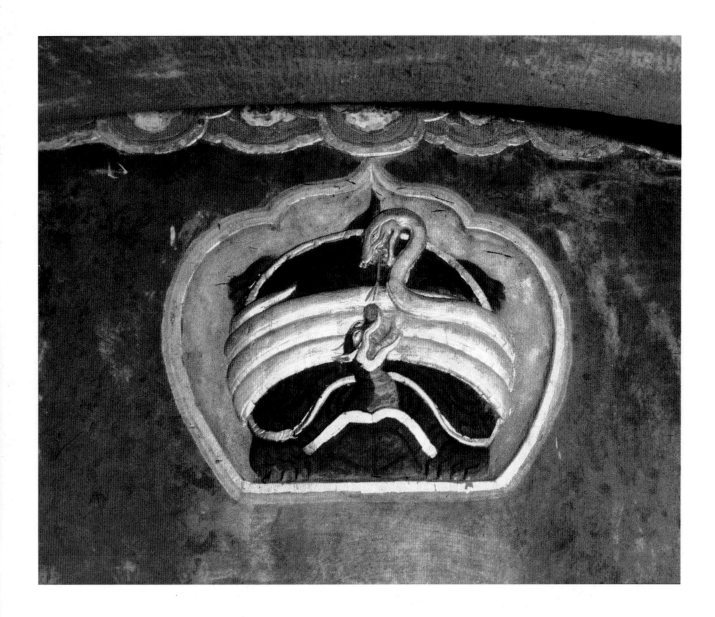

# 79. 玄武图

后晋天福四年（939年）

龛高45、宽54厘米

1997年浙江省临安市玲珑镇祥里村吴越国康陵出土。原址保存。

墓向45°。位于后室后壁上部。玄武刻于一壶门状浅龛内，龛底为红色，浅浮雕的龟体绘成黑色，唇部及龟甲边缘贴饰金箔，缠绕龟体的蛇通体贴饰金箔。龟蛇两首相对，色彩对比强烈。

<div align="right">（撰文：文人言　摄影：张玉兰）</div>

## Sombre Warrior

4th Year of Tianfu Era, Later Jin (939 CE)

Niche's height 45cm; Width 54cm

Unearthed from the Kang Mausoleum of Wuyue Kingdom at Xianglicun of Linglong in Lin'an, Zhejiang, in 1997. Preserved on the original site.

## 80. 生肖人物图（局部一）

北宋（960~1127年）

1987年福建省尤溪县麻洋村宋墓出土。原址保存。

墓向160°。位于墓室后室西壁。右边一人头戴马头形冠，身着紫色褙子，襟、袖饰黑边。其左者头戴蛇形冠饰，脸颊尚存浅朱色渲染痕，身着白色广袖褙子，下身长裙曳地。二生肖人物皆双手执笏于胸前。

（撰文、摄影：杨琮）

## Zodiac Figures (Detail 1)

Northern Song (960-1127 CE)

Unearthed from the tomb of Song Dynasty at Mayangcun in Youxi, Fujian, in 1987. Preserved on the original site.

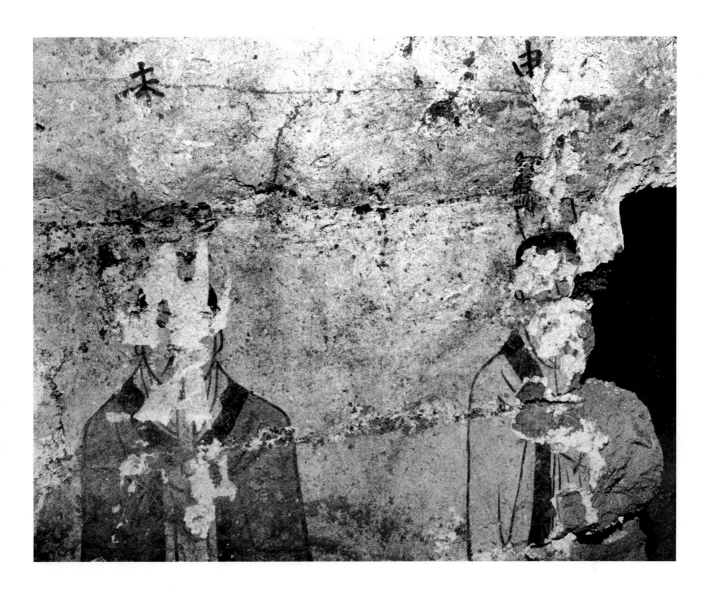

## ▲81.生肖人物图（局部二）

北宋（960～1127年）

1987年福建省尤溪县麻洋村宋墓出土。原址保存。

墓向160°。位于墓室后室东壁。左边一人头戴羊头形冠，身着灰色广袖裙子，双手执笏于胸前，其头上方尚存有墨书"未"字。右边一人头戴猴形冠，身着白色敞领士人服，冠顶的猴头有长须，其上墨书一"申"字。

（撰文、摄影：杨琮）

## Zodiac Figures (Detail 2)

Northern Song (960-1127 CE)

Unearthed from the tomb of Song Dynasty at Mayangcun in Youxi, Fujian, in 1987. Preserved on the original site.

## ▼82.仪卫图

北宋（960～1127年）

人物高45～50厘米

1990年福建省尤溪县城关第一中学一号墓出土。现存于福建博物院。

墓向100°。壁画位于墓室北壁。其人络腮长须，戴黑色幞头，身着大红色圆领束袖袍服，双手执杖于胸前。该文吏为六个文吏人物形象中的第一人。人物旁边为墓壁砖雕。

（撰文、摄影：杨琮）

## Guard of Honor

Northern Song (960-1127 CE)

Height of Figure 45-50 cm

Unearthed from the tomb at the No.1 Middle School of Youxi County, Fujian, in 1990. Preserved in the Fujian Musem.

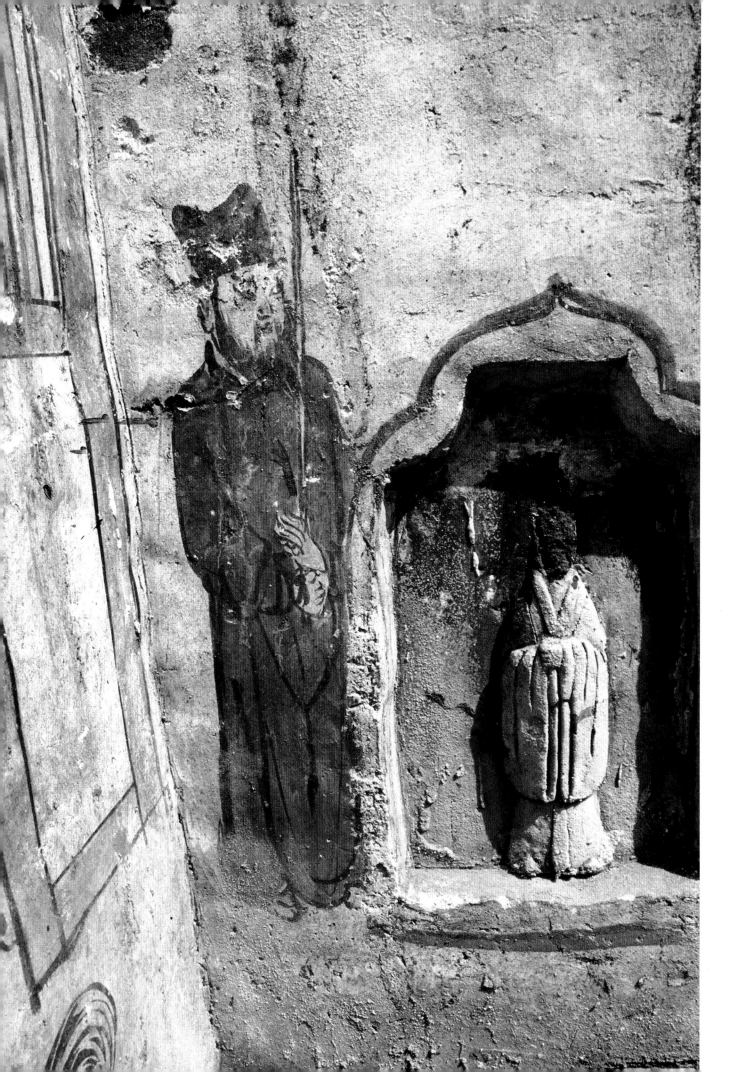

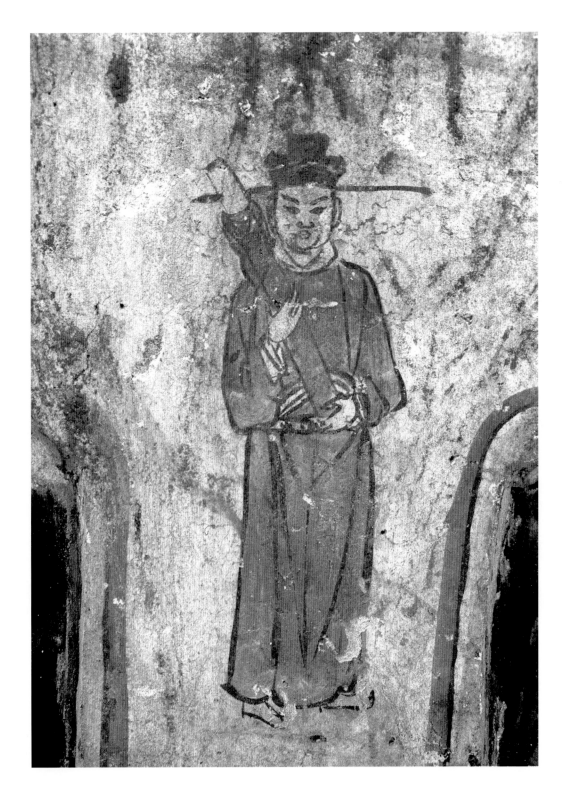

## 83.捧物文吏图

北宋（960～1127年）

人物高度为45～50厘米

1990年福建省尤溪县城关第一中学一号墓出土。现存于福建博物院。墓向100°。位于墓室南壁。画中绘捧物文吏，头戴黑色展脚幞头，身着大红色圆领窄袖长袍，系腰带，足穿翘头尖靴，双手于右胸前捧抱一圆筒状物，外有红布包裹。该文吏为六个文吏人物形象中的第二人。

（撰文、摄影：杨琮）

## Civil Official

Northern Song (960-1127 CE)

Height of Figure 45-50 cm

Unearthed from the tomb at the No.1 Middle School of Youxi County, Fujian, in 1990. Preserved in the Fujian Musem.

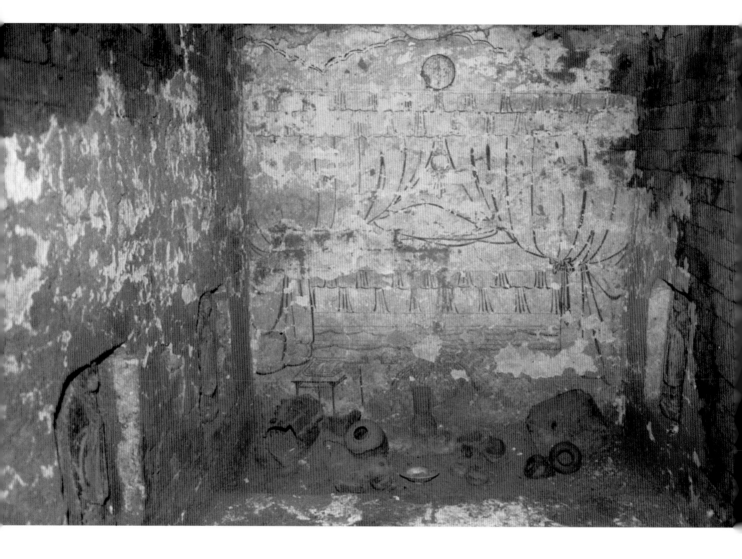

## 84. 床榻图（两幅）

北宋（960～1127年）

1996年福建省尤溪县城关第一中学二号墓出土。原址保存。

墓向100°。位于墓室西壁。最上方嵌一圆铜镜，铜镜下方绘一幅床纬幔帐，幔帐被丝带系于两边，幔帐之中有一圆形挂饰，床上有铺盖。床边左边绘一张矮凳。床正下方绘一动物，头部残缺，推测为鸡。下图与其相似，所不同之处，床边矮凳绘于右侧。

<div align="right">（撰文、摄影：杨琮）</div>

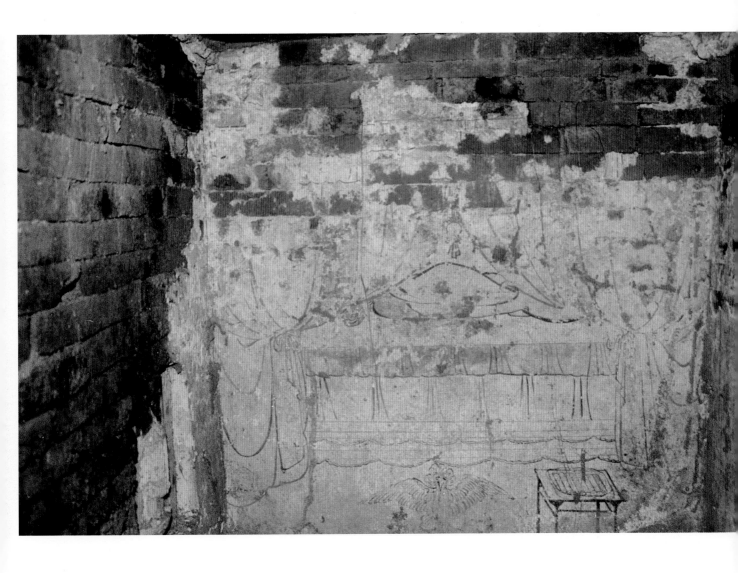

## Beds

Northern Song (960-1127 CE)

Unearthed from the tomb at the No.2 Middle School of Youxi County, Fujian, in 1996. Preserved on the original site.

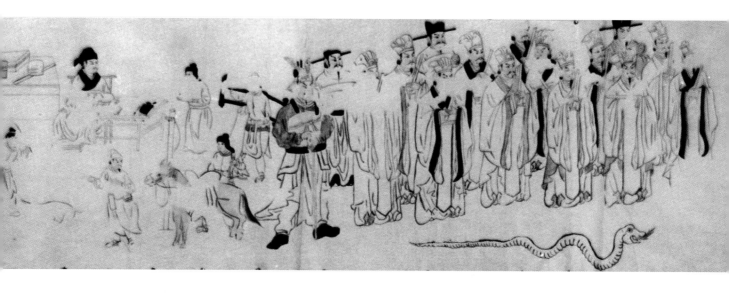

## ▲85. 官宦文吏人物图（摹本）

北宋（960～1127年）

人物高约50、蛇长约70厘米

1988年福建省尤溪县梅仙乡坪寨村一号墓出土。原址保存。墓向80°。位于墓左室西壁。壁画左边为墓主及六位仆役形象，右为参差排列的文吏朝仪的场面，人物残存16人，从左到右，第一人是个身材高大的武将，其人头戴鹖冠，足穿黑靴，着武士服装，雄纠纠按剑（也可能是铜）而立。余则皆为文吏，服饰姿态大体分两种：一种头戴进贤冠，身着对襟广袖长袍，足穿双耳翘头履，双手持笏而立。另一种头戴黑色展脚幞头，身着圆领官袍，腰系黑色腰带，足穿黑靴，双手皆捧纸卷。着前一种服饰的文吏为12人，大多数交错站于前排的位置，其长服的襟、袖边饰或黑或白或紫，双耳翘头履则或紫或白。而在这组文吏画面的下方，绘着一条躬曲爬行的大白蛇。

（临摹、撰文、摄影：杨琮）

## Tomb Occupant, Officials, and Attendants (Replica)

Northern Song (960-1127 CE)

Height of Figure 50 cm; Length of snake 70 cm

Unearthed from the Tomb No.1 at Pingzhaicun of Meixianxiang in Youxi, Fujian, in 1988. Preserved on the original site.

## 86. 寝室图 ▶

北宋（960～1127年）

侍女人物高38厘米

1988年福建省尤溪县梅仙乡坪寨村一号墓出土。原址保存。墓向80°。位于墓室南壁。此壁整幅绘一木构房屋。屋顶、梁柱、斗拱均涂金黄色，房下正面，猩红色的幔帐从中间分开，两边各系于柱上。帐内是长方形的大床，床后壁有一排四幅相连的画屏，皆绘着水墨山水画，画屏的边幅染淡青色。此床前房柱两端各立一捧物侍女，她们的面庞、胸、颈及手均晕染肉色或淡红色。

（撰文、摄影：杨琮）

## Bedroom

Northern Song (960-1127 CE)

Height of Maid 338 cm

Unearthed from the Tomb No.1 at Pingzhaicun of Meixianxiang in Youxi, Fujian, in 1988. Preserved on the original site.

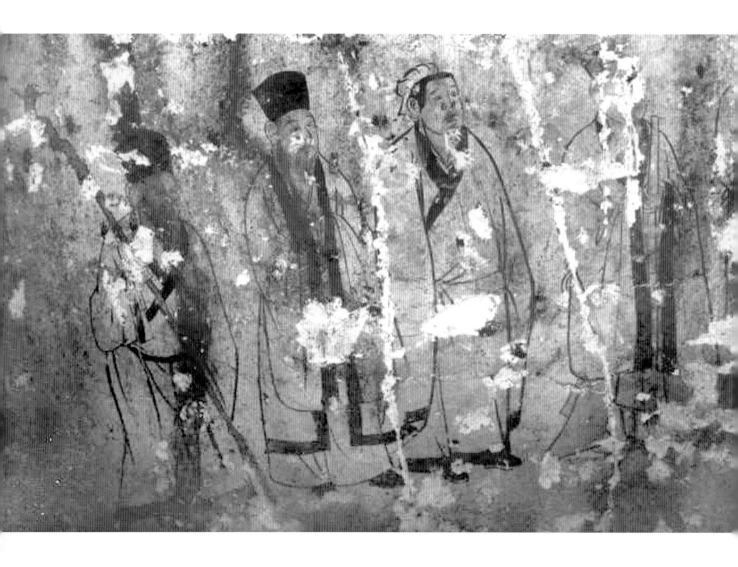

## 87. 人物图（局部）

南宋（1127～1279年）

人物高32～35厘米

1993年福建省三明市岩前镇岩前村南宋墓出土。原址保存。

墓向100°。位于墓室北壁。从左至右，第一人持杖，头戴进贤冠，着广袖袍；第二人拱手而立；第三人头戴巾，肃立；第四人为文吏形象，头戴进贤冠，手执笏板。人物唇染红色，脸、颈部用淡红色晕染。

（撰文、摄影：杨琮）

## Figures (Detail)

Southern Song (1127-1279 CE)

Height of figures 32-35 cm

Unearthed from the tomb of Southern Song at Yanqiancun in Sanming, Fujian, in 1993. Preserved on the original site.

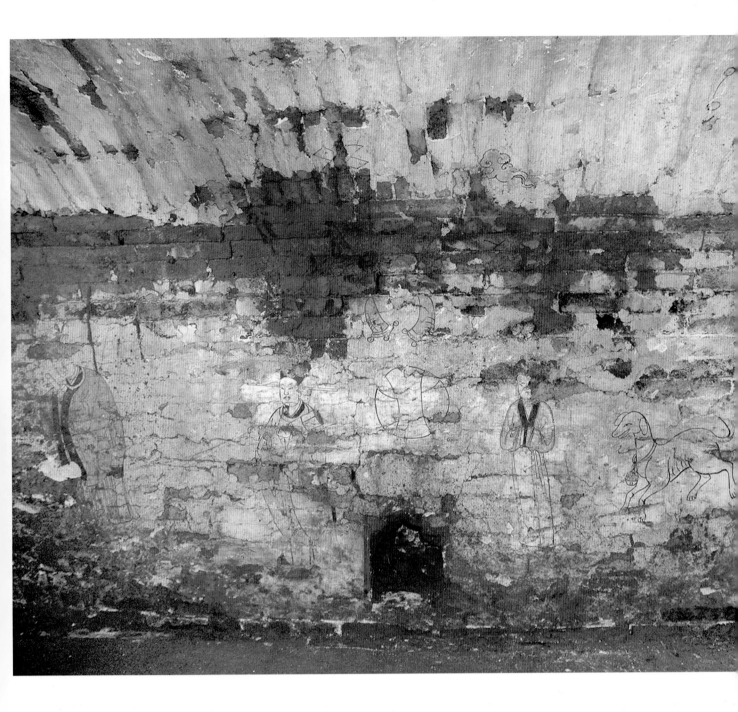

# 88.侍立人物图（局部）

元（1206～1368年）

2007年福建省松溪祖墩乡山元村元墓出土。原址保存。

墓向150°。位于墓室东壁，此壁画面有三个抄手侍立的人物形象，右为一女子，左为两男子，女子右侧绘颈挂铃铛的家犬，男女之间上有如意八宝的图案。

<div align="right">（撰文、摄影：杨琮）</div>

## Standing Attendants (Detail)

Yuan (1206-1368 CE)

Unearthed from the tomb of Yuan Dynasty at Shanyuancun of Zudun in Songxi, Fujian, in 2007. Preserved on the original site.

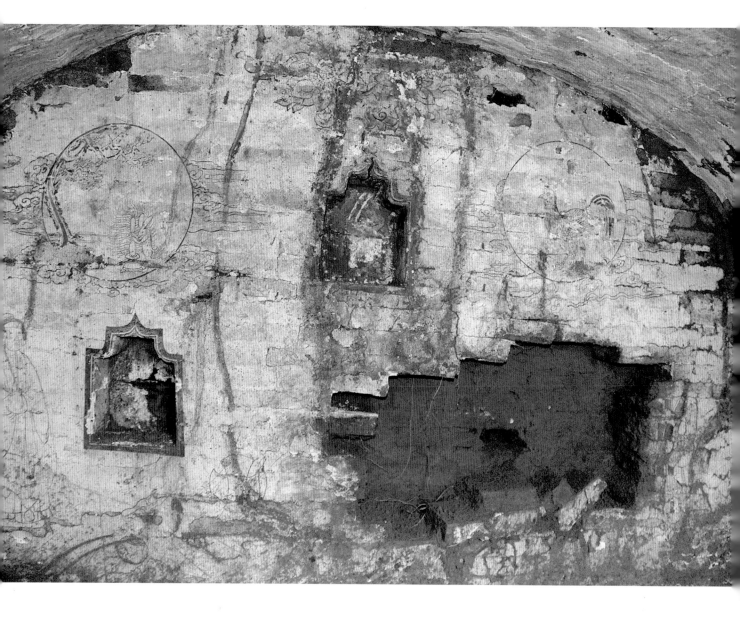

# 89.日月人物图

元（1206～1368年）

2007年福建省松溪县祖墩乡山元村元墓出土。原址保存。

墓向150°。位于墓室北壁，有三龛呈品字形分布，上龛两侧分别为太阳和月亮，挂在祥云之中。左为一圆月，月中有桂树，树下为玉兔捣药。右侧为太阳，日中有三足金鸡。月下有一站立妇女形象，应为合葬中的女墓主形象，梳包髻，上着广袖衫，下着裙。日下亦有人物形象，应为男墓主形象，出土时候被破坏。

（撰文、摄影：杨琮）

## The Sun, Moon, and Figures

Yuan (1206-1368 CE)

Unearthed from the tomb of Yuan Dynasty at Shanyuancun of Zudun in Songxi, Fujian, in 2007. Preserved on the original site.

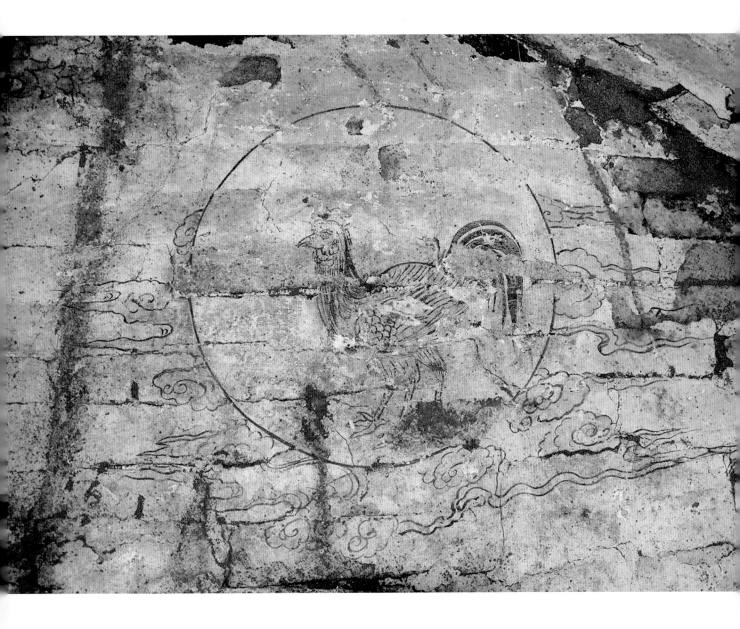

## 90.日轮图

元（1206～1368年）

2007年福建省松溪祖墩乡山元村元墓出土。原址保存。

墓向150°。位于墓室北壁。为日月人物图局部。为右侧的太阳，日中有三足金鸡。

（撰文、摄影：杨琮）

## The Sun

Yuan (1206-1368 CE)

Unearthed from the tomb of Yuan Dynasty at Shanyuancun of Zudun in Songxi, Fujian, in 2007. Preserved on the original site.

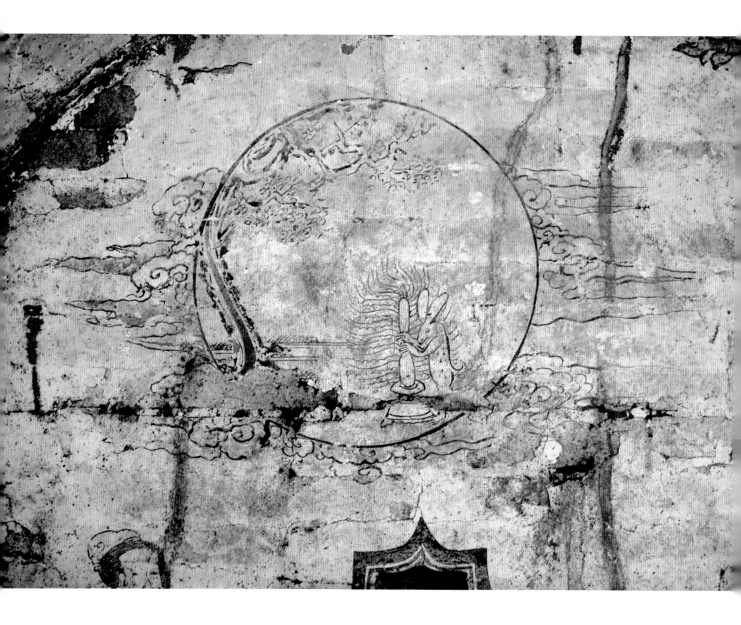

# 91. 月轮图

元（1206～1368年）

2007年福建省松溪祖墩乡山元村元墓出土。原址保存。

墓向150°。位于墓室北壁。为日月人物图局部。为左侧圆月，月中有桂树，树下为玉兔捣药。

<div align="right">（撰文、摄影：杨琮）</div>

## The Moon

Yuan (1206-1368 CE)

Unearthed from the tomb of Yuan Dynasty at Shanyuancun of Zudun in Songxi, Fujian, in 2007. Preserved on the original site.

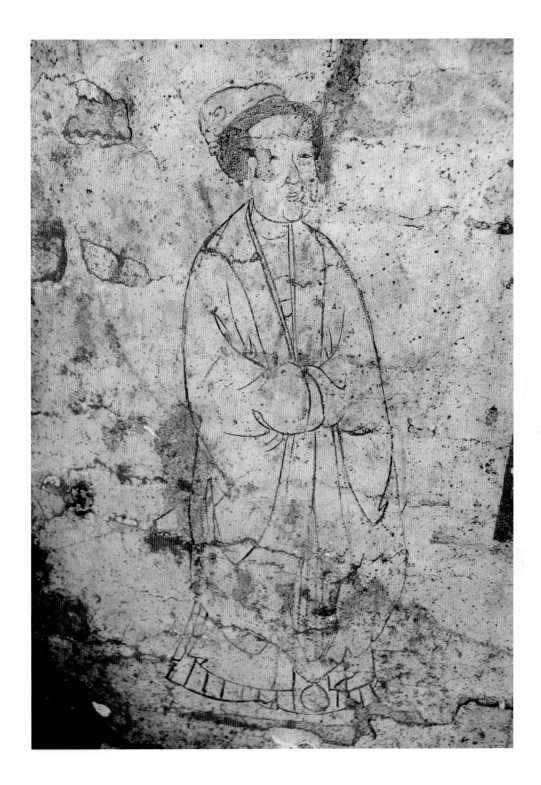

## 92.女墓主

元（1206～1368年）

2007年福建省松溪县祖墩乡山元村元墓出土。原地保存。

墓向150°。位于墓室北壁。有为日月人物图局部。为月下的女墓主形象。

<div align="right">（撰文、摄影：杨琮）</div>

## Portrait of Tomb Occupant

Yuan (1206-1368 CE)

Unearthed from the tomb of Yuan Dynasty at Shanyuancun of Zudun in Songxi, Fujian, in 2007. Preserved on the original site.

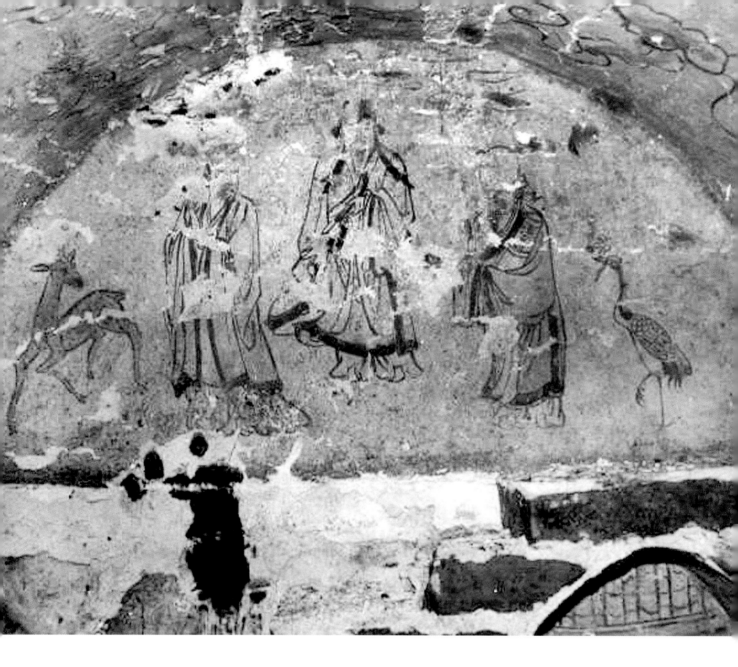

## 93.福禄寿三星图

元（1206～1368年）

1990年福建省将乐县光明乡元墓出土。原址保存。

墓向20°。位于左室西壁。为呈品字形站立的福禄寿三神仙。左为禄仙，头顶部残，从束发的发式上看，应为戴冠形象。身着广袖长袍，双手捧笏侧立，下著长裙，足穿翘头履。一只欢蹦乱跳的梅花仙鹿，在身前蹦跳。中间的人物为福仙，头戴黑色巾，身著交领广袖长袍，一手下垂，一手(左手)执羽扇，扇头向下。右侧绘一拱手拢卷的寿仙，大额头，脑后扎巾结，身著交领对襟黄色镶黑边的长袍。旁一仙鹤口衔灵芝，昂首独脚站立。所捧卷文上有墨书"注寿"。三仙头上绘有祥云。

<div align="right">（撰文、摄影：杨琮）</div>

## Three Immortals Symbolizing Happiness, Fortunes, and Longevity

Yuan (1206-1368 CE)

Unearthed from the tomb of Yuan Dynasty at Guangmingxiang in Jiangle, Fujian, in 1990. Preserved on the original site.

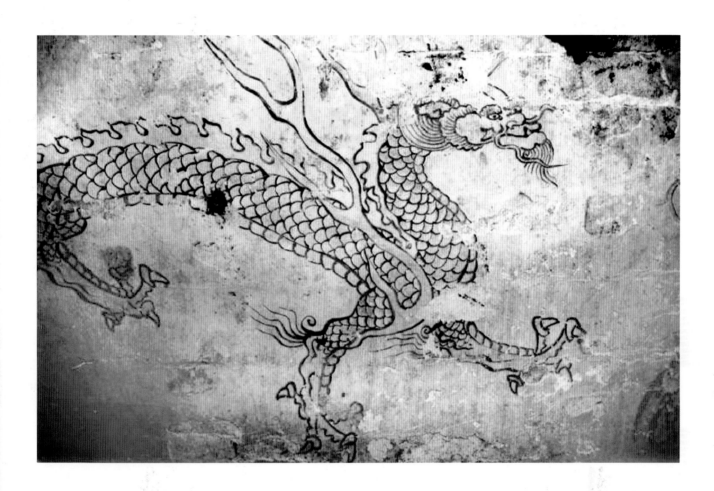

# 94.青龙图（局部）

元（1206～1368年）

龙首尾长约113厘米

1990年福建省将乐县光明乡元墓出土。原址保存。

墓向20°。位于墓室左室西壁。龙头角部分遭破坏，龙身两侧有形如火焰状的双翼，浑身鳞甲，四爪，背部有火焰状竖纹，尾部粗大，突收为秃尾。苍龙形象生动，线条流畅，气势磅礴，背上方有密集的流云。

（撰文、摄影：杨琮）

## Green Dragon (Detail)

Yuan (1206-1368 CE)

Length of dragon 113 cm

Unearthed from the tomb of Yuan Dynasty at Guangmingxiang in Jiangle, Fujian, in 1990. Preserved on the original site.

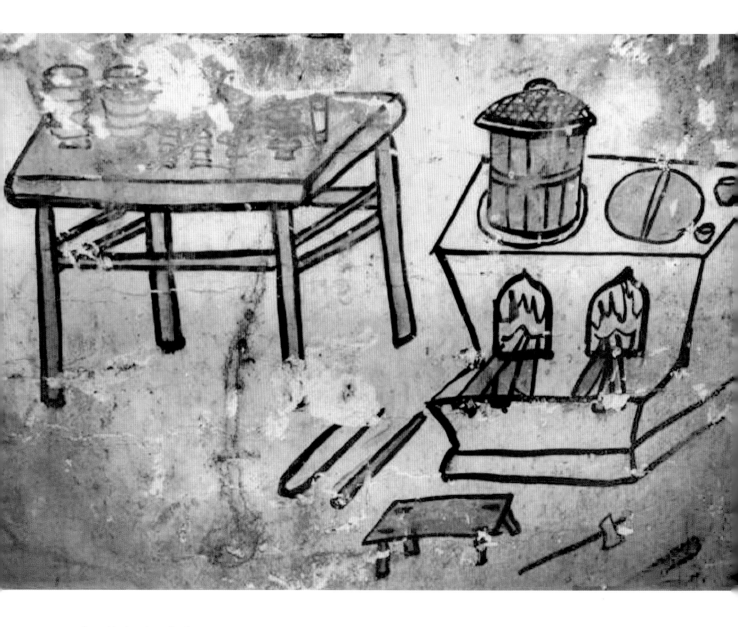

## 95.庖厨图（局部）

元（1206～1368年）

1990年福建省将乐县光明乡元墓出土。原址保存。

墓向20°。位于墓室右室东壁，画面绘有一张案桌，桌上摆有碗、托盏等，碗、盏皆成双叠放，小盏倒扣成叠。桌右侧绘有一座双火膛的灶，火膛中有木柴，灶上架有两锅，左边的锅上置一木蒸桶，蒸桶上有竹编的盖，右边锅台旁置二个小罐、钵。灶前有烧火人坐的小木凳，凳左边搁置有夹火钳、捅火棍，凳右侧有劈柴的斧头及已劈好的一堆木柴。

（撰文、摄影：杨琮）

## In the Kitchen (Detail)

**Yuan (1206-1368 CE)**

Unearthed from the tomb of Yuan Dynasty at Guangmingxiang in Jiangle, Fujian, in 1990. Preserved on the original site.

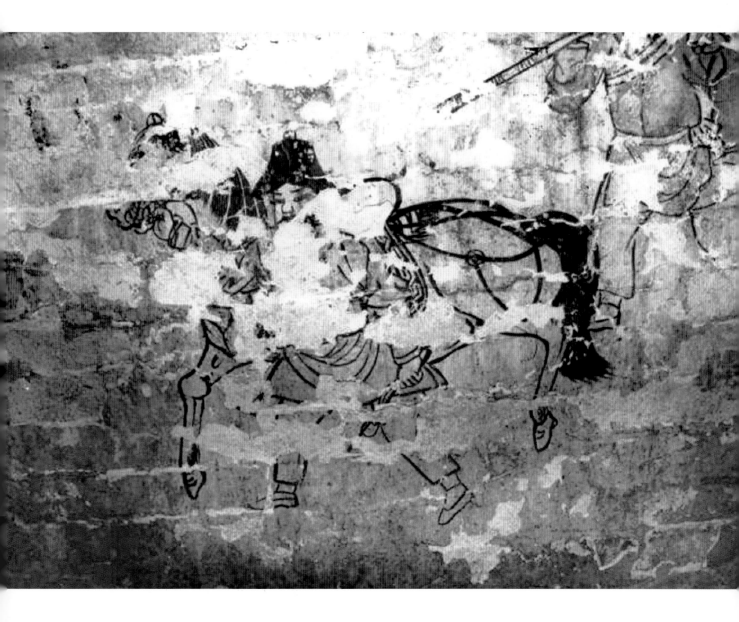

# 96.鞍马图（局部）

元（1206～1368年）

1990年福建省将乐县光明乡元墓出土。原址保存。

墓向20°。位于墓室左室东壁，画面上最前边的是一位牵着鞍马的男子，画面严重毁坏，仍可看出此人物头戴黑色的屏斗笠，蓄须，身着小袖短袍，下著窄腿裤，足穿布鞋，右手牵马，左手握马鞭，马后跟随一扛杖人物。

（撰文、摄影：杨琮）

## Saddled Horse (Detail)

Yuan (1206-1368 CE)

Unearthed from the tomb of Yuan Dynasty at Guangmingxiang in Jiangle, Fujian, in 1990. Preserved on the original site.

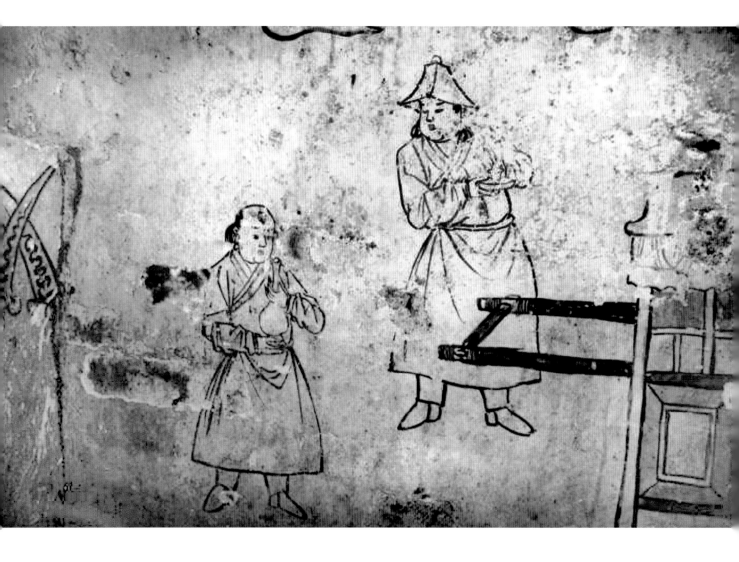

# 97.人物轿舆图（局部一）

元（1206～1368年）

1990年福建省将乐县光明乡元墓出土。原址保存。

持杖人物高约42、小童高约30厘米

墓向20°。位于墓室左室西壁。画面上右一人，面对一童子，持杖躬身，蓄须，头戴巾，着圆领窄袖袍。手持物的上部已残，仅存柄杖部分。面前的小童，双手抄拢于胸前躬身作揖拜状。小童身后有一顶落于地上的抬轿。轿后立有二人，前上方一人头戴戽斗笠，身着交领小袖长袍，腰系带，足穿靴，脑后两侧露出垂辫环，双手捧一劝盏于胸前。后下方一人双手捧酒瓶(玉壶春瓶)，头上留三鹁角，衣着与前者相同。

（撰文、摄影：杨琮）

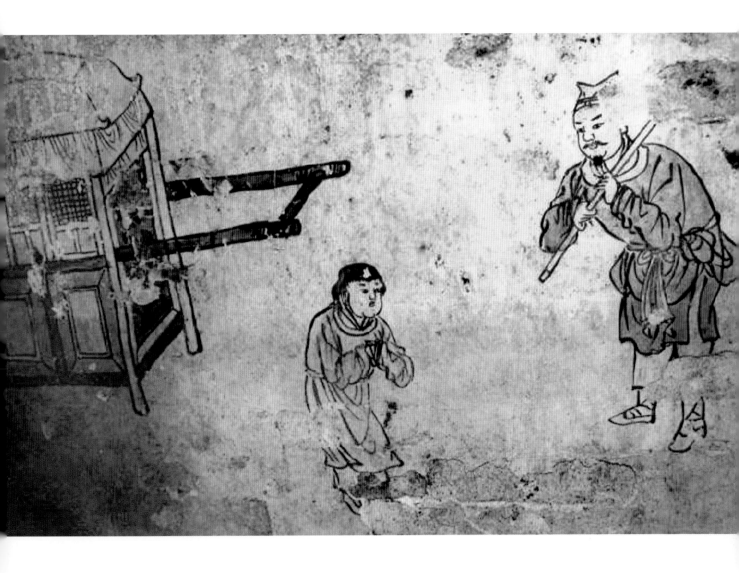

## Sedan and Attendants

Yuan (1206-1368 CE)

Height of attendants 42 cm; Height of boy servant 30 cm

Unearthed from the tomb of Yuan Dynasty at Guangmingxiang in Jiangle, Fujian, in 1990. Preserved on the original site.

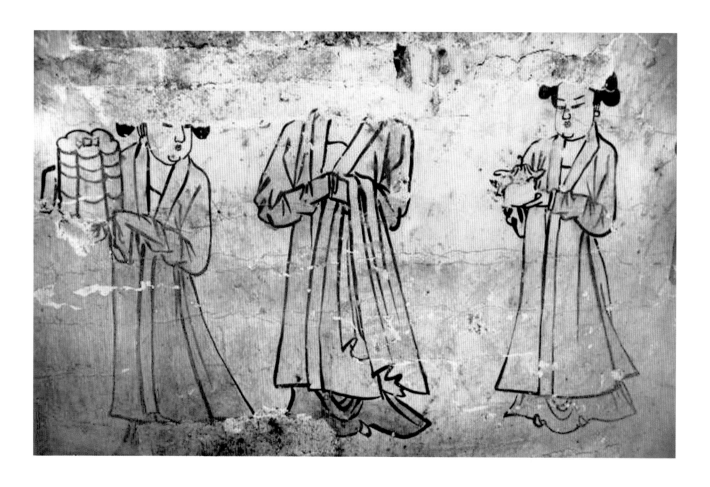

# 98.捧物妇女图

元（1206～1368年）

人物高45～48厘米

1990年福建省将乐县光明乡元墓出土。原址保存。

墓向20°。位于墓室右室东壁。壁画上三妇女皆作徐行状。三女皆外著对襟窄袖长衫，内有曳地长裙。左侧人物梳有发髻，带耳坠(环)，双手捧着花瓣形的多层盒奁。中间的人物个头较高，抄手而立，左臂搭有帨巾，内着黄色裙。右侧人物双手捧一荷叶盖小罐，耳下垂小环。

<div align="right">（撰文、摄影：杨琮）</div>

## Maids in Attending

Yuan (1206-1368 CE)

Height of figures 45-48 cm

Unearthed from the tomb of Yuan Dynasty at Guangmingxiang in Jiangle, Fujian, in 1990. Preserved on the original site.

# 99. 仪卫图（一）

北宋（960～1127年）

高约110、宽154厘米

2006年江西省德安县望夫山北宋墓出土。现存于江西省德安县博物馆。

墓向南。位于墓室东壁南部。为墓室东壁九人组成仪仗队伍中的第一至四人，四人均头戴软脚幞帽，身着圆领窄袖袍衫，手持"骨朵"。

（撰文：杨军　摄影：周宏伟　杨军）

## Ceremonial Guards (1)

Northern Song (960-1127CE)

Height ca. 110 cm; Width 154 cm

Unearthed from the tomb of Northern Song at Wangfushan in De'an, Jiangxi, in 2006. Preserved in the De'an County Museum of Jiangxi.

## 100.侍女图

北宋（960～1127年）

高约110、宽78厘米

2006年江西省德安县望夫山北宋墓出土，现存于江西省德安县博物馆。

墓向南。位于墓室东壁中部。为墓室东壁九人中的第七人，梳高髻，上身着褙子，下着罗裙，体态丰腴。

（撰文：杨军　摄影：周宏伟　杨军）

## Maid

Northern Song (960-1127CE)

Height ca. 110 cm; Width 78 cm

Unearthed from the tomb of Northern Song at Wangfushan in De'an, Jiangxi, in 2006. Preserved in the De'an County Museum of Jiangxi.

# 101.仪卫图（二）

北宋（960～1127年）

高约110、宽144厘米

2006年江西省德安县望夫山北宋墓出土。现存于江西省德安县博物馆。

墓向南。位于墓室西壁中部，为墓室西壁九人中的第四至六人，左侧二人头戴展脚幞头，身着圆领窄袖袍，手执宝剑；右一人头戴交脚幞头，身着圆领广袖袍，双手捧笏。

（撰文：杨军　摄影：周宏伟　杨军）

## Ceremonial Guards (2)

Northern Song (960-1127CE)

Height ca. 110 cm; Width 144 cm

Unearthed from the tomb of Northern Song at Wangfushan in De'an, Jiangxi, in 2006. Preserved in the De'an County Museum of Jiangxi.

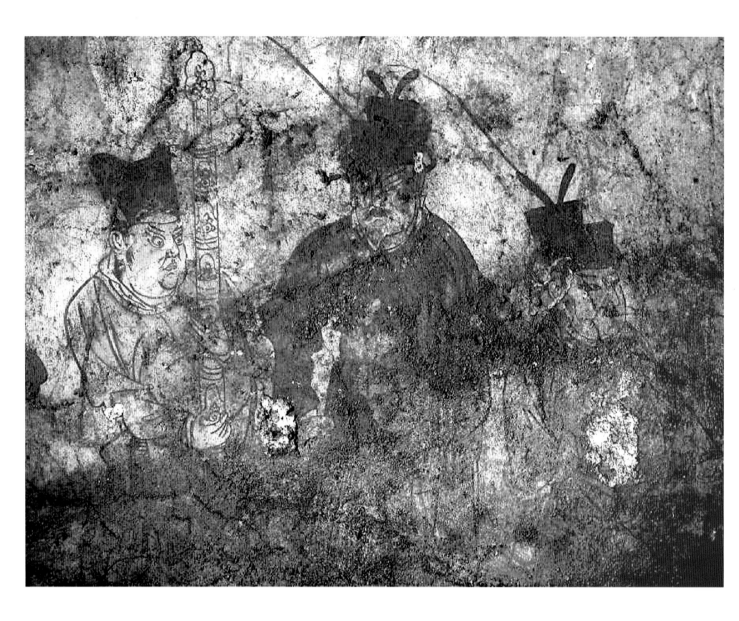

# 102.仪卫图（三）

北宋（960～1127年）

高约110、宽154厘米

2006年江西省德安县望夫山北宋墓出土。现存于江西省德安县博物馆。

墓向南。位于墓室西壁北部，为墓室西壁九人中的第七至九人。第七人头戴幞帽，身穿圆领窄袖衫，双手持剑。第八、九两人均头戴交脚幞头，身着圆领广袖袍，双手捧笏。

（撰文：杨军　摄影：周宏伟　杨军）

## Ceremonial Guards (3)

Northern Song (960-1127CE)

Height ca. 110 cm; Width 154 cm

Unearthed from the tomb of Northern Song at Wangfushan in De'an, Jiangxi, in 2006. Preserved in the De'an County Museum of Jiangxi.

## 103.仪卫图（四）

北宋（960～1127年）

高约110、宽154厘米

2006年江西省德安县望夫山北宋墓出土。现存于江西省德安县博物馆。

墓向南。位于墓室西壁南部，为墓室西壁九人组成仪仗队伍中的第一至三人，三人均头戴巾子，身着圆领窄袖衫，手执宝剑。

<div align="right">（撰文：杨军　摄影：周宏伟、杨军）</div>

## Ceremonial Guards (4)

Northern Song (960-1127CE)

Height ca. 110 cm; Width 154 cm

Unearthed from the tomb of Northern Song at Wangfushan in De'an, Jiangxi, in 2006. Preserved in the De'an County Museum of Jiangxi.

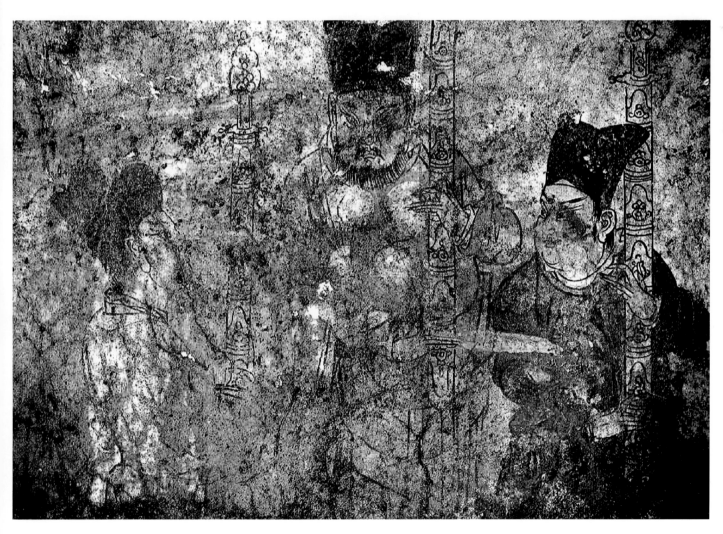

# 104.星相图

北宋（960～1127年）

高约110、宽154厘米

2006年江西省德安县望夫山北宋墓出土。现存于江西省德安县博物馆。

墓向南。位于墓室顶部（局部），由金乌（太阳）、玉蟾（月亮）、星辰、云朵组成。

<div align="right">（撰文：杨军　摄影：周宏伟　杨军）</div>

## Constellations

Northern Song (960-1127CE)

Height 110 cm; Width 154 cm

Unearthed from the tomb of Northern Song at Wangfushan in De'an, Jiangxi, in 2006. Preserved in the De'an County Museum of Jiangxi.

## 105.金乌图

北宋（960～1127年）

高约110、宽154厘米

2006年江西省德安县望夫山北宋墓出土。现存于江西省德安县博物馆。

墓向南。位于墓室顶部。在日轮上用黑彩画乌鸦。

（撰文：杨军　摄影：周宏伟　杨军）

## Three-legged Crow (symbolizing the Sun)

Northern Song (960-1127CE)

Height 110 cm; Width 154 cm

Unearthed from the tomb of Northern Song at Wangfushan in De'an, Jiangxi, in 2006. Preserved in the De'an County Museum of Jiangxi.

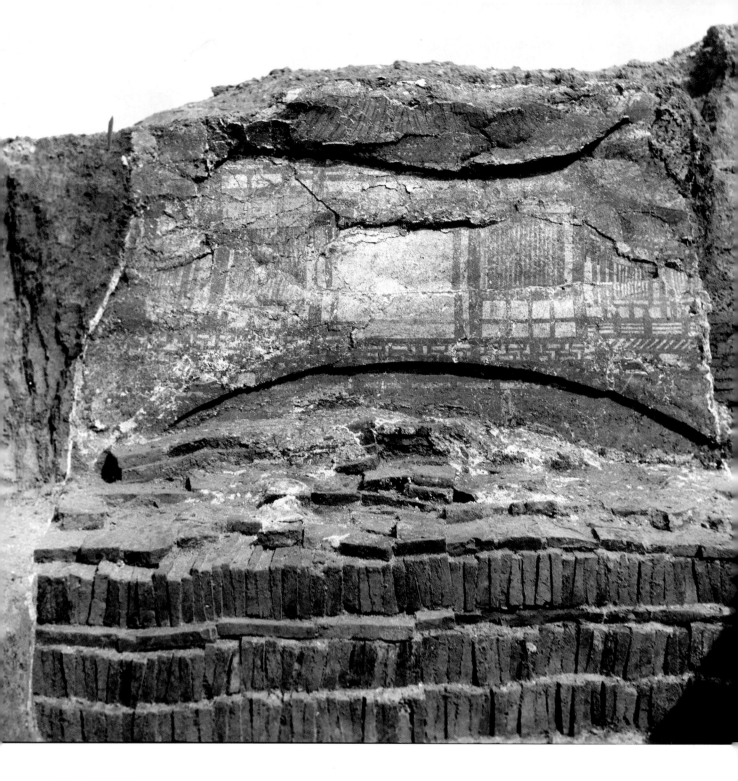

## 106. 楼阁图

唐永徽四年（653年）

1975年湖北省郧县城关东马檀山李泰墓出土。已残毁。

墓向170°。位于墓门外的正上方。为一正面五开间的重檐歇山顶宫殿建筑，两侧和殿顶部分已残毁。

（撰文：田桂萍　摄影：陈家麟）

## Building

4th Year of Yonghui Era, Tang (653 CE)

Unearthed from Li Tai's tomb at Matanshan in Yunxian, Hubei, in 1975. Not Preserved.

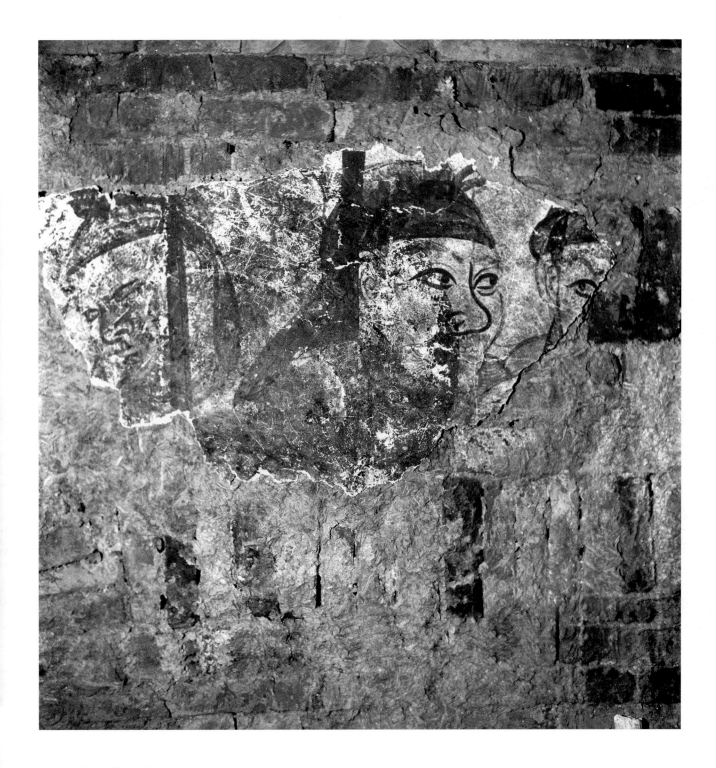

## 107. 仪仗队列图（局部）

唐永徽四年（653年）

1975年湖北省郧县城关东马檀山李泰墓出土。已残毁。

墓向170°。位于甬道西壁。中间男仪卫头戴幞头，右手持棒，目光炯炯有神。

（撰文：田桂萍、周兴明　摄影：陈家麟）

## Guards of Honor in Procession (Detail)

4th Year of Yonghui Era, Tang (653 CE)

Unearthed from Li Tai's tomb at Matanshan in Yunxian, Hubei, in 1975. Not Preserved.

# 108.天象图

唐永徽四年（653年）

1975年湖北省郧县城关东马檀山李泰墓出土。已残毁。

墓向170°。位于墓室顶部。仅残存墓顶中心部分图像，但仍可见点点星宿，天河如带，横亘天穹。

（撰文：田桂萍、周兴明　摄影：陈家麟）

## Constellations

4th Year of Yonghui Era, Tang (653 CE)

Unearthed from Li Tai's tomb at Matanshan in Yunxian, Hubei, in 1975. Not Preserved.

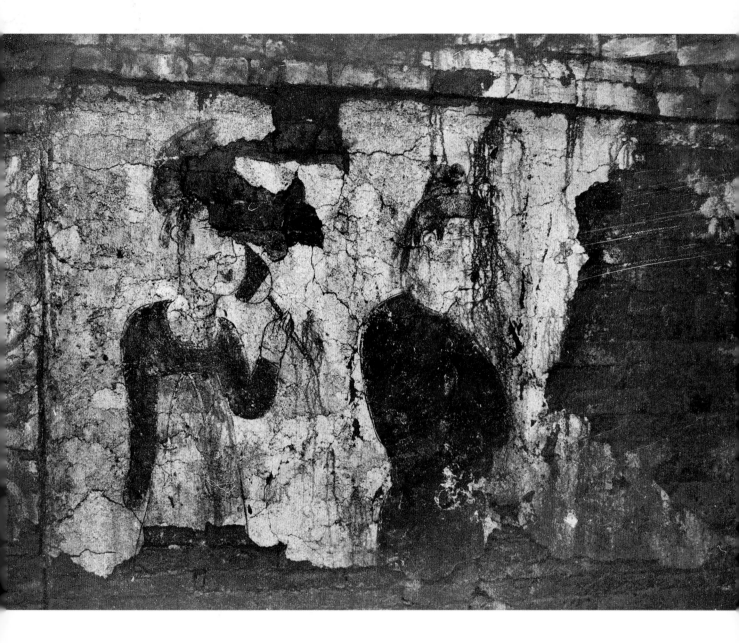

## 109.侍者图

唐嗣圣元年（684年）

1985年湖北省郧县城关东马檀山李徽墓出土。已残毁。

墓向190°。位于墓室东壁彩绘立柱南。面向墓门。男侍戴黑幞头，穿圆领红袍，腰系带，双手拱于胸前。女侍穿贴身窄袖圆领红短衫，下着绿花黄长裙，系于胸前，头梳螺形高髻，黑眉朱唇，在面颊近眼处有一红点，左手执团扇，右手下垂。

<div style="text-align: right">（撰文：田桂萍　摄影：潘炳元）</div>

## Attendants

1st Year of Sisheng Era, Tang (684 CE)

Unearthed from Li Tai's tomb at Matanshan in Yunxian, Hubei, in 1985. Not Preserved.

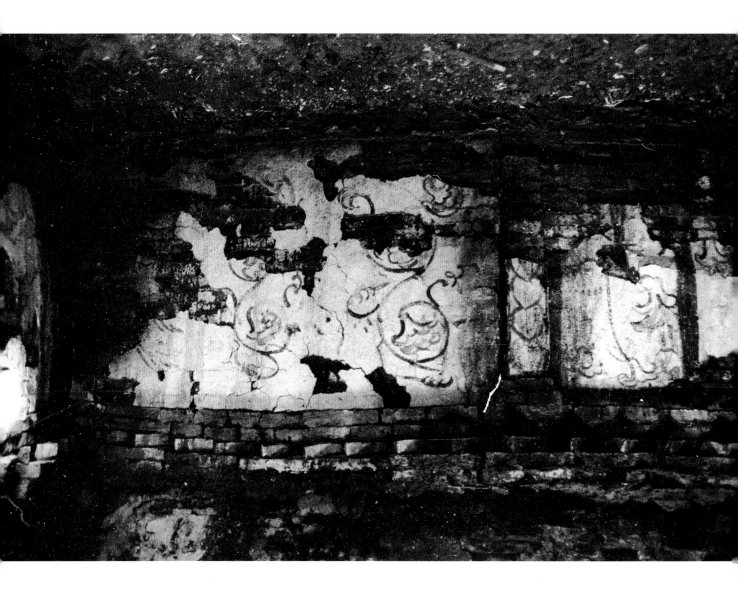

## 110.屏风花卉图

唐嗣圣元年（684年）

1985年湖北省郧县城关东马檀山李徽墓出土。已残毁。

墓向190°。位于墓室西壁彩绘立柱北侧，绘三扇花卉屏风，和北壁立柱西侧三扇花卉屏风在西北角衔接，成一折绘的六扇花卉屏风画。立柱南侧为缠枝花卉。

（撰文：田桂萍　摄影：潘炳元）

## Flower on Screen

1st Year of Sisheng Era, Tang (684 CE)

Unearthed from Li Tai's tomb at Matanshan in Yunxian, Hubei, in 1975. Not Preserved.

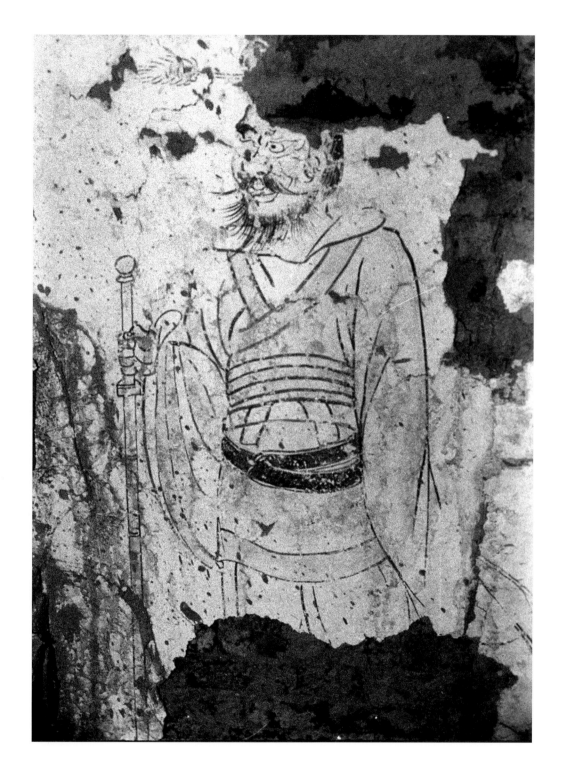

## 111. 侍吏图（局部）

唐开元十二年（724年）

1985年湖北省郧县城关东马檀山阎婉墓出土。已残毁。

墓向190°。位于甬道西壁，为南起第一人。面相威猛，髭须斜翘纷披，目视墓门。头戴进贤冠饰金蝉珥貂，着衣翻领、右衽、宽袖，腰束皮带，右手拄杖。

（撰文：田桂萍、周兴明　摄影：陈家麟）

## Attending Official (Detail)

12th Year of Kaiyuan Era, Tang (724 CE)

Unearthed from Yan Wan's tomb at Matanshan in Yunxian, Hubei, in 1985. Not Preserved.

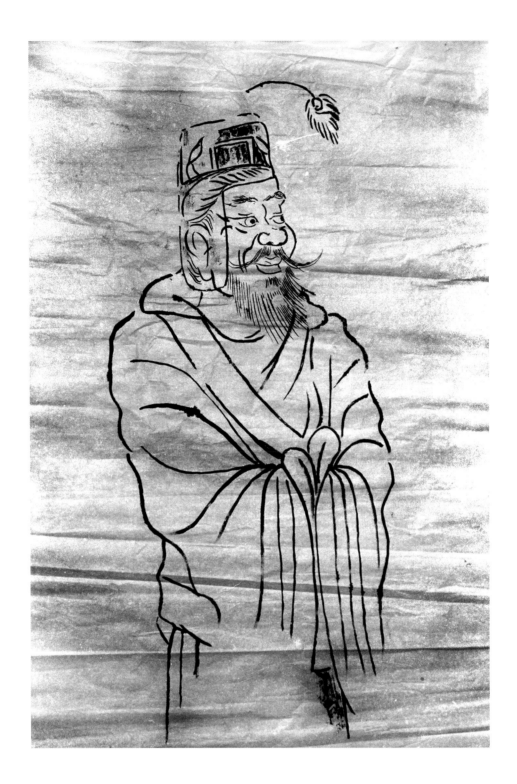

# 112.侍吏（摹本）

唐开元十二年（724年）

1985年湖北省郧县城关东马檀山阎婉墓出土。已残毁。

墓向190°。位于甬道东壁南起第二人。慈眉善目，髭须斜翘纷披，袖手侍立。头戴笼冠饰金蝉珥貂，着衣翻领、右衽、宽袖。

（临摹：不详　撰文：田桂萍　摄影：不详）

## Attending Official (Replica)

12th Year of Kaiyuan Era, Tang (724 CE)

Unearthed from Yan Wan's tomb at Matanshan in Yunxian, Hubei, in 1985. Not Preserved.

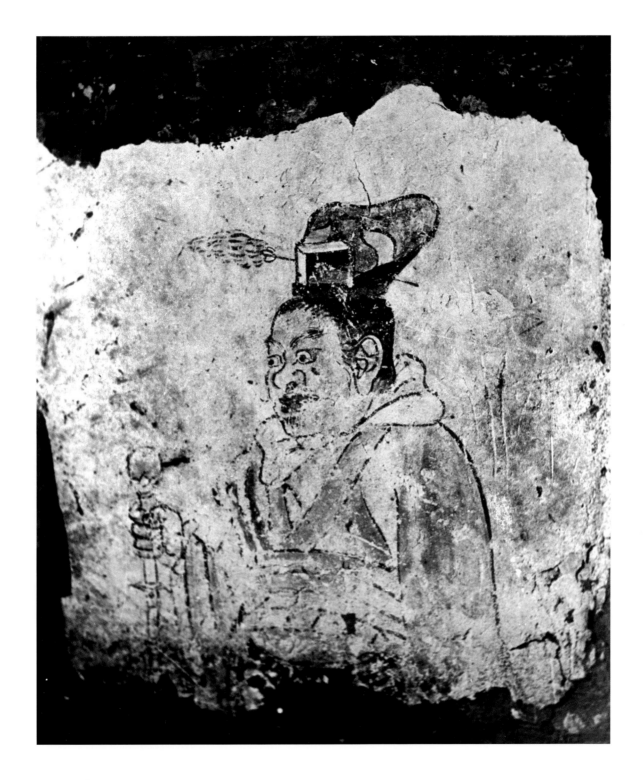

## 113.侍吏图

唐开元十二年（724年）

1973年湖北省郧县城关东马檀山李欣墓出土。已残毁。

墓向158°。位于甬道西壁。侍吏身材魁梧，怒目圆睁，胡须稀疏。头戴进贤冠饰金蝉珥貂，着衣翻领、右衽、宽袖，右手拄杖。

（撰文：田桂萍　摄影：潘炳元）

## Attending Official

12th Year of Kaiyuan Era, Tang (724 CE)

Unearthed from Li Xin's tomb at Matanshan in Yunxian, Hubei, in 1973. Not Preserved.

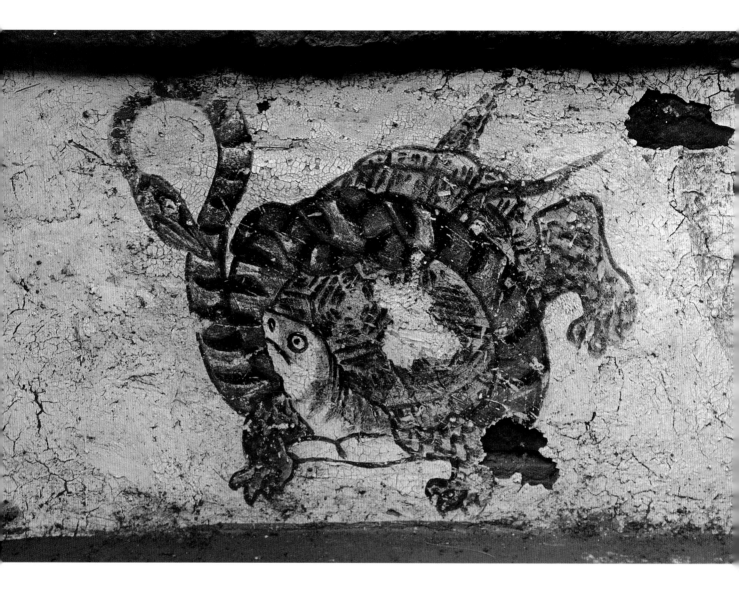

## 114. 玄武图

南宋（1127～1279年）

长约33、高27厘米

2007年湖北省襄樊市襄城区檀溪墓地196号墓出土。现存于襄樊博物馆。

墓向195°。位于墓室北壁上层。为龟蛇合体之玄武。

（撰文：陈千万、杨一　摄影：杨力）

## Sombre Warrior

Southern Song (1127-1279 CE)

Length ca. 33 cm; Height 27 cm

Unearthed from Tomb No.196 of Tanxi Cemetery at Xiangcheng District in Xiangfan, Hubei, in 2007. Preserved in the Xiangfan Museum.

## 115.牡丹图

南宋（1127～1279年）

下长112、上长81、高28厘米

2007年湖北省襄樊市襄城区檀溪墓地196号墓出土。现存于襄樊博物馆。

墓向195°。位于墓室东壁南段拱眼壁。为一幅绘黄色边框的折枝牡丹图案，有卷云缠绕。

（撰文：陈千万、杨一 摄影：杨力）

## Peony

Southern Song (1127-1279 CE)

Length 81-112 cm; Height 28 cm

Unearthed from Tomb No.196 of Tanxi Cemetery at Xiangcheng District in Xiangfan, Hubei, in 2007. Preserved in the Xiangfan Museum.

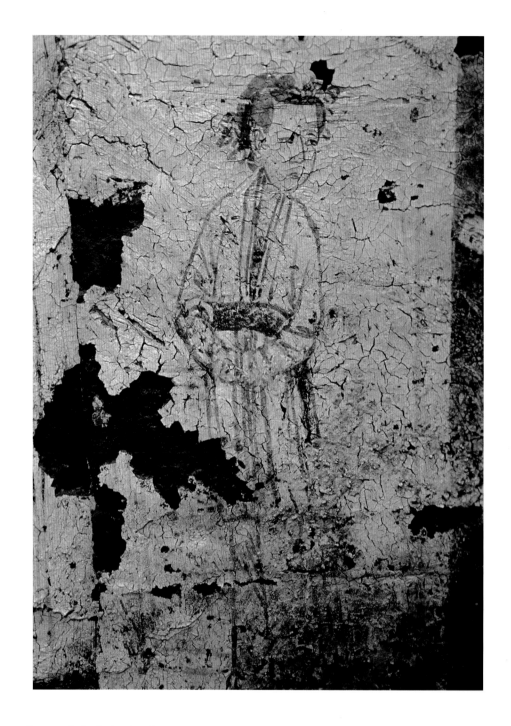

# 116.妇人启门图（一）

南宋（1127～1279年）

人物高约43厘米

2007年湖北省襄樊市襄城区檀溪墓地196号墓出土。现存于襄樊博物馆。

墓向195°。位于墓室北壁。一簪花侍女袖手侍立，颔首面东，上着对襟窄袖长襦及膝，内束抹胸，腰系宽带，下穿宽腿开裆裤曳地，足穿圆头鞋。站立于板门前，板门用墨线画边框。

（撰文：陈千万、杨一　摄影：杨力）

## Lady Opening the Door Ajar (1)

Southern Song (1127-1279 CE)

Lady's height ca. 43 cm

Unearthed from Tomb No.196 of Tanxi Cemetery at Xiangcheng District in Xiangfan, Hubei, in 2007. Preserved in the Xiangfan Museum.

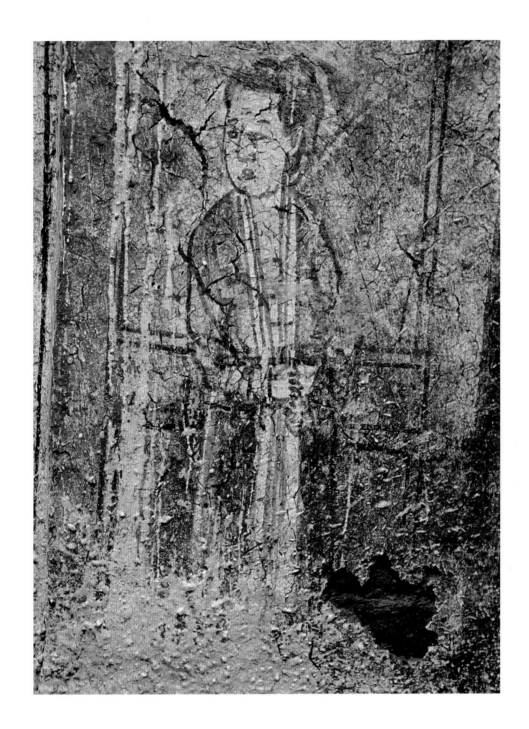

# 117.妇人启门图（二）

南宋（1127～1279年）

人物残高约32厘米

2007年湖北省襄樊市襄城区檀溪墓地196号墓出土。现存于襄樊博物馆。

墓向195°。位于墓室南壁。一微胖侍女颔首面东，双手置于腹前，站立于板门前，上着红对襟窄袖长襦及膝，内束抹胸，腰系宽带，下穿宽腿开裆裤曳地，足穿云头履。板门用墨线画边框。

（撰文：陈千万、杨一　摄影：杨力）

## Lady Opening the Door Ajar (2)

Southern Song (1127-1279)

Surviving height of Lady ca. 43 cm

Unearthed from Tomb No.196 of Tanxi Cemetery at Xiangcheng District in Xiangfan, Hubei, in 2007. Preserved in the Xiangfan Museum.

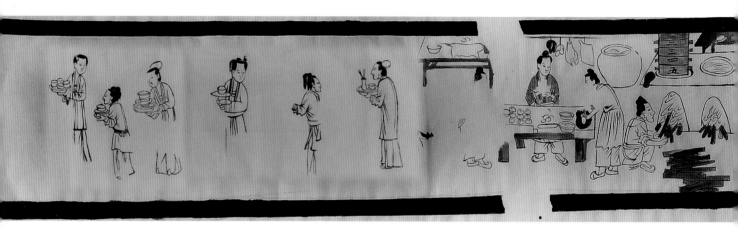

# 118. 庖厨与进奉图（摹本）

南宋（1127～1279年）

高约67、宽268厘米

2007年湖北省襄樊市襄城区檀溪墓地196号墓出土。现存于襄樊博物馆。

墓向195°。位于墓室东壁下层。全幅共有忙碌男、女侍仆十人。右侧四人为准备宴席的庖厨场景，左侧六人分别捧持炉瓶和茶盏等。一条狗穿行其中。

<div align="right">（临摹：不详　撰文：陈千万、杨一　摄影：杨力）</div>

## Attending and Cooking (Replica)

Southern Song (1127-1279 CE)

Height ca. 67 cm; Width 268 cm

Unearthed from Tomb No.196 of Tanxi Cemetery at Xiangcheng District in Xiangfan, Hubei, in 2007. Preserved in the Xiangfan Museum.

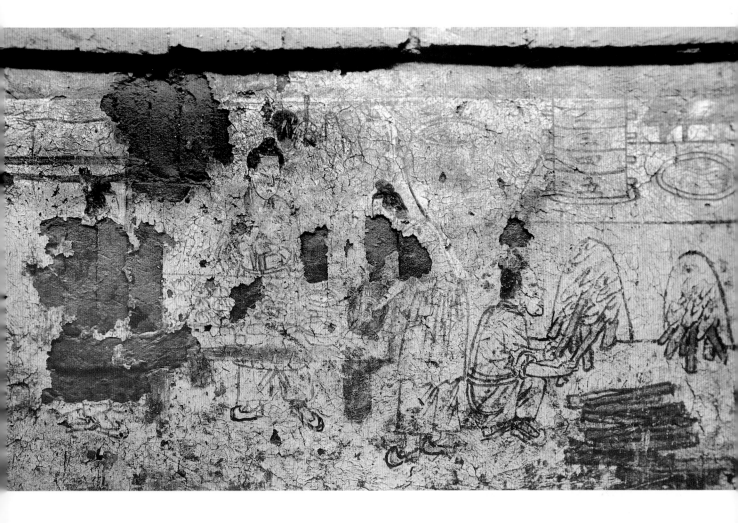

# 119. 庖厨与进奉图（局部一）

南宋（1127~1279年）

高约60、宽102厘米

2007年湖北省襄樊市襄城区檀溪墓地196号墓出土。现存于襄樊博物馆。

墓向195°。位于墓室东壁下层南段。为庖厨与进奉图局部。四位厨仆加工"包子"，右边为一灶，上置蒸笼，灶堂内柴火熊熊，一人蹲于灶口添柴；灶上蒸笼边放一水瓢，侧面有水缸，水缸侧上方挂有猪肝、全鸭、方块猪肉，画面左后方摆放加工肉食的案。

（撰文：陈千万、杨一　摄影：杨力）

## Attending and Cooking (Detail 1)

Southern Song (1127-1279 CE)

Height ca. 60 cm; Width 102 cm

Unearthed from Tomb No.196 of Tanxi Cemetery at Xiangcheng District in Xiangfan, Hubei, in 2007. Preserved in the Xiangfan Museum.

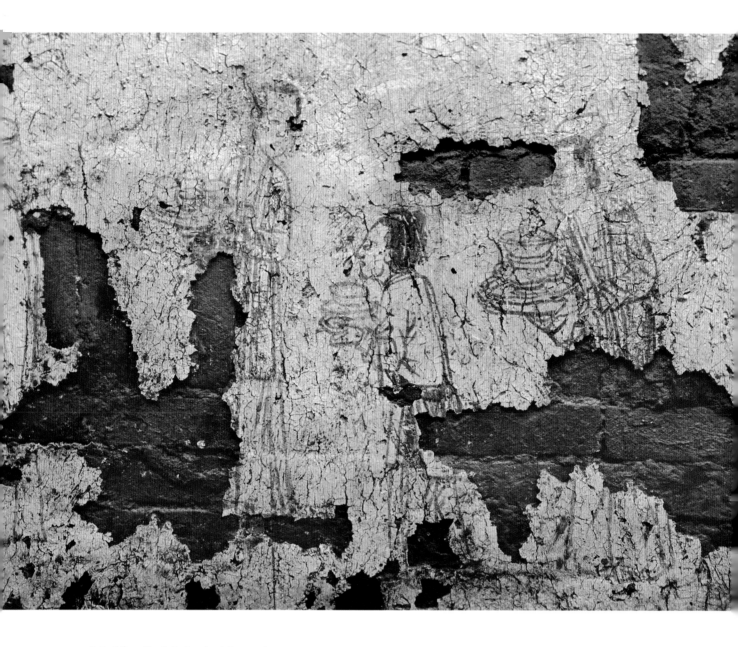

## 120.庖厨与进奉图（局部二）

南宋（1127～1279年）

高约48、宽75厘米

2007年湖北省襄樊市襄城区檀溪墓地196号墓出土。现存于襄樊博物馆。

墓向195°。位于墓室东壁下层中段。为庖厨与进奉图局部。为右起第五至七人，三名侍女前二人持杯、台盏等，后一人持香炉，最前一人回首正与后面二侍女交谈。

（撰文：陈千万、杨一　摄影：杨力）

## Attending and Cooking (Detail 2)

Southern Song (1127-1279 CE)

Height 48 cm; Width 75 cm

Unearthed from Tomb No.196 of Tanxi Cemetery at Xiangcheng District in Xiangfan, Hubei, in 2007. Preserved in the Xiangfan Museum.

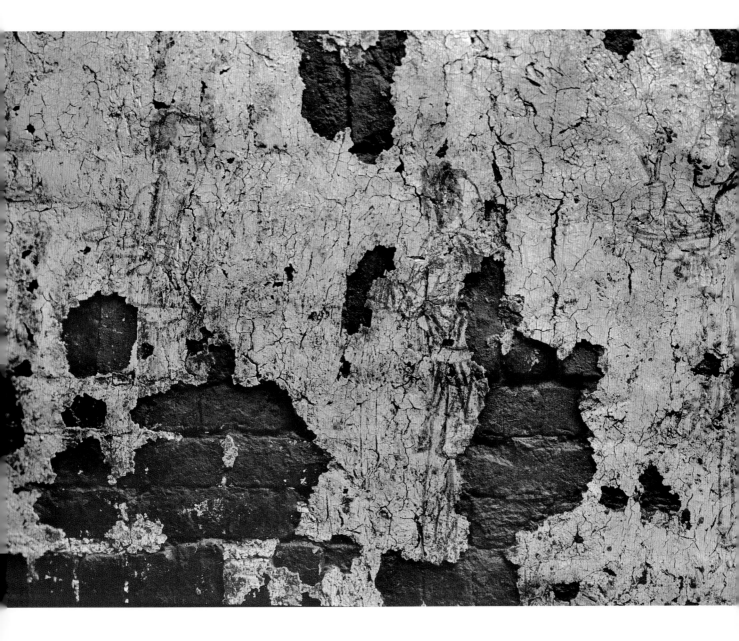

# 121. 庖厨与进奉图（局部三）

南宋（1127～1279年）

高约67、宽74厘米

2007年湖北省襄樊市襄城区檀溪墓地196号墓出土。现存于襄樊博物馆。

墓向195°。位于墓室东壁下层北段。为庖厨与进奉图局部。为右起第八至十人。三名女侍手托器物等正向左行进，前面二女侍回首与后者交谈。第一人捧托盏，第三人似捧箸瓶与盒。六人共同构成进奉茶、酒、香的场景。

（撰文：陈千万、杨一　摄影：杨力）

## Attending and Cooking (Detail 3)

Southern Song (1127-1279 CE)

Height 67 cm; Width 74 cm

Unearthed from Tomb No.196 of Tanxi Cemetery at Xiangcheng District in Xiangfan, Hubei, in 2007. Preserved in the Xiangfan Museum.

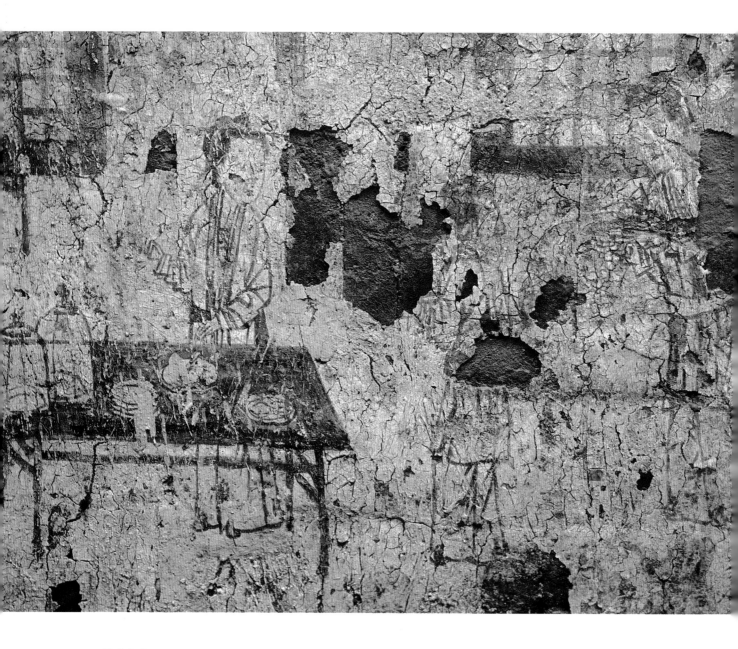

## 122. 分装糕点图

南宋（1127～1279年）

高约46、宽70厘米

2007年湖北省襄樊市襄城区檀溪墓地196号墓出土。现存于襄樊博物馆。

墓向195°。位于墓室西壁下层南段下部。为南起第一至三人。一簪花鬟髻侍女边分装糕点，边与北侧的两人交淡。三人都上穿对襟窄袖长襦及膝，内束抹胸，腰系宽带，下着宽腿裤，足穿云头履。左侧有一案，上置器皿。

（撰文：陈千万、杨一　摄影：杨力）

## Casing Cookies

Southern Song (1127-1279 CE)

Height 46 cm; Width 70 cm

Unearthed from Tomb No.196 of Tanxi Cemetery at Xiangcheng District in Xiangfan, Hubei, in 2007. Preserved in the Xiangfan Museum.

## 123.仓储图

南宋（1127～1279年）

高约6、宽11厘米

2007年湖北省襄樊市襄城区檀溪墓地196号墓出土。现存于襄樊博物馆。

墓向195°。位于墓室西壁南段。主体为一案，上置储存食物的大坛子四个，分别写有"□□煎"、"樱桃前"、"木瓜"、"山□煎"。

（撰文：陈千万、杨一　摄影：杨力）

## Storage Receptacles

Southern Song (1127-1279 CE)

Height ca. 6 cm; Width 11 cm

Unearthed from Tomb No.196 of Tanxi Cemetery at Xiangcheng District in Xiangfan, Hubei, in 2007. Preserved in the Xiangfan Museum.

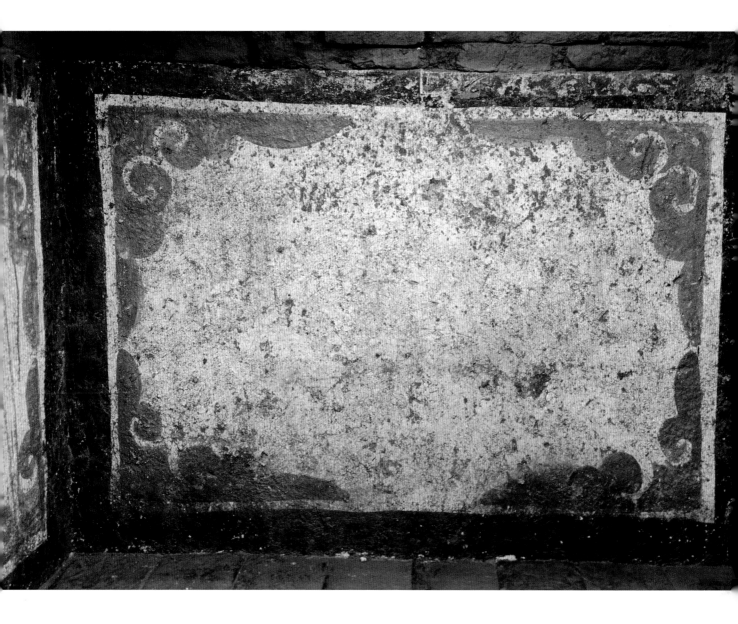

# 124. "海棠开光"图

南宋（1127～1279年）

高67、宽130厘米

2007年湖北省襄樊市襄城区檀溪墓地197号墓出土。现存于襄樊博物馆。

墓向195°。位于墓室西壁北段。为一幅长方形边框内四角做出云头状雀替的"海棠开光"图案。

（撰文：陈千万、杨一　摄影：杨力）

## Chinese Crabapple Flower

Southern Song (1127-1279 CE)

Height 67 cm; Width 130 cm

Unearthed from Tomb No.197 of Tanxi Cemetery at Xiangcheng District in Xiangfan Hubei, in 2007. Preserved in the Xiangfan Museum.

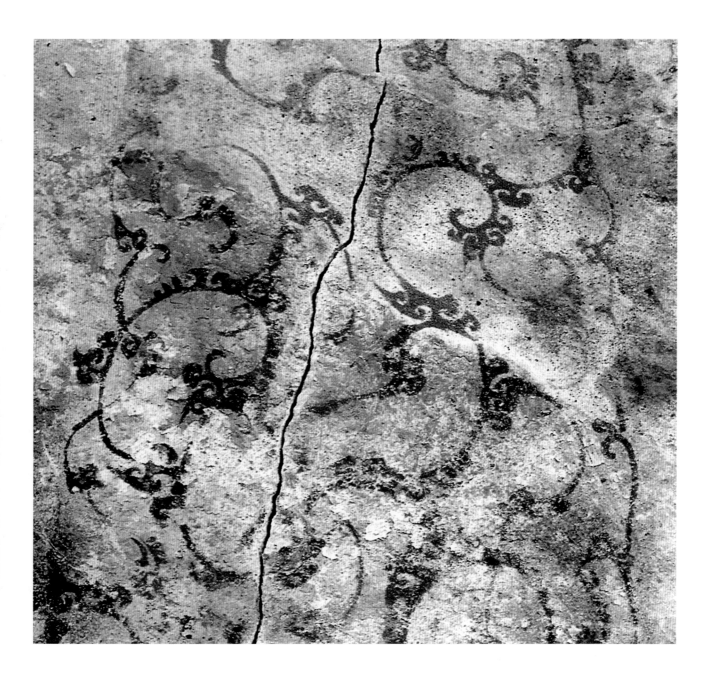

# 125.云纹图案

西汉元狩元年（前122年）

1983年广东省广州市象岗山南越王墓出土。原址保存。

墓向南。位于前室顶部。为大幅云纹图案，在石面上涂朱彩为地，以墨彩绘云纹。云纹飘逸流畅，用以表示前室是下葬时祭祀场所。

（撰文：文人言　摄影：不详）

## Cloud Designs

1st Year of Yuanshou Era, Western Han (122 BCE)

Unearthed from the tomb of King of Nanyue Kingdom at Xianggangshan in Guangzhou, Guangdong, in 1983. Preserved on the original site.

## 126.云纹图案

西汉元狩元年（前122年）

1983年广东省广州市象岗山南越王墓出土。原址保存。

墓向南。位于前室东北角上部。为大幅流畅的云纹图案，以朱彩为地，以墨彩绘云纹。从图像可知前室满绘云纹图案。

（撰文：文人言　摄影：不详）

## Cloud Designs

1st Year of Yuanshou Era, Western Han (122 BCE)

Unearthed from the tomb of King of Nanyue Kingdom at Xianggangshan in Guangzhou, Guangdong, in 1983. Preserved on the original site.

## 127.侍女蟠桃图（摹本）

唐开元二十九年（741年）

高约130、宽300厘米

1960年广东省韶关市西北郊罗源洞张九龄墓出土。

墓向125°。位于甬道北壁。画面上两个侍女形象，左面侍女高髻长衫，面庞圆润，双手袖于胸前，面半侧向东；右面侍女仅存上半身，右手轻握长衫左袖；二人中间偏上部有一结有蟠桃的桃枝。

（临摹：不详　撰文：文人言　摄影：不详）

## Flat Peach and Maids (Replica)

29th Year of Kaiyuan Era, Tang (741 CE)

Height ca. 130 cm; Width 300 cm

Unearthed from Zhang Jiuling's tomb at Luoyuandong in Shaoguan, Guangdong, in 1960.

# 128.花鸟图（一）

元（1206～1368年）

高约75、宽95厘米

2005年重庆市巫山县庙宇镇大庙元墓出土。现存于重庆市文物考古所。

墓向南。位于东墓室东壁，牡丹枝叶茂盛，繁花似锦，长尾鸟飞翔于花丛中。

（撰文：林必忠、刘春鸿　摄影：刘春鸿）

## Flowers and Birds (1)

Yuan (1206-1368 CE)

Height ca. 75 cm; Width 95 cm

Unearthed from the tomb of Yuan Dynasty at Damiao of Miaoyu in Wushan, Chongqing, in 2005. Preserved in the Chongqing Institute of Archaeology.

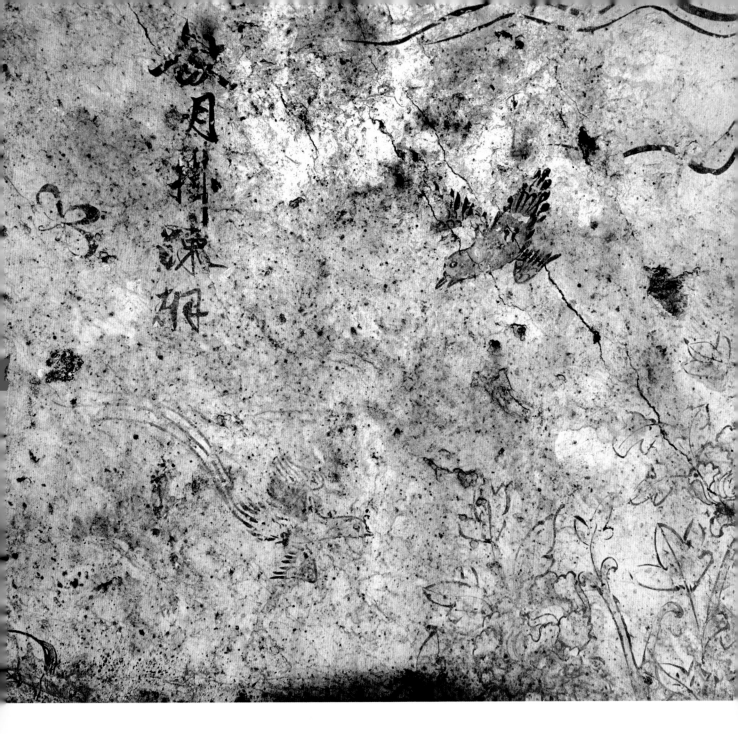

# 129. 花鸟图（二）

元（1206～1368年）

高约60、宽80厘米

2005年重庆市巫山县庙宇镇大庙元墓出土。现存于重庆市文物考古所。

墓向南。位于东墓室东壁，牡丹枝叶茂盛，两朵花头含苞欲放，长尾鸟、飞鸟、蝴蝶纷飞花丛间等，题"故月挂疏桐"。

<div align="right">（撰文：林必忠、刘春鸿　摄影：刘春鸿）</div>

## Flowers and Birds (2)

Yuan (1206-1368 CE)

Height ca. 60 cm; Width 80 cm

Unearthed from the tomb of Yuan Dynasty at Damiao of Miaoyu in Wushan, Chongqing, in 2005. Preserved in the Chongqing Institute of Archaeology.

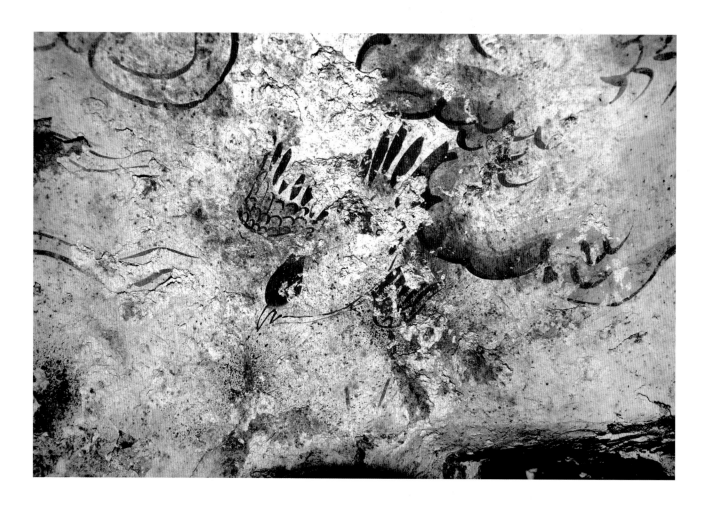

## 130. 雀鸟图

元（1206～1368年）

高约25、宽30厘米

2005年重庆市巫山县庙宇镇大庙元墓出土。现存于重庆市文物考古所。

墓向南。位于东墓室顶部。雀鸟展翅飞翔于祥云间。

<div align="right">（撰文：林必忠、刘春鸿　摄影：刘春鸿）</div>

## Birds

Yuan (1206-1368 CE)

Height ca. 25 cm; Width 30 cm

Unearthed from the tomb of Yuan Dynasty at Damiao of Miaoyu in Wushan, Chongqing, in 2005. Preserved in the Chongqing Institute of Archaeology.

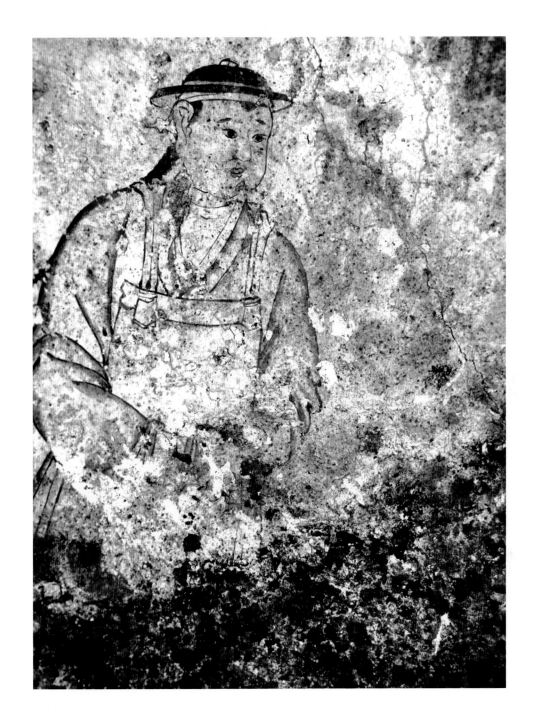

## 131. 男侍从图

元（1206～1368年）

高约80、宽35厘米

2005年重庆市巫山县庙宇镇大庙元墓出土。现存于重庆市文物考古所。

墓向南。位于西墓室东壁。男侍左侧身，面部丰满，头戴宽沿笠，束辫垂于后背，头后插簪，着右衽交领窄袖袍，外套裲裆，抄手而立。

<div align="right">（撰文：林必忠、刘春鸿　摄影：刘春鸿）</div>

## Attendant

Yuan (1206-1368 CE)

Height ca. 80 cm; Width 35 cm

Unearthed from the  tomb of Yuan Dynasty at Damiao of Miaoyu in Wushan, Chongqing, in 2005. Preserved in the Chongqing Institute of Archaeology.

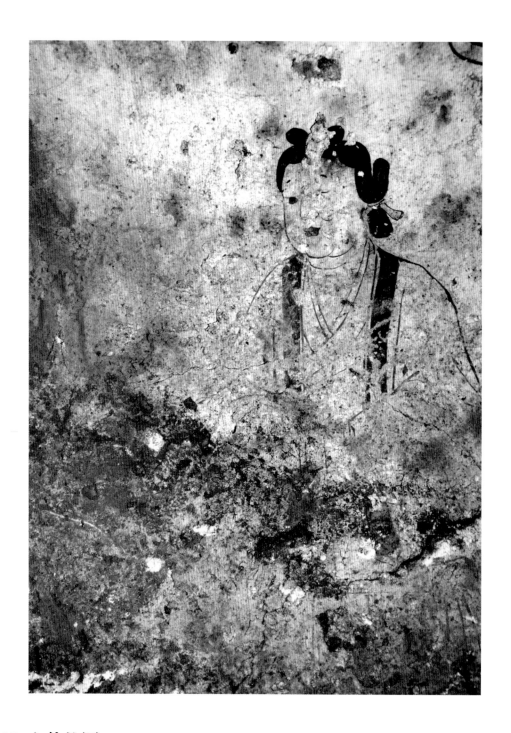

## 132. 女侍从图

元（1206～1368年）

高约80、宽35厘米

2005年重庆市巫山县庙宇镇大庙元墓出土。现存于重庆市文物考古所。

墓向南。位于西墓室西壁。女侍右侧身，面庞丰满，双髻卷束于两颊，插簪花，内着交领襦，外罩宽边半袖，抄手而立。

（撰文：林必忠、刘春鸿　摄影：刘春鸿）

## Maid

Yuan (1206-1368 CE)

Height ca. 80 cm; Width 35 cm

Unearthed from the tomb of Yuan Dynasty at Damiao of Miaoyu in Wushan, Chongqing, in 2005. Preserved in the Chongqing Institute of Archaeology.

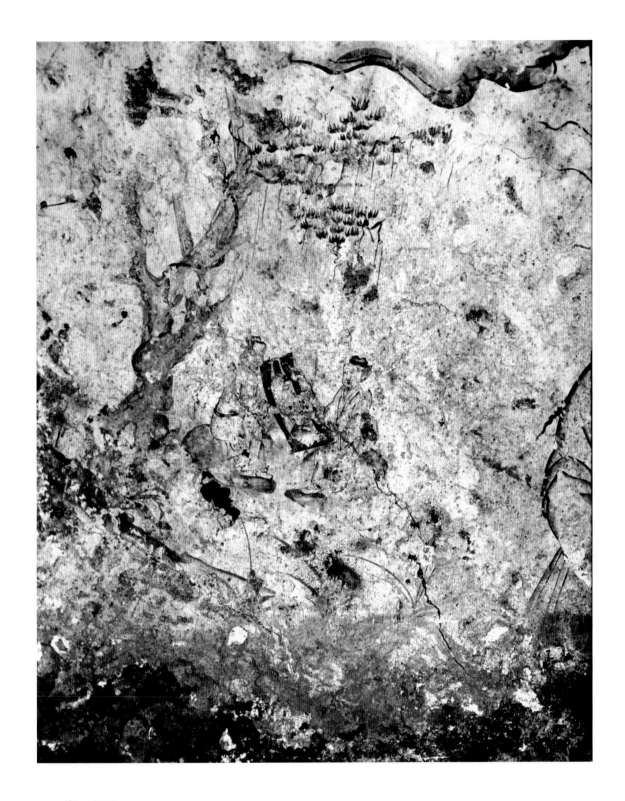

## 133.赏画图

元（1206～1368年）

高约70、宽50厘米

2005年重庆市巫山县庙宇镇大庙元墓出土。现存于重庆市文物考古所。

墓向南。位于西墓室东壁。松树虬干数枝，枝上攀藤。树下两人踞石相对而坐，各执长条画幅两端，手指画面，正在鉴赏。

（撰文：林必忠、刘春鸿　摄影：刘春鸿）

## Enjoying the Painting

Yuan (1206-1368 CE)

Height ca. 70 cm; Width 50 cm

Unearthed from the tomb of Yuan Dynasty at Damiao of Miaoyu in Wushan, Chongqing, in 2005. Preserved in the Chongqing Institute of Archaeology.

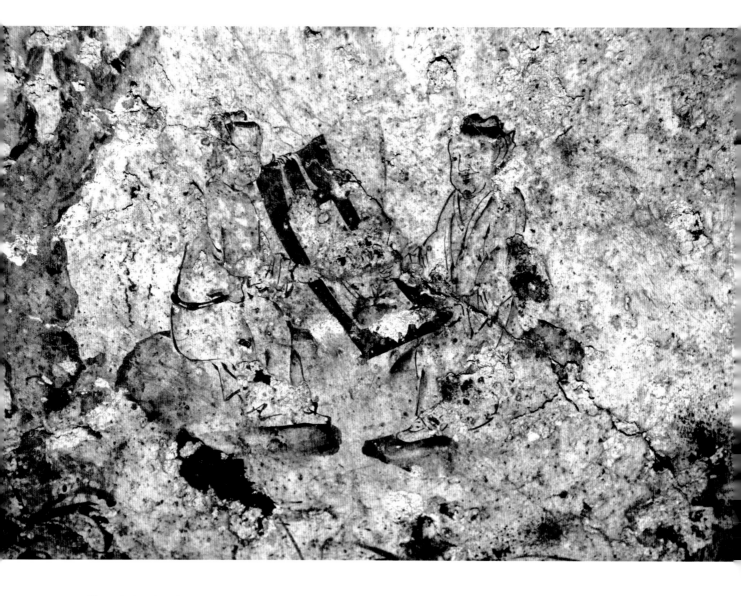

## 134.赏画图（局部）

元（1206～1368年）

高约25、宽40厘米

2005年重庆市巫山县庙宇镇大庙元墓出土。现存于重庆市文物考古所。

墓向南。位于西墓室东壁。松树下两人踞石相对而坐，均着交领长衫，腰束带，面丰满，蓄须，头着巾。各执长条画幅两端，手指画面，正在鉴赏。

（撰文：林必忠、刘春鸿　摄影：刘春鸿）

## Enjoying the Painting (Detail)

Yuan (1206-1368 CE)

Height ca. 25 cm; Width 40 cm

Unearthed from the tomb of Yuan Dynasty at Damiao of Miaoyu in Wushan, Chongqing, in 2005. Preserved in the Chongqing Institute of Archaeology.

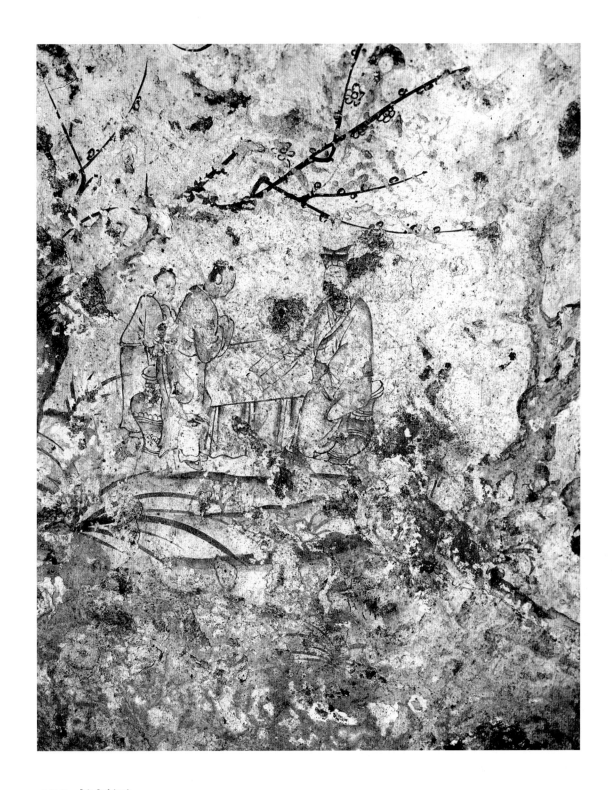

## 135. 教授图

元（1206～1368年）

高约70、宽50厘米

2005年重庆市巫山县庙宇镇大庙元墓出土。现存于重庆市文物考古所。

墓向南。位于西墓室东壁。左侧有一株梅树，下置书案，书案南侧，一老者坐于鼓形凳，左手放于膝，右手执书于案上；书案北侧有两人肃然而立，拱手聆听。

（撰文：林必忠、刘春鸿　摄影：刘春鸿）

## Teaching

Yuan (1271-1368 CE)

Height ca. 70 cm; Width 50 cm

Unearthed from the tomb of Yuan Dynasty at Damiao of Miaoyu in Wushan, Chongqing, in 2005. Preserved in the Chongqing Institute of Archaeology.

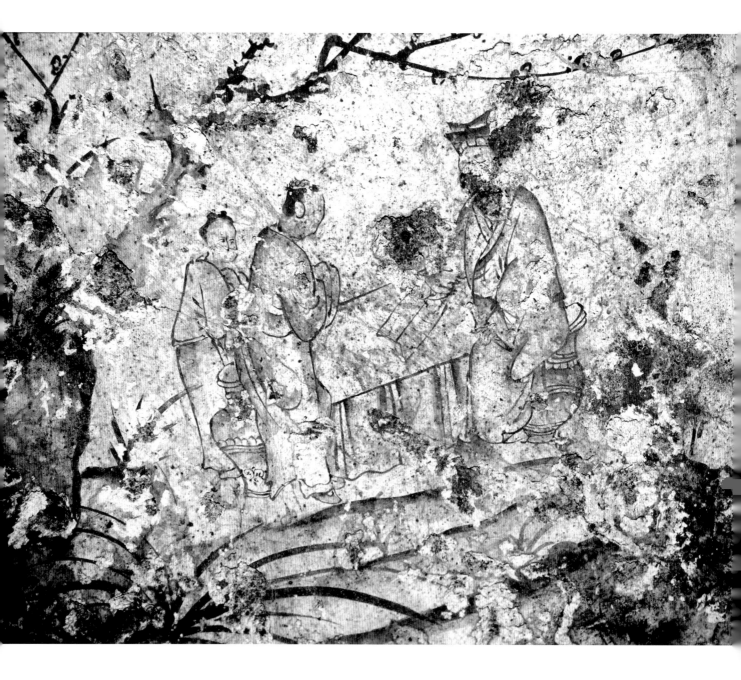

# 136.教授图（局部）

元（1206～1368年）

高约25、宽40厘米

2005年重庆市巫山县庙宇镇大庙元墓出土。现存于重庆市文物考古所。

墓向南。位于西墓室东壁。梅树下，书案右侧，一老者坐于鼓凳上，头戴东坡巾，着交领广袖袍，左手放于膝，右手执书于案上；书案左侧有两人束发，着广袖袍，拱手而立。两人之间有一大盘口瓶。

（撰文：林必忠、刘春鸿　摄影：刘春鸿）

## Teaching (Detail)

Yuan (1206-1368 CE)

Height ca. 25 cm; Width 40 cm

Unearthed from the tomb of Yuan Dynasty at Damiao of Miaoyu in Wushan, Chongqing, in 2005. Preserved in the Chongqing Institute of Archaeology.

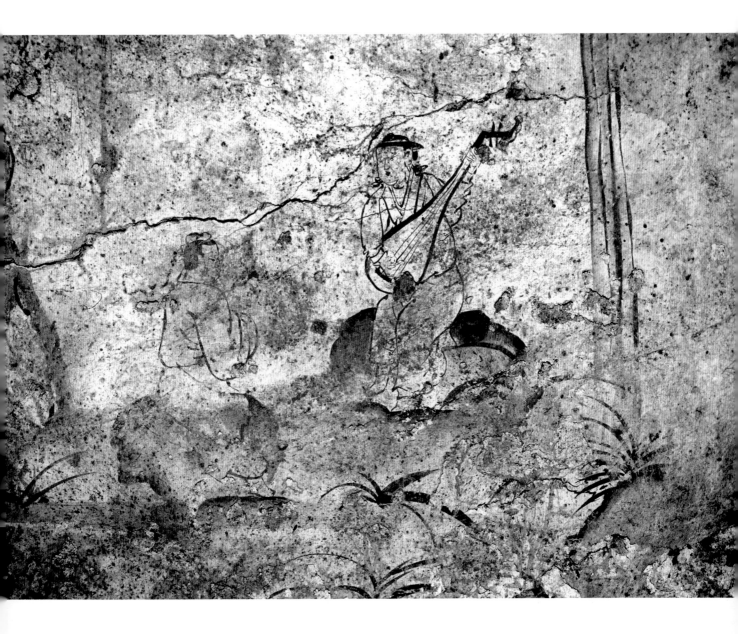

## 137.听琴图

元（1206～1368年）

高约30、宽40厘米

2005年重庆市巫山县庙宇镇大庙元墓出土。现存于重庆市文物考古所。

墓向南。位于西墓室西壁。绘两人对坐，右侧一女，执曲颈琵琶，正弹奏；左侧一人束包髻，拱手而听；背景为高山飞瀑。

（撰文：林必忠、刘春鸿 摄影：刘春鸿）

## Listening to the Zither

Yuan (1206-1368 CE)

Height 30 cm; Width 40 cm

Unearthed from the tomb of Yuan Dynasty at Damiao of Miaoyu in Wushan, Chongqing, in 2005. Preserved in the Chongqing Institute of Archaeology.

## 138.画案图

元（1206～1368年）

高约60、宽40厘米

2005年重庆市巫山县庙宇镇大庙元墓出土。现存于重庆市文物考古所。

墓向南。位于西墓室西壁。画案四周围帷，画案上置笔架、砚，笔架上放朱、墨两色画笔各一支。上部画瑞云。

（撰文：林必忠、刘春鸿　摄影：刘春鸿）

## Painting Table

Yuan (1206-1368 CE)

Height ca. 60 cm; Width 40 cm

Unearthed from the tomb of Yuan Dynasty at Damiao of Miaoyu in Wushan, Chongqing, in 2005. Preserved in the Chongqing Institute of Archaeology.

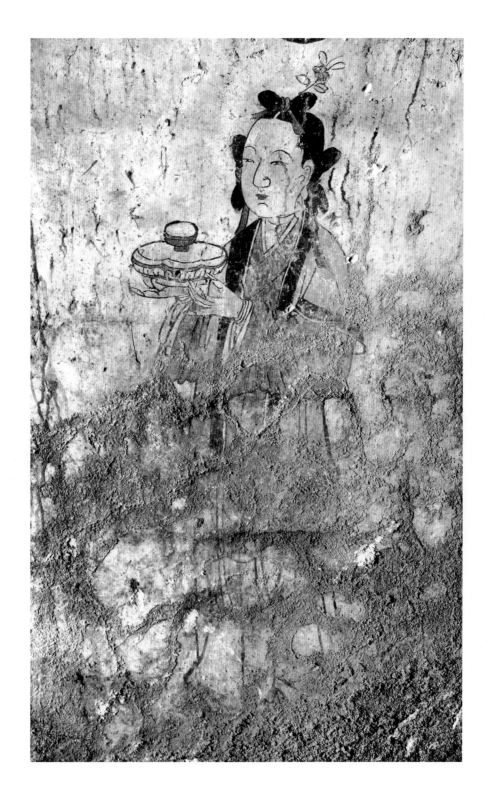

# 139.持劝盏图

明（1368～1644年）

高80、宽31厘米

2008年重庆市永川区凌阁堂村明墓出土。现存于重庆市文物考古所。

墓向175°。位于墓室东壁最南端靠墓门处。女子梳双髻，簪花，上身内着交领衫，外罩黄色半袖，下身隐约见白色长裙，着尖头屦。双手托一劝盏，劝盏下为莲瓣形圆盘，盘内有一红色盏。

（撰文：林必忠、汪伟　摄影：汪伟）

## Lady Holding a Cup

Ming (1368-1644 CE)

Height 80 cm; Width 31 cm

Unearthed from the tomb of Ming Dynasty at Linggetangcun in Yongchuan District, Chongqing, in 2008. Preserved in the Chongqing Institute of Archaeology.

## 140.持注壶图

明（1368～1644年）

高80、宽30厘米

2008年重庆市永川区凌阁堂村明墓出土。现存于重庆市文物考古所。墓向175°。位于墓室西壁最南端靠墓门处。女子梳双髻，上身内着交领衫，外罩红色半袖，下身穿白色长裙，着尖头屐。身右侧腰下垂系一红色佩囊。双手合持一注壶。此图与对壁的侍女图共同构成奉茶进酒场景。

（撰文：林必忠、汪伟　摄影：汪伟）

## Lady Holding a Pitcher

Ming (1368-1644 CE)

Height 80 cm; Width 30 cm

Unearthed from the tomb of Ming Dynasty at Linggetangcun in Yongchuan District, Chongqing, in 2008. Preserved in the Chongqing Institute of Archaeology.

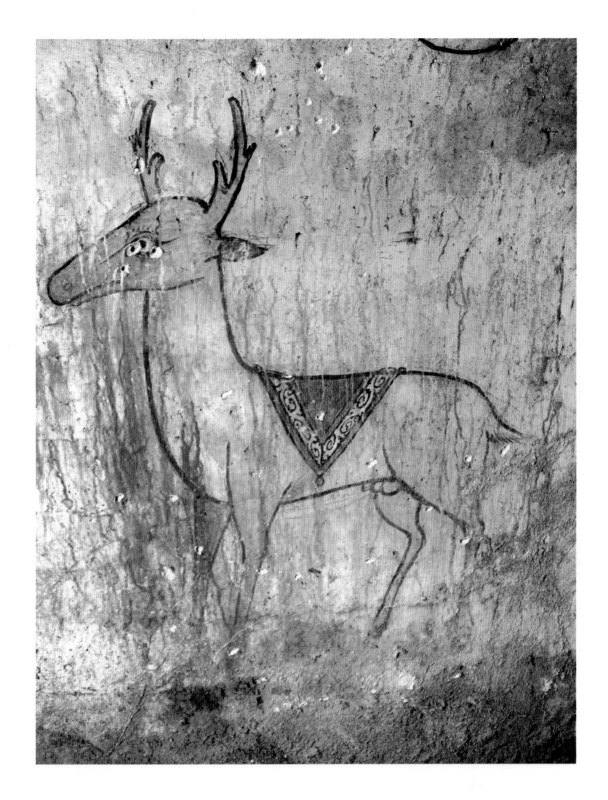

# 141.瑞鹿图

明（1368～1644年）

高80、宽65厘米

2008年重庆市永川区凌阁堂村明墓出土。现存于重庆市文物考古所。墓向175°。位于墓室东壁中部。鹿作站立状，平视前方。全身除颈下至腹部留白、鹿耳涂朱以外，其余部位染黄。背部铺搭一红色菱形坐垫，坐垫边缘装饰宽幅墨线缠枝忍冬纹带。

（撰文：林必忠、汪伟　摄影：汪伟）

## Auspicious Deer

Ming (1368-1644 CE)

Height 80 cm; Width 65 cm

Unearthed from the tomb of Ming Dynasty at Linggetangcun in Yongchuan District, Chongqing, in 2008. Preserved in the Chongqing Institute of Archaeology.

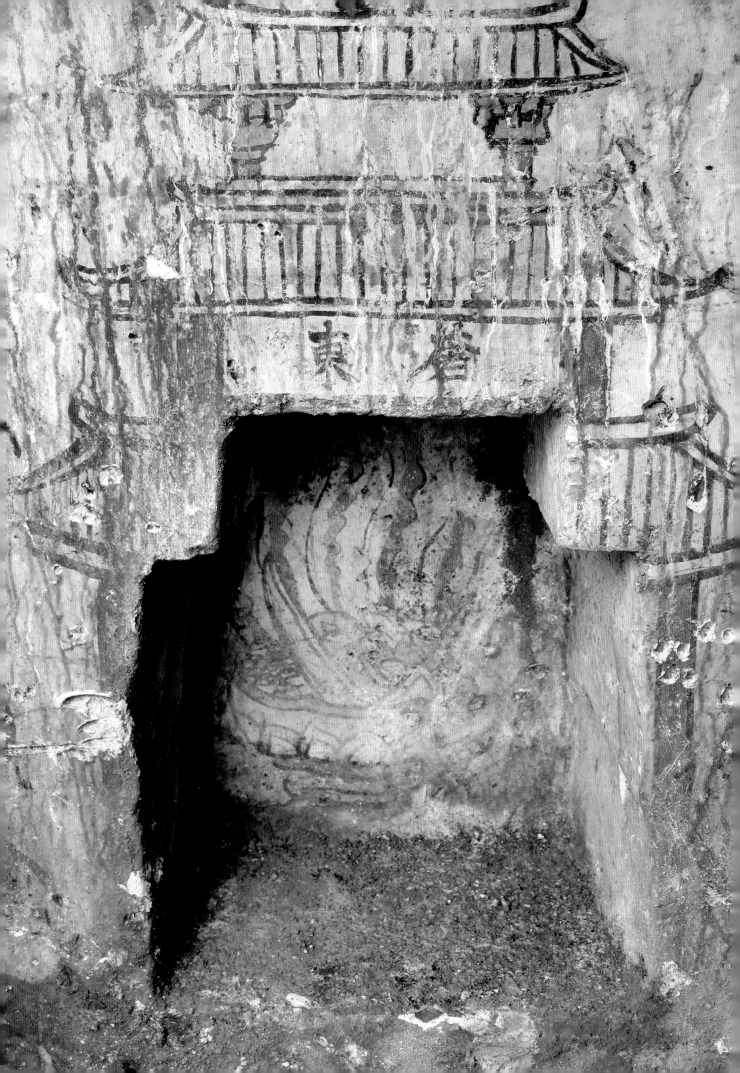

## ◀142.东仓图

明（1368～1644年）

高80、宽60厘米

2008年重庆市永川区凌阁堂村明墓出土。现存于重庆市文物考古所。

墓向175°。位于墓室东壁中部小龛处。画中表现东仓。仓为三重檐庑殿顶的牌楼式建筑，中间墨笔题记"東蒼"，字作仿宋体。画像利用了壁龛的外缘及纵深形成了立体效果。此图与对壁的西库共同构成了墓室中常见的"东仓西库"题材。

（撰文：林必忠、汪伟　摄影：汪伟）

## Granary

Ming (1368-1644 CE)

Height 80 cm; Width 60 cm

Unearthed from the tomb of Ming Dynasty at Linggetangcun in Yongchuan District, Chongqing, in 2008. Preserved in the Chongqing Institute of Archaeology.

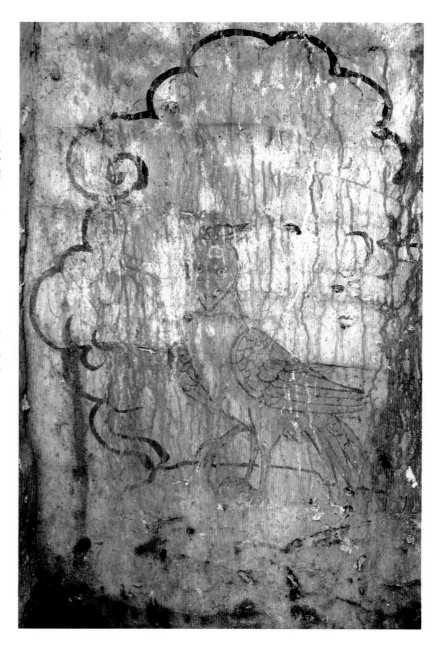

## ▲143.人面三足乌图

明（1368～1644年）

高80、宽60厘米

2008年重庆市永川区凌阁堂村明墓出土。现存于重庆市文物考古所。

墓向175°。位于墓室东壁北端。底部为一形状不规则的的石头，其上立一人面三足乌，墨线勾勒乌身、羽翅，身染黄色，冠、爪红色，尖嘴人面，一足前伸抬起，羽翅合拢，外罩黑色粗笔云气纹。

（撰文：林必忠、汪伟　摄影：汪伟）

## Three-legged Crow with a Human Head

Ming (1368-1644 CE)

Height 80 cm; Width 60 cm

Unearthed from the tomb of Ming Dynasty at Linggetangcun in Yongchuan District, Chongqing, in 2008. Preserved in the Chongqing Institute of Archaeology.

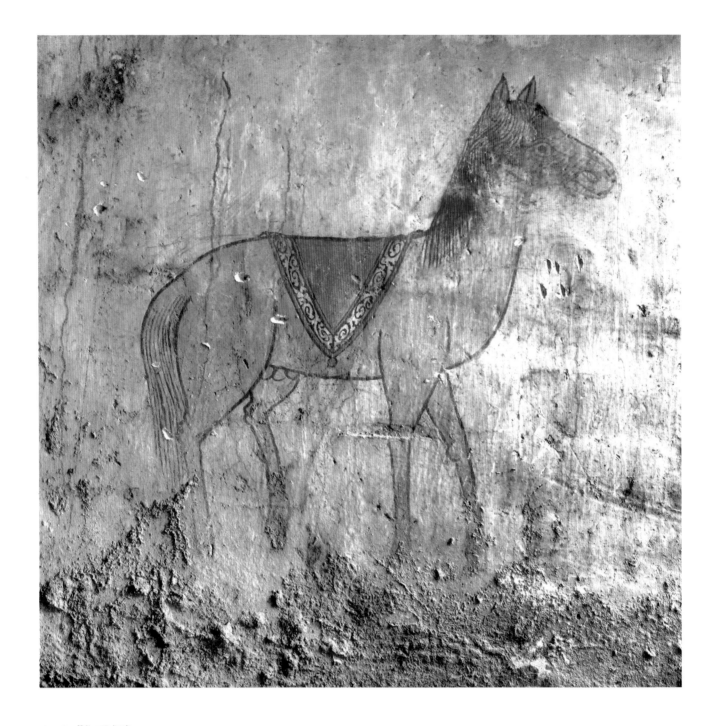

## 144.鞍马图

明（1368～1644年）

马高80、宽66厘米

2008年重庆市永川区凌阁堂村明墓出土。现存于重庆市文物考古所。

墓向175°。位于墓室西壁中部。马作站立状，平视前方，尾巴下搭于马身右侧。全身染黄，背部铺搭一红色菱形坐垫，坐垫边缘装饰宽幅墨线忍冬纹带。

（撰文：林必忠、汪伟　摄影：汪伟）

## Saddled Horse

Ming (1368-1644 CE)

Height 80 cm; Width 66 cm

Unearthed from the tomb of Ming Dynasty at Linggetangcun in Yongchuan District, Chongqing, in 2008. Preserved in the Chongqing Institute of Archaeology.

## 145.插花花瓶图

明（1368～1644年）

高88、宽32厘米

2008年重庆市永川区凌阁堂村明墓出土。现存于重庆市文物考古所。墓向175°。位于墓室后壁东部。底部是红色矮几，几上放置黄釉盘口长颈高足花瓶，瓶内插带叶牡丹花枝。

（撰文：林必忠、汪伟 摄影：汪伟）

## Flowers in Vase

Ming (1368-1644 CE)

Height 88 cm; Width 32 cm

Unearthed from the tomb of Ming Dynasty at Linggetangcun in Yongchuan District, Chongqing, in 2008. Preserved in the Chongqing Institute of Archaeology.

## 146. "福"字图

明（1368～1644年）

直径48厘米。

2008年重庆市永川区凌阁堂村明墓出土。现存于重庆市文物考古所。墓向175°。位于墓室顶部中央。画以墨书的巨大粗体"福"字为中心，"福"字外环两周墨笔圆圈，圆圈外接八瓣变形莲花图案，花瓣以墨线勾勒，局部填充红色。

（撰文：林必忠、汪伟　摄影：汪伟）

## Design of Character "Happiness"

Ming (1368-1644 CE)

Diameter 48 cm

Unearthed from the tomb of Ming Dynasty at Linggetangcun in Yongchuan District, Chongqing, in 2008. Preserved in the Chongqing Institute of Archaeology.

## 147.彩绘人物像

东汉元初四年（117年）

高33、宽25厘米

2002年四川省三台县郪江镇柏林坡一号崖墓出土。原址保存。

墓向108°。位于前室北壁门扉。白彩铺地，靛青绘髻和勾画袍服领缘，朱红填衣。其东侧有朱书纪年题记。

<div align="right">（撰文：于春　摄影：江聪）</div>

## Color-painted Figure

4th Year of Yuanchu Era, Eastern Han (117 CE)

Height 33 cm; Width 25 cm

Unearthed from the Cliff Tomb No.1 at Bailinpo of Qijiang in Santai, Sichuan, in 2002．Preserved on the original site.

## 148.宴饮图

东汉元初四年（117年）

残高32、宽67厘米

2002年四川省三台县郪江镇柏林坡一号崖墓出土。原址保存。

墓向108°。位于中室北侧室西壁。上部绘朱红垂幔，下有三人分坐白色席上，中间置案、尊等物品。该图为整幅画面的上部分，下部分为一只彩绘白虎。

<div style="text-align: right">（撰文：于春　摄影：江聪）</div>

## Feast Scene

4th Year of Yuanchu Era, Eastern Han (117 CE)

Height 32 cm; Width 67 cm

Unearthed from the Cliff Tomb No.1 at Bailinpo of Qijiang in Santai, Sichuan, in 2002．Preserved on the original site.

# 149.升仙图（一）

东汉元初四年（117年）

高35、宽20厘米

2002年四川省三台县郪江镇柏林坡一号崖墓出土。原址保存。

墓向108°。位于中室北侧室北壁上层，是三幅升仙图之一。图中一人立于长颈、朱喙的飞禽上，躬身，头戴黑色平巾帻，双手笼于白色袖中拱于胸前，朱红粗线勾勒衣衫身形，人像后方有朱书"齐光"榜题。

（撰文：于春　摄影：江聪）

## Ascending Fairland (1)

4th Year of Yuanchu Era, Eastern Han (117 CE)

Height 35 cm; Width 20 cm

Unearthed from the Cliff Tomb No.1 at Bailinpo of Qijiang in Santai, Sichuan, in 2002．Preserved on the original site.

## 150.升仙图（二）

东汉元初四年（117年）

高32、宽16厘米

2002年四川省三台县郪江镇柏林坡一号崖墓出土。原址保存。

墓向108°。位于中室北侧室北壁上层，是三幅升仙图之二。墨线勾画一站立人物像，躬身，头戴加屋帻，像头部及身后侧有曲尺形朱书榜题"□品杨臣衡"。

（撰文：于春　摄影：江聪）

## Ascending Fairland (2)

4th Year of Yuanchu Era, Eastern Han (117 CE)

Height 32 cm; Width 16 cm

Unearthed from the Cliff Tomb No.1 at Bailinpo of Qijiang in Santai, Sichuan, in 2002．Preserved on the original site.

## 151.升仙图（三）

东汉元初四年（117年）

残高27、宽20厘米

2002年四川省三台县郪江镇柏林坡一号崖墓出土。原址保存。

墓向108°。位于中室北侧室北壁上层，是三幅升仙图之三。墨线勾勒一站立人物像，靛青色加屋帻，面似涂朱，白彩绘长袍。身后侧朱书榜题"张进平"。

<div align="right">（撰文：于春　摄影：江聪）</div>

## Ascending Fairland (3)

4th Year of Yuanchu Era, Eastern Han (117 CE)

Surviving height 27cm; Width 20cm

Unearthed from the Cliff Tomb No.1 at Bailinpo of Qijiang in Santai, Sichuan, in 2002. Preserved on the original site.

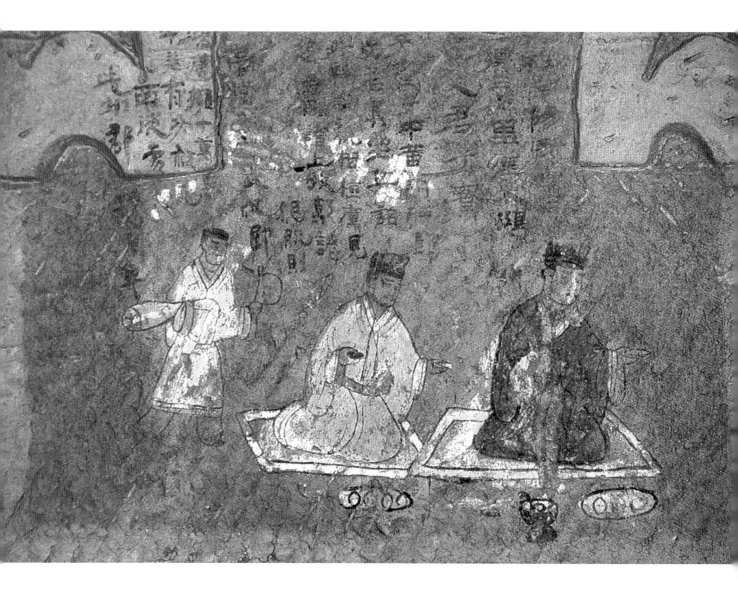

## 152.宴饮图（一）

东汉（25～220年）

高约65～70、宽75～98厘米

2002年四川省中江县民主乡桂花村塔梁子三号崖墓出土。原址保存。

墓向225°。位于三室南侧室东壁，为该墓室内八幅宴饮图之一。共绘四人，二人坐于席上，面前摆盘、豆等用具，另二人分立于后，似奴仆，左侧奴仆左手执便面，右手捧棒。人物上方有长篇墨书题记。

<div align="right">（撰文：于春　摄影：江聪）</div>

## Feast Scene (1)

Eastern Han (25-220 CE)

Height ca. 65-70 cm; Width 75-98 cm

Unearthed from the Cliff Tomb No.3 at Taliangzi of Guihuacun in Minzhu Town, Zhongjiang, Sichuan, in 2002. Preserved on the original site.

## 153.宴饮图（二）

东汉（25～220年）

高约65～70、宽75～98厘米

2002年四川省中江县民主乡桂花村塔梁子三号崖墓出土。原址保存。

墓向225°。位于三室南侧室东壁，为该墓室内八幅宴饮图之二。共绘四人，右侧二人坐于席上，面前摆盘、豆等用具，左侧二人模糊不清，似站立。人物上方有榜题。

（撰文：于春　摄影：江聪）

## Feast Scene (2)

Eastern Han (25-220 CE)

Height 65-70 cm; Width 75-98 cm

Unearthed from the Cliff Tomb No.3 at Taliangzi of Guihuacun in Minzhu Town, Zhongjiang, Sichuan, in 2002. Preserved on the original site.

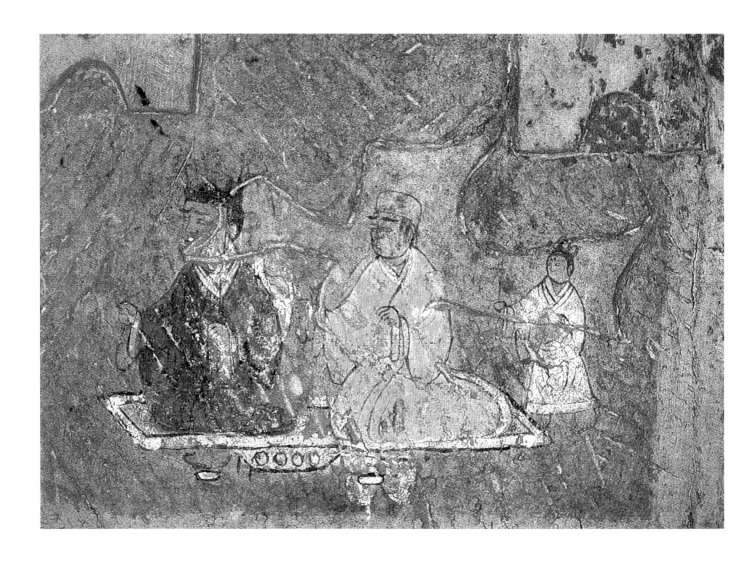

# 154.宴饮图（三）

东汉（25～220年）

高约65～70、宽75～98厘米

2002年四川省中江县民主乡桂花村塔梁子三号崖墓出土。原址保存。

墓向225°。位于三室南侧室东壁，为该墓室内八幅宴饮图之三。共绘三人，左侧二人坐于席上，面前摆案、豆等用具，右侧一人站立于后，右手执便面。

（撰文：于春　摄影：江聪）

## Feast Scene (3)

Eastern Han (25-220 CE)

Height 65-70 cm; Width 75-98 cm

Unearthed from the Cliff Tomb No.3 at Taliangzi of Guihuacun in Minzhu Town, Zhongjiang, Sichuan, in 2002. Preserved on the original site.

## 155. 宴饮图（四）

东汉（25～220年）

高约65～70、宽75～98厘米

2002年四川省中江县民主乡桂花村塔梁子三号崖墓出土。原址保存。

墓向225°。位于三室南侧室东壁，为该墓室内八幅宴饮图之四。共绘三人，左侧二人坐于席上，面前摆盘、豆等用具，另一人站立于后。

（撰文：于春　摄影：江聪）

## Feast Scene (4)

Eastern Han (25-220 CE)

Height ca. 65-70 cm; Width 75-98 cm

Unearthed from the Cliff Tomb No.3 at Taliangzi of Guihuacun in Minzhu Town, Zhongjiang, Sichuan, in 2002. Preserved on the original site.

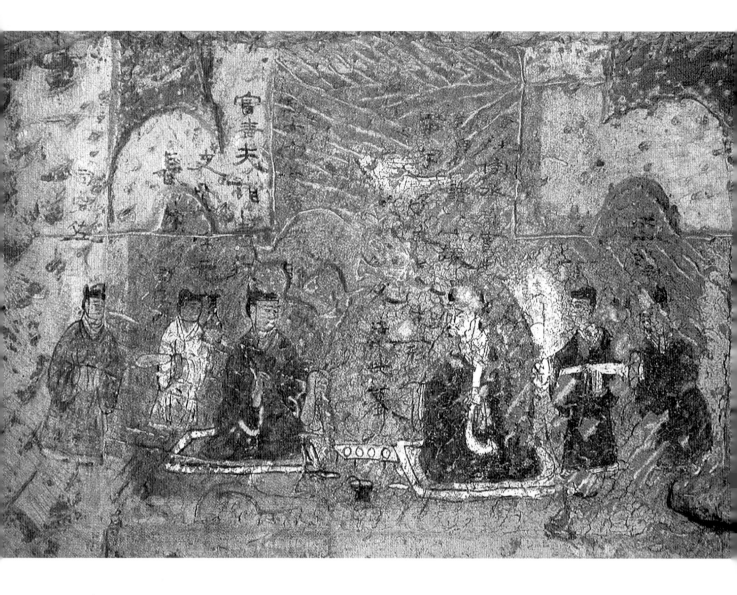

# 156. 宴饮图（五）

东汉（25～220年）

高约65～70、宽75～98厘米

2002年四川省中江县民主乡桂花村塔梁子三号崖墓出土。原址保存。

墓向225°。位于三室南侧室南壁，为该墓室内八幅宴饮图之五。共绘六人，中间二人坐于席上，面前摆案、豆等用具，另四人分立于后。人物上方有榜题。

（撰文：于春　摄影：江聪）

## Feast Scene (5)

Eastern Han (25-220 CE)

Height 65-70 cm; Width 75-98 cm

Unearthed from the Cliff Tomb No.3 at Taliangzi of Guihuacun in Minzhu Town, Zhongjiang, Sichuan, in 2002. Preserved on the original site.

# 157.宴饮图（六）

东汉（25～220年）

高约65～70、宽75～98厘米

2002年四川省中江县民主乡桂花村塔梁子三号崖墓出土。原址保存。

墓向225°。位于三室南侧室南壁，为该墓室内八幅宴饮图之六。壁画模糊不清，似二人对坐，中间置案，左右两边各站一人。

<div align="right">（撰文：于春　摄影：江聪）</div>

## Feast Scene (6)

Eastern Han (25-220 CE)

Height 65-70 cm; Width 75-98 cm

Unearthed from the Cliff Tomb No.3 at Taliangzi of Guihuacun in Minzhu Town, Zhongjiang, Sichuan, in 2002. Preserved on the original site.

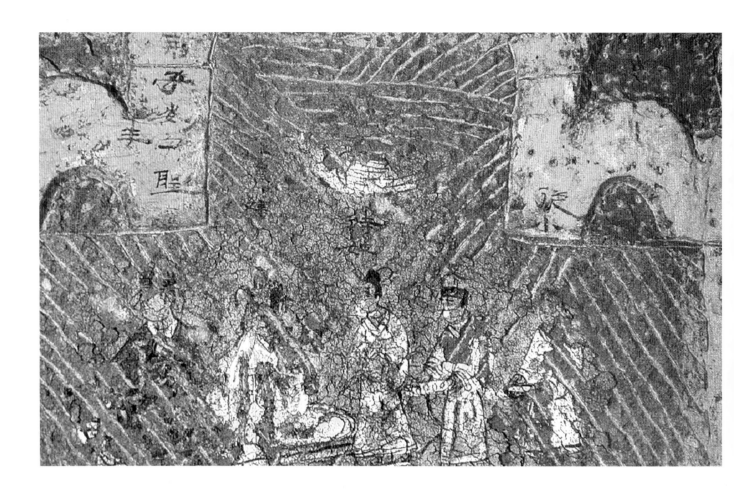

## 158.宴饮图（七）

东汉（25~220年）

高约65~70、宽75~98厘米

2002年四川省中江县民主乡桂花村塔梁子三号崖墓出土。原址保存。

墓向225°。位于三室南侧室南壁，为该墓室内八幅宴饮图之七。共绘五人，左侧二人同坐一席，面前摆案、杯、盘等用具，右侧三人皆侍立，双手捧物状。

<div align="right">（撰文：于春　摄影：江聪）</div>

## Feast Scene (7)

Eastern Han (25-220 CE)

Height ca. 65-70 cm; Width 75-98 cm

Unearthed from the Cliff Tomb No.3 at Taliangzi of Guihuacun in Minzhu Town, Zhongjiang, Sichuan, in 2002. Preserved on the original site.

# 159.宴饮图（八）

东汉（25～220年）

高约65～70、宽75～98厘米

2002年四川省中江县民主乡桂花村塔梁子三号崖墓出土。原址保存。

墓向225°。位于三室南侧室南壁，为该墓室内八幅宴饮图之八。共绘三人，左侧二人同坐一席，面前摆杯盘等用具，右侧一人似站立。

（撰文：于春　摄影：江聪）

## Feast Scene (8)

Eastern Han (25-220 CE)

Height 65-70 cm; Width 75-98 cm

Unearthed from the Cliff Tomb No.3 at Taliangzi of Guihuacun in Minzhu Town, Zhongjiang, Sichuan, in 2002. Preserved on the original site.

## 160.博戏图

东汉（25～220年）

高约65、宽112厘米

2002年四川省中江县民主乡桂花村塔梁子三号崖墓出土。原址保存。

墓向225°。位于三室北侧室北壁，墨绘二人对坐席上，两人中间似绘有博局。

（撰文：于春　摄影：江聪）

## Liubo Game Playing

Eastern Han (25-220 CE)

Height 65 cm; Width 112 cm

Unearthed from the Cliff Tomb No.3 at Taliangzi of Guihuacun in Minzhu Town, Zhongjiang, Sichuan, in 2002. Preserved on the original site.

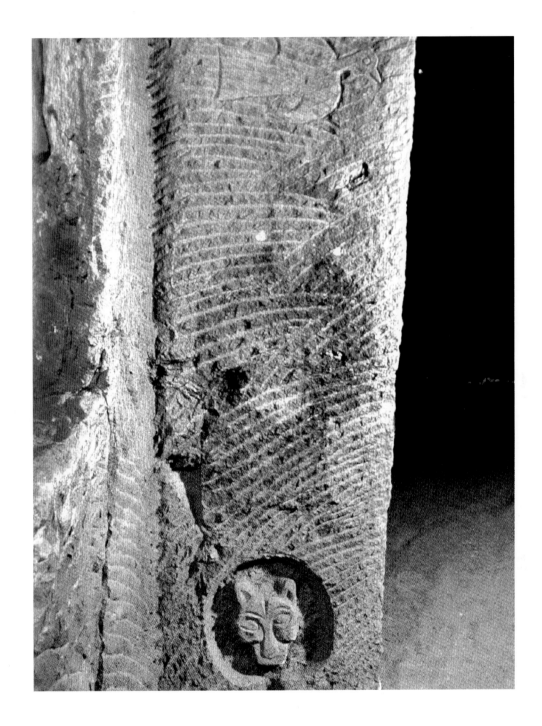

## 161.门吏图

东汉（25～220年）

高约70、宽38厘米

2002年四川省中江县民主乡桂花村塔梁子三号崖墓出土。原址保存。

墓向225°。位于三室门柱上。门吏躬身站立，头戴冠，冠上似插一羽毛，双手合拢于胸前。墨线勾画轮廓，涂红彩。

（撰文：于春　摄影：江聪）

## Door Official

Eastern Han (25-220 CE)

Height ca. 70 cm; Width 38 cm

Unearthed from the Cliff Tomb No.3 at Taliangzi of Guihuacun in Minzhu Town, Zhongjiang, Sichuan, in 2002. Preserved on the original site.

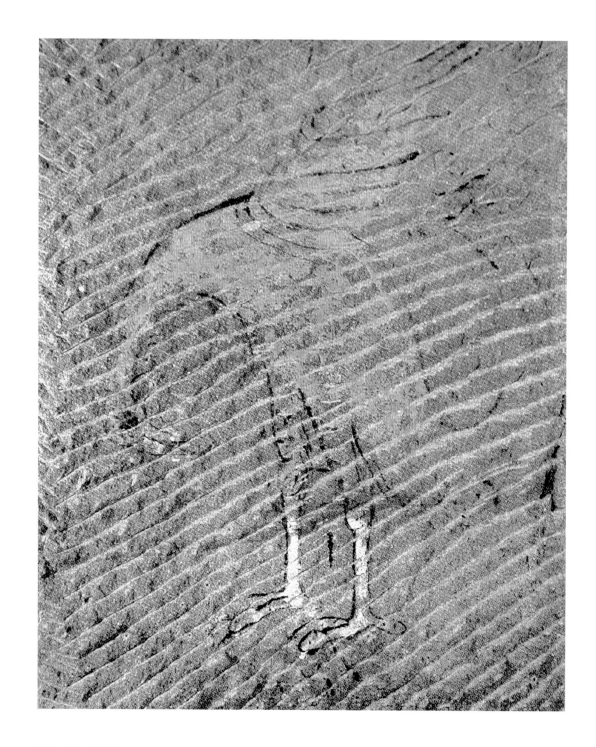

## 162.朱雀图

东汉（25～220年）

高约75、宽60厘米

2002年四川省中江县民主乡桂花村塔梁子三号崖墓出土。原址保存。

墓向225°。位于后室甬道北壁，用朱红、黑、绿三色勾画，朱雀头上有一长羽冠，低头展翅，尾羽上翘。

<div align="right">（撰文：于春 摄影：江聪）</div>

## Scarlet Bird

Eastern Han (25-220 CE)

Height ca. 75 cm; Width 60 cm

Unearthed from the Cliff Tomb No.3 at Taliangzi of Guihuacun in Minzhu Town, Zhongjiang, Sichuan, in 2002. Preserved on the original site.

## 163. 霍承嗣墓北壁壁画

东晋太元十一年至十九年（386～394年）

高220、宽300厘米

1963年云南省昭通市昭阳区后海子中寨霍承嗣墓出土。现存于昭通市第三中学内。

墓向南。位于墓室北壁。壁画由二方连续云纹带分为上下两层。上层下部绘玄武，上部绘云纹，云纹下方绘一人张弓射鹿，其间点缀五朵莲花图像。下层绘墓主正襟危坐于榻上，旁有兵器架和众多侍从，墓主比例远大于周围人物，墓主像西侧有八行墨书题记。

（撰文：杨德聪　摄影：邢毅）

## North Wall of Huo Chengsi's Tomb

11th -19th Year of Taiyuan Era, Eastern Jin (386-394 CE)

Height 220 cm; Width 300 cm

Unearthed from Huo Chengsi's tomb of Houhaizi Zhongzhai at Zhaoyang District in Zhaotong, Yunnan, in 1963. Preserved in the 3rd Middle School of Zhaotong City.

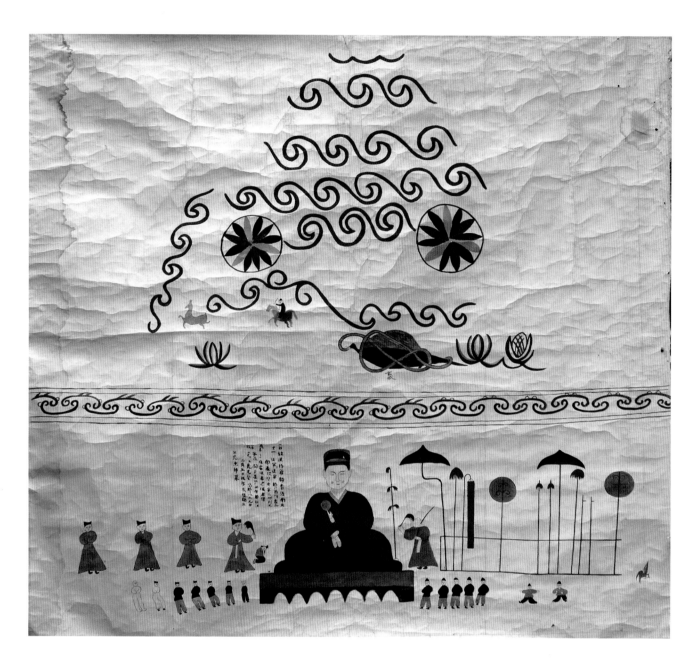

## 164.霍承嗣墓北壁壁画（摹本）

东晋太元十一年至十九年（386～394年）

高220、宽300厘米

1963年云南省昭通市昭阳区后海子中寨霍承嗣墓出土。现存于昭通市第三中学内。

墓向南。位于墓室北壁。

（临摹：马荫何　撰文：杨德聪　摄影：邢毅）

## North Wall of Huo Chengsi's Tomb (Replica)

11th -19th Year of Taiyuan Era, Eastern Jin (386-394 CE)

Height 220 cm; Width 300 cm

Unearthed from Huo Chengsi's tomb of Houhaizi Zhongzhai at Zhaoyang District in Zhaotong, Yunnan, in 1963. Preserved in the 3rd Middle School of Zhaotong City.

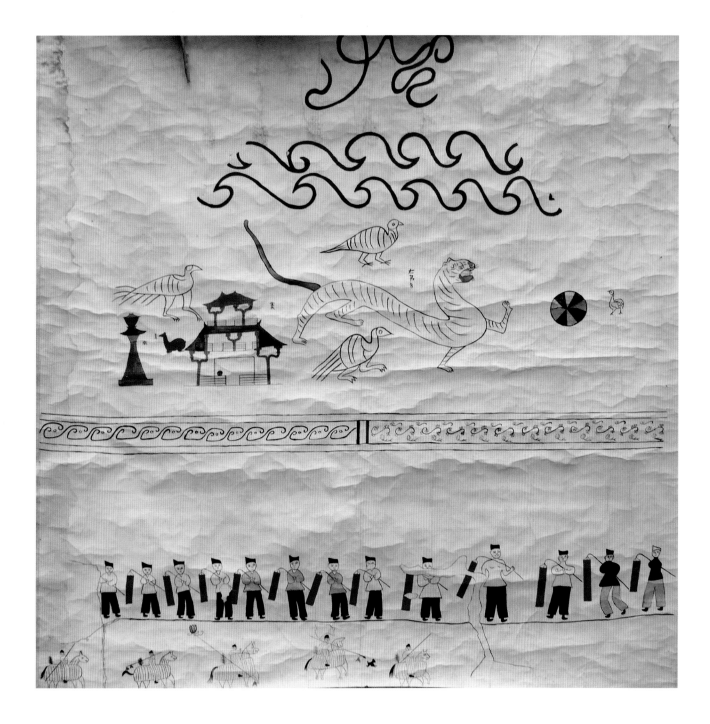

## 165.霍承嗣墓东壁壁画（摹本）

东晋太元十一年至十九年（386～394年）

高220、宽300厘米

1963年云南省昭通市昭阳区后海子中寨霍承嗣墓出土。现存于昭通市第三中学内。

墓向南。位于墓室东壁。壁画由二方连续云纹带分为上下两层。上层下部绘白虎，旁有"左帛虎"的墨书题记，上部绘云纹，白虎周围绘有神鸟、门阙、楼阁。下层绘上下两列人物，上列为十三名执幡人物组成的队列，下列为五名甲马持矛的骑吏。

（临摹：马荫何　撰文：杨德聪　摄影：邢毅）

## East Wall of Huo Chengsi's Tomb (Replica)

11th -19th Year of Taiyuan Era, Eastern Jin (386-394 CE)

Height 220 cm; Width 300 cm

Unearthed from Huo Chengsi's tomb of Houhaizi Zhongzhai at Zhaoyang District in Zhaotong, Yunnan, in 1963. Preserved in the 3rd Middle School of Zhaotong City.

## 166.执幡仪仗图（局部）

东晋太元十一年至十九年（386～394年）

人物高21～23厘米

1963年云南省昭通市昭阳区后海子中寨霍承嗣墓出土。现存于昭通市第三中学内。

墓向南。位于东壁下层壁画的上部。全列共13名执幡人物，均头戴元宝式黑帽，分别穿黄、黑、白色上衣，双手执幡。

<div align="right">（撰文：杨德聪 摄影：邢毅）</div>

## Guard of Honor Holding a Steamer (Replica)

11th -19th Year of Taiyuan Era, Eastern Jin (386-394 CE)

Height of figures 21-23 cm

Unearthed from Huo Chengsi's tomb of Houhaizi Zhongzhai at Zhaoyang District in Zhaotong, Yunnan, in 1963. Preserved in the 3rd Middle School of Zhaotong City.

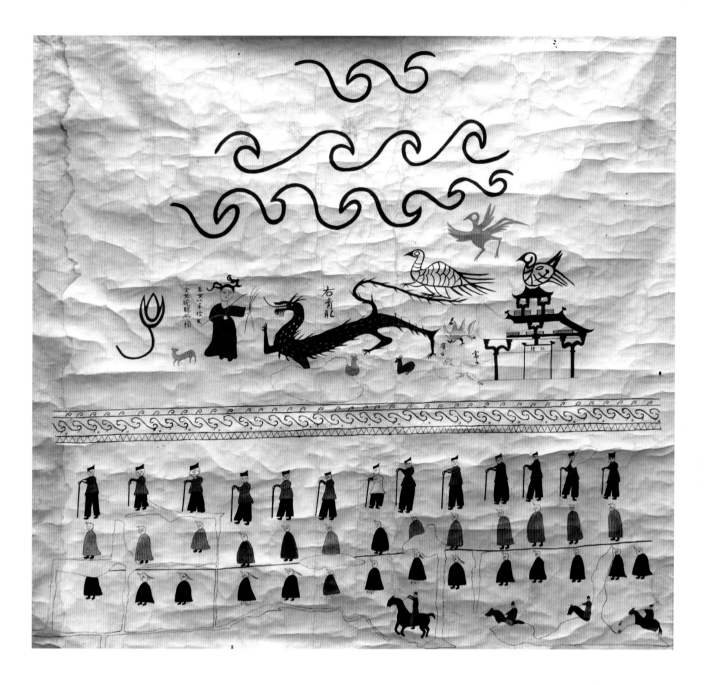

## 167. 霍承嗣墓西壁壁画（摹本）

东晋太元十一年至十九年（386～394年）

高220、宽300厘米

1963年云南省昭通市昭阳区后海子中寨霍承嗣墓出土。现存于昭通市第三中学内。

墓南向。位于墓室西壁。壁画由二方连续云纹带分为上下两层。上层下部正中绘青龙，上有"右青龙"墨书题记，龙头前绘持仙草的玉女，旁有"玉女以草授龙"的墨书题记，龙身后绘楼阁。上部绘云纹。下层绘四列人物，第一列13人，均头戴元宝式黑帽持刀而立；第二列13人和第三列14人，均为少数民族形象，身着黑色、红色、黄色披毡，头梳彝族"天菩萨"式长髻，应为霍氏的少数民族部曲；第四列为4名骑吏。四列人物表现的可能是霍氏的"夷汉部曲"祭祀墓主的参毗阵列。

（临摹：马荫何　撰文：杨德聪　摄影：邢毅）

## West Wall of Huo Chengsi's Tomb (Replica)

11th -19th Year of Taiyuan Era, Eastern Jin (386-394 CE)

Height 220 cm; Width 300 cm

Unearthed from Huo Chengsi's tomb of Houhaizi Zhongzhai at Zhaoyang District in Zhaotong, Yunnan, in 1963. Preserved in the 3rd Middle School of Zhaotong City.

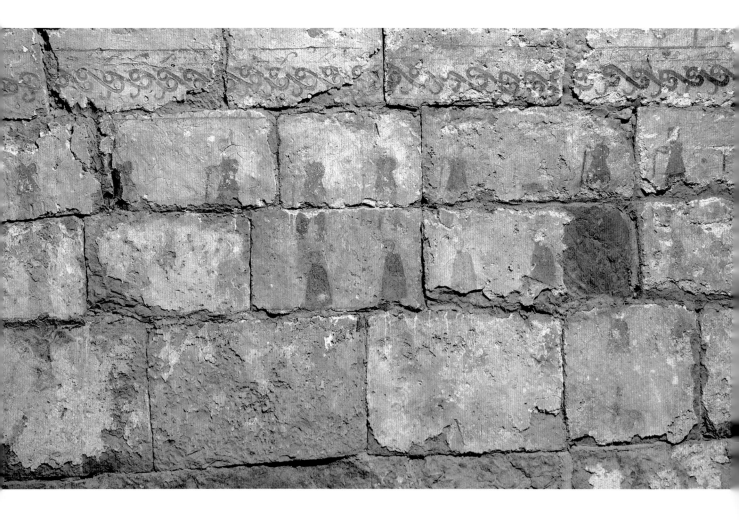

## 168.参毗阵列图（局部）

东晋太元十一年至十九年（386～394年）

人物高11～20厘米

1963年云南省昭通市昭阳区后海子中寨霍承嗣墓出土。现存于昭通市第三中学内。

墓向南。位于墓室西壁下部。参毗阵列由三列人物和一列骑吏组成。第一列均头戴元宝式黑帽，身着黑衣黑裤，双手握持环首铁刀，侧面向南作行走状。第二列均着黄色披毡，发髻斜突于额前，作面南伫立状。第三列均着黑色或黄色披毡，赤足，发髻斜突于额前，亦向南作行走状。第四列为四名骑吏。史载霍承嗣先祖"甚善参毗之礼"，四列人物表现的可能就是霍氏的"夷汉部曲"祭祀墓主的参毗阵列。

（撰文：杨德聪　摄影：邢毅）

## Scene of Procession (Detail)

11th -19th Year of Taiyuan Era, Eastern Jin (386-394 CE)

Height of figures 11-20cm

Unearthed from Huo Chengsi's tomb of Houhaizi Zhongzhai at Zhaoyang District in Zhaotong, Yunnan, in 1963. Preserved in the 3rd Middle School of Zhaotong City.

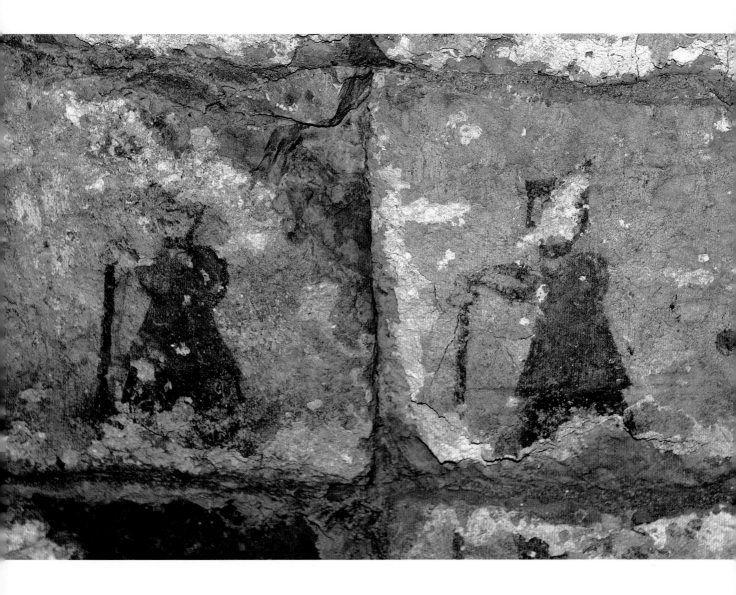

# 169. 执刀部曲图（局部）

东晋太元十一年至十九年（386～394年）

人物高18～20厘米

1963年云南省昭通市昭阳区后海子中寨霍承嗣墓出土。现存于昭通市第三中学内。

墓南向。位于墓室西壁下部。为参毗阵列图中的第一列北起第三、四人。两人均头戴元宝式黑帽，身着黑衣黑裤，足登黑履，双手拄刀面南而立。

（撰文：杨德聪　摄影：邢毅）

## Family Servants Holding Swords (Detail)

11th -19th Year of Taiyuan Era, Eastern Jin (386-394 CE)

Height of figures 18-20 cm

Unearthed from Huo Chengsi's tomb of Houhaizi Zhongzhai at Zhaoyang District in Zhaotong, Yunnan, in 1963. Preserved in the 3rd Middle School of Zhaotong City.

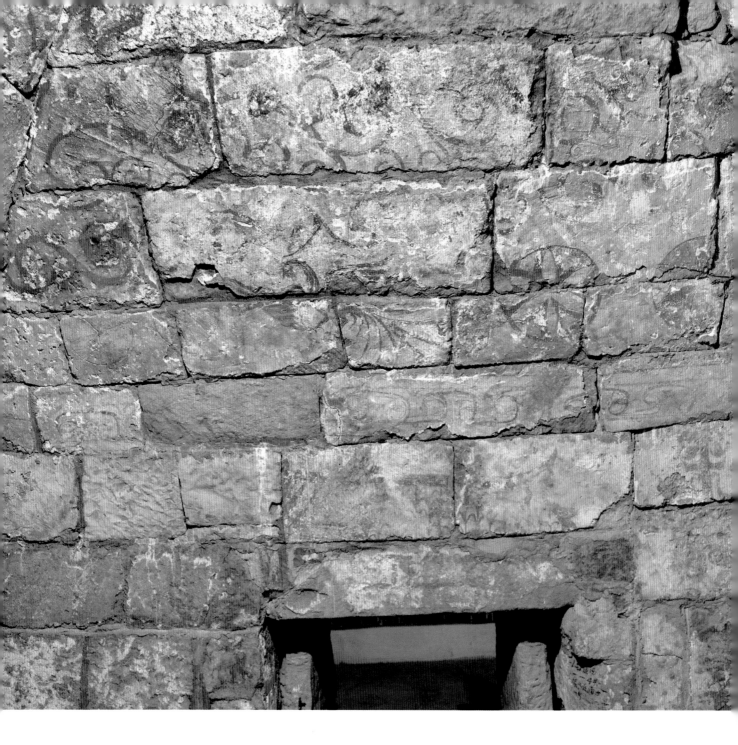

## 170.霍承嗣墓南壁壁画

东晋太元十一年至十九年（386～394年）

高220、宽300厘米

1963年云南省昭通市昭阳区后海子中寨霍承嗣墓出土。现存于昭通市第三中学内。

墓向南。位于墓室南壁。壁画由二方连续云纹带分为上下两层。上层为朱雀图，朱雀作展翅欲飞状，旁有"朱雀"二字题记，雀身前后各有两朵圆圈状莲花，上部为流云纹。下层正中绘一高大厅堂，厅堂西侧绘一披甲执刀的武士，其旁有"中门侯"墨书题记。武士西侧有粗重的"天米"二字的花体文字题记。

<div align="right">（撰文：杨德聪　摄影：邢毅）</div>

## South Wall of Huo Chengsi's Tomb

11th -19th Year of Taiyuan Era, Eastern Jin (386-394 CE)

Height 220 cm; Width 300 cm

Unearthed from Huo Chengsi's tomb of Houhaizi Zhongzhai at Zhaoyang District in Zhaotong, Yunnan, in 1963. Preserved in the 3rd Middle School of Zhaotong City.

## 171.霍承嗣墓南壁壁画（摹本）

东晋太元十一年至十九年（386～394年）

高220、宽300厘米

1963年云南省昭通市昭阳区后海子中寨霍承嗣墓出土。现存于昭通市第三中学内。

墓向南。位于墓室南壁。

<div align="right">（临摹：马荫何　撰文：杨德聪　摄影：邢毅）</div>

## South Wall of Huo Chengsi's Tomb (Replica)

11th -19th Year of Taiyuan Era, Eastern Jin (386-394 CE)

Height 220 cm; Width 300 cm

Unearthed from Huo Chengsi's tomb at Houhaizi Zhongzhai at Zhaoyang District, Zhaotong City, Yunnan Province in 1963; preserved at the 3rd Middle School of Zhaotong City.

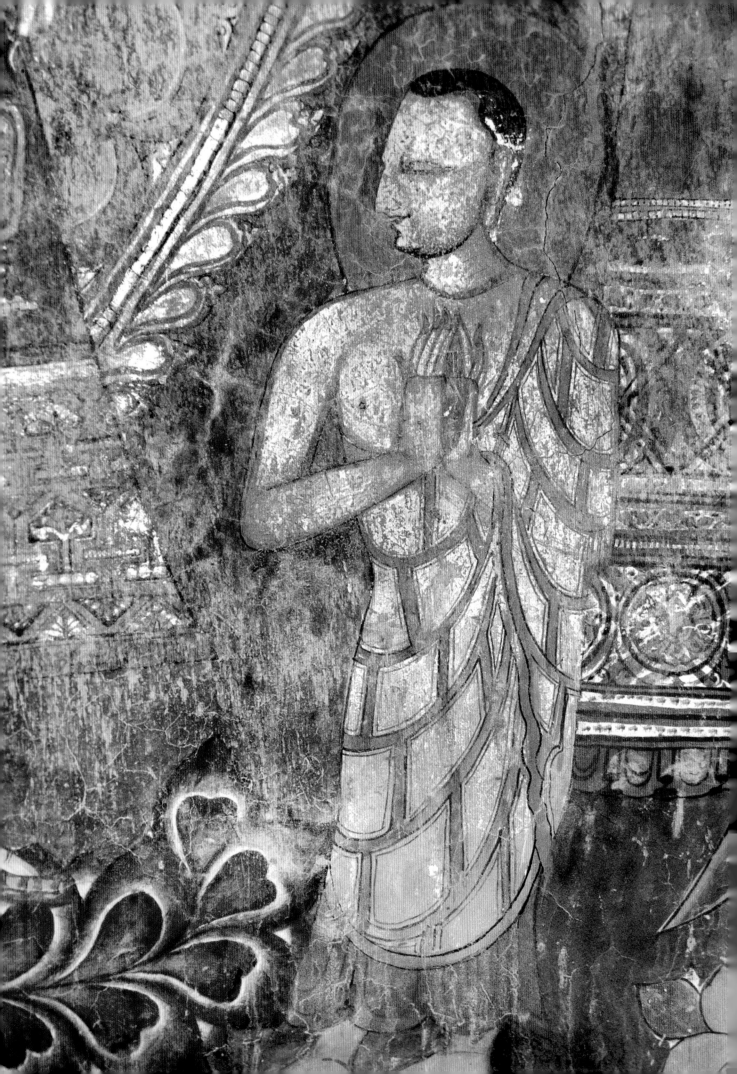

◀ **172. 比丘像**

11世纪初

高68、宽45厘米

西藏札达县托林寺50号塔佛堂内出土。原址保存。

位于塔身佛堂北壁。比丘身体正面站立，头部和足部为侧面。短发，鼻梁挺直，眼细长，口微张，大耳。身穿袒右袈裟及红裙，双手合掌，双脚前后错置。肌肤使用晕染法表现明暗凹凸。

（撰文、摄影：张建林）

## Monk

Early 11th Century

Height 68 cm; Width 45 cm

Unearthed from the Buddhist Hall of Pagoda No.50 at Toding Temple in Zanda, Tibet. Preserved on the original site.

▼ **173. 水难图**

11世纪初

高48、宽80厘米

西藏札达县托林寺50号塔佛堂内出土。原址保存。

位于佛堂南壁正中。为观音救八难图像之一。八难分别为狮难、虎难、象难、蛇难、水难、火难、强盗难、牢狱难。此幅为水难图，整个"水难"画面呈长方形，以细密的蓝线表现水波，周绘红线边框。左上角有两人乘小船，其中一人奋力划桨，一人手足无措。下方有一倾覆的小船，中部一人在水中挣扎。周围有上下游动的鱼、摩羯鱼以及羊首鱼尾、马首鱼尾的怪兽，还有熊形怪兽及海螺、各色宝珠等。画面充满动感。

（撰文、摄影：张建林）

## Anecdotes Series of Avalokitesvara's Salvation: from the Water

Early 11th Century

Height 48 cm; Width 80 cm

Unearthed from the Buddhist Hall of Pagoda No.50 at Toding Temple in Zanda, Tibet. Preserved on the original site.

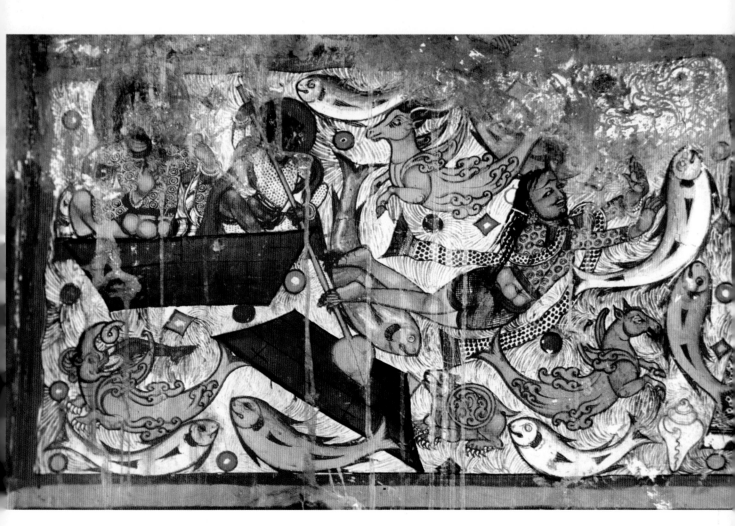

# 174. 六臂观音

11世纪初

高202、宽255厘米

西藏札达县托林寺50号塔佛堂内出土。原址保存。

位于塔身佛堂北壁正中。为立姿的六臂观音像，两侧分布侍立菩萨、比丘、飞天。六臂观音头戴三叶冠，耳饰大环，上身裸，佩项饰、胸饰、花环、长巾，下着裙。左侧三臂分别手持净瓶、花枝、花盘，右侧三臂手姿各异。椭圆形莲瓣纹头光、身光。肌肤用晕染技法表现出立体感。

（撰文、摄影：张建林）

## Avalokitesvara with Six Arms

Early 11th Century

Height 202 cm; Width 255 cm

Unearthed from the Buddhist Hall of Pagoda No.50 at Toding Temple in Zanda, Tibet. Preserved on the original site.

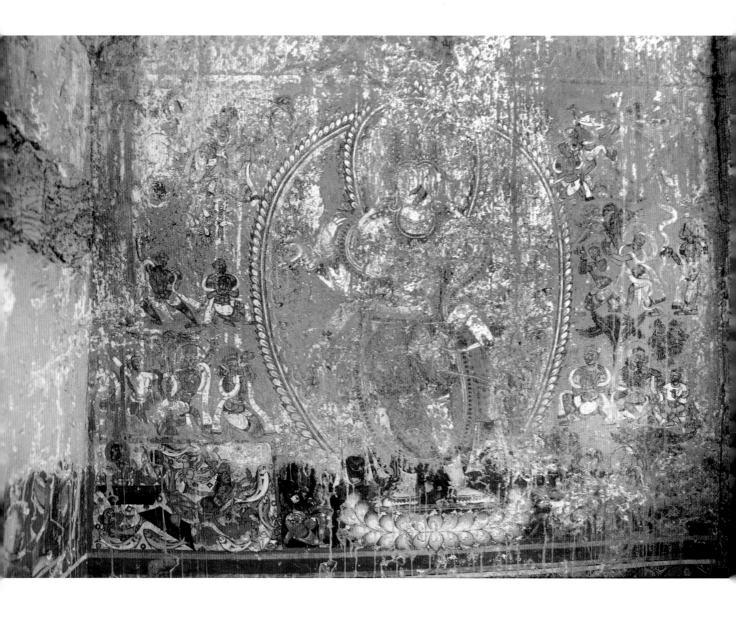

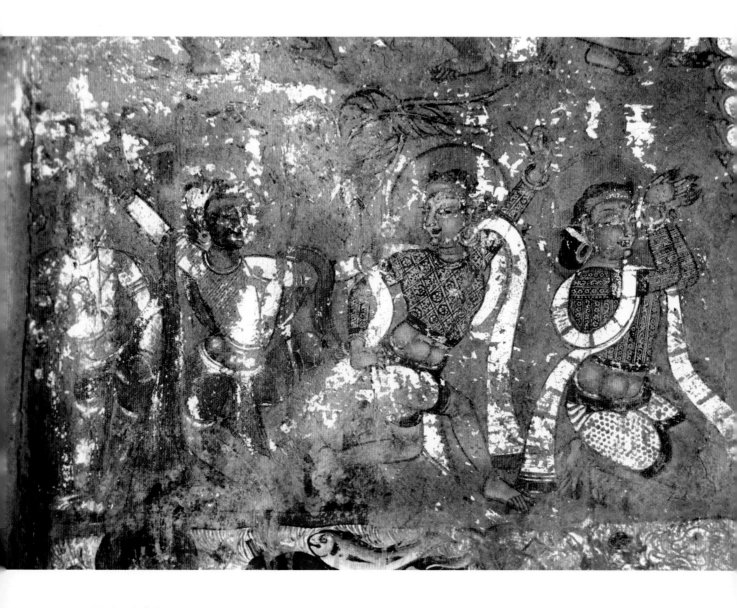

## 175. 强盗难图

11世纪初

高50、宽78厘米

西藏札达县托林寺50号塔佛堂内出土。原址保存。

位于佛堂南壁水难画面上方。右侧一人跪地祈祷求救，其后一人仓惶奔逃。左侧两人紧追不舍，其中前者右手举刀，左手前伸欲抓逃者。人物服饰略同，均为圆领紧身短衣，肩披条帛，下着短裤，跣足。气氛紧张，扣人心弦。

（撰文、摄影：张建林）

## Anecdotes Series of Avalokitesvara's Salvations: from the Bandit

Early 11th Century

Height 50 cm; Width 78 cm

Unearthed from the Buddhist Hall of Pagoda No.50 at Toding Temple in Zanda, Tibet. Preserved on the original site.

## ▲176. 狮难图

11世纪初

高45、宽70厘米

西藏札达县托林寺50号塔佛堂内出土。原址保存。

位于佛堂南壁左上方。画面虽脱落严重，大体可辨。右下侧一人举手低头，跪地祈祷，后面一人奔跑求生，一白色雄狮扑向奔跑的人，前爪已抓住人身，狮头高昂，急欲撕咬。

（撰文、摄影：张建林）

## Anecdotes Series of Avalokitesvara's Salvations: from the Lion

Early 11th Century

Height 45 cm; Width 70 cm

Unearthed from the Buddhist Hall of Pagoda No.50 at Toding Temple in Zanda, Tibet. Preserved on the original site.

## 177. 菩萨塑像和两侧的壁画 ▶

11世纪初

残高约190、宽约160厘米

西藏札达县托林寺55号塔佛堂内出土。原址保存。

位于佛堂南壁。佛堂东、北、南三面各有塑像一尊，四壁均有壁画。图中所见南壁菩萨塑像两侧壁画原各有金刚菩萨坐像五尊，上下排列，依菩萨的排列组合及形象，很可能是金刚界曼荼罗三十二金刚菩萨中的一组。下部绘有两排供养人，根据藏文题名分析，应为古格王室成员。

（撰文：张建林　摄影：宗同昌）

## Statue of Bodhisattva and Murals

Early 11th Century

Surviving height ca. 190 cm; Width 160 cm

Unearthed from the Buddhist Hall of Pagoda No.50 at Toding Temple in Zanda, Tibet. Preserved on the original site.

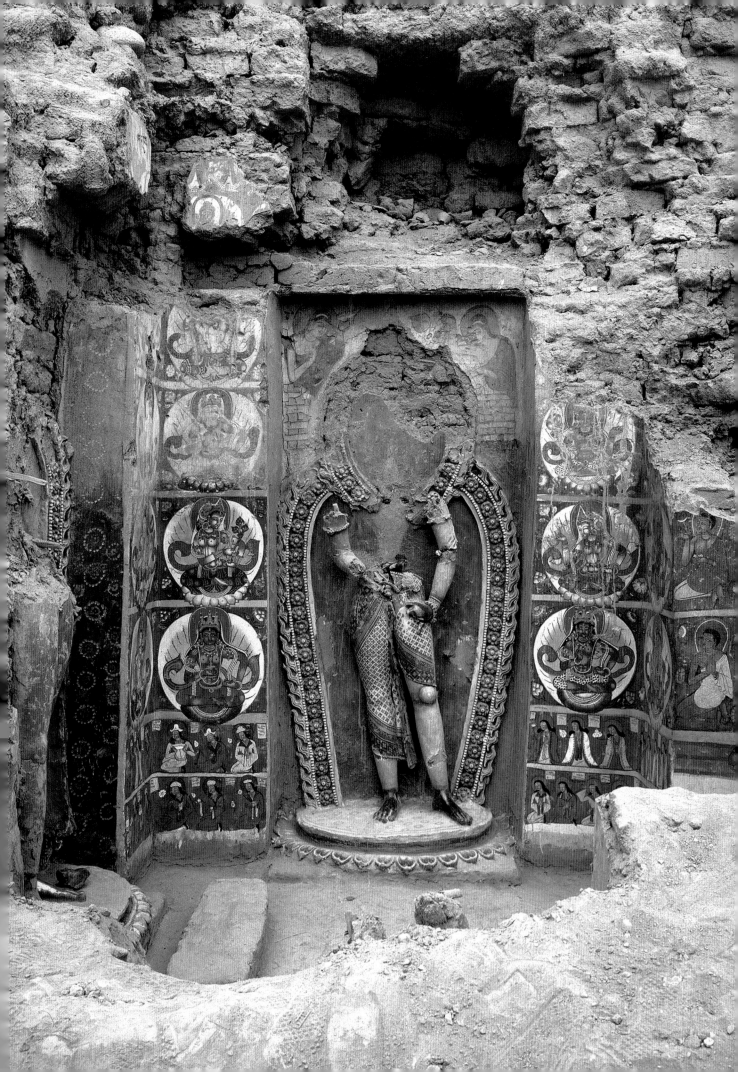

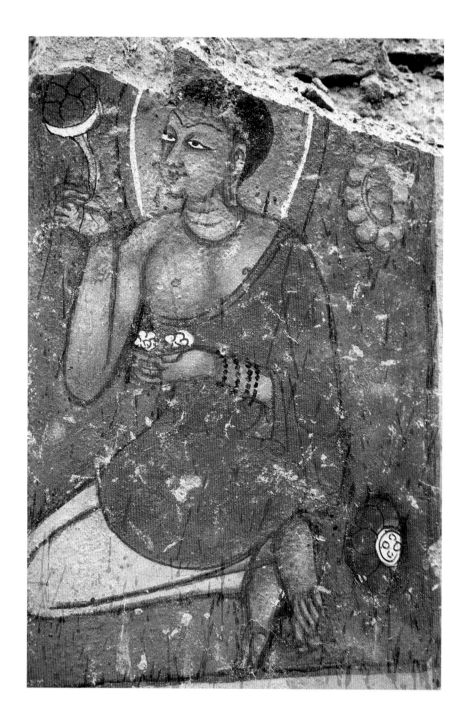

# 178. 僧人礼拜图

11世纪初

高38、宽30厘米

西藏札达县托林寺55号塔出土。原址保存。

位于塔门道南壁。僧人一头短发，眉目清秀，大耳下垂及颈，头周围有红白轮廓的椭圆形头光。上着红色袒右衫，下着黄色长裤。右手持一茎莲蕾，左手托两朵小白花，手腕缠绕念珠串。屈膝跪坐，跣足。身后装饰两朵莲花。肌肤采用晕染法表现明暗凹凸，衣服则采用单线平涂。

（撰文、摄影：张建林）

## Worshiping Monk

Early 11th Century

Height 38 cm; Width 30 cm

Unearthed from the Buddhist Hall of Pagoda No.50 at Toding Temple in Zanda, Tibet. Preserved on the original site.

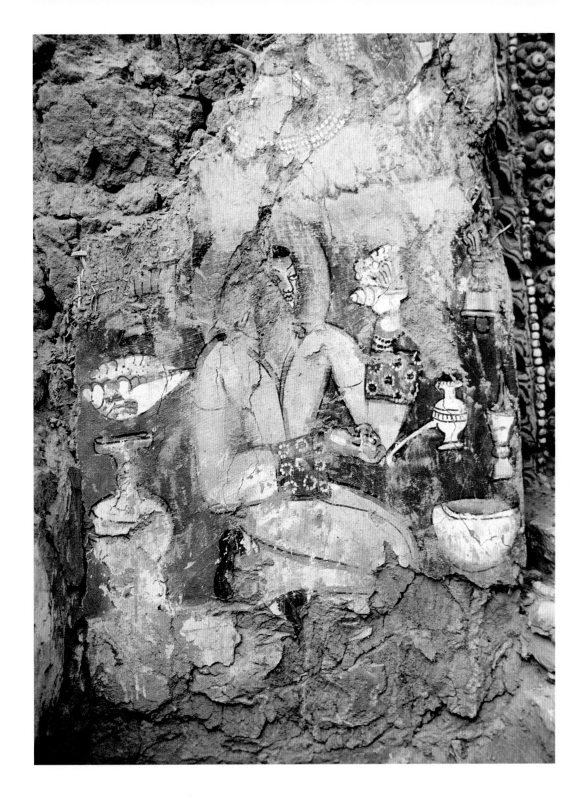

## 179. 供养人像

11世纪初

高36、宽36厘米

西藏扎达县托林寺55号塔佛堂内出土。原址保存。

位于佛堂东壁北侧。残损严重。供养人长发披肩，唇上有髭，头周有绿色圆形头光。身穿浅黄色交领长袍，袖口镶红地黑白花的袖头，足穿黑靴，屈膝跪坐。右手略拳屈，左手持一白色海螺，手腕缠绕念珠串。身前散布有金刚铃、油灯、长柄净瓶、敛口钵，身后有长颈瓶、海螺、托盏。

（撰文、摄影：张建林）

## Portrait of Sponsor

Early 11th Century

Height 36 cm; Width 36 cm

Unearthed from the Buddhist Hall of Pagoda No.50 at Toding Temple in Zanda, Tibet. Preserved on the original site.

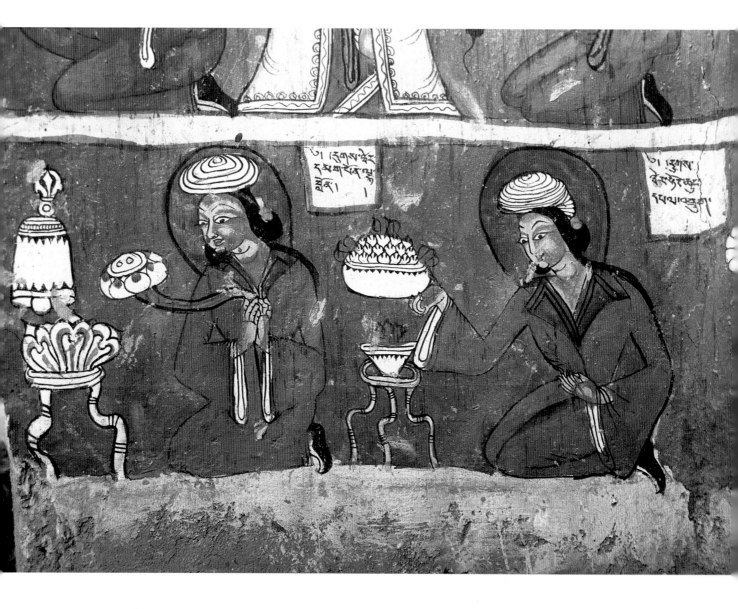

## 180. 两供养人像

11世纪初

高23、宽50厘米

西藏札达县托林寺55号塔佛堂内出土。原址保存。

位于南壁西侧最下方。两供养人形象、服饰略同，头顶缠白巾，长发垂肩，长发后部饰有蓝色饰物，头周有椭圆形红色头光；身穿三角翻领的红色长袍，足穿尖头黑靴。面向左侧屈膝跪坐。前者双手合十，持一茎白莲花；后者右手持一盛满花朵的圜底钵，左手置腹前。两人后上方各有一黄色方框，框内墨书藏文供养人名。前供养人面前绘金刚铃及置于三足架（漏绘一足）上的莲花，两人之间另有三足架，上置一碗。线条简洁，人物面部、手部略加晕染。

（撰文、摄影：张建林）

## Portrait of Sponsors

Early 11th Century

Height 23 cm; Width 50 cm

Unearthed from the Buddhist Hall of Pagoda No.50 at Toding Temple in Zanda, Tibet. Preserved on the original site.

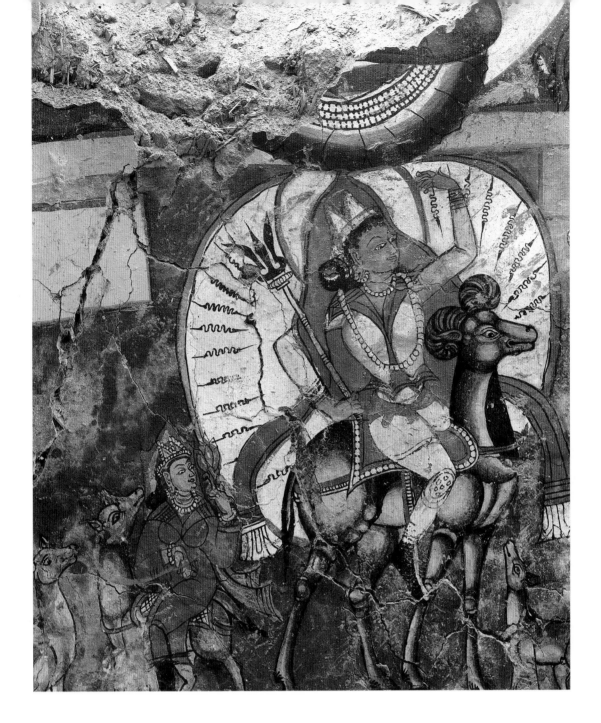

# 181. 骑羊女神像

11世纪初

高45、宽43厘米

西藏札达县托林寺55号塔佛堂内出土。原址保存。

位于佛堂北壁西侧。画面有大小两尊女神，较大的一尊女神头戴三叶冠（仅表现出两叶），长发后披并做成卷髻，佩珠串耳饰、项饰、胸饰。上身穿紧身长袖衫及翻领对襟半臂，略显双乳，头后有红色披帛飘下，腰间系红带，下身穿紧身长裤，足穿黑靴。左手上举，右手持三叉戟。坐骑为盘角雄羚羊，昂首伫立，备有鞍鞯。女神有白地红边的背光、头光，身光中绘放射状光芒线。较小的女神头戴三叶冠（仅表现出两叶），长发后披，佩珠串耳饰、项饰、腕饰。身穿质地轻薄的红色翻领长袍，隐现双乳及腰腿轮廓，头后有披帛垂飘两侧，足穿黑靴。坐骑为雌羚羊，回首张望，备有鞍鞯，旁侧另有一只雌羚羊。

（撰文：张建林　摄影：宗同昌）

## Goddess Riding on Sheep

Early 11th Century

Height 45 cm; Width 43 cm

Unearthed from the Buddhist Hall of Pagoda No.50 at Toding Temple in Zanda, Tibet. Preserved on the original site.

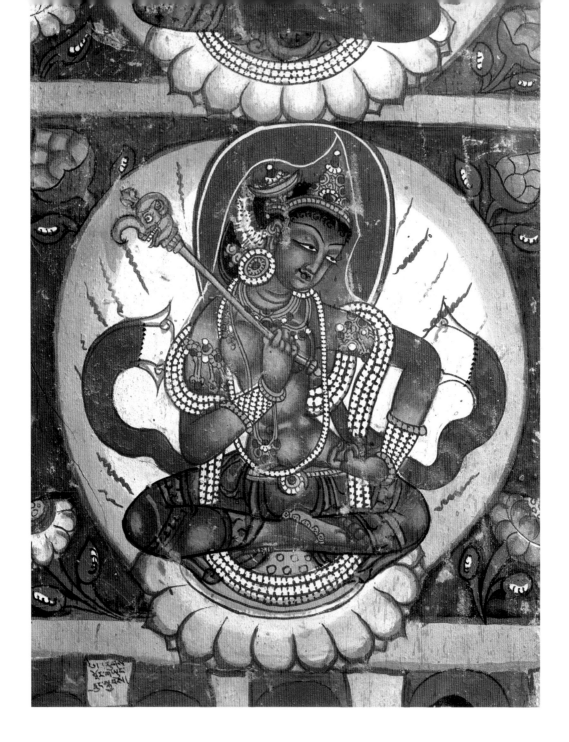

## 182. 金刚钩菩萨像

11世纪初

高36、宽38厘米

西藏札达县托林寺55号塔佛堂内出土。原址保存。

位于佛堂西壁南侧。三十二金刚菩萨之一。头戴宝冠，长发后垂，发、耳、项、胸、臂、手腕、足腕均佩华丽饰物，其中耳饰、发饰、臂饰、项饰似为嵌宝石的金饰品，其余为珠串连缀而成。肤色红褐，上身裸，肌肤丰满圆润，下穿蓝色长裙，头后有上红下蓝的披帛垂飘身体两侧，结跏趺坐于莲台上。左手握拳置左胯前，右手斜持金刚钩。圆形黄白色身光，椭圆形红色头光。下方两侧各一茎莲花，上方两侧各一莲蕾。菩萨肌肤部分采用晕染法，表现明暗凹凸。

（撰文：张建林　摄影：宗同昌）

## Vajra Hook Bodhisattva

Early 11th Century

Height 36 cm; Width 38 cm

Unearthed from the Buddhist Hall of Pagoda No.50 at Toding Temple in Zanda, Tibet. Preserved on the original site.

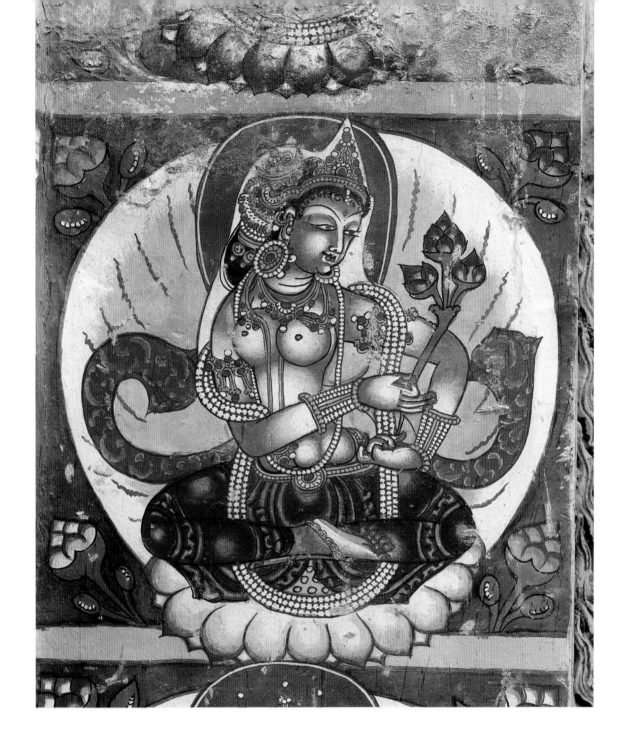

## 183. 金刚华菩萨像

11世纪初

高36、宽38厘米

西藏札达县托林寺55号塔佛堂内出土。原址保存。

位于佛堂南壁东侧。三十二金刚菩萨之一。头戴宝冠，长发后垂，发、耳、项、胸、臂、手腕、足腕均佩华丽饰物，其中耳饰、发饰、臂饰、项饰似为嵌宝石的金饰品，其余为珠串连缀而成。服色青蓝，上身裸，丰满圆润，下穿绛红色长裙，头后有上白下红的披帛垂飘身体两侧，结跏趺坐于莲台上。左手握拳置左胯前，右手持单茎三朵莲蕾。圆形黄白色身光，椭圆形红色头光。上下方两侧各伸出一茎莲蕾。菩萨肌肤部分采用晕染法，表现明暗凹凸。

<div align="right">（撰文：张建林　摄影：宗同昌）</div>

## Vajra Flower Bodhisattva

Early 11th Century

Height 36 cm; Width 38 cm

Unearthed from the Buddhist Hall of Pagoda No.50 at Toding Temple in Zanda, Tibet. Preserved on the original site.

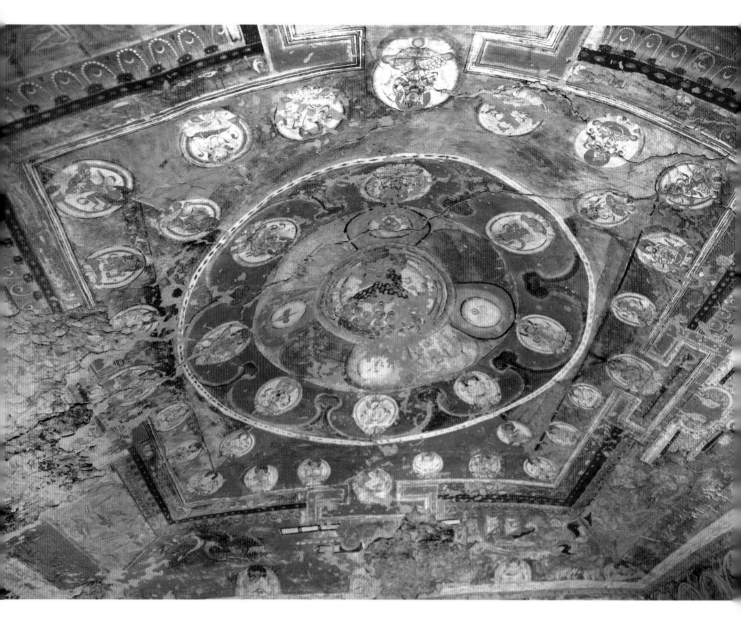

## 184. 一切智大日明照佛曼陀罗（穹庐）

约11世纪

长3.9、宽3.1米

西藏札达东嘎遗址 I 区三号窟内发掘。原址保存。

三号窟穹庐虽然不及一号窟四层方井状藻井和二号窟四层坛城式藻井华丽和神奇，却也独具韵味。一切智大日明照佛曼陀罗居于中心位置，构图简单朴实。时间略晚于前两窟。

<div align="right">（撰文、摄影：安然）</div>

### Sarvavid-Vairocana Mandala (the Ceiling)

About 11th Century

Height 390 cm; Width 310 cm

Unearthed from Donggar Murals Cave No.3, Ngari, Tibet. Preserved on the original site.

# 185. 佛传故事画——宫中生活（局部）

12世纪

高约30、宽约40厘米

西藏札达县东嘎遗址Ⅰ区一号窟西壁。原址保存。

原画面中心部位绘一宫殿，表现释迦牟尼为太子时，在宫中众妃子一起生活的场景。此图为"宫中生活"画面的右上角局部，表现宫殿周围戒备森严的情景：众士兵手持圆形盾牌严密守护；方形窗户中有一人向外张望；上方有一塔形建筑，旁边有一人屈膝而坐。

（撰文：毕华　摄影：安然）

## Anecdotes Series of Buddha's Life: Daily Royal Life (detail)

12th Century

Height ca. 30cm, width ca. 40cm

Unearthed from Donggar Murals Cave No.1, Ngari, Tibet. Preserved on the original site.

## 186．金刚界曼荼罗外配诸天像

12世纪

高约28、宽约36厘米

西藏札达县东嘎遗址Ⅰ区一号窟西壁。原址保存。

1号窟西壁绘有并列的两个金刚界曼荼罗，主尊为大日如来，四面配置四部如来和一应眷属和天部。此图为右侧曼荼罗右下方的两尊天部。图左侧天部着俗装，头戴宝冠，身穿三角形翻领袍服，左侧拥明妃，以双马为坐骑。图右侧天部为菩萨装，上身裸，佩戴璎珞、臂钏等饰物，左侧拥明妃。两尊像的背光顶部均有华盖。

（撰文、摄影：安然）

## *Deva* Guardians of Vajradhātu Mandala

12th Century

Height ca. 30cm, width ca. 40cm

Unearthed from Donggar Murals Cave No.1, Ngari, Tibet. Preserved on the original site.

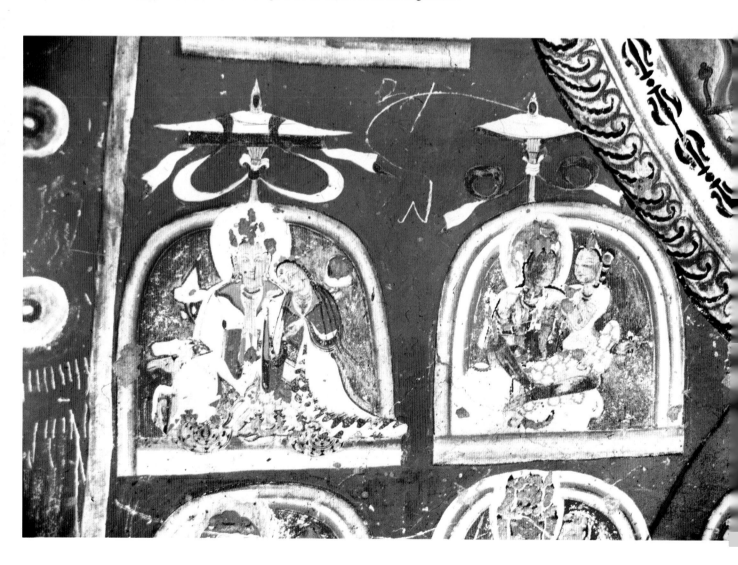

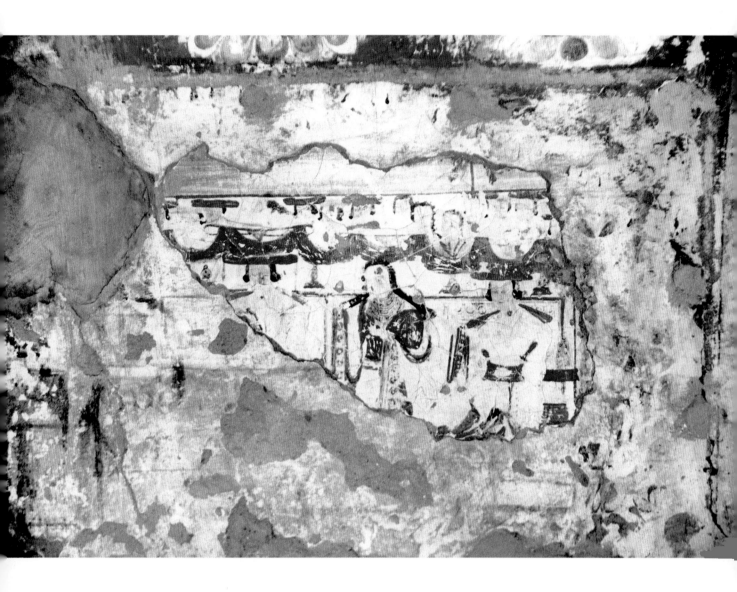

# 187. 供养人像

12世纪

高约60、宽约80厘米

西藏札达县东嘎遗址Ⅰ区二号窟南壁东侧。原址保存。

壁画绘制在草泥层的白色涂料上。在一道连弧垂幔之下，并排坐三位供养人，中间一人蓄长发，身穿宽袖长袍，配有项饰；左右二人头戴宽檐帽，身披披风，内穿三角形翻领长袍。垂幔之上可见9人，只露出头部。人物服饰表现了较为典型的古格王国早期贵族服饰的特征。

（撰文：毕华　摄影：安然）

## Portraits of Sponsors

12th Century

Height ca. 60cm, width ca. 80cm

Unearthed from Donggar Murals Cave No.2, Ngari, Tibet. Preserved on the original site.

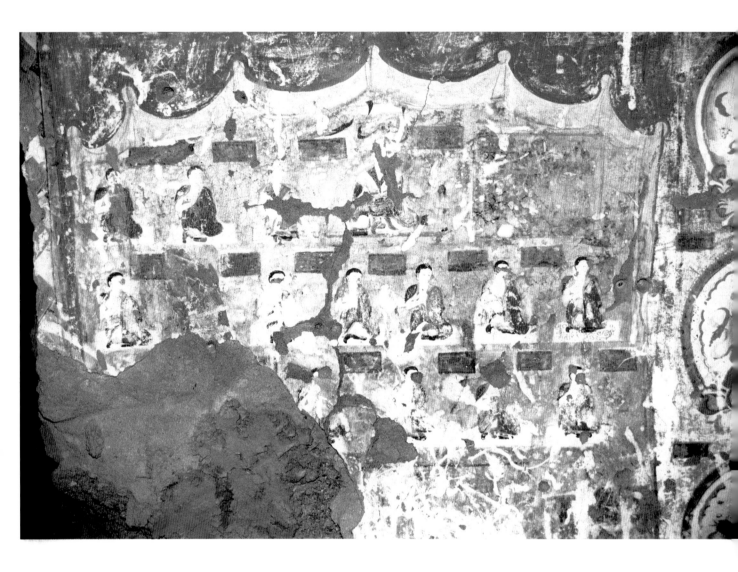

# 188. 僧俗听法礼佛图

12世纪

高约60、宽约80厘米

西藏札达县东嘎遗址Ⅰ区二号窟南壁西侧，原址保存

画面上方环绕垂幔，其下绘三排人物。上排中央人物显然是整组人物中地位显赫者，头戴宽檐帽，身穿三角形翻领长袍，上有华盖，旁有侍童。其右侧一人穿三角形翻领长袍，未带帽。其余人物均穿袒右僧装，或盘腿而坐，或右膝屈起。整组人物排列有序，每个人物头侧均有小方框，原应为人物名字的题榜，现均漫漶不清。从画面内容分析，可能是该窟供养人有关的僧俗听法礼佛图。

（撰文：毕华　摄影：安然）

## Monks and Laymen Listening in and Worshiping

12th Centtury

Height ca. 60cm, width ca. 80cm

Unearthed from Donggar Murals Cave No.2, Ngari, Tibet. Preserved on the original site.

## 189. 佛传故事——树下诞生

12世纪

高80、宽115厘米

西藏札达县东嘎遗址Ⅰ区一号窟南壁西侧。原址保存。

画面中央绘摩耶夫人，穿袍披巾，右手攀树枝，释迦牟尼从右肋下的袍袖间出生，旁边有天人作承接状。图右侧中心是站立的童子（释迦牟尼）立像，像上下左右伸出连续的莲花，端头站立相同的童子（释迦牟尼）像。图右上角绘一建筑，建筑内的莲座上是童子相的释迦牟尼侧卧其上。周围隐约可见大象、孔雀、黄牛等动物。依据佛经，释迦牟尼从母亲摩耶夫人右肋下诞生，天降花雨，大地震动，各种瑞兽同时产子；释迦牟尼向四方各行七步，步步生莲花。画面将几种情节集中在一起表现，场面热烈生动。

（撰文：毕华　摄影：安然）

## Anecdotes Series of Buddha's Life Born Under the Tree

12th Century

Height 80cm, width 115cm

Unearthed from Donggar Murals Cave No.1, Ngari, Tibet. Preserved on the original site.

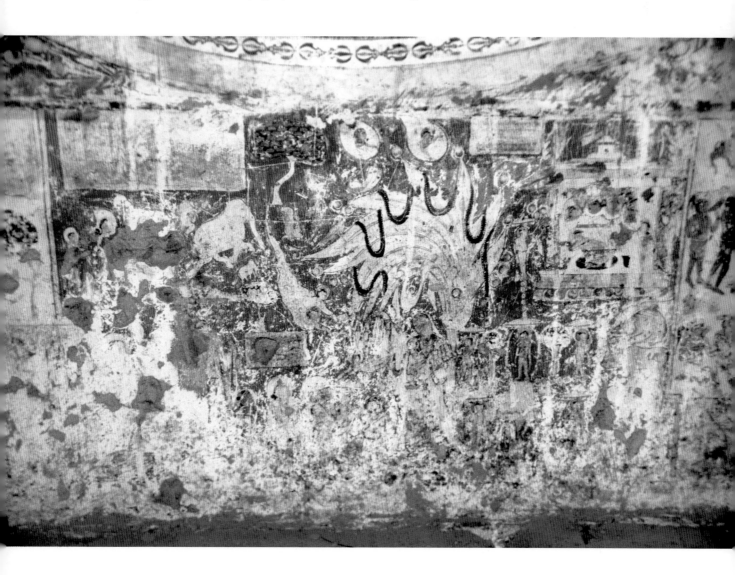

## 190. 十一面观世音像

12世纪

高94、宽72厘米

西藏札达县东嘎遗址Ⅰ区一号窟北壁。原址保存。

双足齐立在莲花台上的观世音，六臂十一面，身白色、苗条，有明显S形造型，戴镯、钏等饰物。左右为胁侍菩萨文殊和金刚手。胁侍圆隆的双乳和下腹，以及纤细的腰身处理，呈现出当时西藏西部菩萨造型的特征。

（撰文、摄影：安然）

## Eleven-Faced Avalokitesvara

12th Centtury

Height 94 cm; Width 72cm

Unearthed from Donggar Murals Cave No.1, Ngari, Tibet. Preserved on the original site.

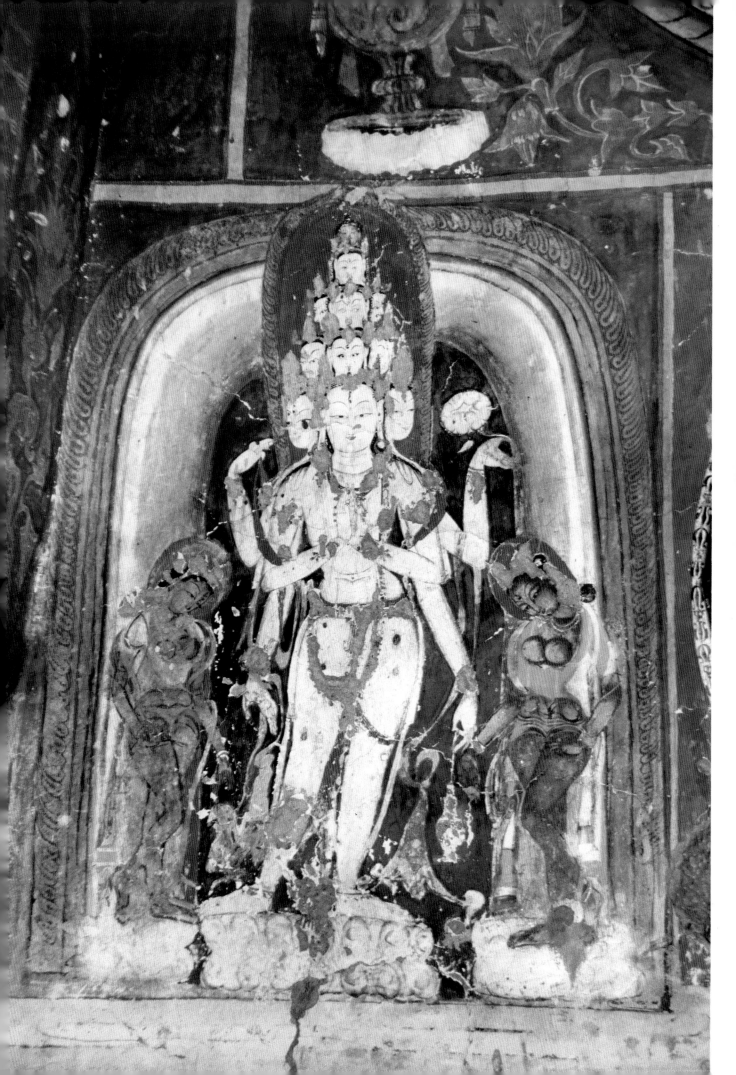

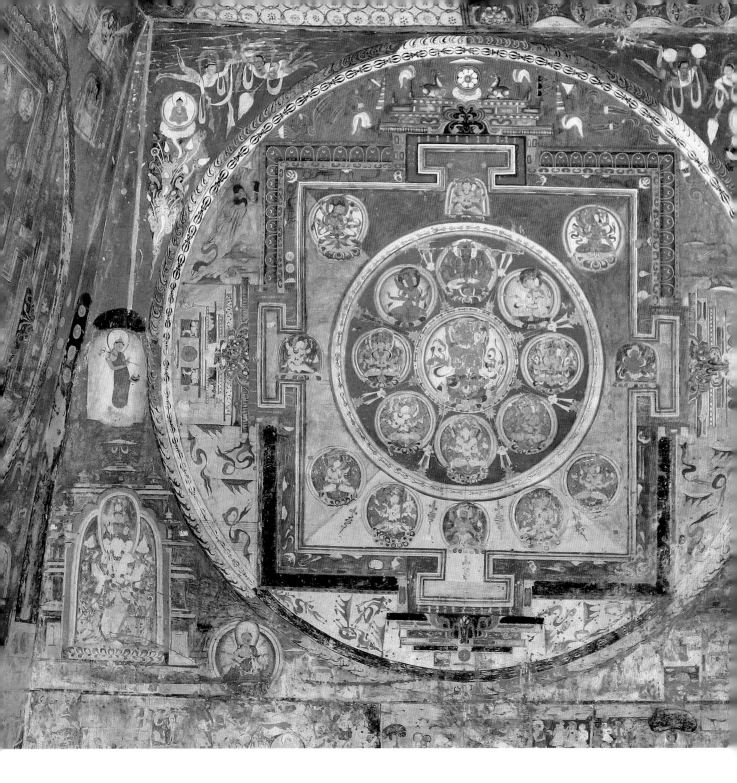

## 191. 文殊师利根本曼陀罗（左）和金刚萨埵曼陀罗（右）

12世纪

高4.24、宽6.47米

西藏札达东嘎遗址Ⅰ区一号窟内。原址保存。

曼陀罗是藏传佛教中十分重要而又意义深远的象征符号。一般理解为修法时众神齐聚、防魔入侵时的坛城或道场。两曼陀罗院外中央绘有伎乐天，吹号、击鼓、摇铃，体态轻盈，造型优美。

<div style="text-align: right">（撰文、摄影：安然）</div>

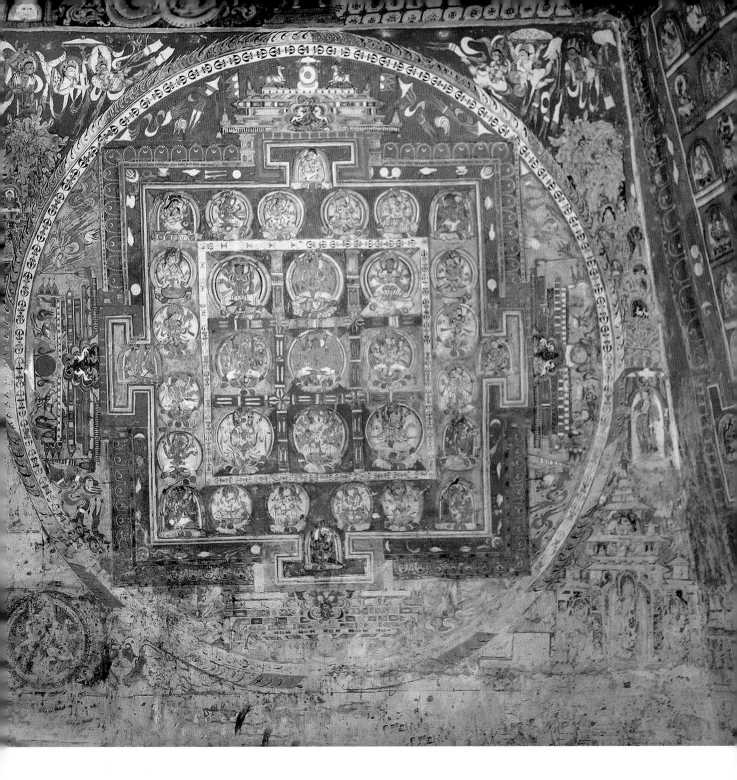

## Manjusri Mandala (Left), Vajrasattva Mandala (Right)

12th Centtury

Height 424 cm; Width 647 cm

Unearthed from Donggar Murals Cave No.1, Ngari, Tibet. Preserved on the original site.

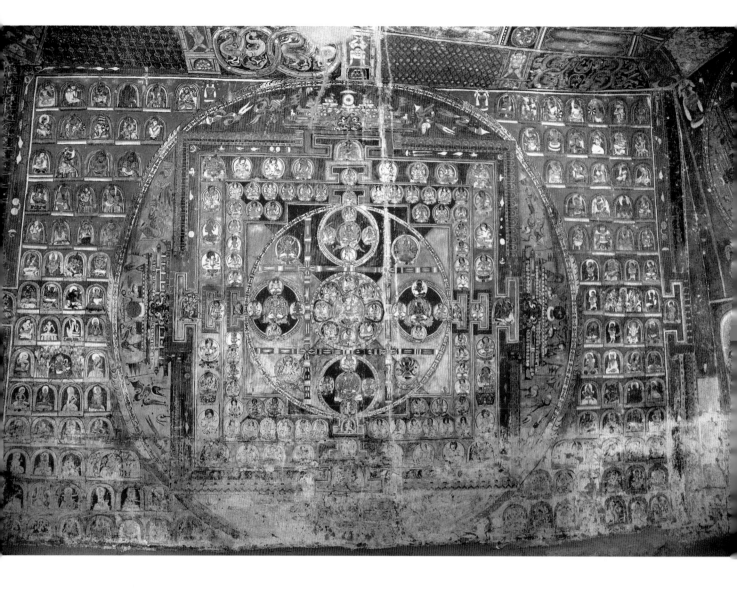

## 192. 普明大日如来曼陀罗

12世纪

高4.24、宽6.47米

西藏札达东嘎遗址Ⅰ区一号窟。原址保存。

位于东壁内宫中心院的大日如来恩惠众生，是至上伟人。周围是四空行母和四供养天女。一至四院为佛、菩萨、法器、天女、大成就者、夜叉、共命鸟等。其中四院的哺婴图尤为生动，图中母亲在为两子哺乳，14个孩子在周围嬉戏。人物神情惟妙惟肖，生活气息浓郁。

（撰文、摄影：安然）

## Sarvavid-Vairocana Mandala

12th Centtury

Height 424 cm; Width 647 cm

Unearthed from Donggar Murals Cave No.1, Ngari, Tibet. Preserved on the original site.

### ▲193. 佛传故事——白象入胎图

13世纪

高约60、宽约80厘米

西藏札达县托林寺迦萨殿十一号房址出土。原址保存。

位于礼拜道东侧。为分幅连环画佛传故事壁画中的一幅，表现释迦牟尼的母亲摩耶夫人梦见白象入胎的情节。画面左上方是一只即将投胎的白象，头部及前腿略残，身搭红色鞍鞯。摩耶夫人侧卧榻上，右手支颐，头戴花冠，身穿短袖衫，盖彩被，一只小白象正在钻入被中。榻后有五个宫女隔帷帐注视摩耶夫人，其中三人以手护持。下方绘两层平顶藏式小楼，象征伽比罗卫城的王宫。

（撰文：张建林　摄影：宗同昌）

#### Anecdotes Series of Buddha's Life: White Elephant Entering Mother's Womb

13th Century

Height 60 cm; Width 80 cm

Unearthed from the 11th Building Site of Gyasa Hall at Tuolin Temple in Zhada, Tibet. Preserved on the original site.

### ▼194. 佛传故事——树下诞生图

13世纪

残高约70、宽约40厘米

西藏札达县托林寺迦萨殿十一号房址出土。原址保存。

画面表现释迦牟尼降生的情节。摩耶夫人在蓝毗尼园的无忧树下，右手攀无忧树枝，释迦牟尼从母亲右肋下出生。一侍女在摩耶夫人身旁护持，一天人用白色条帛承接出生的释迦牟尼，另有三面天人站立旁侧关注释迦牟尼降生。右上方是小释迦牟尼垂手站立在白色莲台上。画面构图紧凑，无忧树变形夸张，人物动态表现较好。

（撰文：张建林　摄影：宗同昌）

#### Anecdotes Series of Buddha's Life: Born Under the Tree

13th Century

Surviving height ca. 70 cm; Width ca. 40 cm

Unearthed from the 11th Building Site of Gyasa Hall at Tuolin Temple in Zhada, Tibet. Preserved on the original site.

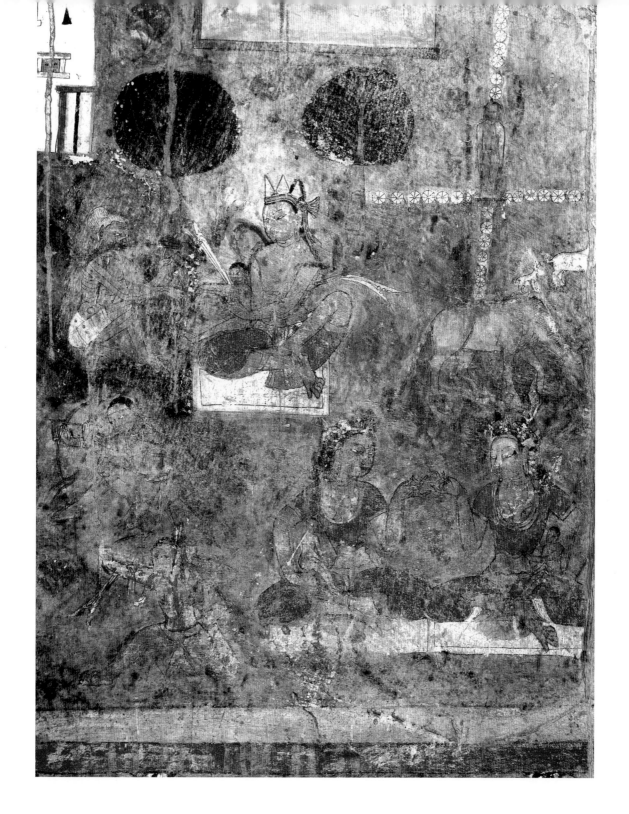

## 195．佛传故事——步步生莲、阿私陀占相、释迦牟尼成长图

13世纪

高82、宽50厘米

西藏札达县托林寺迦萨殿十一号房址出土。原址保存。

位于礼拜道东壁。画面中表现较多情节，右上方表现释迦牟尼出生后向四方各行七步，步步生莲。左上方表现阿私陀为之占相，预言释迦牟尼或为转轮王，或为大觉悟者。右下方是姨母和乳母抚育释迦牟尼。左下方是释迦牟尼年幼时习武强身的场面。

（撰文：张建林　摄影：宗同昌）

Anecdotes Series of Buddha's Life: Appearance of Lotus; Prophecy; Growth

13th Century

Height 82 cm; Width 50 cm

Unearthed from the 11th Building Site of Gyasa Hall at Tuolin Temple in Zhada, Tibet. Preserved on the original site.

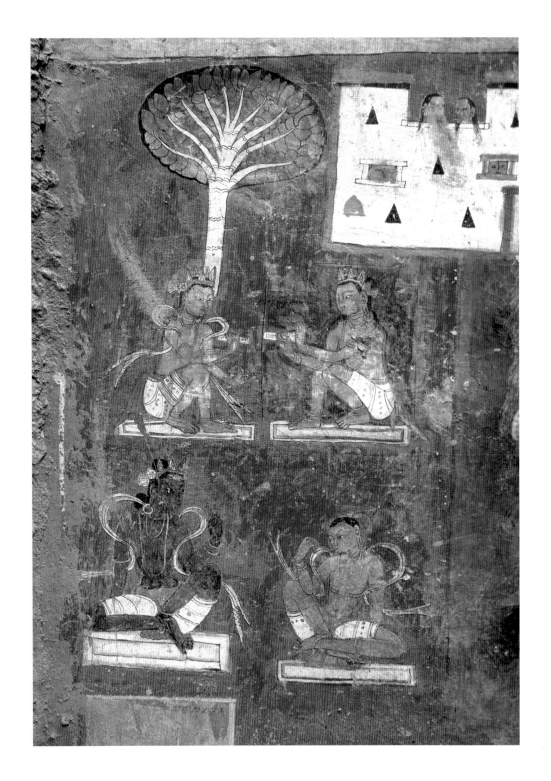

## 196．佛传故事——学书习定图

13世纪

高82、宽40厘米

西藏札达县托林寺迦萨殿十一号房址出土。原址保存。

位于礼拜道南壁。画面表现释迦牟尼向老师学习文字、书法的场面。右上角一栋藏式三层平顶小楼横跨左右两幅之间，象征王宫。上半部的右侧是坐于带背屏坐垫上的老师，一手持书，一手持笔，释迦牟尼与老师对坐，同样持笔和书。上部一棵大树，周围点缀花草。下半部释迦牟尼与老师相向而坐，似在一问一答。

（撰文、摄影：张建林）

Anecdotes Series of
Buddha's Life: Learning

13th Century

Height 82 cm; Width 40 cm

Unearthed from the 11th Building
Site of Gyasa Hall at Tuolin Temple
in Zhada, Tibet. Preserved on the
original site.

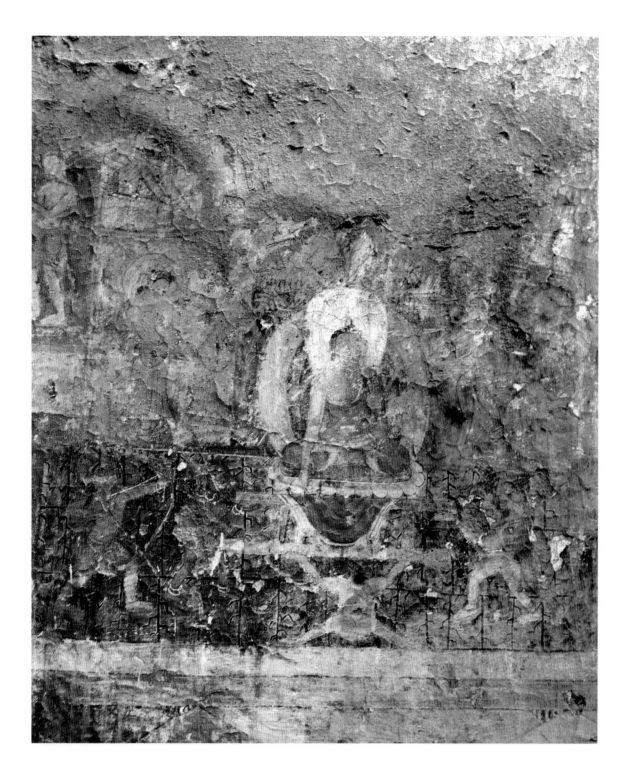

## 197．佛传故事——降魔图

13世纪

残高约60厘米、宽68厘米

西藏札达县托林寺迦萨殿十一号房址出土。原址保存。

位于礼拜道北壁。上半部残损。释迦牟尼结跏趺坐于菩提树下的金刚座上，左手结无畏印，右手结触地印。左侧是两个搔首弄姿的少女，右侧是两个形容枯槁的老妪，表现释迦牟尼用法力将引诱他的两个少女变成老妪。下方两侧是干扰释迦牟尼的妖魔，或张弓射箭，或用力摇撼佛座。

（撰文、摄影：张建林）

13th Century

Surviving heigh 60 cm; Width 68 cm

Unearthed from the 11th Building Site of Gyasa Hall at Tuolin Temple in Zhada, Tibet. Preserved on the original site.

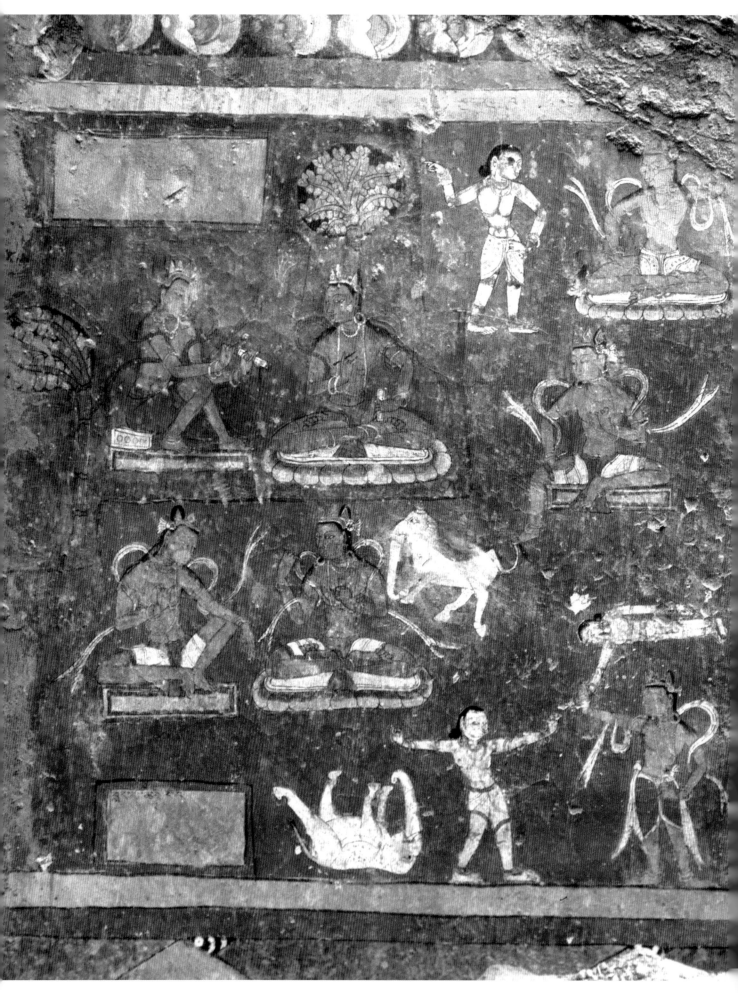

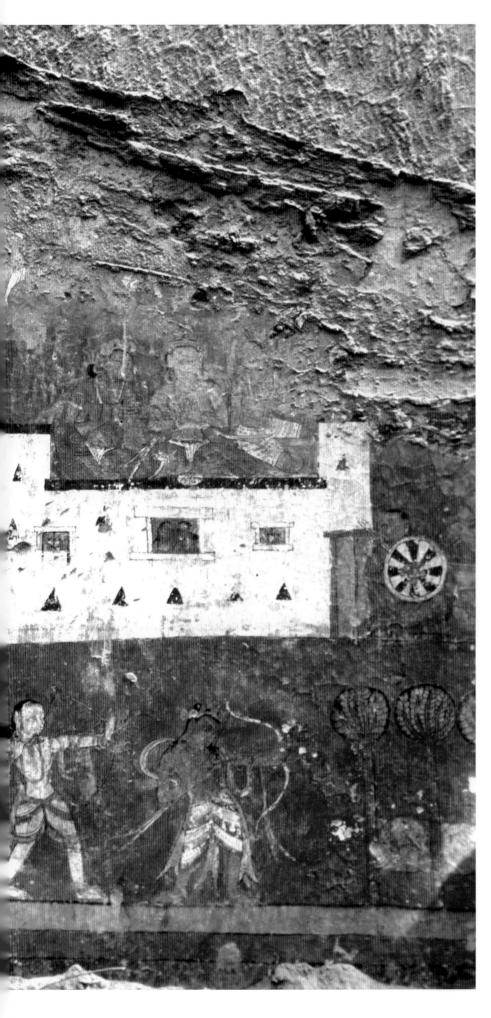

## 198．佛传故事——婚配赛艺、宫中生活图

13世纪

高85、宽约110厘米

西藏札达县托林寺迦萨殿十一号房址出土。原址保存。

位于礼拜道南壁。画面表现净饭王为释迦牟尼选妃所进行的各种比赛以及婚后在宫中的生活。左侧是辩论场景，中间是斗象和角力场景，右下方是射箭场景。在这些比赛中释迦牟尼均以超常的能力获胜，如将大象用脚挑出一俱卢舍远，将角力对手抡上头顶，一箭射穿七只铁鼓和铁猪。右上角一栋藏式平顶二层小楼表示王宫，释迦牟尼坐于屋顶正中，两侧各一王妃，楼下门外有持盾卫兵守卫。

（撰文、摄影：张建林）

## Anecdotes Series of Buddha's Life: Marriage Activities; Life in the Court

13th Century

Height 85 cm; Width 110 cm

Unearthed from the 11th Building Site of Gyasa Hall at Tuolin Temple in Zhada, Tibet. Preserved on the original site.

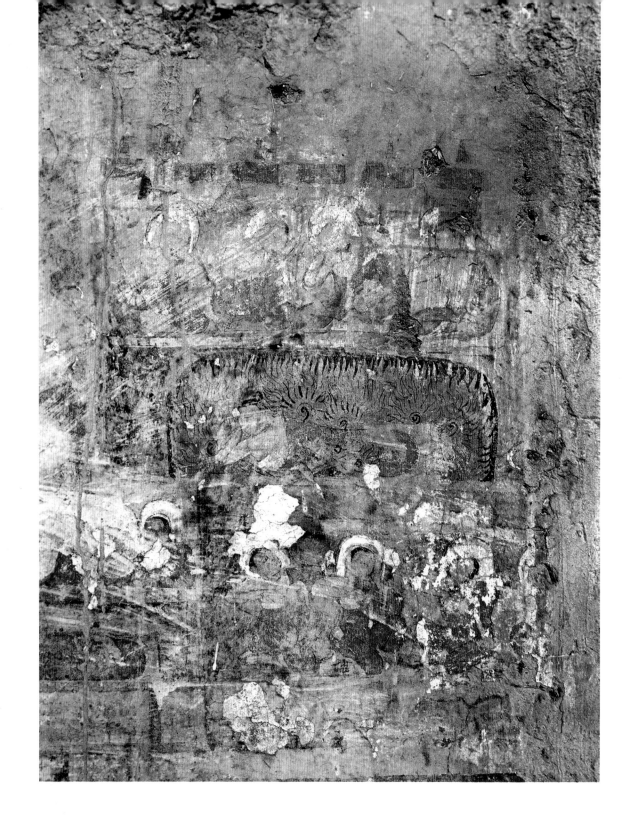

## 199. 佛传故事——荼毗、建八塔图

13世纪

高约60、宽36厘米

西藏札达县托林寺迦萨殿十一号房址出土。原址保存。

位于礼拜道北壁。"荼毗",梵语火化意。画面中间是侧卧在台上的释迦牟尼,右手支颐,身穿红色袒右袈裟,周身火焰升腾,近身的火焰绘成菊花状。山下各有四个悲痛欲绝的弟子或捶胸顿足、或抱头痛哭。最上方有一排佛塔,虽已模糊不清,但仍可看出有六个红色塔座和白色的塔身,应为八王分舍利后建立的八塔。

（撰文、摄影：张建林）

Anecdotes Series
of Buddha's Life:
Cremation; Eight Stupas

13th Century
Height ca. 60 cm; Width 36 cm
Unearthed from the 11th Building
Site of Gyasa Hall at Tuolin Temple
in Zhada, Tibet. Preserved on the
original site.

# 200．行走的三佛像

13世纪

残高45、宽72厘米

西藏札达县托林寺迦萨殿十六号房址出土。原址保存。

位于房址北壁。构图简洁，画面上三佛身体稍侧，似相随徐徐前行。后两佛头部残损，前者头顶有肉髻，头周有头光，身穿红色袒右袈裟，长及脚踝，跣足。三佛姿势略同，胯稍前扭。每尊佛前各伸出一支莲蕾。线条纤细流畅，色彩单一。

（撰文、摄影：张建林）

## Walking Tri-Buddha

13th Century

Surviving height 45 cm; Width 72 cm

Unearthed from the 16th Building Site of Gyasa Hall at Tuolin Temple in Zhada, Tibet. Preserved on the original site.

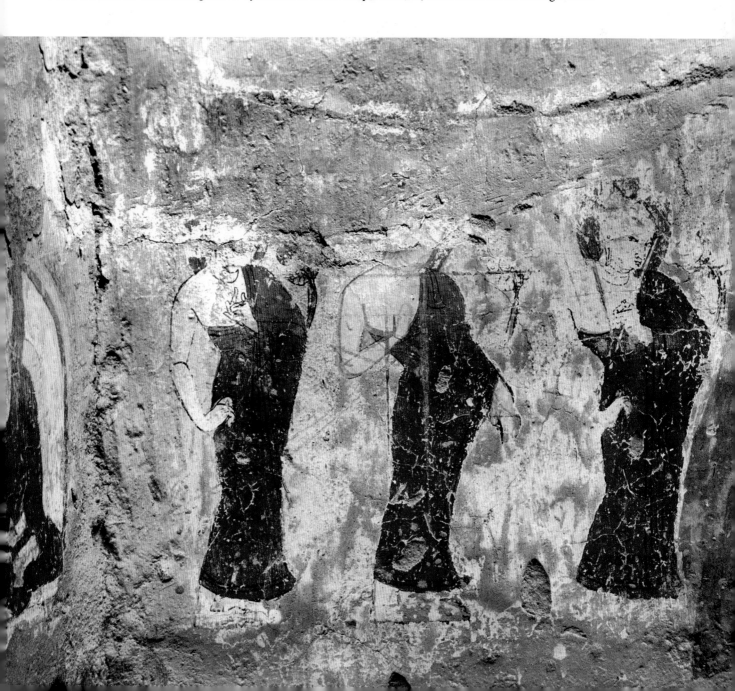

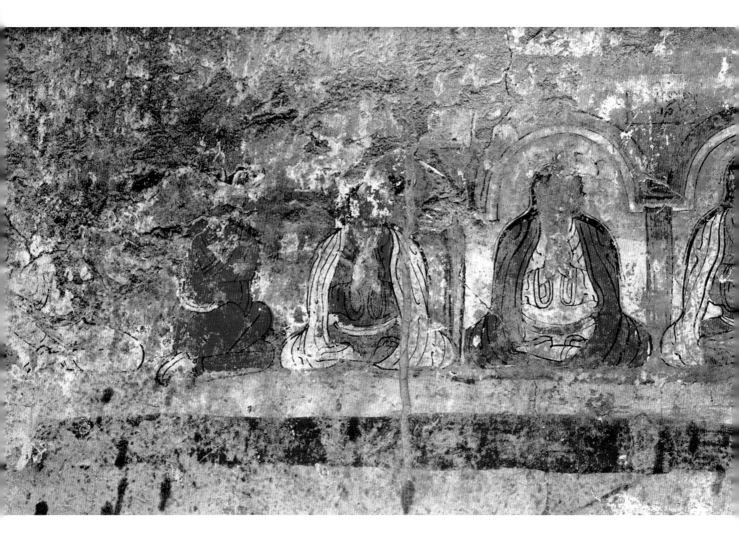

## 201. 供养人群像

13世纪

高20、宽约120厘米

西藏札达县托林寺迦萨殿十六号房址出土。原址保存。

位于房址南壁。在壁面的下方横向绘出一排连拱长廊，每个拱门中一个盘腿而坐的供养人。中间六个供养人形象、姿势、服饰略同，长发披肩，头顶似有缠巾，外罩披风，内穿交领长袍，腰系带，足穿靴，均为结跏趺坐。两侧两供养人无披风，游戏坐。连拱之间原有藏文题名，多漫漶不可辨识。

（撰文：张建林　摄影：宗同昌）

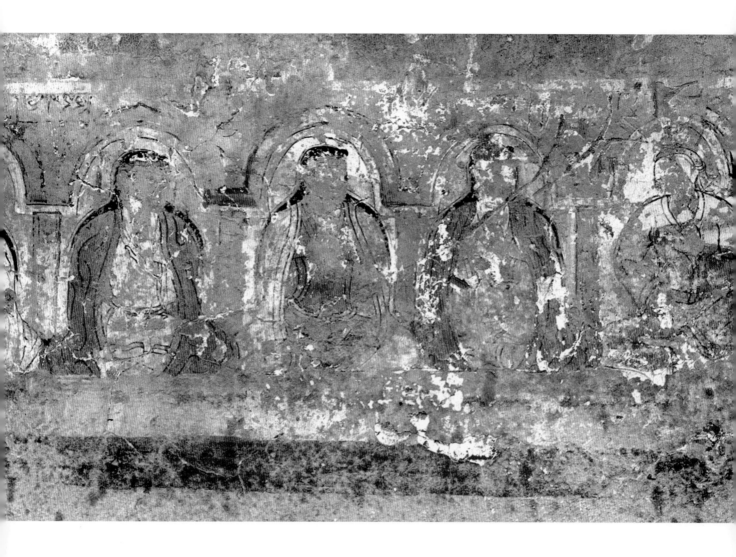

## Portraits of Sponsors

13th Century

Height 20 cm; Width ca. 120 cm

Unearthed from the 16th Building Site of Gyasa Hall at Tuolin Temple in Zhada, Tibet. Preserved on the original site.

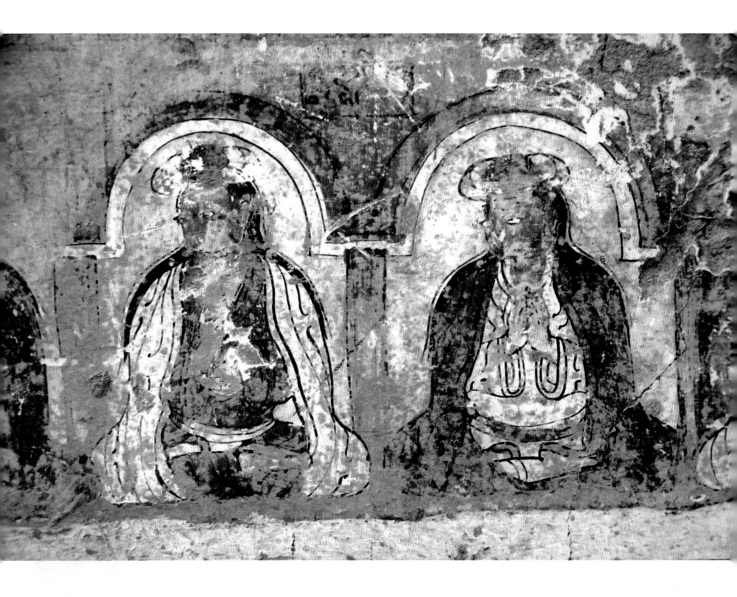

## 202．供养人像（局部）

13世纪

高20、宽32厘米

西藏札达县托林寺迦萨殿十六号房址出土。原址保存。

位于房址南壁。供养人结跏趺坐于拱门之中，头顶以缠巾为冠，长发披肩，外罩披风，内传交领长袍，腰系带，足穿靴。线条洗练，色彩简单，服装仅红白二色。连拱之间有藏文题名。

（撰文、摄影：张建林）

## Portraits of Sponsors (Detail)

13th Century

Height 20 cm; Width 32 cm

Unearthed from the 16th Building Site of Gyasa Hall at Tuolin Temple in Zhada, Tibet. Preserved on the original site.

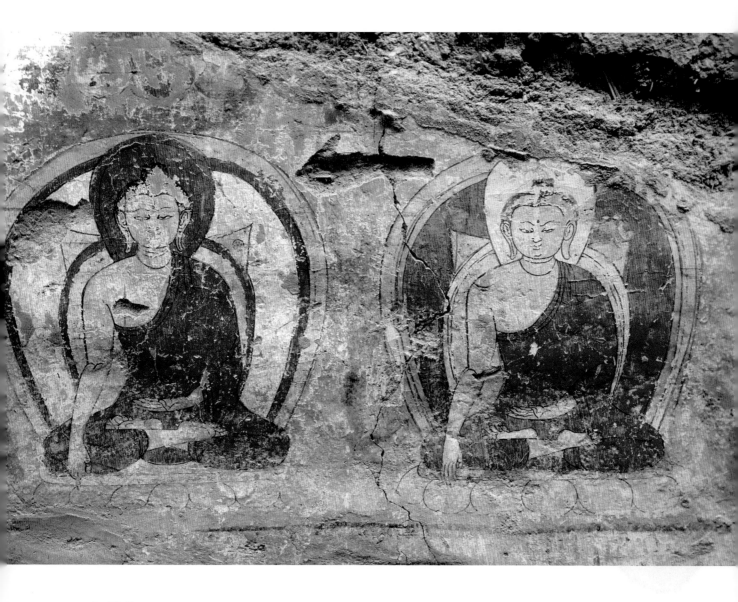

## 203. 坐佛像

13世纪

高23、宽40厘米

西藏札达县托林寺迦萨殿十六号房址出土。原址保存。

位于房址东壁。两尊坐佛除了头光和两圈身光之间的色彩有别，造型、服饰等相同。较小的肉髻，脸部几乎呈圆形，五官小巧而集中，眉间的白毫呈雨滴状。身穿红色的袒右袈裟，左手定印，右手触地印，结跏趺坐，这是释迦牟尼降魔成道的典型坐姿。头光和内外身光略呈圆形，内身光上方两侧有三角形炎肩。线条纤细圆滑，设色淡雅。

（撰文、摄影：张建林）

## Seated Buddha

13th Century

Height 23 cm; Width 40 cm

Unearthed from the 16th Building Site of Gyasa Hall at Tuolin Temple in Zhada, Tibet. Preserved on the original site.

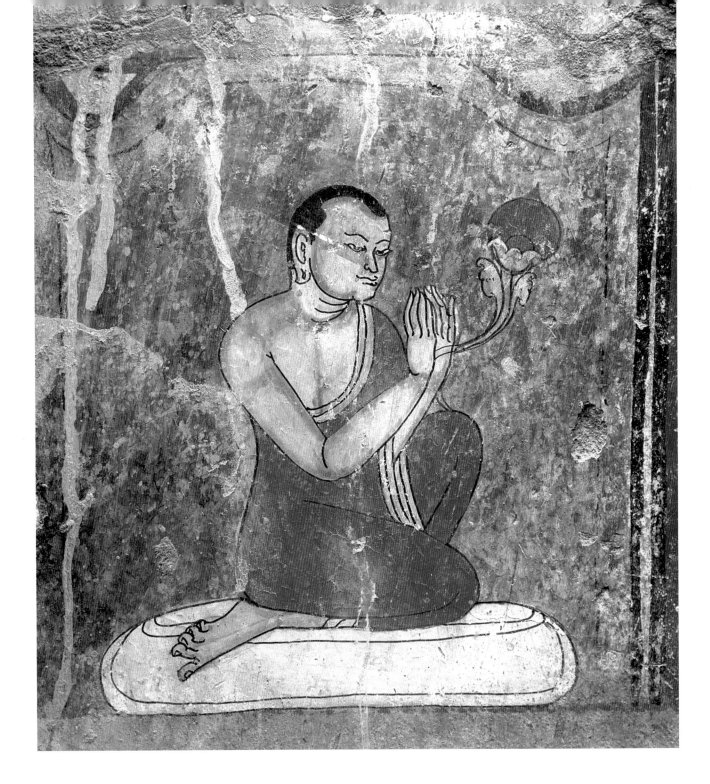

## 204. 僧人礼佛图

13世纪

高约40、宽约50厘米

西藏札达县托林寺迦萨殿十七号房址出土。原址保存。

位于房址南壁。蓝色为地的方框内绘礼佛的僧人，圆脸短发，着红色袒右袈裟，双手合十持一茎莲蕾，跪坐于圆形坐垫上，神情虔诚。

<div style="text-align:right">（撰文：张建林　摄影：宗同昌）</div>

## Worshiping Monk

13th Century

Height ca. 40 cm; Width ca. 50 cm

Unearthed from the 17th Building Site of Gyasa Hall at Tuolin Temple in Zhada, Tibet. Preserved on the original site.

## 205. 鹅王本生图

13世纪

残高约50、宽36厘米

西藏札达县托林寺迦萨殿二号房址出土。原址保存。

位于房址北壁。上部藏文残损。画面呈圆形，周有红色边框。11只鹅浮游水面，中间两只形体较大，正中者应为鹅王，其余众鹅或振翅欲飞，或引颈觅食。佛经云："尔时菩萨鹅王，名曰善时。摄诸鹅众，以正念心利益一切众生之心。观诸鹅众，心受快乐。"

（撰文、摄影：张建林）

## Anecdotes Series of Buddha's Previous Life: King of Geese

13th Century

Surviving height ca. 50 cm; Width 36 cm

Unearthed from the 17th Building Site of Gyasa Hall at Tuolin Temple in Zhada, Tibet. Preserved on the original site.

## 206. 持宝珠的菩萨像

13世纪

高45、宽88厘米

西藏札达县托林寺迦萨殿二十二号房址出土。原址保存。

位于房址西壁。菩萨肤色靛蓝，头顶束高髻，戴宝珠冠，耳、项、胸、臂、手腕、足腕均佩饰品。上身裸，肩披条帛绕臂飘向两侧，下身穿长裙，结跏趺坐于覆莲座上。左手握拳置左胯前，右手持火焰宝珠。有圆形红色头光、身光。左侧有装饰性很强的大小树各一株。

（撰文：张建林　摄影：宗同昌）

## Bodhisattva Holding a Pearl

13th Century

Height 45 cm; Width 88 cm

Unearthed from the 22nd Building Site of Gyasa Hall at Tuolin Temple in Zhada, Tibet. Preserved on the original site.

## 207．湖中游鱼图

13世纪

高约40、宽约80厘米

西藏札达县托林寺迦萨殿二十二号房址出土。原址保存。

位于房址西壁。椭圆形的湖岸线，湖水碧蓝，五条细长的鱼在水中游弋，岸边有小山和大树。色彩浓艳，造型夸张，极具装饰意味。

（撰文：张建林　摄影：宗同昌）

## Swimming Fishes in the Lake

13th Century

Height ca. 40 cm; Width ca. 80 cm

Unearthed from the 22nd Building Site of Gyasa Hall at Tuolin Temple in Zhada, Tibet. Preserved on the original site.

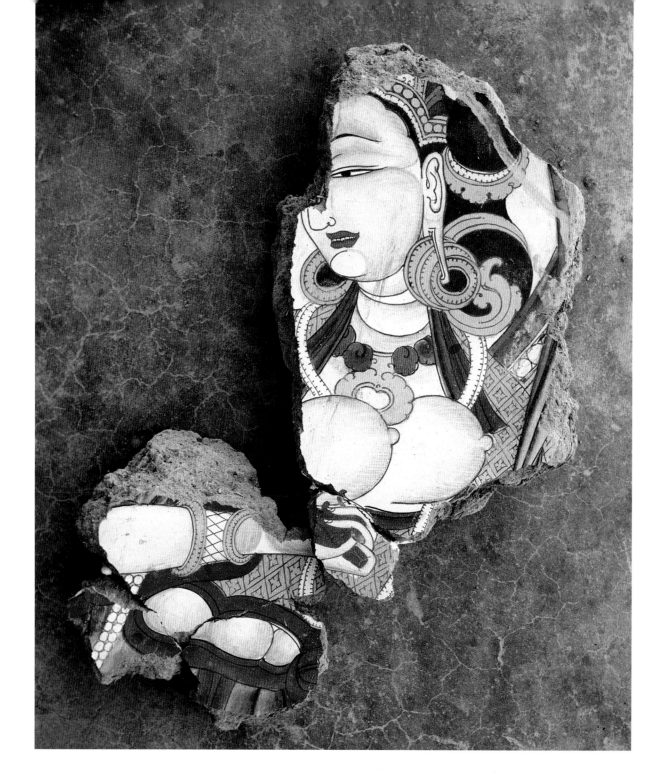

## 208．菩萨像

13世纪

残高52、残宽40厘米

西藏札达县托林寺迦萨殿九号房址出土。现存于西藏博物馆。

房址中的原位置不明。菩萨肌肤丰满圆润，头饰、耳饰、胸饰华丽，头戴宝冠，长发后披，上着紧身半袖衫，袒胸露腹。肌肤用晕染法表现凹凸。

（撰文、摄影：张建林）

## Bodhisattva

13th Century

Surviving height 52 cm; Width 40 cm

Unearthed from the 9th Building Site of Gyasa Hall at Tuolin Temple in Zhada, Tibet. Preserved in the Tibet Museum.

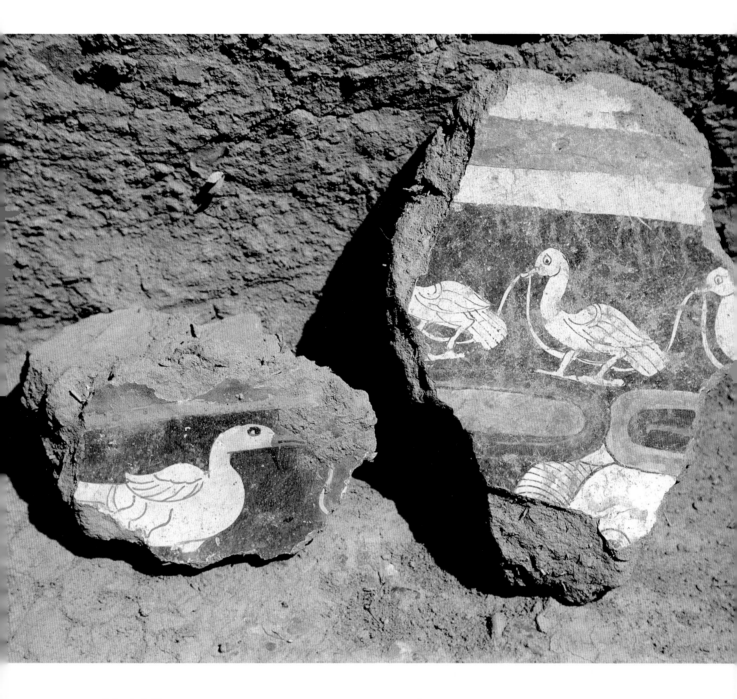

## 209. 鸭衔绶带

13世纪

右侧残块高36、宽22厘米；左侧残块高10、宽18厘米

西藏札达县托林寺迦萨殿九号房址出土。现存于西藏博物馆。

房址中的原位置不明。此类鸭衔绶带图案通常出现在壁面顶端，作为上部装饰条带。两块显然不是一个壁面的。右者鸭次第相随，口衔同一条长绶带。白鸭黑地，反差强烈。

（撰文、摄影：张建林）

## Ducks Holding Ribbons

13th Century

Right: surviving height 36 cm; Width 22 cm; Left: surviving height 10 cm; Width 18 cm

Unearthed from the 9th Building Site of Gyasa Hall at Tuolin Temple in Zhada, Tibet. Preserved in the Tibet Museum.

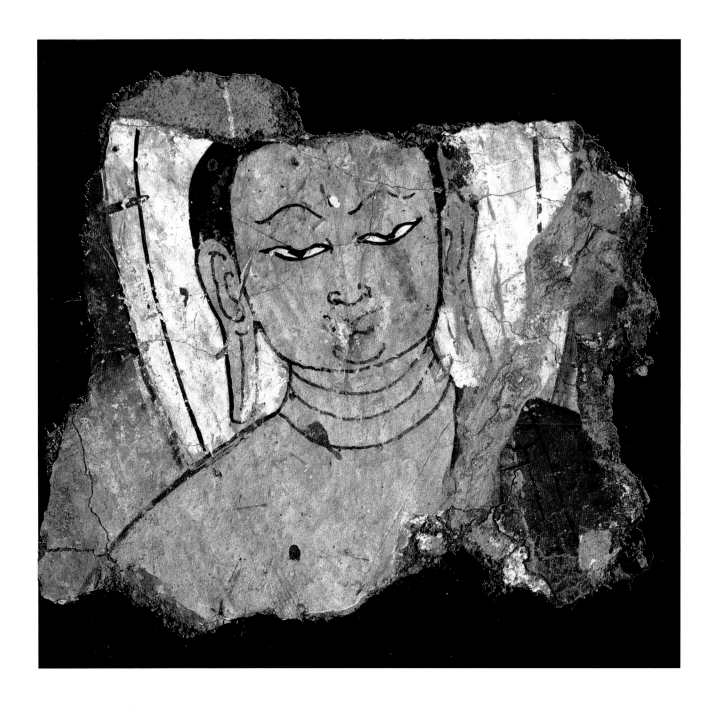

## 210. 佛头像

13世纪

残高28、残宽42厘米

西藏札达县托林寺阿扎惹拉康出土。现存于西藏博物馆。

房址中的原位置不明。肤色青灰，头顶残损，面部浑圆，大耳垂肩，弯眉细目，上眼睑如弯弓，眉间有白毫，穿袒右袈裟。有白色椭圆形头光。

（撰文：张建林　摄影：宗同昌）

## Buddha's Head

13th Century

Surviving height 28 cm; Surviving width 42 cm

Unearthed from Azharelakang at Tuolin Temple in Zhada, Tibet. Preserved in the Tibet Museum.

# 211. 佛传故事图

13世纪

高29、残宽约260厘米

西藏札达县托林寺玛尼拉康出土。原址保存。

位于西壁壁面下方，以分幅长卷的形式表现佛传故事，其上残存有千佛壁画。残存的佛传故事壁画地仗层开裂脱落，表面严重褪色，但仍可辨有婚配赛艺、宫中生活、出家、转法轮等画面。画幅较小，构图紧凑。

（撰文、摄影：张建林）

## Anecdotes of Buddha's Life

13th Century

Height 29 cm; Surviving width ca. 260 cm

Unearthed from Manilakang at Tuolin Temple in Zhada, Tibet. Preserved on the original site.

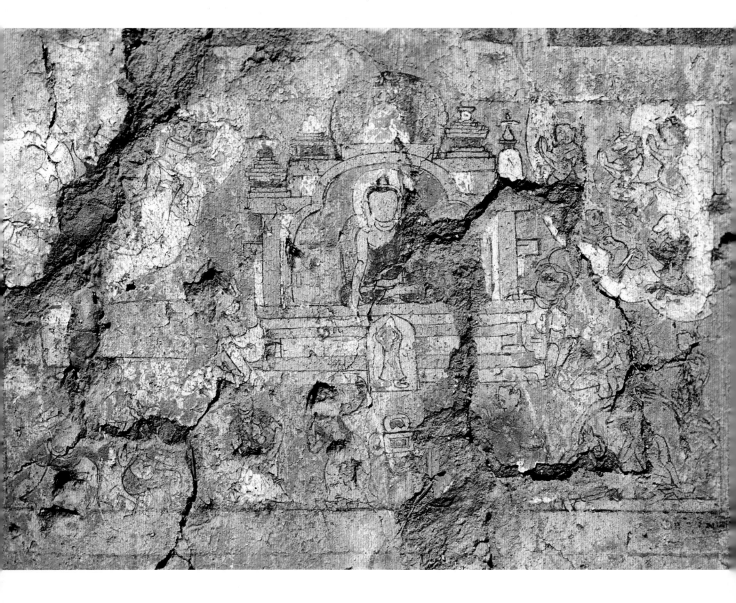

## 212. 佛传故事——转法轮图

13世纪

高29、宽42厘米

西藏札达县托林寺玛尼拉康出土。原址保存。

位于西壁画面正中。为端坐在拱形龛中的释迦牟尼，龛上部中间有一尊小坐像，两侧各有两塔，下面两侧各有一力士用力抬起龛座。周围有各色人等、各种动物向佛陀合掌礼拜。表面色彩脱落严重，仅具墨线勾勒的轮廓和白、红、蓝等较为稳定的颜色。

（撰文：张建林　摄影：宗同昌）

## Anecdotes Series of Buddha's Life: Rotating the Cakra

13th Century

Height 29 cm; Width 42 cm

Unearthed from Manilakang at Tuolin Temple in Zhada, Tibet. Preserved on the original site.

## 213. 佛转故事——观众宫女睡相

14世纪

高约40厘米、宽约60厘米

西藏札达县达巴遗址A区佛殿，原址保存

该佛殿遗址出土壁画均为墙壁下部，多为佛传故事画。画面表现释迦牟尼身为王子时，在宫中的生活场景。一栋饰有宝珠顶的建筑表示王宫，释迦牟尼坐于王宫的卧榻正中，两侧各一王妃偎依，宫殿外有持盾卫兵守卫。

（撰文：毕华　摄影：安然）

**Anecdotes Series of Buddha's Life: Watching Sleeping Maids**

14th Century

Height ca. 40cm, width ca. 60cm .

Unearthed from Buddhist Temple in Region A of Datat Site in Zanda, Tibet. Preserved on the original site.

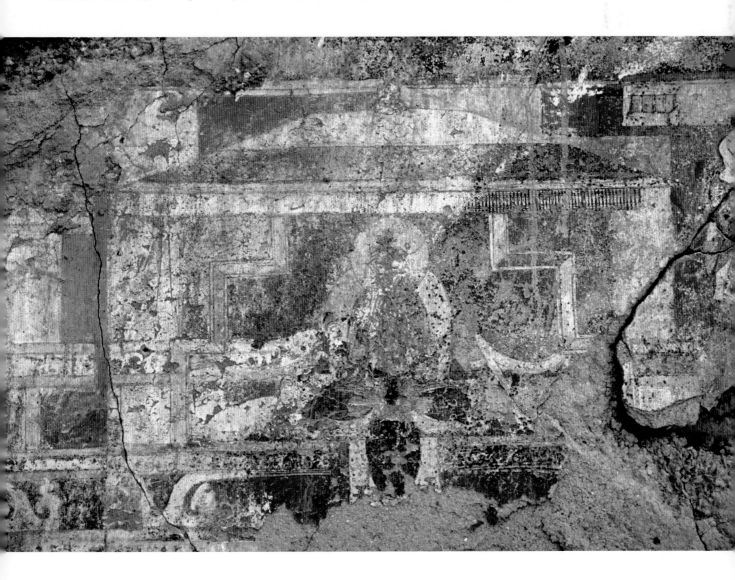

## 214. 力士图

14世纪

高约30厘米、宽约20厘米

西藏札达县达巴遗址A区佛殿，原址保存

此图绘于佛像须弥座束腰部分。力士上身赤裸，下着短裙，足穿高靿藏靴，细长的帛带由双肩绕过双臂飘向两侧。右脚前伸，左脚蹬地，手上举，作奋力扛顶佛座状。

<div align="right">（撰文：毕华　摄影：安然）</div>

## Dvarapala Guardian

14th Century

Height ca. 30cm, width ca. 20cm

Unearthed from Buddhist Temple in Region A of Datat Site in Zanda, Tibet. Preserved on the Original site.

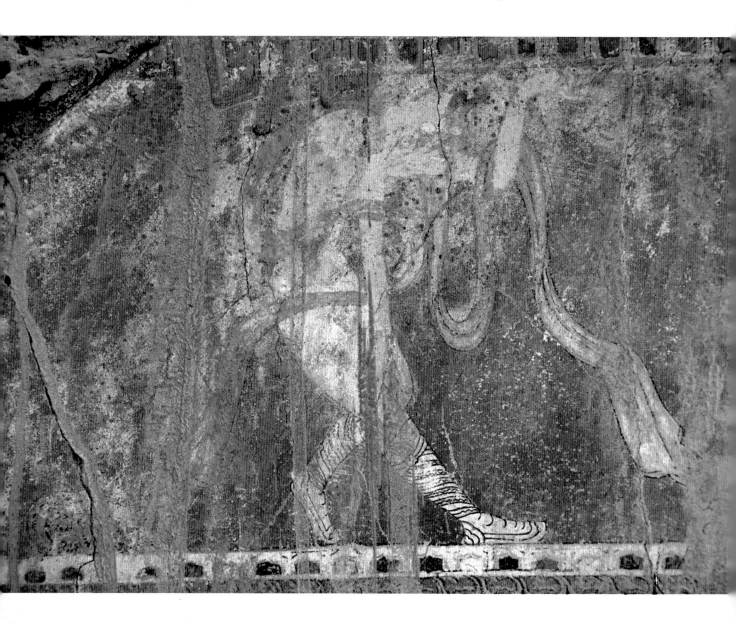

## 215．金刚杵纹装饰图案

16世纪

残高约55、宽约80厘米

西藏萨迦县萨迦北寺法王寝殿北壁出土。

法王寝殿位于萨迦北寺得确颇章(胜乐宫殿)院内北部，据载为阿羌·扎巴罗追所建。建筑损坏严重，壁画仅存部分装饰图案。图案是金刚杵和对称的五联变形莲花。两图案间隔排列成二方连续装饰条带，由粗细不等的墨线绘制，精细而不拘谨，随意而又规矩。

（撰文：毕华　摄影：安然）

## Vajras

16th Century

Surviving Height ca. 55 cm; Width ca. 80 cm

Unearthed from Chos rje Lhakhang, the Northen Monastery of Saskya, Saskya County, Tibet. Preserved on the original site.

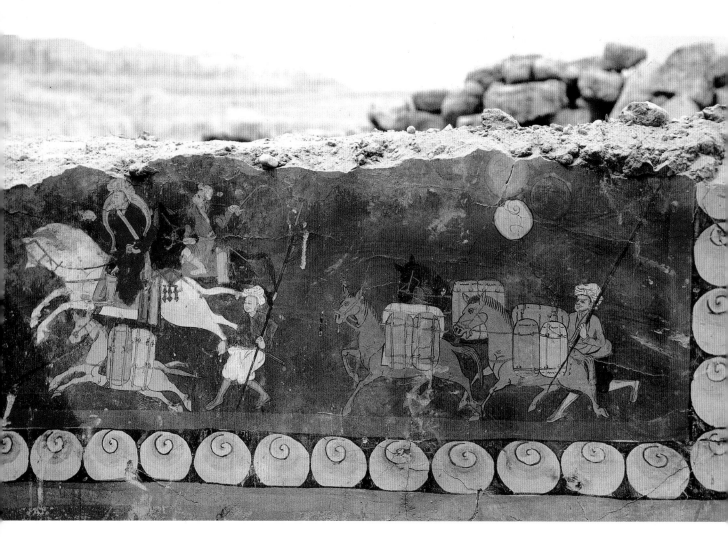

# 216. 行旅图

18世纪

残高62、宽125厘米

古格故城毗沙门天殿出土。原址保存。

位于西壁。画面左侧是一长一幼两位主人骑马疾驰，长者头缠青巾，穿红色左衽长袍，足穿高筒靴，左手执缰。白马鞍鞯俱全，马具华丽。幼者头戴白巾，穿青色长袍，扬鞭催马。后有两随从，手持长矛，驱赶驮着包囊的四匹马奔跑。下面和右面有装饰宝珠纹的边框。

（撰文、摄影：张建林）

## Traveling

18th Century

Surviving height 62 cm; Width 125 cm

Unearthed from the Vaisravana Hall of ancient Guge City, Xizang. Preserved on the original site.